Public Art
New Directions

Louis G. Redstone, FAIA

WITH Ruth R. Redstone

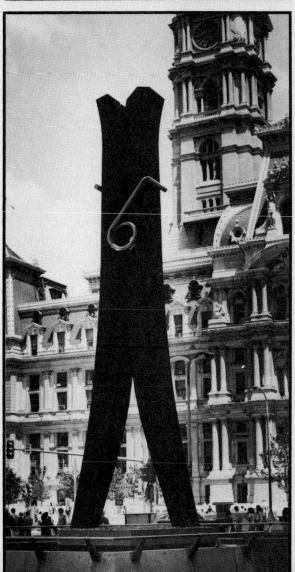

McGraw-Hill Book Company

New York St. Louis San Francisco Auckland
Bogotá Hamburg Johannesburg London
Madrid Mexico Montreal New Delhi
Panama São Paulo Singapore
Sydney Tokyo Toronto

To our sons, Daniel and Eliel, and to architects,
artists, and civic leaders of all countries
for whom art in the daily living environment
is an essential element

Library of Congress Cataloging in Publication Data
Redstone, Louis G
 Public art.

 Includes index.
 1. Art and state. 2. Art patronage. 3. Art,
Municipal. 4. Street art. I. Redstone, Ruth R., joint author. II. Title
N8798.R42 706'.8 80-16189
ISBN 0-07-051345-7

1234567890 HDHD 8987654321

The editors for this book were Jeremy Robinson
and Christine M. Ulwick, the designer was Naomi Auerbach,
and the production supervisor was Paul A. Malchow.
It was set in Optima by The Clarinda Company.

Printed and bound by Halliday Lithograph.

Contents

OVERVIEW V

PART ONE **The United States and Canada**

ONE **Public Art: Government Sponsored** 3

TWO **Public Art in the Educational and Civic Environment** 35

THREE **Public Art in the Commercial and Corporate Environment** 85

PART TWO **Foreign Countries**

FOUR **Public Art Around the World** 129

Australia · Austria · Belgium · Brazil · Denmark · England · Finland · France Greece · Holland · Ireland · Israel · Italy · Japan · Mexico · New Zealand · Norway · Philippines · Portugal · South Africa · Spain · Switzerland · Sweden · West Germany · Yugoslavia

APPENDIX **Commissioning the Artist** 209

INDEX 211

PHOTOGRAPHERS' CREDITS 2, 128

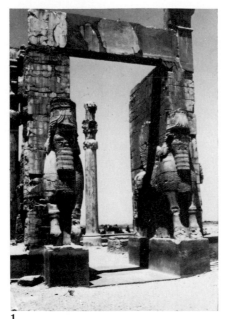

1

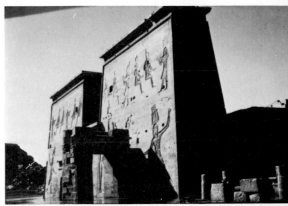

4

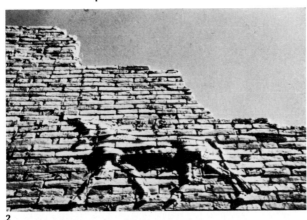

5

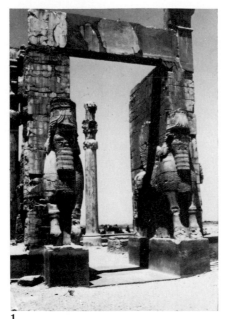

2

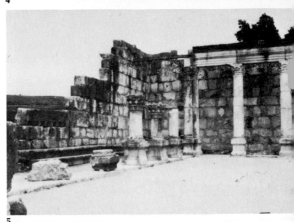

7

3

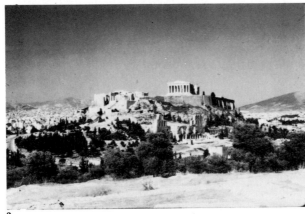

6

Since the beginning of human history, there has always existed the quest to express experience—whether historical, religious, or quotidian—through art. Evidence of this can be seen in the ancient cities of Asia, the Middle East, Africa, and the Americas. In all of these cultures, there can be recognized an intuitive understanding of the interrelation of art forms with both architecture and the total living environment. Then as now, art fulfilled a spiritual need—a function as important as the satisfaction of the utilitarian need. Then as now, art served to stimulate the thoughts of the onlooker and satisfy his or her aesthetic requirements.

It may be of interest to cast a fleeting glance at our rich heritage of public art from the ancient world:

1. Palace—Persopolis, Ancient Persia (Iran), ca. 500 B.C.
2. Brick Mural, Ancient Babylon (Iraq), ca. 575–530 B.C.
3. Parthenon Temple, Acropolis, Greece, 500 B.C.
4. Karnak Temple, Egypt, 1470 B.C.
5. Stone Carvings, Capernaum, Israel, A.D. 200–300
6. Elephants Cave Religious Stone Carvings (Goddess Siva), India, A.D. 600–1200
7. Laliabela Stone Church Carvings, Ethiopia, A.D. 1137.
8. Tower of Four Lakes, Angkor Thom, Cambodia, A.D. 1200
9. Temple of Incas, Machu Picchu, Peru, A.D. 1500
10. Inca religious figures, Tiahuanaco Temple, Bolivia, A.D. 1500

There is a radical difference between the use of art in the ancient and the contemporary world: Art is no longer limited to the domain of temples and palaces. Contemporary art expresses itself in every phase of our environment, and people in every walk of life seek the joy and excitement that art can bring. The contemporary forms of art are integrated with all the elements that create a good living environment.

We believe that today's public art serves the same needs that were served by art in earlier cultures. Today's public art aims to express the multifaceted character of our society, and this trend has been influenced by several factors: the public interest in the arts; the sponsorship and support of art by government on all levels—federal, state, city, and county; educational institutions; commercial and industrial corporations; civic art associations; and an increasing number of art patrons. The 1960s and 1970s saw a significant upswing in the recognition of the importance of art in every phase of daily life. Even more important, these two decades saw the implementation of many programs in the field of public art.

A significant factor in this development was the federal government's interest in introducing art to many federal buildings. This has been accomplished through the revitalized Art-in-Architecture Program, conducted by the General Services Administration (GSA). The favorable reaction that this program has received over the past decade has spurred the GSA not only to continue but to broaden the policy of art for the people. The GSA expanded the range of public art by introducing new forms, including environmental sculpture, earth- and lightworks, kinetic art, murals in various media, and building crafts such as ornamental grills, stained glass, wood, fiber, and fabric arts. The program accelerated efforts to start art projects early in building design, and initial building concepts were expected to include provision for works of art, thereby bringing

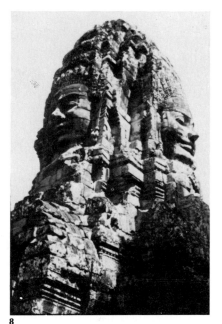

8

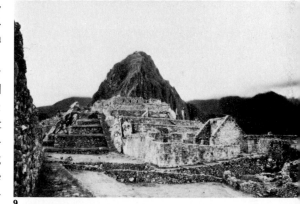

9

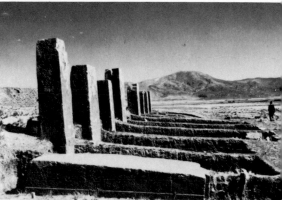

10

together art and architecture at the very conception of the building. The program also includes existing buildings and historic landmarks.

In January 1963, the GSA established an allowance for fine arts of 0.5 to 1 percent of the estimated construction costs for each new federal building. The results of the federal government's interest in this area are seen in the ever-increasing number and quality of the artworks involved. In the period between 1962 and 1966, forty-five works were commissioned. The program was temporarily halted from 1966 to 1972 because of inflation in the construction industry and a lack of funding in the budget. As of October 1978, the GSA had commissioned 136 works for federal buildings located throughout all the states.

In addition to the GSA, the Department of Transportation (DOT) established a policy in 1977 of stressing good design and integrating art and graphics into all the facilities used by the four branches of transportation; these include air terminals, railroad and subway stations, and seaports undergoing renovation in the northeast corridor. A number of important air terminals have commissioned significant works of art, thereby adding a new dimension to the traveler's experience. Outstanding are the international terminals of Miami, Seattle-Tacoma, New York's JFK, Honolulu, Cleveland, Tampa, Dallas–Fort–Worth, and the Michael Berry Terminal in Detroit.

An important stimulus for promotion of the arts was provided by Congress in September 1965, when it established the National Endowment for the Arts (NEA). The first allocation, for the amount of $140,000 was to be used as matching funds for outdoor art placed in public spaces in three geographic sections of the country. Grand Rapids, Michigan made the first request for $45,000 to commission Alexander Calder to build a large steel sculpture, "La Grande Vitesse," on a new site in the downtown renewal area. Private local sources provided matching funds, and the sculpture was installed in 1971. The reaction of the community was so positive that a policy of continuing the commissioning of meaningful works of art became a prime interest and source of civic pride.

The announcement by the NEA in the spring of 1977 of a new architectural program added an important dimension to planners' efforts to improve the quality of life in cities. The "Livable Cities" program was designed to reinforce the basic goals of the NEA, that is, "to make the arts more widely available to Americans, to strengthen cultural organizations, to preserve our rich cultural heritage for present and future generations, and encourage the creative development of our nation's fine talent."*

The budget for the "Livable Cities" program was $1.6 million for the year 1978. Matching grants of up to $30,000 were available for design and planning assistance for research and feasibility studies to groups intending to build, replace, or improve their physical facilities. Eligible activities are architecture, landscape architecture, urban design, city and regional planning, interior design, industrial design, and other recognized design professions. The program gave highest priority to projects that both represent a compelling immediate need and give promise of economic and social benefit to community. The overriding aim of the "Livable Cities" program, according to Geraldine Bachman, Art Specialist, Architecture and Environmental Art Program, is to find "creativity and imagination —to get it from the artist and apply it to the problems of the built environment."

The celebration of the Bicentennial in 1976 was another vital factor "sparking" the commissioning of many artists throughout the country to create large, permanent works of art. The NEA played an important, supportive role by contributing matching funds up to $30,000 for each individual project. Where state councils for the arts were active, they, along with local private-sector funding, also helped to implement significant art programs.

Artrain, a very significant and unique effort to bring art to the people throughout the

*National Endowment for the Arts, *Application Guidelines, Architecture and Environmental Arts Program, Fiscal Year 1978,* Washington, DC.

entire state, was initiated in Michigan in 1971. Artrain is composed of six railroad cars renovated and refurbished to serve as a group of traveling museum rooms and a craft studio. Started by interested citizens and supported by the Michigan Council for the Arts, it has traveled to many towns, villages, and cities statewide, as well as to twenty other states.

Universities and colleges and a wide range of other public institutions are showing an ever-increasing interest in commissioning works of art for their grounds and buildings. In many instances this effort is part of an ongoing program connected with campus expansion projects.

In the commercial field, the regional shopping center continues to play an important role in presenting significant artworks of both regional and national artists. For thousands of shoppers, the presence of art has become an enjoyable experience and an accepted part of daily life. Corporations also have been important leaders in promoting the use of art in both interior and exterior public areas of their office buildings. The concept of public spaces in recently built hotels and theaters also generally includes art as part of the total plan.

Even with these very positive steps initiated by government, educational, institutional, and commercial groups, there still remains a great scope for new as well as recently developed ways to bring the arts to the people on the street. One very successful activity has been the program for mural paintings on building walls in urban areas. In many cities, especially those with sizable ethnic populations, the wall murals depict historic backgrounds and present-day life experiences—as they brighten drab, rundown neighborhoods.

The projects featured in this book have been selected from the United States, Canada, and many countries around the world. Examples in the United States include the art-in-architecture projects of the GSA, the projects funded by matching grants from the NEA, projects sponsored by many states and cities, works of art commissioned by the commercial and industrial private sectors and by educational and art institutions. Examples of public art in Canada likewise vary from government supported to educationally and commercially sponsored. Since 1964 it has been government policy to allocate 1 percent of the building costs of all Canadian federal projects for works of art.

Examples shown from foreign countries include those of western Europe, eastern Europe, South America, Australia, Mexico, Israel, the Philippines, India, Japan, and the Republic of South Africa. The fact that a number of these countries, especially in western Europe, make by law, an allocation for art in public and educational buildings has contributed greatly to the ever-increasing number of completed, as well as planned, environmental art projects. Art goes underground in subway stations of large cities in the United States, Canada, and abroad.

It is our sincere hope that this book will, in some measure, encourage leaders at all levels of government, architects and planners, and civic and business leaders to advance the environmental arts and that it will stimulate the general public to become aware of the value of beauty in everyday life.

Louis G. Redstone
Ruth R. Redstone

Acknowledgments

During the preparation of this material, we have become greatly indebted to the many chapters of the American Institute of Architects and the architectural societies of many foreign countries that publicized this project among their members; to the Washington embassies of the countries represented in this book; to the government agencies who administer the public art programs, especially in the United States, Canada, and in a number of foreign countries; to the many universities that are implementing public art programs; to the many museum and art gallery directors whose advice and material were helpful; to the architects who supplied significant examples of civic, corporate, and privately funded public art; and to the many artists, here and abroad, who shared both their philosophical and technical approaches. The enthusiasm and cooperation of all who shared with us their knowledge and inspired thinking made this work an event of joy and discovery.

In the United States and Canada we are indebted to John Berry, Smith, Hinchman, and Grylls Associates, Inc., Detroit, Michigan; Donald Bowman, Federal Aviation Administration, Washington, DC; Herbert Conlan, Blue Cross Blue Shield of Michigan, Detroit, Michigan; Mel Forsythe and Karen Lundeen, Dayton Hudson Properties, Minneapolis, Minnesota; Doris C. Freedman, Public Arts Council, New York, New York; Thomas J. Houha, Skidmore, Owings, and Merrill, Portland, Oregon; Mary Ann Keeler and Nancy Mulnix, community leaders, Grand Rapids, Michigan; R. Kirikiri, Information Officer, New Zealand Embassy, Washington, DC; Tatjana Lenard-Trkuljc, Yugoslav Cultural Center, New York, New York; Stuart J. Lottman, Gruen Associates, Inc., Los Angeles, California; Jayne Lynch, The Taubman Company, Inc., Troy, Michigan; Alfred R. Neuman, Chancellor, and Patrick J. Nicholson, Vice President, University of Houston, Houston, Texas; R. L. Nutter, Jr., Public Information Officer, Baltimore, Maryland; Hope Hughes Pressman, University of Oregon, Eugene, Oregon; Peeter Sepp, Fine Arts Program, Public Works, Ottawa, Canada; Niels Toft, Royal Danish Embassy, Washington, DC; Donald W. Thalacker, Director, Art-in-Architecture Program, General Services Administration, Washington, DC; Kiichi Usui, Oakland University, Rochester, Michigan; and Renate Wasserman, Westchester County Executive Aide, Westchester County, New York.

Abroad we are indebted to Steingrim Laursen, Director, Louisiana Museum of Modern Art, Humblebaek, Denmark; Maaaretta Jaukkuri, Secretary, Artists' Association, Helsinki, Finland; Monique Faux, Art Consultant to the Ministry of Culture and Communication, Paris, France; J. Kuentz, Regional Transportation for Paris (RATP), Paris, France; Serge Lemoine, Regional Director for Cultural Affairs, Dijon, France; Marie-Zoe Greene-Mercier, Paris, France; J. J. Beljon, Amsterdam, Holland; A. van Ijperen, Stichting Kunsten Bedrijf, Amsterdam, Holland; Patrick Hamilton, Scott Tallon Walker, Architects, Dublin, Ireland; Aba Elhanani, Chairman, Institute of Architects, Tel Aviv, Israel; Shigeo Hirata, Matsuda, Hirata, and Sakamoto, Architects, Tokyo, Japan; Gunnar Sorensen, Munch Museum, Oslo, Norway; Arturo R. Luz, Executive Director, Design Center Philippines, Makati, Rizal, Philippines; Eduardo Nery, Lisbon, Portugal; Britt Olander, Lund, Sweden; Maillis Stensman, Swedish Arts Council, Stockholm, Sweden; Christina Hamacher, Secretary, Modern Museum, Stockholm, Sweden; Jan Torsten Ahlstrand, Lunds University, Lund, Sweden; Dr. Thomas Matthews, Rhodes University, Grahamstown, South Africa; Esmé Berman, Art Institute, Craighall, South Africa; Liliana Daneel, President, Human Sciences Research Council, Pretoria, South Africa; J. M. Miller, Hassell and Partners, Architects, North Adelaide, South Australia; and Tina Grutter, Secretary, Society of Painters and Sculptors, Zurich, Switzerland.

A special word of appreciation goes to our secretarial assistants, Gloria Barnabo Tonelli and Helen Cooper, whose personal interest made this a pleasant experience.

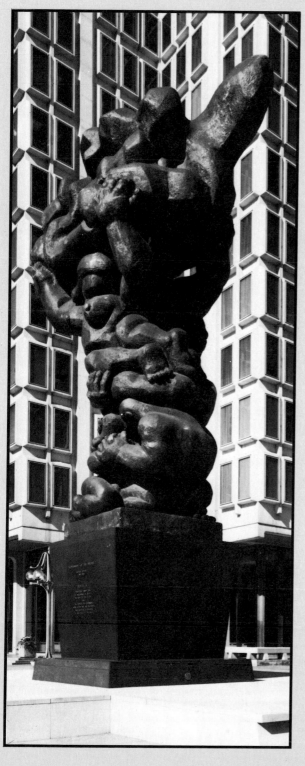

The United States and Canada

Photographers' Credits

Chapter 1

1 Courtesy General Services Administration
2 Courtesy Redevelopment Authority
3 Photographer: D. H. Zurovetz; Photo: Courtesy Fort Worth Fire Department
4 Courtesy Highland Park Police Department
5–8 Courtesy General Services Administration
9–13 Richer, National Capitol Commission
14–17 Don Ladely, Director, Sheldon Film Theater
18 Drawing: Courtesy Nebraska Interstate 80 Bicentennial Sculpture Corp.
19–20 Louis G. Redstone
21 Courtesy city of Grand Rapids
22 Louis G. Redstone
23 Courtesy Development Authority
24 Courtesy General Services Administration
25 Photographer: Tom Hisamura; Photo: Courtesy city and county of Honolulu
26 Tom Crane
27 Donald Doremus, Office of General Services
28 Courtesy General Services Administration
29 Robert Wallace
30 Stuart Lynn
31–35 Courtesy General Services Administration
36 Adams
37–38 Courtesy Xavier Fourcade, Inc.
39 Balthazar Korab
40–42 Courtesy General Services Administration
43 Photographer: Tom Crane; Photo: Courtesy of Pace Gallery
44–45 O. Baitz, Inc.
46–47 Paul Ryan
48–49 Courtesy city of Portland, Oregon
50 Courtesy SOM/LHA
51 James Lemkin, Architectural Photography
52 C. Bruce Forster
53 James Lemkin, Architectural Photography
54–55 Courtesy CHNMB (formerly Lawrence Halprin and Associates)
56 Richard Andrews
57–60 Robert J. Eovaldi
61 Courtesy of Department of Housing and Community Development
62–63 Courtesy General Services Administration
64–65 Lisa Oliner
66 Joseph W. Molitor
67 Mark Cohen

Chapter 2

1 Vasilia Smithsi
2 Jacques Overhoff
3 Vasilia Smithsi
4 Courtesy Elaine Ester, Director, Des Moines Public Library
5–8 Courtesy Alan Sonfist
9–10 Douglas Bennet
11 © 1979 Mary Randlett
12–13 © 1979 Mike Arst Photography
14 Mark Morrison, M. Paul Friedberg, and Partners
15 Louis Pounders
16 Oded Halahmy
17 Hillel Burger
18 Louis Pounders
19 Clement Meadmore
20 Courtesy Anthony Padovano
21 Courtesy George Rickey
22–124 Francis Haar
25 Herrington Olson
26–27 Balthazar Korab
28 J. W. Goodspeed
29–30 Courtesy Fine Art Programme, Department of Public Works, Canada
31–32 Louis G. Redstone
33 J. Krieber
34 Louis G. Redstone
35 Courtesy Peter Bradford and Associates
36 Bill Maris
37–38 Nelson Pau, Applied Photography Limited, Toronto
39–40 Courtesy National Air and Space Museum
41 Nir Bareket
42–43 Oliver Andrews
44–46 Courtesy Artpark
47 Sid Hoeltzell
48–49 Courtesy Artpark
50–51 John Weber
52 Cyril Miles
54–55 Maria Hanak
56–58 Courtesy Michigan Artrain, Inc.
59–60 Rich Gardner
61 Rob Muir
62–67 Courtesy University of Houston
68 Tom Molyneaux
69 Courtesy University of Michigan Information Service
70 Courtesy University of Iowa Museum of Art
71–72 Courtesy University of Houston
73–74 Courtesy Richard Lippold
75 Courtesy Hess's Hamilton Mall
76 Courtesy Kosso Eloul
77 Kosso Eloul
78 Hans Keehl Studio
79–80 E. P. Schroeder
81 Igael Tumarkin
82 Courtesy Ivy Sky Rutzky
83–84 D. Shigley
85 Courtesy University of Texas, Dallas, Texas
86 Courtesy Anthony Padovano
87–88 Jacques Overhoff
89–90 Robert Lautman
91–92 Photographer: Joe Ruh; Photo: Courtesy Northern Kentucky University
93–94 Vasilia Smithsi
95 George Norris
96 Phyllis Piddington
97 George Norris
98 Courtesy University of Illinois at Chicago Circle
99 Thom Abel
100–103 Courtesy Cranbrook Academy of Art
104–108 Ron Finne
109 Hedrich Blessing
110 James Patterson

Chapter 3

1 Courtesy The First National Bank of Chicago
2 Harr, Hedrich-Blessing
3 Courtesy Paul Von Ringelheim
4 Courtesy Sears, Roebuck and Company
5–6 Courtesy Standard Oil Company (Indiana) and Amoco Subsidiaries
7 Courtesy Lathrop Douglass
8 Robert Powell
9 Ronald Kirkwood
10 Stuart Lynn
11 Courtesy Pace Gallery
12 Courtesy PepsiCo, Inc.
13 Herbert A. Feuerlicht
14 Wheeler-Larsen
15 Courtesy Don Snyder
16 Gordon H. Schenck, Jr., A.S.M.P., A.P.A.
17 Courtesy Marine Midland Bank
18–19 Balthazar Korab
20–21 Courtesy Gruen Associates
22 Balthazar Korab
23 Bernie Moser
24 Courtesy Emery Roth and Sons
25–26 Balthazar Korab
27–28 Courtesy SITE
29 Courtesy Leo Castelli Gallery
30 Ferenc Berko
31 Simeon Posen
32 Steve Grubman Photography
33 J. A. McDonnell
34 Photographer: Joel Strasser; Photo: Courtesy Spitznagel Partners
35 Al Stephenson
36 Rob Wheless
37 Jock de Swart
38 Jan de Swart
39–42 Balthazar Korab
43 William Kessler
44 Balthazar Korab
45–47 Louis G. Redstone
48–49 Balthazar Korab
50–53 Daniel Bartush
54 John Kimpel
55 Daniel Bartush
56 Bruce Goldstein
57–58 Rick Fairchild
59 Bruce Goldstein
60–63 Wolfgang Volz
64 Jean-Claude Adam, Travail Photographique
65 Alice Baumann-Rondez
66 Courtesy Jordi Bonet
67 James Ballard
68 Don Snyder
69 Narendra Patel
70 Bernd Taeger, Photovision
71 Photgrapher: Gianfranco Gorgoni; Photo: Courtesy Xavier Fourcade, Inc.
72 Kermit Johnson
73 Photographer: Ray W. Jones; Photo: Courtesy Somerset Inn
74 Balthazar Korab
75 Abe Frajndlich
76 Photographer: Dan Brinzac; Photo: Courtesy of Borgenicht Gallery
77 Saunder Schaevitz, A.I.A.
78 Gabriel Benzur
79 Gordon Schenck, Jr., A.S.M.P., A.P.A.
80 Saunder Schaevitz, A.I.A.
81 O. Baitz, Inc.
82–83 Bruce Carse
84–85 Photographer: David Gulick Photo: Courtesy Scopia
86 Michio Ihara

Color Section

1–2 Don Ladely, Director, Sheldon Film Theater
4 Louis G. Redstone
5 Michel Proulx
6 Courtesy Rita Letendre
7–12 Courtesy General Services Administration
13 M. Fitzgerald
14 Courtesy General Services Administration
15 Sherri Smith
16–18 Courtesy General Services Administration
19–21 Courtesy Civic Design Commission
22 Ray O. Welch
22 Dorothy Gillespie
24 Francis Haar
25 Courtesy Martha Benson
26 Jerry L. White
27 David S. Lavine
28 George Thompson, City Walls, Inc.
29 Michael Miller, City Walls, Inc.
30 Chris Warner, City Walls, Inc.
31–33 Joel Peter Witkin, City Walls, Inc.
34 John Weber
35 Lucyna Radycki
36 John Weber
37–40 Louis G. Redstone
41 Courtesy Gerhardt Knodel
42 James Gilbert
43 R. Scott Sutton
44 Courtesy Buel Mullen
45 Courtesy R. L. White Company, Inc., subsidiary of American Broadcasting Co.
46 Saunder Schaevitz, A.I.A.
47 Louis G. Redstone
48 Shunk-Kender
49 Wolfgang Volz

Public Art:
Government
Sponsored

T his chapter features a number of examples of public art commissioned by all levels of government: federal, state, county, and city.

The federal governments of Canada and the United States were the largest single patrons of the arts in those countries in the 1970s. In the United States the program of art-in-architecture administered by the General Services Administration (GSA) allots 0.5 percent of the construction costs of new federal buildings for art. Art projects are incorporated during the initial design of new federal buildings and are developed generally by the architects and the GSA art-in-architecture director. (The process of commissioning the artist is discussed in the appendix.)

In addition to this major art program, the National Endowment for the Arts (NEA), established by Congress, provides matching funds to enable states, counties, and cities to commission public artworks. Examples of the way that the matching funds program has been implemented are shown in this chapter. The multifaceted programs—all encouraging excellence in design—involve architecture, landscape architecture, urban design, city and regional planning, interior design, industrial design, fashion design, and other recognized design professions. The NEA also supports professions that are allied to the design field. The program attempts to encourage creativity and to make the public aware of the benefits of good design.

In response to growing public interest, a number of states, counties, and cities now allot a percentage of their revenues for art in public projects, for example, in buildings, parks, plazas, and malls. At the time of this writing these are: Alaska; Albuquerque, NM; Anchorage, AK; Atlanta, GA; Baltimore, MD; Bellevue, WA; Boston, MA; Broward County, FL; Cambridge, MA; Chicago, IL; Colorado; Connecticut; Dade County, FL; Edmond, WA; Everette, WA; Florida; Grand Rapids, MI; Hawaii; Illinois; Iowa; Kansas City, MO; King County, WA; Los Angeles, CA; Maine; Miami Beach, FL; Mountlake Terrace, WA; Nebraska; New Hampshire; New Jersey; Oregon; Philadelphia, PA; Pierce County, WA; Pittsburgh, PA; Renton, WA; Rockville, MD; Salt Lake City, UT; San Francisco, CA; Santa Barbara, CA; Seattle, WA; South Dakota; Tacoma-Pierce County, WA; Toledo, OH; Tulsa, OK; Washington; Wenatchee, WA; and Wilkes-Barre, PA.*

It is no accident that those cities that have long-standing ongoing plans for the aesthetic enhancement of their communities are also among the top choices on a national list of communities selected as offering their inhabitants the best of "quality of life."

With some variations, the Canadian experience was similar to the American one in this area. In addition to making an allotment of funds for art in public buildings, Canada developed the concept of a national art bank, from which works by Canadian artists can be borrowed by federal agencies.

There is no doubt that these ongoing programs are playing a leading role in bringing art to the people and will continue to do so in the coming decade.

*From the report of the National Endowment for the Arts, on percentage for art programs dated July 13, 1979.

1

FEDERAL BUILDING, ENTRANCE
Buffalo, New York

ARTIST: George Segal, "The Restaurant," 1976.
ARCHITECTS: Pfohl, Roberts, Biggie

2

MUNICIPAL SERVICE BUILDING, PLAZA
Philadelphia, Pennsylvania

ARTIST: Jacques Lipchitz, "Government of the People,"
 sculpture, 36' high bronze, 1976.
ARCHITECT: Kling Partnership

The sculpture consists of a restaurant facade 16 feet wide and 10 feet high holding a 12-foot by 8¼-foot window made of tempered glass. Three life-size figures are arranged around the facade—a male and female pedestrian on the sidewalk outside and a female figure seated inside the restaurant.

The figures are cast in bronze and have a matte white patina produced through a chemical oxidation process. The chair and table in the restaurant are done in dark brown bronze. The wall is made of cinder block faced with brick.

The artist calls his concept "the wellspring of life." "Surging upward in spiral movement from this group is a young couple—the hope and future of society. They look to the present adult generation above them, represented by two adult figures—male and female—who support the symbol and emblem of government—a bold turbulent banner of the city of Philadelphia."

The sculpture was financed partially by the Fairmount Park Association, a nonprofit organization, and partially by the city of Philadelphia.

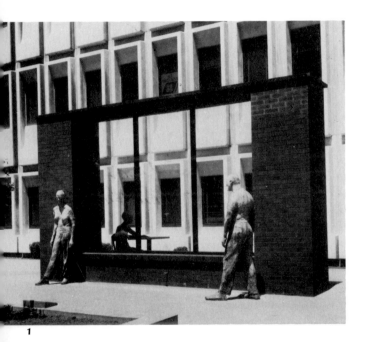

1

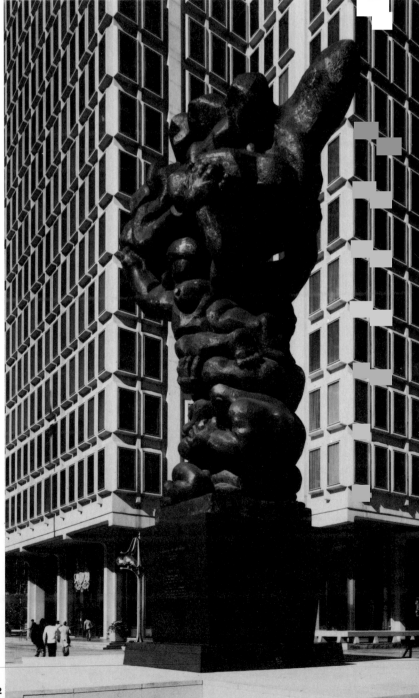

2

George Rickey comments:

The sculpture consists of six units, each made of a horizontal triangle 16 feet long and 5 feet wide at the base. From this rises a triangular sail 8 feet long and 4 feet wide.

Each unit is balanced on knife-edges so that it can rock in response to air currents. The knife-edges and the cradles on which they ride are specially hardened and polished to reduce friction. The distribution of the weight is critical; it determines the posture at rest and the speed. The speed varies with each unit—some need a minute to go through one up-and-down cycle; some do it in half that time. Nor is the speed for any one unit constant. The speed and the time are also determined by the speed and gentle turbulence of the air moving through the building. The sculpture should breathe and sometimes sigh, rather than pant or blow or billow.

The surfaces have been ground to make them responsive to changes of light and to changes of the direction from which the light falls on the surface. There is no significance to the grinding marks; they are applied in a random way, but with a limit to the size and length of each stroke.

Works of art, like flowers, need have no meaning in themselves, though meanings of all kinds can be attributed to them or suggested by them. The twelve triangles—which are almost geometrical but not quite, since they curve slightly in response to the forces necessary to cut, grind, and weld them—are combined in a regular geometrical manner, end for end, side by side. In combining they produce more complex shapes and almost countless other triangles, which vary in size and shape with the movement. Since this is a moving object, there is no "correct" position. Its form is made up not only by the sum of the triangles; the form is also movement, as distinct from the shapes. Because of perspective and parallax, the outlines and the apparent movement appear different from different viewpoints. The changing light outside the building will also change the relations within the sculpture.

Katherine Kuh, art critic, speaking about Peter Voulkos's environmental sculpture, comments:

I think Highland Park is very lucky to have gained the services of an artist as good as Voulkos. He is a sculptor of great strength, and the work he has planned for your city looks marvelously alive. Every one of its parts has an inner virility.

So often, the outdoor sculpture you see in the suburban settings has an offensively decorative cuteness about it, but this Voulkos piece is a fine exception to that rule. It is a serious effort, and especially appropriate to the space it's meant for.

3

FORT WORTH MUNICIPAL BUILDING, LOBBY
Fort Worth, Texas

ARTIST: George Rickey, "Twelve Triangles," total length of sculpture 51', stainless steel, 1974. (Funded by municipal construction bond funds with matching grant of the National Endowment for the Arts.)
ARCHITECT: Edward Durell Stone and Associates and Preston M. Geren and Associates

4

CITY HALL, PARKWAY
Highland Park, Illinois

ARTIST: Peter Voulkos, untitled, sculpture, 10' high × 60' long bronze, 1973. (Funding: $20,000 from NEA; $20,000 from private donations.)

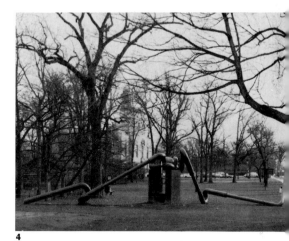

4

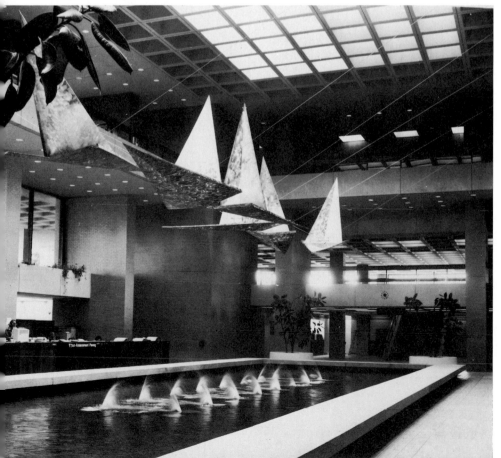

3

5

WILLIAM J. GREEN, JR. FEDERAL BUILDING AND JAMES A. BYRNE U.S. COURTHOUSE, LOBBY
Philadelphia, Pennsylvania

ARTIST: Louise Nevelson, "Bicentennial Dawn," 45' × 30' × 90' painted white wood, 1976.
ARCHITECTS: Carroll, Grisdale, and Von Alen Bartley and Long, Mirinda, Reynolds, and Nolan

6

FEDERAL BUILDING, ENTRANCE
Portland, Oregon

ARTIST: Dimitri Hadzi, "River Legend," sculpture, 10' × 13' carved basalt, 1976.
ARCHITECTS: Skidmore, Owings, and Merrill

Louise Nevelson explains:

My search in life has been for a new seeing, a new image, a new insight, a new consciousness. This search includes the object as well as the in-between places—the dawns and the dusks, the objective world, the heavenly spheres, the places between the land and the sea. . . . Man's creations arrest the secret images that can be found in nature.

"Bicentennial Dawn" is a place, an environment that exists between night and day, solid and liquid, temporal and eternal substances. It can be experienced as a monument to the past as well as the spores of the future. Contemplation is the means by which we extend our awareness. "Bicentennial Dawn" is a contemplative experience in search of awareness that already exists in the human mind. The inner and the outer equal one.

"The sculpture was developed," Hadzi said, "after a trip to the Columbia River gorge where the natural formations, the wilderness, and the memory of the exploratory spirit of adventurers such as Lewis and Clark inspired me to express man's power over nature as seen in his expansion over, and taming of, the wilderness."

5

6

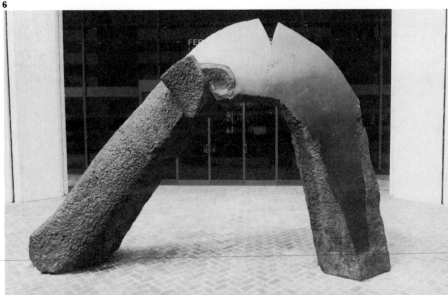

At first glance one might think that five sculptured stone pieces, separately placed as they are on Fred Bassetti's red-brick plaza, would clutter the already busy atmosphere of the Second Avenue entrance area of the new Federal office building. To the right, coming into the plaza from Second Avenue, one notices seven pine trees, each surrounded by a concrete tub and so providing a circular sitting-bench. The plaza surface is herringbone patterned brickwork, seemingly not such a sympathetic base for the Noguchi environment. To the left of the entrance-way steps, several honey locust trees thread here and there through and around the granite pieces. Farther on, more pine trees in their concrete circles, and over to the left, just off the street, is the demolished Burke building fragmented arch—a reminder of previous tenancy. The stones—five— miraculously placed through and beyond the busyness and indifference of the metropolis, create an urban oasis—a wellspring of quiet serenity and great power.

*From Northwest Arts, Seattle, Washington, October, 10, 1975. Reprinted by permission.

The early controversy over the sculpture was inflamed by Senator William Proxmire (D, Wis.), who called it an example of foolish federal spending. However, the public has come not only to accept it, but to value it as a part of the city's cultural enrichment.

Regarding his concept, Oldenburg said: "Its diamond pattern and cagelike appearance symbolize a baseball diamond and batting cage. The sculpture could be called a monument both to baseball and to the construction industry . . . a celebration of steel construction as well as of the ambition and vigor Chicago likes to see in itself.

"'Batcolumn' has been a labor of enthusiasm, sacrifice, and love, with no other goal than the achievement of a beautiful work of art."

7

FEDERAL BUILDING, PLAZA
Seattle, Washington

ARTIST: Isamu Noguchi, "Landscape of Time," five pink granite stones each weighing from 1500 to 7000 lb, 1975.
ARCHITECTS: John Graham and Company and Fred Bassetti and Company

8

SOCIAL SECURITY ADMINISTRATION BUILDING, PLAZA
Chicago, Illinois

ARTIST: Claes Oldenburg, "Batcolumn," sculpture, 100' high open lattice work welded steel weighing 20 tons, 1977.
ARCHITECTS: Lester B. Knight and Associates, Inc.

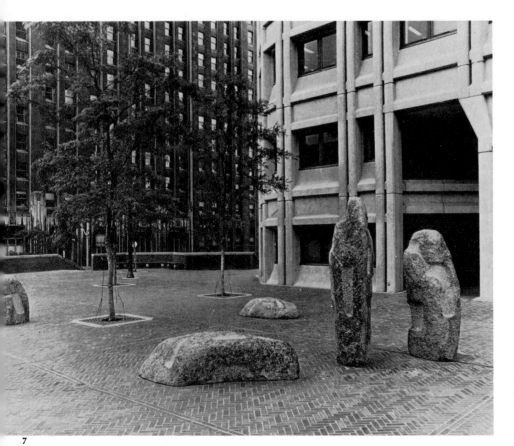

7

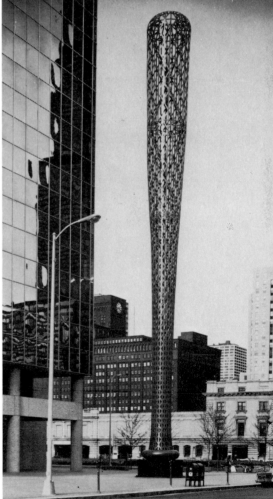

8

SCULPTURE WALK
Ottawa, Ontario, Canada

ARTIST: William McElcheran, untitled, 4'6" × 9'6" × 9",
base 1'4" × 10'9" × 3'4" bronze, 1976.
COLLECTION: Department of Public Works

The Sculpture Walk in Ottawa includes thirty-four sculptures; some are traditional and realistic, others are contemporary and nonobjective. They are situated on both sides of the Ottawa River within easy walking distance of one another. Most of the sculptures are owned by federal departments and agencies, but in coming years, as the walk is expanded, more sculptures will be rented directly from Canadian artists. (Because of limited space, only five works of art can be shown here.)

Outdoor sculptures make daily life more interesting by adding something special, something rich and human, to the environment.

In 1964 the Canadian government decided to provide 1 percent of the building costs of all federal projects for works of art. Since that time 206 pieces have been bought or commissioned for permanent installation in 104 communities across Canada, at a total cost of $3,000,000. But it hasn't been an easy program to administer. Most installations have been quietly accepted by most sectors of each community, some pieces have been unheralded successes, and some have resulted in expressions of fierce local resentment and debate.

Most of the resentment can be attributed to a lack of local participation in the selection process, a lack of communication between art historians and the public, and the desire of some past selection committees to introduce what they felt to be the best contemporary art to a public that had not been prepared for it.

Centennial year programs and Expo '67 brought pride to our design professions and a new awareness of Canadian talent to the public. Canada Council, provincial arts councils, and ministries of culture responded to new public demands for cultural support. More than sixty new public art galleries have been opened in the last ten years, with more than two-thirds of their budgets coming from local communities. Art schools and art history courses have sprouted throughout the country, producing a new generation of informed graduates. University education, global communication, travel, immigration, and a reappraisal of social values have rapidly transformed our sense of reality and attitudes.

It is interesting to see how the senior officials of Public Works Canada reacted to the criticism, controversy, and resentment that the fine arts program provoked in late 1976. The program was temporarily halted, the policy reviewed, amended, and then fully reinstated by the minister in May 1977. (The program was again temporarily halted in October 1978.)

The amended policy is intended to decentralize the selection process, provide up to 2½ percent of building costs for smaller projects, establish better communications, run more open competitions, develop new forms of design integration, and streamline administrative support systems. They hired me as an interdisciplinary administrator in October 1977 and appointed a new small advisory committee, in which three out of six members are working artist/designers, in March 1978. In addition there appears to be tremendous internal support for making the program universal, flexible, and efficient. Senior officials are promising to help protect the art allocation from internal "budget raiders," politicians would like to see it nonbureaucratically responsive to local conditions, and senior administrators are helping with support systems and resources. And there is pressure to get it rolling in a hurry.

The key players in the process are: the local project manager, who, controlling budget and schedules, is responsible for briefing the design architect, who, in turn, is responsible for preparing a design solution including the art proposal to be submitted for approval to a project committee now including client/user, local community representatives, and one or more National Advisory Committee members. Once the architect's art proposal is approved, the artist is hired to prepare specific proposals in maquette form for acceptance by the project committee. A recommendation from this committee is then presented to the Minister of Public Works for approval and the successful artist is awarded a contract for completing and installing the work of art in collaboration with the architect.*

*Excerpted from an article by Peeter Sepp, *Artmagazine,* June, 1978, pp. 7–10.

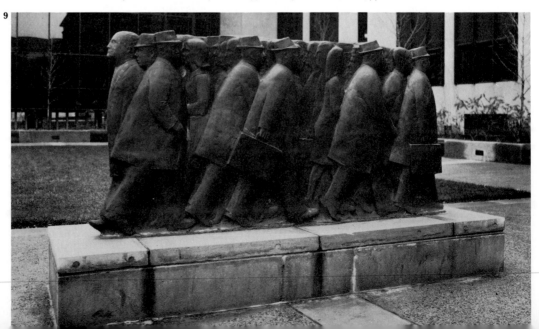

9

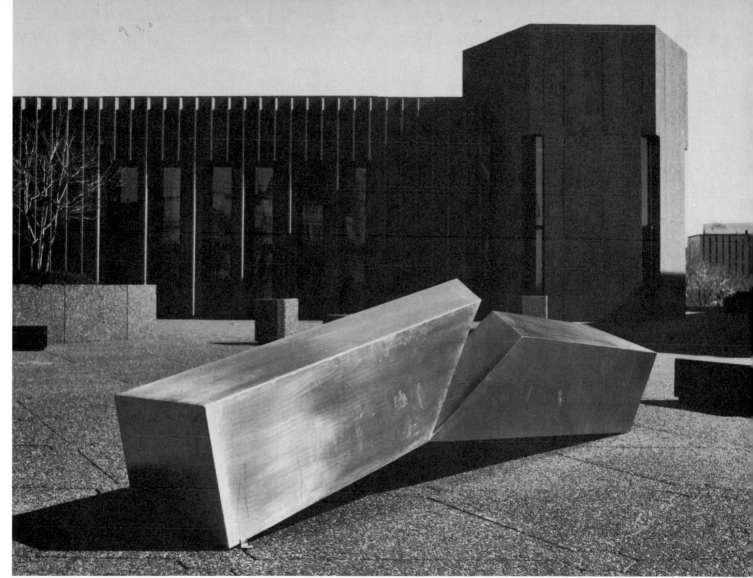

10

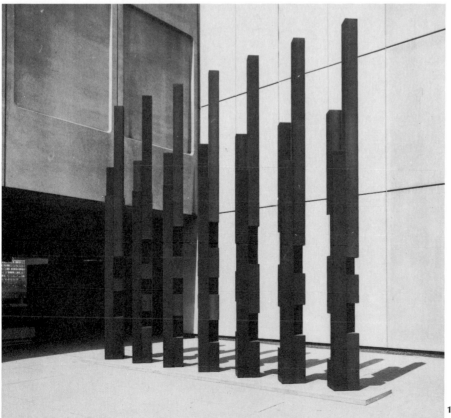

11

10

SCULPTURE WALK
Ottawa, Ontario, Canada

ARTIST: Kosso Eloul, "Anada," 3'4" × 2' × 13'4" stainless steel, 1973.
COLLECTION: Department of Public Works

11

SCULPTURE WALK
Ottawa, Ontario, Canada

ARTIST: Gino Lorcini, untitled, 20' × 13' × 3' anodized aluminum.
COLLECTION: Department of Public Works

12

SCULPTURE WALK
Ottawa, Ontario, Canada

ARTIST: Hugh Leroy, untitled, 28′ × 60′ × 30′ fiberglass.
COLLECTION: Department of Public Works

13

SCULPTURE WALK
Ottawa, Ontario, Canada

ARTIST: Robert Murray, "Tundra," 11′ × 24′ × 15′
 weathering steel, 1972.
COLLECTION: Department of Public Works

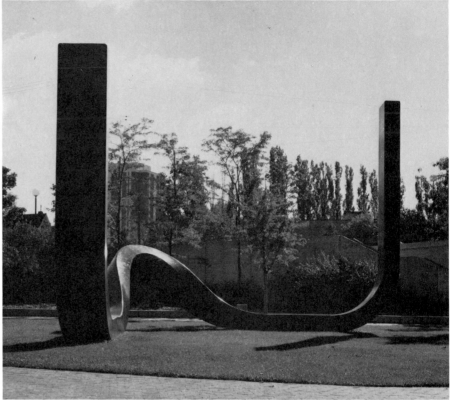

12

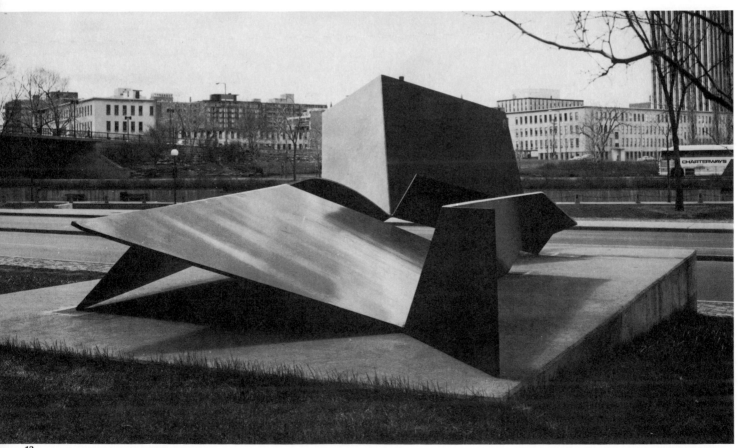

13

The purpose of the project was to celebrate the nation's Bicentennial by:

1. Providing Nebraskans and visitors to the state access to some of the best sculptures of our time outside of museum walls.

2. Providing Nebraskans, through the artist-in-residence program, the unique opportunity of meeting the sculptors, sharing in the creative process, and learning more about sculpture.

3. Contributing to Nebraska's cultural heritage through the installation of ten original contemporary sculptures.

The plan called for the commissioning of ten American sculptors to create monumental outdoor sculptures for placement at ten roadside park rest areas along Interstate 80 in Nebraska. Each of the ten artists would serve as an artist-in-residence in the community near the rest area where the sculpture would be located.

John W. Warner, National Administrator of the American Revolution Bicentennial Administration (ARBA), officially conferred national recognition on the sculpture project in a ceremony in Lincoln in March 1975.

When the project was registered with the American Revolution Bicentennial Administration, it was placed under the Horizons category because the sculptures were to be created by contemporary artists and placed permanently on the interstate for the enjoyment of today's travelers and future generations and because the goal was not to look back, but to celebrate the culmination of 200 years and the beginning of the third century.

One hundred twenty-one sculptors from all over America responded to the competition announcement. In October 1974 three independent jurors selected forty-six sculptors to submit specific proposals. In January 1975 another panel of jurors reviewed those proposals, as did the state Department of Roads and representatives of the Nebraska communities that would host the artists while they were in residence in the state. Ten sculptors were selected, and their names were announced in New York City and Lincoln, Nebraska, on July 9, 1975.

The announcement generated intense interest in a large segment of Nebraska's population. Although many supported the project, many were outraged by the abstract designs and the lack of Nebraska artists. The extent of these feelings was evidenced on the editorial pages of the state's newspapers, one of which received more letters on only one other subject—Watergate. An investigation into the project was undertaken by the Nebraska Legislature to determine whether the state should accept the proposed sculptures which would be placed on public property and maintained by public funds. Hearings were held in five communities across the state, with vocal spokespersons appearing for both sides, but an overwhelming majority in favor of the project. A review of the testimony by the legislature resulted in a favorable vote in January 1976, when the legislature agreed to accept the sculptures on behalf of the state, and Governor James Exon, who had been a supporter of the project since its inception, concurred. The controversy was very important to the project; many Nebraskans became involved who might not have done so under other circumstances, and a larger forum for discussion and explanation of the project developed.

Preliminary plans and the development of engineering drawings proceeded through the fall and winter of 1975–1976. In March 1976 the first of the sculptors arrived in Nebraska to begin work. By June seven of the ten sculptors were in Nebraska and completed works began to appear on the horizon.

Nebraska's 500-mile sculpture garden was dedicated on July 4th, 1976. The ceremonies began in the east at noon near Omaha and progressed westward with the last dedication beginning at 7:30 P.M. near Sidney, Nebraska.

The most important aspect of the project, other than the sculpture itself, has been the involvement of people. Many organizations, agencies of government, businesses, and individuals became involved in developing the concept, gaining acceptance for it, and completing the sculptures and artist-in-residence programs. Because one of the basic precepts was to provide Nebraskans the unique experience of meeting the artists and

14

NEBRASKA INTERSTATE 80 BICENTENNIAL SCULPTURE PROJECT, 1976

ARTIST: Richard Field, "Memorial to American Bandshell," 9' high × 10' long weathering steel (at Platte River eastbound Omaha rest area).

15

NEBRASKA INTERSTATE 80 BICENTENNIAL SCULPTURE PROJECT, 1976

ARTIST: Anthony Padovano, "Nebraska Gateway," 14' high × 25' long× 15 wide granite (at Brady-North Platte westbound rest area).

16

NEBRASKA INTERSTATE 80 BICENTENNIAL SCULPTURE PROJECT, 1976

ARTIST: Paul Von Ringelheim, "Arrival," 40' high × 28' long × 28' wide bright anodized aluminum (at Blue River, Seward/Milford, eastbound rest area).

17

NEBRASKA INTERSTATE 80 BICENTENNIAL SCULPTURE PROJECT, 1976

ARTIST: Hans Van de Bouvenkamp, "Roadway Confluence," 35' high alluminum (at Sidney westbound rest area).

18

NEBRASKA INTERSTATE 80 BICENTENNIAL SCULPTURE PROJECT, 1976

LOCATION MAP: W. B. means westbound; E.B. means eastbound.

watching their work, ten communities in Nebraska were each asked to host one of the artists. Committees in each community agreed to take responsibility for providing room, board, transportation, work space, and coordination of the residency program. Through their generous efforts, Nebraskans have had an opportunity to learn more about modern sculpture, and the artists have been able to learn about Nebraska, its people and way of life.

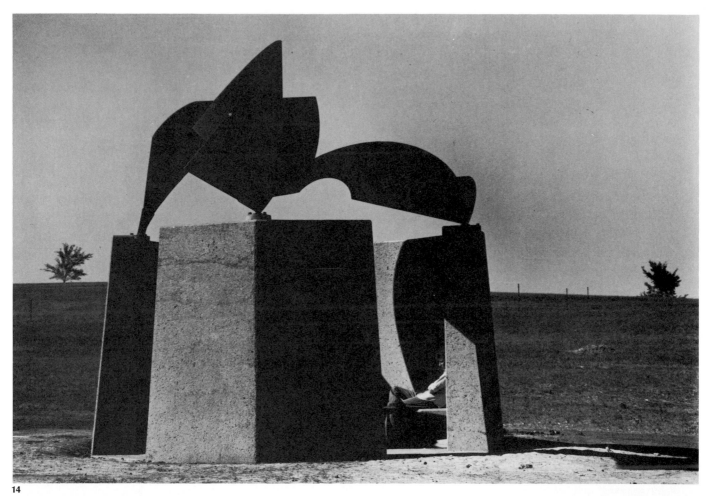

14

15

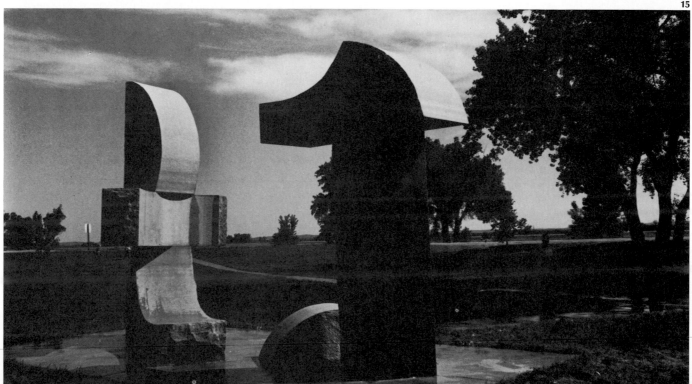

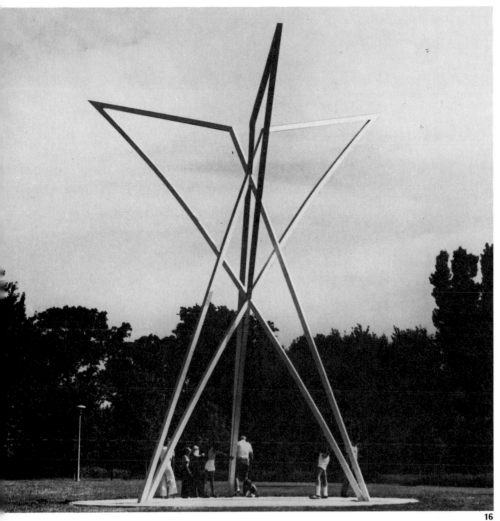

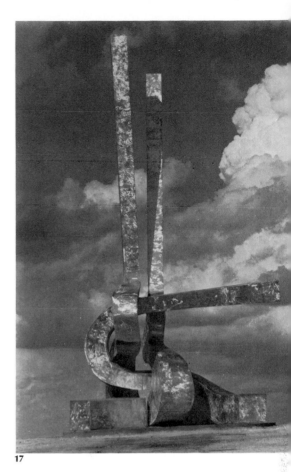

17

16

18

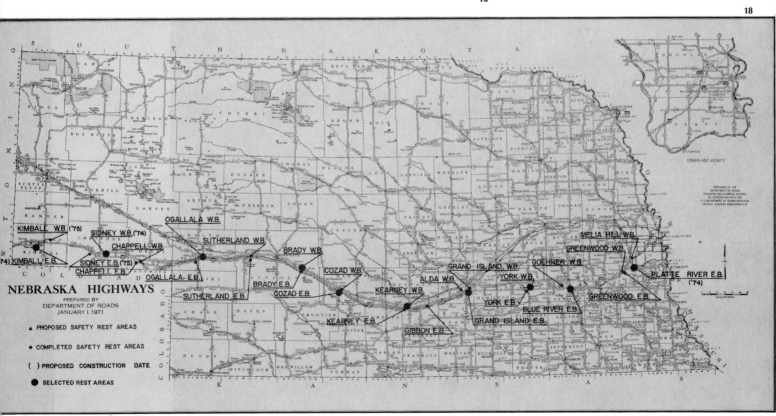

NEBRASKA HIGHWAYS

PREPARED BY
DEPARTMENT OF ROADS
JANUARY 1, 1971

▲ PROPOSED SAFETY REST AREAS

■ COMPLETED SAFETY REST AREAS

() PROPOSED CONSTRUCTION DATE

● SELECTED REST AREAS

19

BELKNAP PARK, NORTH OF DOWNTOWN
Grand Rapids, Michigan

ARTIST: Robert Morris, "Earth Sculpture," a huge X formed by footpaths on a steep hillside, 1974.

20

FEDERAL BUILDING, COURTHOUSE, PLAZA
Grand Rapids, Michigan

ARTIST: Mark Di Suvero, "Motu," sculpture, 35' high unpainted steel with a gondola painted yellow made from an outsize rubber tire, 1977.
ARCHITECT: Kingscott Associates, Inc.

21

GRAND RIVER, FISH LADDER/SCULPTURE
Grand Rapids, Michigan

ARTIST: Joe Kinnebrew, "Fish Ladder," concrete fish ladder, 1974.

22

GRAND RIVER, FISH LADDER/SCULPTURE
Grand Rapids, Michigan

ARTIST: Joe Kinnebrew, "Fish Ladder," concrete fish ladder, 1974.

When the sculpture was completed, a question arose over its acceptance by the GSA because Di Suvero deviated from his original proposal without consulting the agency. However, when over 600 signatures on a petition and more than 400 letters from community leaders and citizens of Grand Rapids were received, the decision to accept was made. It was clear that the people wanted the sculpture.

When Di Suvero was asked how he liked the sculpture in the setting his response was: "Ask the kids. All of us are children at heart—or were children and have forgotten it. The child in us can respond to the piece."

Di Suvero said the name is "Motu" from "Motu Viget," meaning strength and activity. "I thought it appropriate to choose the city's motto for the piece," he said.

The Grand River runs through Grand Rapids, and it is the site of a project which combines an innovative approach to art and the environment—the fish ladder/sculpture—creation of sculptor Joe Kinnebrew. The first ladder allows the Coho and Chinook salmon to return upstream in the Grand River every year to spawn. The functional sculpture, which allows people to walk across the ladder and watch the salmon leap over the rapids, is a prefabricated mortar platform bolted to the top of the concrete, box-shaped fish ladder.

The fish ladder/sculpture, which was completed in 1974, was financed by the Michigan Department of Natural Resources, the National Endowment for the Arts, and local gifts.

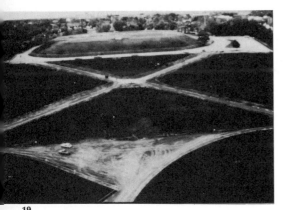

19

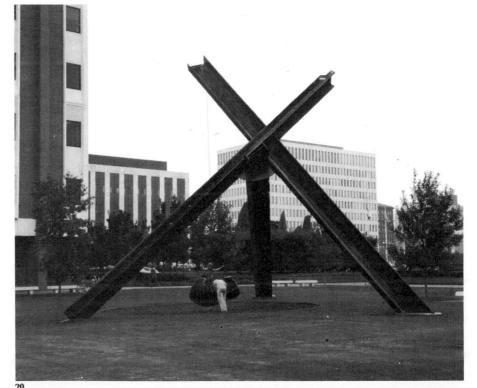

20

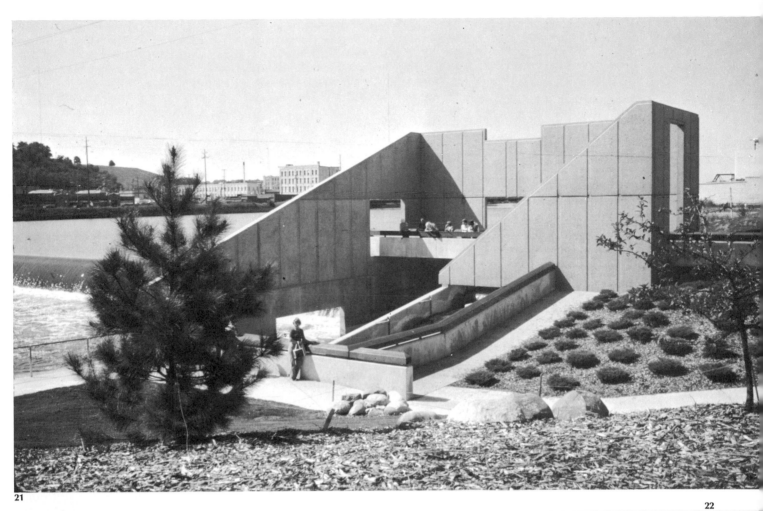

21

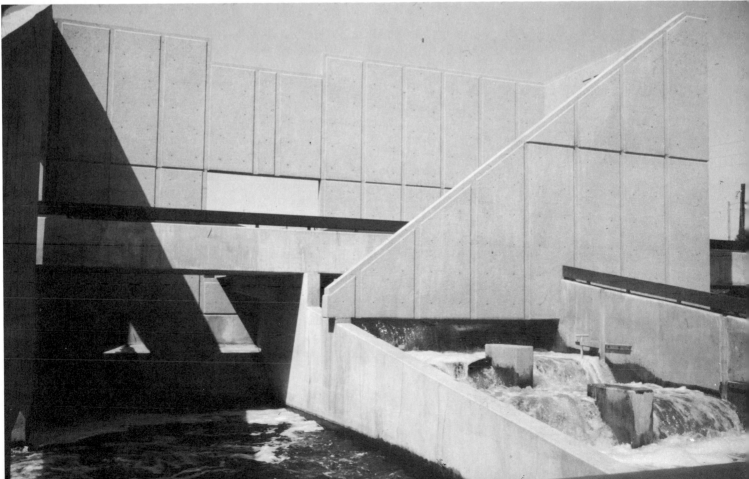

22

CENTRAL SQUARE, PLAZA
Philadelphia, Pennsylvania

ARTIST: Claes Oldenburg, "Clothespin," 45' high steel
 with stainless steel spring forming the numbers "76,"
 1976.

FEDERAL BUILDING AND U.S. COURTHOUSE, COURT
Eugene, Oregon

ARTIST: Robert Maki, "Trapezoid E," 12' × 15' × 10'
 painted aluminum.
ARCHITECTS: Wilmsen-Endicott-Green-Bernard

Claes Oldenburg, in explaining his "Clothespin," which was initially controversial, comments: "It's a structure—a clothespin is a little thing you hold in your hand. This is big. So, it no longer functions as a clothespin. By using a common subject, you involve people. When you put up a piece like this, you get a mixed reaction until people get adjusted to it. Once they see it sitting on its pedestal, I hope the work will say, 'I'm going to be here whether you like it or not.' "

The artwork was placed in Central Square, downtown Philadelphia, because of the redevelopment authority's 1 percent ordinance, which earmarks for art 1 percent of the total cost of a structure on authority land.

23

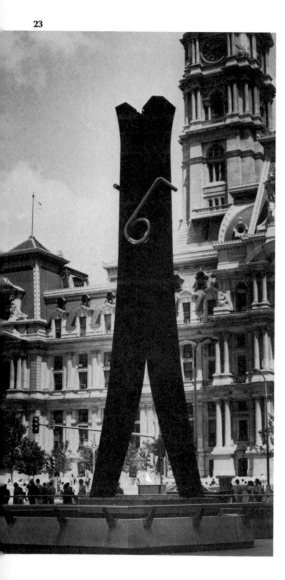

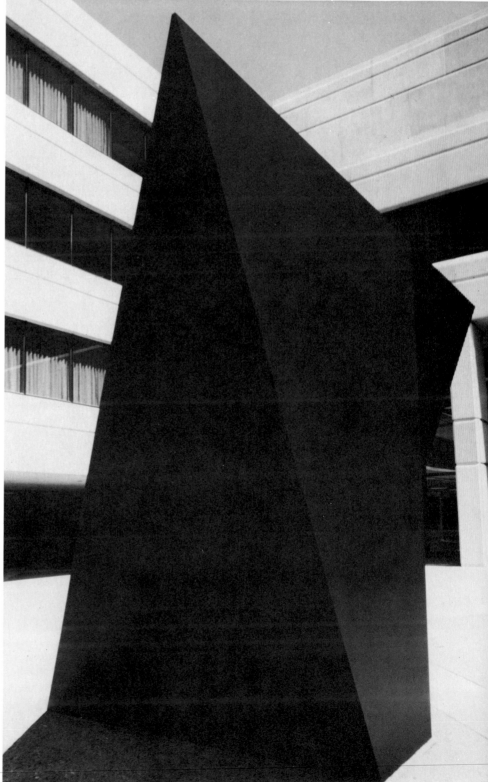

24

"Sky Gate" represents the artist's quest to develop a work that is complete in itself and that simultaneously interrelates the numerous visual elements of the civic center environs. Exemplifying Noguchi's preoccupation with balanced stress, the sculpture's three matching legs provide classic strength and stability, pushing upward to support an undulating crown which continually changes in shape and direction as the viewer moves around the piece. The resulting tension between the seemingly static legs and the kinetic, oscillating crown creates a visually dynamic relationship, imbuing the piece with a visual "life-force."

MUNICIPAL BUILDING, CIVIC CENTER AREA
Honolulu, Hawaii

ARTIST: Isamu Noguchi, "Sky Gate," sculpture, 24' high steel, 1977. (Funding: $72,000 from 1 Percent Fund for Art in Public Buildings; $50,000 from NEA.)

FEDERAL LABOR DEPARTMENT BUILDING, EAST PLAZA
Washington, DC

ARTIST: Tony Smith, "She Who Must Be Obeyed," sculpture, 24' × 30' painted steel (blue), 1976.
ARCHITECTS: Brooks-Barr-Graeber-White

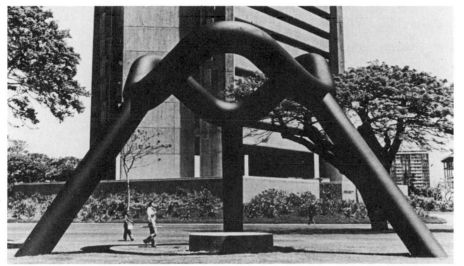

25

26

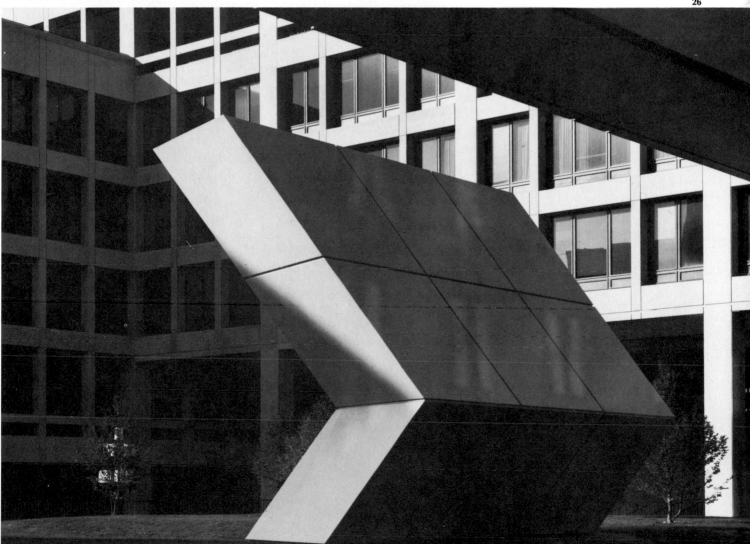

27

TOWER BUILDING, EMPIRE STATE PLAZA

Albany, New York

ARTIST: François Stahly, "Labyrinth," covers an area approximately 180′ × 70′ with 39′ center column, 1971.

28

FEDERAL BUILDING, LOBBY

Lincoln, Nebraska

ARTIST: Charles Ross, twenty-seven suspended primastic sculptures, 9′ long, 1976.
ARCHITECTS: Leo A. Daly Company and Dean E. Arter Associates

29

INDIANA CONVENTION AND EXPOSITION CENTER, ENTRANCE

Indianapolis, Indiana

ARTIST: Mark Di Suvero, "Snowplow," metal blade painted bright yellow, beams, and giant-size tire, 1977. (Total cost of this project was $40,000, half of which came from the National Endowment for the Arts. The sculpture was a gift to the people of Indianapolis from the Indianapolis Sesquicentennial Commission to celebrate the city's 150th birthday.)

In 1964 Nelson A. Rockefeller, then governor of New York, appointed a commission to select the art. Cash allowances totaling over $2 million for the purchase and installation of works of art were written into the construction contracts for the Empire State Plaza.

The triangular prisms are filled with mineral oil and spotlighted to cast rainbows. The transparent geometric sculptures alter dimensions and create intriguing, colorful images through the use of refracted light. A surprisingly unusual effect is achieved with this technique.

27

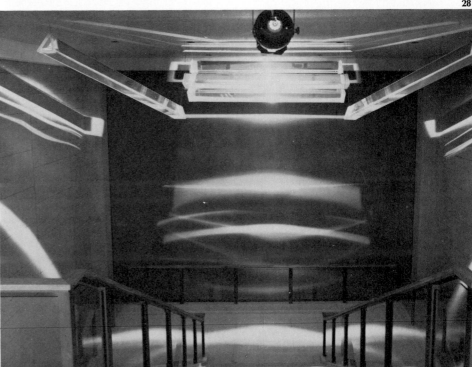

28

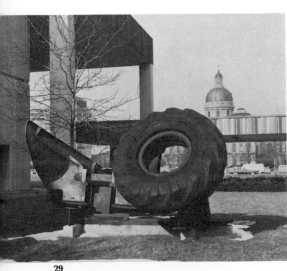

29

According to Lin Emery:

I intend my work to have a more dynamic role than that of echoing architecture; through its movement, I want it to literally animate and participate in the space it occupies. All my work is kinetic. I am concerned with sequences of linked forms and with the way they can exist as an artistic entity empowered with motion. The quality of the movement is of prime importance; it must be organic and not mechanical. It can evoke a gesture, or a pantomime, or a rhythmic pattern of nature. To achieve this I do not mechanize my forms, but use natural forces to activate them: water, magnets, wind. The character of the movement is determined by the infinite variables of the points of balance, the natural frequency of each form, and the construction of the links and bearings. I juggle and juxtapose and adjust to achieve the movement I want; often I am surprised as the finished work invents an added dance of its own.

As to the procedure for handling a commission, Emery says:

At the beginning, I like to explore several approaches to the handling of the space by building a rough mock-up of the site and designing two or three different preliminary models. In collaboration with the architect or the client, one is chosen as the most approrpiate and I develop a series of maquettes. I end with a correctly scaled working model, which serves both to establish hydraulic requirements and to give dimensions for the enlargement process.

I retain an engineering firm for structural analysis, but I do most of my shop drawings myself. I can subcontract some parts of the job to local industrial fabricators, but I supervise all phases of the work and generally have the precision work such as bearing housings, water orifices, final assembly, etc., done by my own machinists and welders (I have a well-equipped welding and machine shop as well as a foundry). I act as my own fountain consultant, using a mechanical engineer as needed for details of pipe and pump sizes, etc.

Regarding contracts, Emery notes:

The format varies with the size of the commission, and the requirements of my client. My state of Louisiana contract required an arrangement in lieu of bond whereby I took out a life insurance policy that would reimburse the state if I died in mid-project. I've kept this assignable policy and find a lot of clients like to know they won't be stuck with half-a-sculpture but will get their money back if something happens to me. I carry all the normal liability and employer's insurance, and I also carry contractual liability and an umbrella liability policy, which I find many sculptors don't know about. I don't include installation in my contract. I do include delivery, assembly, and after-installation adjustments; for this I bring my own assistant and spend several days on the site supervising the installation and balancing out of the work.

A typical contract payment schedule would be:

- 10 percent at preliminary design phase
- 25 percent on completion of working model
- 25 percent on half-way completion of fabrication
- 25 percent on delivery
- 15 percent on acceptance (within three months after installation)

CIVIC CENTER
New Orleans, Louisiana

ARTIST: Lin Emery, "Aquamobile and Memorial Column to de Lesseps S. Morrison," column, 40' × 5' × 5' cast aluminum; aquamobile 4' × 10' × 18' cast nickel silver, 1971. (Funded by the State of Louisiana.)
ARCHITECTS: Mathes, Bergman, Favrot, & Associates, August Perez and Associates, and Parham and Labouisse

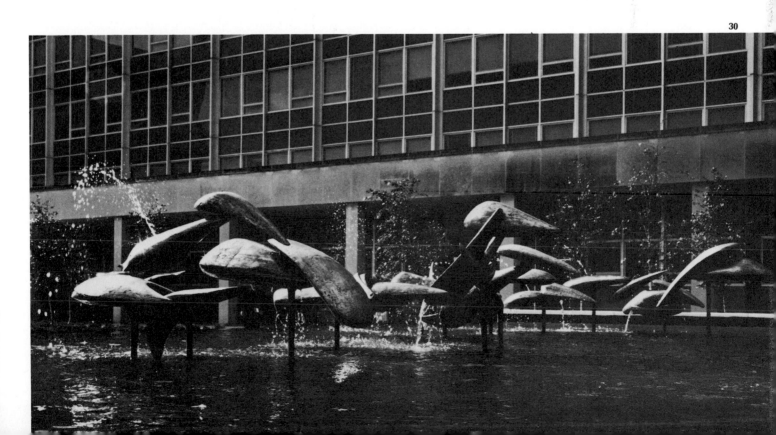

FEDERAL BUILDING, PLAZA
Van Nuys, California

ARTIST: Lyman Kipp, "Highline," sculpture, 18' high blue
 steel beams intersected by red metal plates, 1976.
ARCHITECTS: Honnold and Rex and Rochlin and Baran

32

SOCIAL SECURITY ADMINISTRATION BUILDING, PLAZA
Richmond, California

ARTIST: Richard Hunt, "Richmond Cycle," sculpture, 9'
 high × 35' long bronze plate, 1976.
ARCHITECTS: William L. Pereira Associates

33

FEDERAL BUILDING, ENTRANCE
Seattle, Washington

ARTIST: Harold Balazs, "Seattle Project," 1975.
ARCHITECTS: John Graham and Company and Fred
 Bassetti and Company

" 'Highline,' " Kipp says, "is designed to give human perspective and color to the plaza. The piece 'reads' from a distance, yet the intricate inner space offers another interesting, more personal dimension."

The sculpture is composed of two related—but separate—pieces characterized by abstract organic curvilinear forms suggesting prehistoric animals.

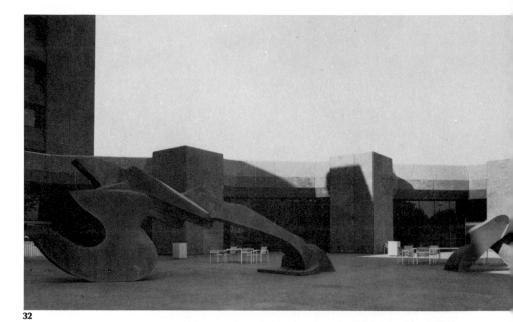

32

31

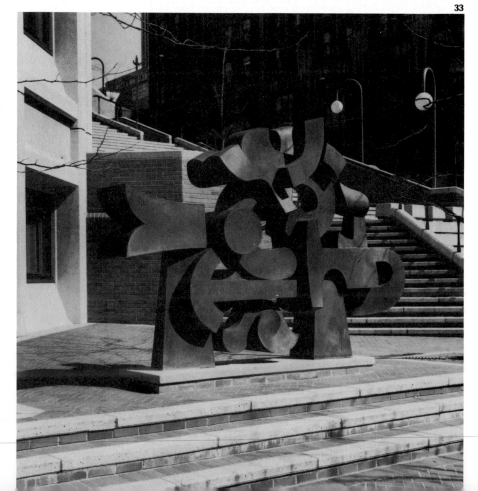

33

"Voyage of Ulysses" has a 16-foot-tall, sail-like figure in the center of a 60-foot-wide pool. Water in three parallel jets strikes the sculpture's curved surface and flows along it before splashing into the pool. A 16-foot-long sheet of water falls into the pool from the bottom of the elevated sail and hydraulic equipment continuously circulates water throughout the artwork. Von Schlegell worked closely with hydraulic engineers in developing the sculpture.

"In the sculpture," von Schlegell said, "there is a quality of stillness and motion. The quiet object and the steady flow of water become a metaphor for the odyssey as charted by Homer and seen by us as a glowing symbol of man's driving toward the unknown."

Held's murals consist of large black and white geometric designs in acrylic paint that appear to advance and recede from the surface as the perspective changes.

Canvas makers spent three months weaving the two 1183-square-foot pieces of cloth. Held constructed a special wall in his Brooklyn studio on which to mount the canvases while he worked on the twenty-one-month project.

The manner in which the body, the mind, and the eye relate to painted forms on a flat surface has been a longstanding concern of mine. Working on a mural of this scale and for a specific space forced a heightened awareness of these perceptual problems. It is my hope that the experience of walking through, into, and around a space of this scale will also enrich the perceptions of the observer, projecting them into a state beyond the visual experience.

34, 35

WILLIAM J. GREEN, JR. FEDERAL BUILDING AND JAMES A. BYRNE U.S. COURTHOUSE, PLAZA

Philadelphia, Pennsylvania

ARTIST: David von Schlegell, "Voyage of Ulysses," 16' high stainless steel, 1977.
ARCHITECTS: Carroll, Grisdale, and Von Alen Bartley and Long, Mirinda, Reynolds, and Nolan

36

SOCIAL SECURITY ADMINISTRATION MID-ATLANTIC PROGRAM CENTER, LOBBY

Philadelphia, Pennsylvania

ARTIST: Al Held, "Order/Disorder/Ascension/Descension," two murals, 13' high × 91' long acrylic paint on canvas, 1977.
ARCHITECTS: Deeter Ritchey Sippel Associates

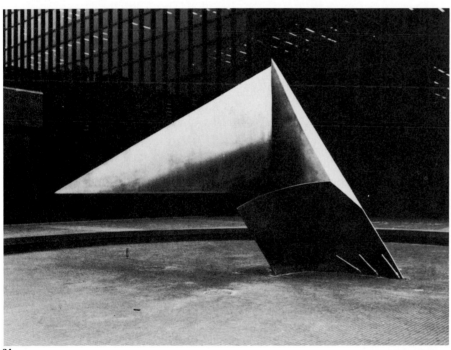

34

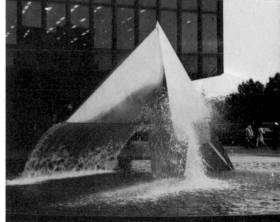

35

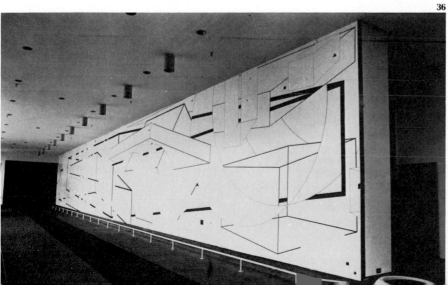

36

MYRTLE EDWARD CITY PARK, WATERFRONT

Seattle, Washington

ARTIST: Michael Heizer, "Adjacent, Against, Upon," environmental sculpture; area measures 130' × 25', its highest point 8'; the group consists of three geometric concrete forms (three-, four-, and five-sided, each weighing 58 tons) and three granite rocks, 1977.

The larger rocks each weigh approximately 50 tons, and the smaller rock weighs approximately 35 tons. The granite rocks were quarried by the artist near Skyomish, Washington, and the concrete forms were poured in place on site. The rocks were then transferred by rail and barge to the park site and positioned in relation to the concrete forms.

The artist was commissioned by the city of Seattle through the Seattle Arts Commission's Art in Public Places program to create a monumental group of three geometric concrete forms and granite shapes. The commission is a Seattle City 1 Percent for Art project, with the 1 percent funds matched by private contributions through the Contemporary Art Council of the Seattle Art Museum and a grant from the National Endowment for the Arts.

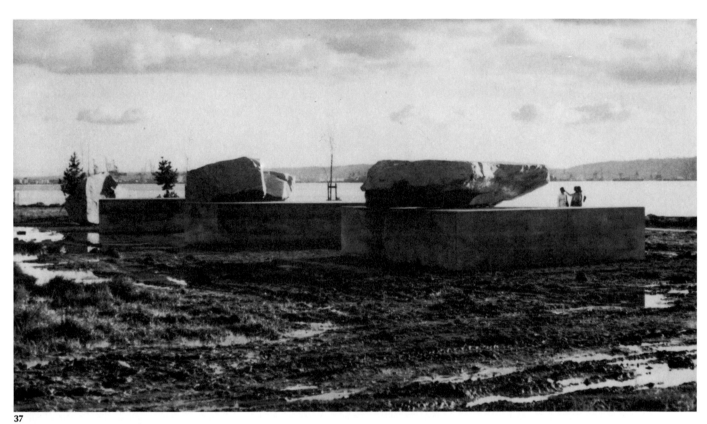

37

38

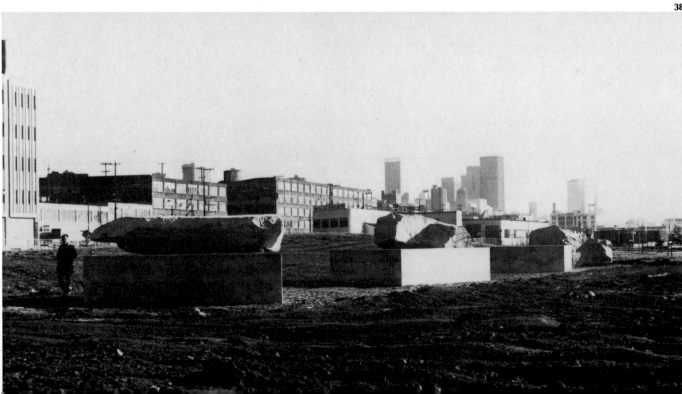

A short account of the background of this Michigan state public art project follows:

Governor William G. Milliken created the Special Commission on Art in State Buildings in 1975. He directed the commission to research the subject, analyze the findings, and recommend a program of implementation. The commission's ultimate goal is the establishment of a program to integrate appropriate art in the spaces and sites of every suitable facility in which the functions of state government are conducted. The commission has recommended a demonstration project which will require interest and financial support from the private sector.

The commission's subcommittee on design selected the green area of the mall just west of the state capitol complex as the top priority site. The site selected is the plaza that serves as the focal point for the four major state government buildings immediately south of, and adjacent to, the state capitol.

The subcommittee also selected from a list of twenty-one art professionals a five-member jury to recommend three artists for the project: The jury evaluated the proposed site, and recommended an "environmental" sculpture that would be open and low to the ground rather than a single massive monumental piece. After preliminary consideration of some forty major artists associated with large-scale public sculptures, the jury narrowed the list to three, and after carefully screening their works, ranked them in order of preference. The first choice (and the first one contacted), Michael Heizer, indicated a willingness to create a work of art within the suggested guidelines.

The proposed concept approved by the commission is designed to create a variety of patterns for people. It will provide them with a place to move around and through and to sit and stand upon. Its many elements and the variety of shadows they cast will provide the viewers with an opportunity to become part of the art itself.

The main source of the funding is corporate donors and individuals. Additional funding was secured from the Michigan Council of the Arts, Michigan Foundation for the Arts, and National Endowment for the Arts.

Of interest may be the comments of one of the jurors, Diane Kirkpatrick, University of Michigan art historian:

Art created for public places must respond to the fact that public space by nature is open to and belongs to the whole people of its community. Thus public art must make potentially accessible to visitors the double effects of all visual art: (1) the expansion of our human understanding through contact with the distilled insights of an artist, and (2) the life enhancement which comes through experiencing a satisfying arrangement of form, color, texture, and material. In addition, public art can sharpen our awareness of our physical existence in the shaped spaces of our world by sensitizing us to spatial aspects of a particular site which might otherwise escape our notice.

The choice of an artist to create a work of art for a public place is a grave responsibility. The panel or jury entrusted with this task must exercise a wide range of expertise to make a fair and successful selection. Such knowledge could hardly be found in one person. But whatever the number of its members, the jury should include the following areas of competence: (1) familiarity with a wide array of artists in the national and international scenes, (2) knowledge of an equally broad spectrum of artists in the local and regional scenes, (3) understanding of various art technologies and their relationship to the monies available to assess the feasibility of various types of art for the particular space, and (4) a representative of the site community who possesses at least good will toward diverse artistic styles.

The jury should be provided with pertinent information about the nature of the particular space and its community. Essential to this overview is some comment on whether the proposed site is wholly local in nature or will serve in addition the wider population of a region or a nation. For any commission, a key factor must be whether symbolism of some sort is appropriate to the piece. If so, how traditional should this symbolism be, given the needs of place and audience?

Once the nature of the art to be commissioned has been clearly thought through, the jury then will proceed to the selection of an artist. Here they must seek one who has demonstrated the ability to be sensitive to the specific needs of the commission as these have now been formulated. Ideally, in the end, the jury will examine candidates from the widest, possible appropriate talent pool to select the one artist best suited to create a work of public art which will grow in importance for the life of its community through the years ahead.

STATE CAPITOL PEDESTRIAN PLAZA
Lansing, Michigan

ARTIST: Michael Heizer, "This Equals That," a series of groupings of geometric figures—circles and portions of circles, steel armature covered with concrete; largest of the group, a 48' diameter disc lying flat and an upright disc 24' high. Scheduled for completion 1980.
DESIGN COORDINATION: Governor's Special Commission on Art in State Buildings

39

40

EDWARD A. GARMATZ FEDERAL BUILDING, U.S. COURTHOUSE, PLAZA

Baltimore, Maryland

ARTIST: George Sugarman, "Baltimore Federal," sculpture, 50′ long multicolored painted aluminum, 1977.
ARCHITECTS: RTKL Associates, Inc.

41

RICHARD H. POFF FEDERAL BUILDING AND COURTHOUSE, PLAZA

Roanoke, Virginia

ARTIST: John Rietta, untitled, steel sculpture, two elements, 30′ × 22′ high, 1976.
ARCHITECTS: Hayes, Seay, Mattern, and Mattern

42

FEDERAL OFFICE BUILDING, COURTHOUSE, FRONT LAWN

Rochester, New York

ARTIST: Duayne Hatchett, "Equilateral Six," sculpture, 12′ high painted steel.
ARCHITECTS: Northrup, Kaelber, and Kopf

After much public controversy and public hearings of Baltimore citizens and members of the Artists Equity Association, the decision was made by the federal authorities to install the sculpture. Because concern for security and safety were elements of the controversy, the General Services Administration agreed to install a television monitoring camera as part of the building's security system as well as additional lighting on the plaza.

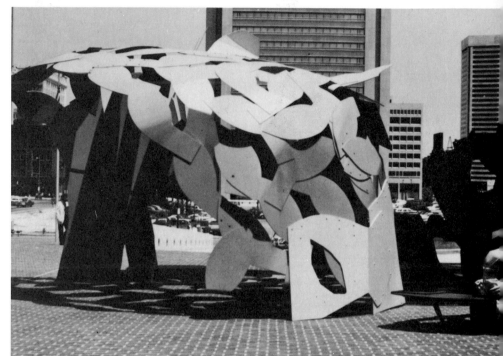

40

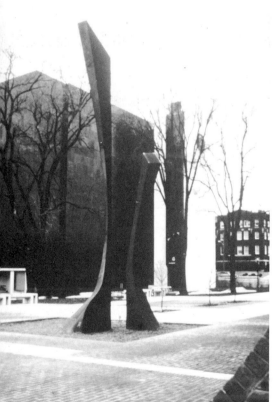

41

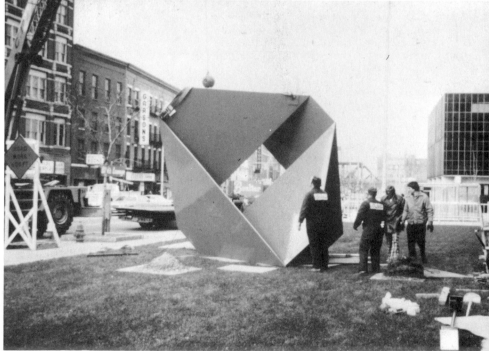

42

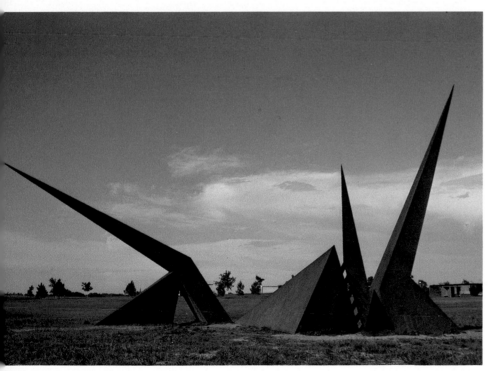

1

Plate 1

NEBRASKA INTERSTATE 80 BICENTENNIAL SCULPTURE PROJECT, 1976

ARTIST: Linda Howard, "Up/Over," 10' × 21' long aluminum (at Agallala westbound rest area).

Plate 2

NEBRASKA INTERSTATE 80 BICENTENNIAL SCULPTURE PROJECT, 1976

ARTIST: John Raimondi, "Erma's Desire," 26' high × 40' long × 30' wide weathering steel (at Grand Island eastbound rest area).

Plate 3

NEBRASKA INTERSTATE 80 BICENTENNIAL SCULPTURE PROJECT, 1976

ARTIST: George Baker, "Nebraska Wind Sculpture," 15' high × 25' long stainless steel (at Kearney westbound rest area).

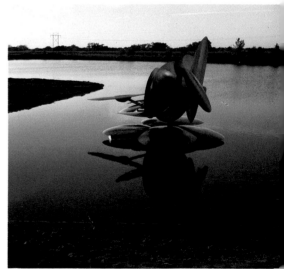

2 3

Plate 4

CIVIC CENTER PLAZA
Grand Rapids, Michigan

ARTIST: Alexander Calder, "La Grande Vitesse" (the great swiftness, or the grand rapids), 40' high, 52' long, 25' wide red painted steel, 1969.

Plate 5

YORKDALE STATION OF THE SPADINA SUBWAY, CEILING
Toronto, Ontario, Canada

ARTIST: Michael Hayden, "Arc-en-ciel," 570' long neon sculpture, 1978.
ARCHITECT: Arthur Erickson

Plate 6

GLENCAIRN SUBWAY STATION, CEILING
Toronto, Ontario, Canada

ARTIST: Rita LeTendre, untitled, 180' × 21' in three sections of 60' × 21' each; glass in two layers, painting done on the inside of the safety glass, exterior protected by an acrylic layer, 1978.
ARCHITECT: Adamson Associates, Frederick Fletcher, principal-in-charge

The Calder stabile, created for Grand Rapids, has the distinction of being the first work of art to be jointly commissioned and financed by federal ($45,000) and private funds ($85,000). No local tax monies were used. It has become the unique symbol of the city as well as the focal point of the downtown urban renewal.

Every spring since 1970, during the first weekend in June, the people of Grand Rapids celebrate the arts. The open-air free festivals were begun by and continue to be sponsored by the Arts Council of Greater Grand Rapids.

The festivals are held in Vandenberg Center, where the Calder stabile is located. They continue for three full days, and every arts organization in the community participates.

Volunteers organize and run the festivals, which attract well over 100,000 people, representing one-third of the metropolitan population.

Comments from Sandra Shaul*:

The visible portion of Hayden's work consists of a series of colored neon tube ribs running from east to west along the interior structure of the roof in order to create an arc over the station, which has a north–south orientation. The colors progress through 140 shades, beginning and ending in violet. According to the movement of trains entering and leaving the station, the tubes light up in a seemingly infinite variety of sequences, which have actually been programmed in the work's own computer, located in another part of the station.

The piece complements both the structure and the function of the building for which it has been created. It also functions according to the environment as can be seen when viewing the pieces out-of-doors. The neon lighting interacts with the variable character of the natural lighting outside the station.

*Sandra Shaul, "Tradition and Antitradition, an Historical Perspective of Canadian Sculpture," *Art Magazine,* June, pp. 10–15, 1978.

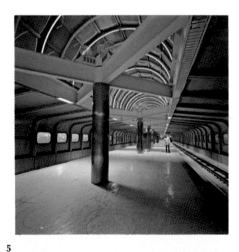

5

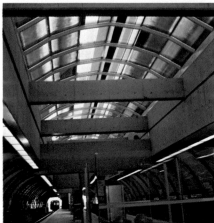

6

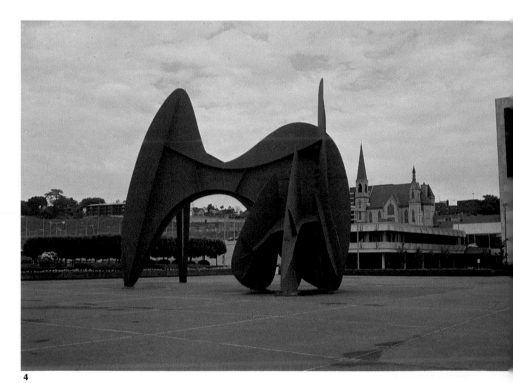

4

Geoffrey Nalyor comments:

I feel one of the few modern materials that can be used for outside sculpture is stainless steel, as most of the materials have a short outdoor life by comparison. The need for durable material and for a strong visual statement sets two limitations. A third is what the material will do once the sculptor starts to manipulate it. These restrictions provide a very strict discipline, and in some ways this sculpture goes to the extremes of what the material permits. In this work, the maximum plastic effect of stainless steel (i.e., movement, change) has been used: bizarre shapes rather than standard shapes, variety of angles rather than 90-degree angles, curves rather than straight lines.

Plate 7

FEDERAL BUILDING AND U.S. COURTHOUSE, PLAZA
Orlando, Florida

ARTIST: Geoffrey Naylor, "Artifact," water sculpture, 21' high stainless steel standing in 20' diameter pool, 1978.
ARCHITECTS: SWS

Plate 8

SOCIAL SECURITY ADMINISTRATION GREAT LAKES PROGRAM CENTER, LOBBY
Chicago, Illinois

ARTIST: Ilya Bolotowsky, untitled, mural, 45' × 14' porcelain enameled steel, 1976.
ARCHITECTS: Lester B. Knight Associates

Plate 9

FEDERAL OFFICE BUILDING, LOBBY
Santa Rosa, California

ARTIST: Lenore Tawney, "The Cloud," linen threads individually dyed, painted, and suspended from a dyed and painted canvas 5' × 30' with the threads on a 3" grid, 1978.
ARCHITECTS: Duncomde, Roland, Miller in joint venture with Frank L. Hope Associates

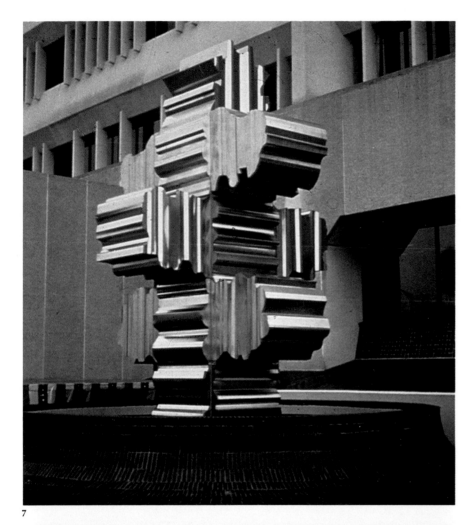

7

8

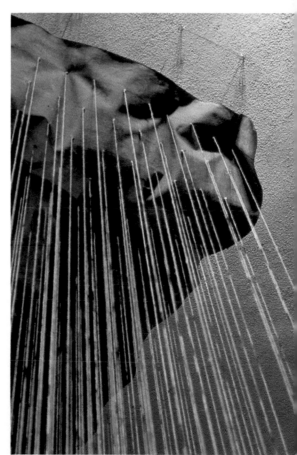

9

Plate 10

WILLIAM J. GREEN, JR. FEDERAL BUILDING AND JAMES A. BYRNE U.S. COURTHOUSE, LOBBY

Philadelphia, Pennsylvania

ARTIST: Charles Searles, "Celebration," mural, 9' × 27' acrylic on linen, 1977.
ARCHITECTS: Carroll, Grisdale, and Von Alen Bartley and Long, Mirinda, Reynolds, and Nolan

Plate 11

PRINCE JOHAH KUHIO KALANIANAOLE FEDERAL BUILDING, U.S. COURTHOUSE

Honolulu, Hawaii

ARTIST: Ruthadell Anderson, "Group Eleven – 1977," woven hangings, 1977.
ARCHITECTS: Belt, Lemmon, and Lo

Plate 12

SOCIAL SERVICE ADMINISTRATION BUILDING, CORRIDOR

Richmond, California

ARTIST: Janet Kuemmerlein, "Odyssey," tapestry, 6' × 30', 1976.
ARCHITECTS: William Pereira Associates

"Celebration" is patterned after a 1970 street festival in north Philadelphia. Searles describes the scene in the painting as "very colorful and festive with many intricate designs, an oval composition within a rectangular format." He intended to have people "visually enter the painting from either end and move their eyes across, down, and back again in an oval movement."

Ruthadell Anderson comments: "The eleven fiber artworks I created for the lobby are a visual summary of my experience with form and color. The various sculptural forms are united through the use of bold colors and repetitive shapes which relate to one another. More importantly, they relate to the entire environment of the two-story lobby area and, as such, were designed to be viewed from both the ground and second floors."

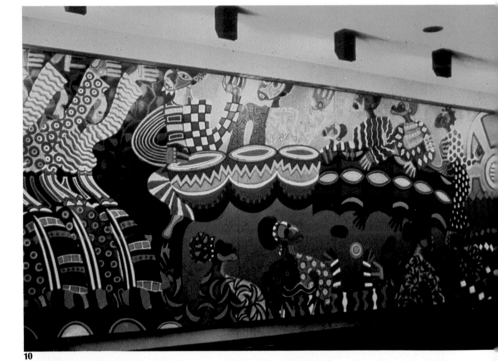

10

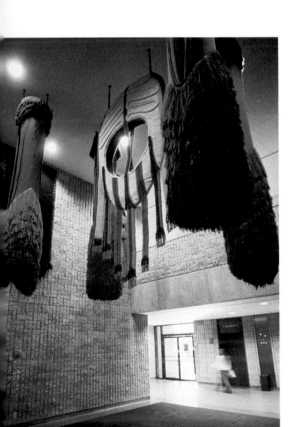

11

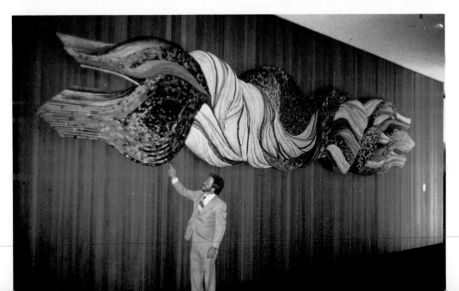

12

Artist's comments:

Ribbons are a means of visual joy. American Indians celebrated their lives by decorating their clothing with ribbons. Nineteenth-century settlers came with ribbons that served as symbols of refinement and elegance in a dusty place. Blue ribbons became signs of ultimate victory or reward for the rancher, the broncobuster, and the farmer. The military decorated their best with strips of colored cloth.

"Sky Ribbons" is a landscape and a skyscape which celebrates all of the best we have been. Like the American flag, it symbolizes and commemorates our origins and history, and in its color, light, life, and order it recognizes elements which are fundamental to all people.

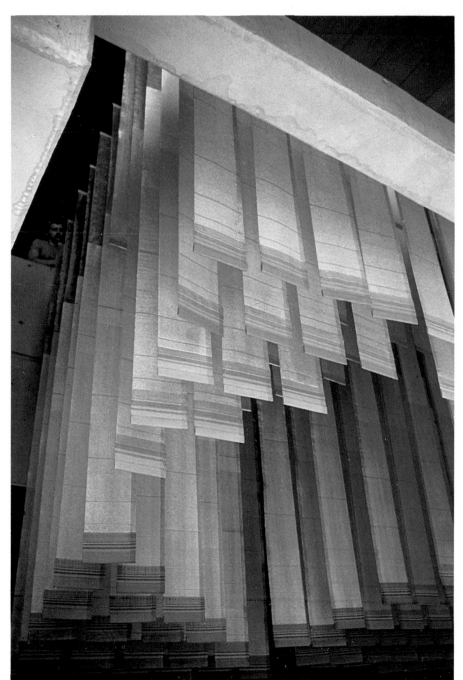

13

Plate 13

ALFRED P. MURRAH FEDERAL BUILDING
Oklahoma City, Oklahoma

ARTIST: Gerhardt Knodel, "Sky Ribbons: An Oklahoma Tribute," fabric sculpture 24' high, 14' wide, 12' long of Mylar, metallic guimpe, and wool. 1978.
ARCHITECTS: Shaw Associates

Plate 14

FEDERAL BUILDING
Columbus, Ohio

ARTIST: Robert Mangold, "Correlation," two white line diagonals and two arcs with a 16' radius, front 16' high × 16' wide, side 8' high × 8' wide, 1978.
ARCHITECT: Kent Brandt Brubaker/Brandt

Plate 15

FEDERAL OFFICE AND COURTHOUSE BUILDING, LOBBY
Ann Arbor, Michigan

ARTIST: Sherri Smith, "Firedrake," 7½' high × 35' long cotton webbing, hand-dyed and constructed, 1978.
ARCHITECT: TMP Associates, Inc.

14

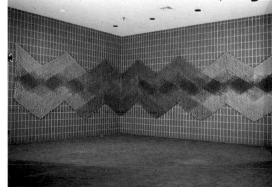

15

Plate 16

FEDERAL OFFICE BUILDING, LOBBY

Portland, Oregon

ARTIST: Jack Youngerman, "Rumi's Dance," tapestry, 14'
× 14' handwoven wool.
ARCHITECTS: Skidmore, Owings, and Merrill

Plate 17

DEPARTMENT OF LABOR BUILDING, LOBBY

Washington, DC

ARTIST: Jack Beal, "History of Labor in American
Industry," murals, 1977.
ARCHITECTS: Brooks-Barr-Graeber-White

Plate 18

FEDERAL BUILDING LOBBY

Dayton, Ohio

ARTIST: Staphen Antonakos, "Red Neon Circle," fragments
on blue wall 10' high × 68' long neon tubing mounted
on eight porcelain enamel panels.
ARCHITECT: Gartner, Burdick, Bauer-Nilsen

16

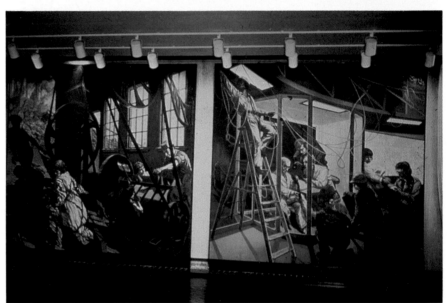

17

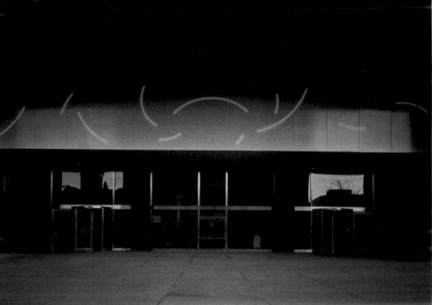

18

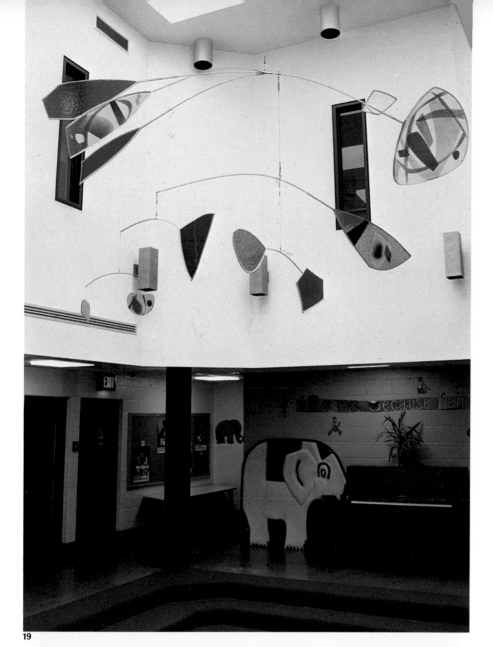

19

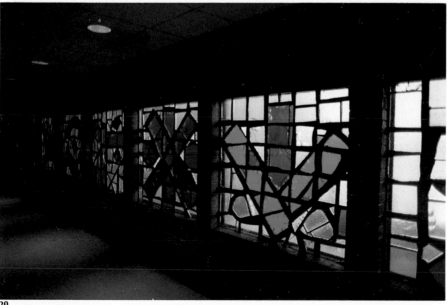

20

21

Plate 19

LUTHER CRAVEN MITCHELL PRIMARY CENTER NO. 135, COMMONS ROOM

Baltimore, Maryland

ARTIST: James Phillips, untitled, stained glass, stainless steel, and wire string mobile, 7' × 11', 1972.
ARCHITECT: Bernard Madison and Associates

Plate 20

COMMODORE JOHN ROGERS ELEMENTARY SCHOOL NO. 27, CORRIDOR

Baltimore, Maryland

ARTIST: Gyorgy Kepes, untitled, two stained glass and epoxy windows, 9' × 40', 1970.
ARCHITECT: Van Fossen Schwab

Plate 21

FURMAN L. TEMPLETON ELEMENTARY SCHOOL NO. 125

Baltimore, Maryland

ARTIST: Betty Wells, "Love," 8' × 40' outside wall mural of passageway connecting two wings of school (over highway), color-grouted tile mosaic, 1973.
ARCHITECT: Bacharach and Associates

Plate 22

SEATTLE WATER DEPARTMENT MAINTENANCE AND OPERATIONS CONTROL CENTER, FRONT LAWN

Seattle, Washington

ARTIST: Ted Jonsson, untitled, fountain, 12' high × 24'
 long mirror polished stainless steel, 1975.
ARCHITECT: The Burke Associates
ENGINEERS: R. W. Beck and Associates
LANDSCAPE ARCHITECTS: Jonge Jan/Gerrard/Associates

Plate 23

PARKWAY, ROOSEVELT ISLAND

New York, New York

ARTIST: Dorothy Gillespie, "Gambol Series #1," 43' long
 × 10½' high painted galvanized steel, 1978.

Plate 24

HONOLULU INTERNATIONAL AIRPORT (OUTSIDE FOREIGN ARRIVALS ON CONCOURSE FACING FIELD)

Honolulu, Hawaii

ARTIST: Kathe Gregory, "Ho'ele'elu," mural, 12' × 40'
 long acrylic on concrete.
ARCHITECT: Ossipoff, Snyder, Rowland, and Goetz

Artist Ted Jonsson comments:

The concept is that of a hugh polished stainless steel pipe in a sculptural form, extended by the shape of water projected out of two intricately designed orifices. These increase the illusion of tremendous volumes of water. The water forms can be manipulated by two valves which the public can operate.

I developed design innovations: hollow water forms—the product of my nozzle design (patent pending)—create the illusion of large volumes of water while using considerably less energy to pump them; also three-fourths less splash and spray is created because the hollow water forms cancel themselves on impact, and because levitation plates regulating water intake are located under the impact zone. The sculptural forms extend to form a curb around the pool, and, since they are located at the water level they act as a "wave damper," their curvature cancelling any wave action. The pumps are located under open grid works adjacent to the pool and are brightly painted so that the viewer is involved in the sensations of sound and vision.

The fountain is not only a successful work of art, but is especially suited for placement in front of the water department's control center. Its theme of water flow and control clearly parallels the center's activity. The fountain is also an unexpected event, making the building and the space around it visually richer and more inviting.

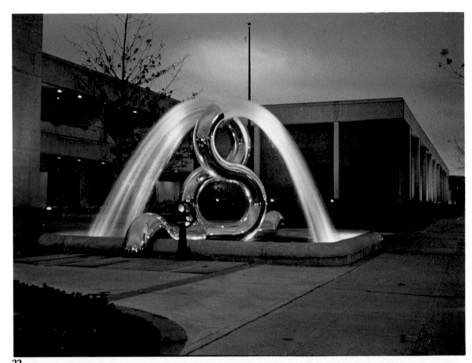

22

23

24

25

Plate 25

DOWNTOWN AMES, WALL MURALS, SUPERGRAPHICS

Ames, Iowa

Murals on the backs of buildings in a two-block area overlooking the city parking lot in downtown Ames. Project directed by Martha Benson, Director, The Octagon Art Center in Ames, through a grant from the Iowa Arts Council with additional funds provided by the Ames Downtown Betterment Bureau and the Community for Human Development of the City of Ames. Murals were painted by local mural artists assisted by twelve young people from the neighborhood Youth Core, participating in the Governor's Youth Opportunity Program.

Plate 26

GREATER BALTIMORE MEDICAL CENTER

Baltimore, Maryland

ARTIST: Van Woodson with apprentice Lyn Ostrov, untitled, mural in two sections, 52' × 48', and 44' × 30' exterior latex paint.

Plate 27

BUILDING WALL AT WILKINS AVENUE AND PAYSON STREET

Baltimore, Maryland

ARTIST: Monique Goss with apprentice Robert Madox, untitled, 32' × 17', exterior latex paint.

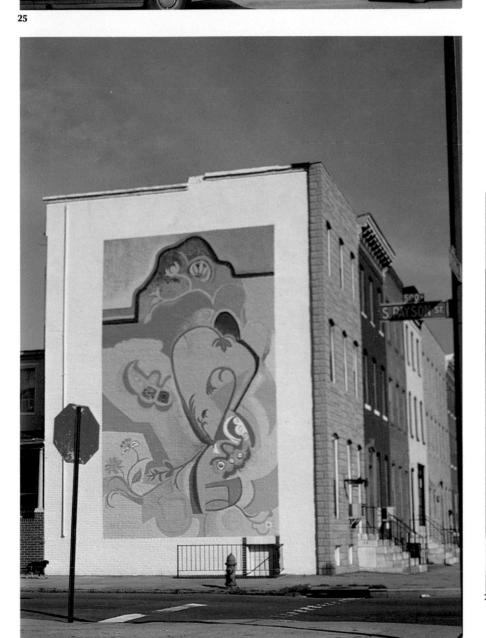

26

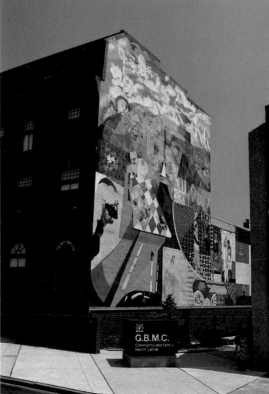

27

Plate 28

OAKLAND, CALIFORNIA

ARTIST: George Meade, "City Spirits '76," 1976.

Plate 29

BOSTON ARCHITECTURAL CENTER

Boston, Massachusetts

ARTIST: Richard Haas, "City Scenes," 1977.

Plate 30

LOUISVILLE, KENTUCKY

ARTIST: Jean Henderson, "City Spirits '76," 1976.

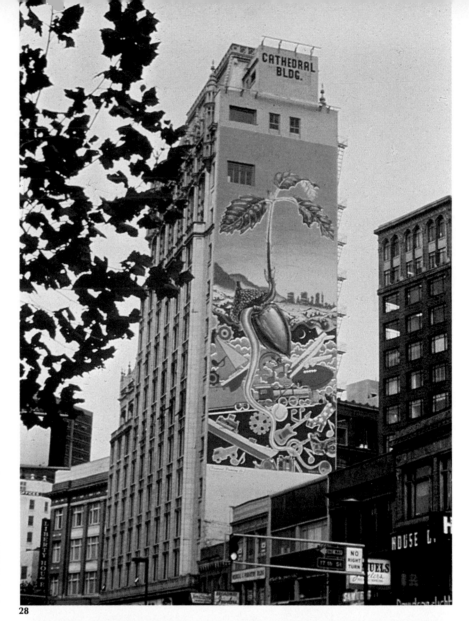

28

29

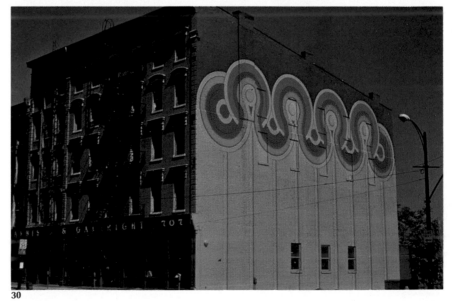

30

Doris C. Freedman, president of the Public Art Fund, Inc., of which City Walls is a program, comments:

After Allan D'Arcangelo completed his first wall painting in 1967, the visual and psychological effects on the community were startling. The drab dismal atmosphere of the block was suddenly transformed by a bright illusionary landscape, and, almost immediately, artists responded to the potential of this new kind of "public art." For artists concerned with halting urban decay, this wall demonstrated new possibilities of eliciting community pride by providing areas throughout the city with colorful focal points.

The effect on the urban environment did not go unnoticed by the city government, business community, architects, and neighborhood groups. As interest and excitement in the concept grew, the need for an organization to work with the artists and communities became apparent. With the help of the J. M. Kaplan Fund, City Walls, Inc. was formed in 1970 as a nonprofit service organization for the initiation and administration of wall painting projects. To date, fifty walls have been painted in neighborhoods throughout Manhattan, the Bronx, Brooklyn, Queens, and Jersey City. Artists participating in the rapidly expanding program have included: Richard Anuskiewicz, Walter Darby Barnard, Clarence Carter, Pierre Clerk, Nassos Daphnos, Errol Dopwell, Richard Haas, Alex Katz, Hugh Kepets, Nicholas Krushenick, Alvin Loving, Knox Martin, Forrest Myers, Reginald Neal, Mel Pekarsky, Jay Rosenblum, Florence Siegal, and Todd Williams.

City Walls is now a program of the Public Art Fund, Inc., which is a nonprofit service organization committed to the incorporation of large-scale sculpture as well as wall paintings into the urban environment. The Public Art Fund works primarily with artists and communities, but also acts as a consultant for corporations and civic agencies, providing expertise in dealing with red tape and coordinating the efforts of the artist with those of the contractor, landlord, and community. Continuing support has enabled City Walls to share its knowledge and experience with diverse groups not only in New York City but also in Chicago, Detroit, Philadelphia, Syracuse, Boston, Cincinnati, Atlanta, Baltimore, San Francisco, and as far away as Toronto, Tel Aviv, Tokyo, Paris, London, and Hanover, as a result of which many cities now have their own wall programs.

Integrating the artist and his or her work into everyday urban life cannot fail to enrich the quality of life in our cities.

Plate 31

YOUNG WOMEN'S CHRISTIAN ASSOCIATION BUILDING
New York, New York

ARTIST: Richard Anuszkiewicz, untitled wall, 1972.

Plate 32

26TH STREET AND MADISON AVENUE
New York, New York

ARTIST: Nassos Daphnis, untitled wall, 1969.

Plate 33

64TH STREET BETWEEN AMSTERDAM AND WEST END AVENUES
New York, New York

ARTIST: Allan D'Arcangelo, untitled wall, 1970.

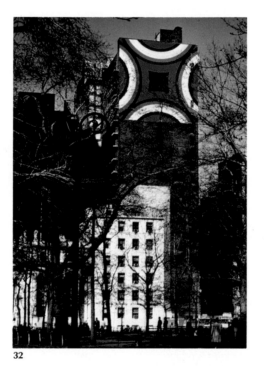

31

32

33

Plate 34

41ST STREET AND DREXEL AVENUE, WALL
Chicago, Illinois

ARTISTS: Justine Devan, Mitchell Canton, Calvin Jones, "Time to Unite," 1976. (Sponsored by NEA and Chicago Mural Group.)

Plate 35

4040 W. BELMONT, WALL
Chicago, Illinois

ARTISTS: Caryl Yasko, Celia Radek, Lucyna Radycki, Justine Devan, Jacek Kokot, "Razem," a Polish heritage mural, 1975. (Sponsored by the Polish American Congress, NEA, and Chicago Mural Group.)

Plate 36

4338 WEST NORTH AVENUE, WALL
Chicago, Illinois

ARTISTS: Celia Radek, Cynthia Weiss, Jose Guerrero, and team of volunteers, "The Fruits of Our Labor," 1976. (Sponsored by the Youth Service Project, NEA, and Chicago Mural Group.)

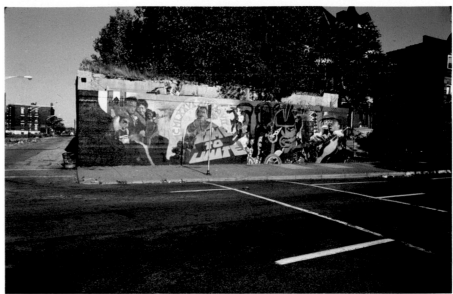

34

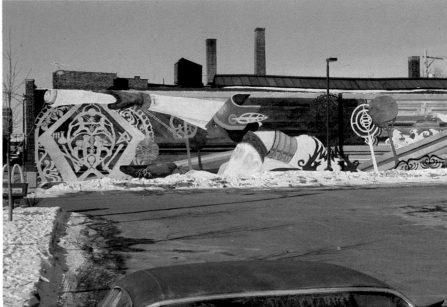

35

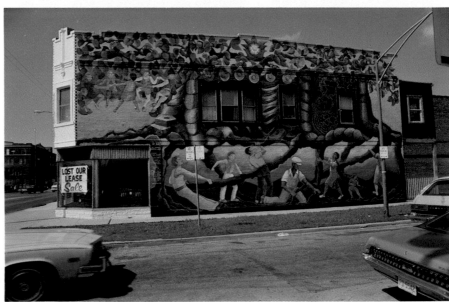

36

Professor Howard Woody of the University of South Carolina developed the space and motion concepts of atmospheric sky sculpture in the late 1960s and has flown over 100 sculptural events to date. This activity has extended the concept of environmental art to include near-earth sky space. These sculptural sensors are designed to respond to natural atmospheric energies and to visualize these forces in an organized manner as they move in a free sky flight. The intent of "Sky Sculpture" is to visually define and document the energy in a selected air structure. This structure consists of air qualities—motion, pressure, temperature, and humidity—formed both by the weather patterns moving across a region and the local topographical features. The vast active space in the near-earth sky environment forms the setting for "Sky Sculpture."

In general, over twenty different designs or concepts have been used with several flown many times, thus documenting the contrasting possibilities of a given design. Each flight is unique because of unique air structure.

This environmental artform begins as a participatory event with groups of twenty to fifty people helping in the launch. During liftoff the helium envelopes permit a buoyant, unrestricted ascent and trajectory. All FAA procedures and regulations are followed in the design, construction, and flight activities. The sensor is tracked by ground and air teams to record and document its flight activities. The floating sensor is activated or modified by the air structure present, which shapes the motions, arrays, and flight pattern. A geographic dispersion flight concept is involved. As it drifts up to a 3000 to 12,000 foot flight altitude, it is viewed by everyone in its flight path until its landing. This distance can be as little as 3 miles or as much as 285. The flight distance is determined by the speed and velocity of the wind. An average flight time is about two hours. Often a string of cars begins to follow the descending unit as it nears its landing point, thus collecting another group of spectators-participants at its destination. All of this is documented to record the ephemeral activity, and the spent elements are removed on behalf of the environment.

Sponsors have included art museums, universities and colleges, state art commissions, public schools, art conferences, art festivals and art fairs, environmental events such as "Sun Day," boy scouts, etc. Launch sites have been at museum and university grounds, parks, public school grounds, city centers, housing developments, parking lots, rooftops, public beaches, open fields, and shopping center plazas.

Plates 37, 38, 39, 40

TENTH INTERNATIONAL SCULPTURE CONFERENCE, BATHHURST QUAY PLAYING FIELD, AT HARBOUR FRONT
Toronto, Ontario, Canada

ARTIST: Howard Woody, "Sky Sculpture," 10' wide × 65' long silver ½-mm Mylar (polyester film) plus helium. Single unit with six gas envelopes. Four photos show sky launch from ground, low, medium, and high position in 6400'-high flight.

37

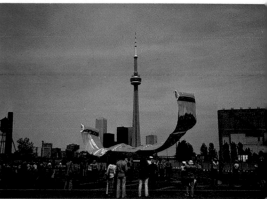

39

38

Plate 41

PLAZA HOTEL, ATRIUM
Renaissance Center, Detroit, Michigan

ARTIST: Gerhardt Knodel, "Free Fall," fabric sculpture, 8′ × 15′ × 70′ handwoven panels of Mylar, metallic guimpe, and wool, combined with Plexiglass tubes, nylon rope, and stainless-steel rods and cable, 1977.
ARCHITECT: John Portman and Associates

Plate 42

EDMONTON PLAZA HOTEL, LOBBY ATRIUM
Edmonton, Alberta, Canada

ARTIST: James Gilbert, "Spatial Transitions," loom-woven panels each 6′ wide, hanging in pairs in lengths from 10′ to 23′, 1977.
ARCHITECT: Reno Negrin and Associates

Plate 43

333 WEST FORT BUILDING, LOBBY
Detroit, Michigan

ARTIST: Louis G. Redstone, untitled, tapestry, woven in Mexico from a watercolor by artist.
ARCHITECTS: Louis G. Redstone Associates, Inc.

Gerhardt Knodel comments:

My work suggests something about the range of my interests in exploring the potential of fabric in interior spaces. I hope that it is apparent that I am looking for solutions that go beyond decoration to become expressively related to the architecture. I am always looking for situations which allow for conversation with the architect before the plans are finalized. I believe that for art and architecture to function well together, they must be conceived and developed together; one does not dominate the other; they are mutually supportive.

The ceiling hangs from the interior of six skylight wells, in the ceiling of the second level (ballroom and conference rooms). A second-floor balcony surrounds the five-sided opening in which the first floor can be seen below. The work hangs from the skylights through this open space down into the cocktail lounge in the lobby area.

It is hung on steel cable wire attached to pulleys which all connect so the work can be lowered for cleaning and adjustments. Up-and-down lights and Tivoli lighting hang in the center of each pair of curved panels.

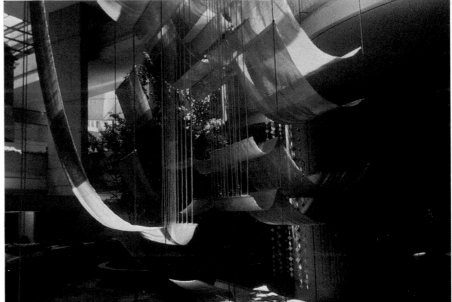

41

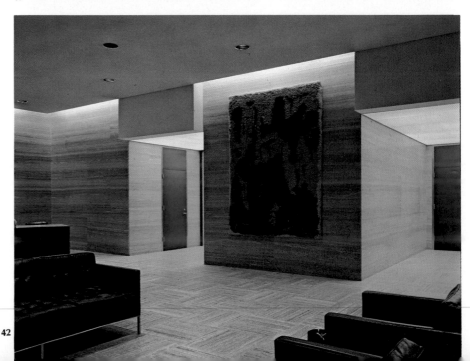

43

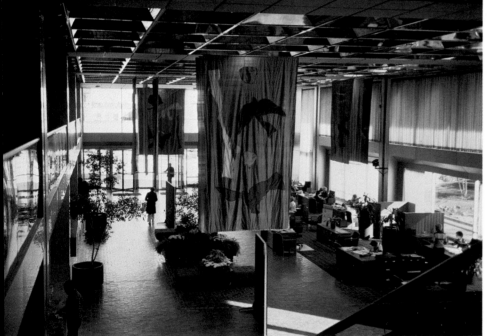

44

Plate 44

WESTERN ELECTRIC BUILDING, LOBBY
New York, New York

ARTIST: Buell Mullen, untitled, mural, 25' high × 52' long stainless steel with epoxy resin colors.

Plate 45

FIRST NATIONAL BANK, FIRST FLOOR
Little Rock, Arkansas

ARTIST: Sheila Hicks, "Migration of Birds," thirteen colored and six gold woven silk banners, 9' high × 5' wide, 1975.
ARCHITECT: Wittenberg, Delony, Davidson, Inc.

Plate 46

MONSANTO CORPORATION, LOBBY
Montvale, New Jersey

ARTIST: John Costanza, "Waterwall," 6' × 20' ceramic mural, 1976.
ARCHITECT: Rouse, Dubin, and Ventura

Plate 47

R. L. WHITE COMPANY, SUBSIDIARY OF THE AMERICAN BROADCASTING COMPANY, RECEPTION AREA
Louisville, Kentucky

ARTIST: Alice Baber, "Swirl of Sounds: Ghost in the Banyan Tree," 72" × 97" oil on canvas, 1976.
ARCHITECT: G. Reynolds Watkins

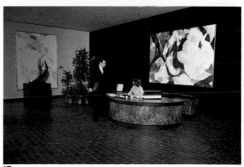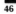

45

46

47

Plate 48

GRAND HOGBACK
Rifle, Colorado

ARTIST: Christo, "Valley Curtain," 1972.

Plate 49

LOOSE PARK
Kansas City, Missouri

ARTIST: Christo, "Wrapped Walk Ways."

At 11 A.M. on August 10, 1972, in Rifle, Colorado, a group of thirty-five construction workers and sixty-four temporary helpers, art school and college students, and intinerant art workers tied down the last of twenty-seven ropes that secured the 200,000 square feet of orange woven nylon "Valley Curtain" to its moorings at Rifle Gap, 7 miles north of Rifle on Highway 325.

"Valley Curtain" was designed by Unipolycon of Lynn, Massachusetts, and the Ken R. White Company of Denver, Colorado. It was built by A and H Builders, Inc. of Boulder, Colorado, under the site supervision of Henry B. Leininger.

Suspended at a width of 1313 feet and a height curving from 365 feet at each end to 182 feet at the center, the curtain remained clear of the slopes and the valley bottom. A 10-foot skirt attached to the curtain visually completed the area between the thimbles and the ground. An outer cocoon, secured to the eleven cable clamp connections at the four main upper cables, was put around the fully fitted curtain for protection during transit and assembly. An inner cocoon, integral to the curtain, provided added insurance. The bottom of the curtain was laced to a 3-inch-diameter dacron rope from which the control and tie-down lines ran to the twenty-seven anchors.

The project took twenty-eight months to complete. On August 11, twenty-eight hours after the "Valley Curtain" had been completed, a gale estimated to be in excess of 60 miles per hour made it necessary to begin its removal.

"Wrapped Walk Ways" consisted of 136,268 square feet of saffron-colored nylon cloth covering 104,836 square feet of formal garden walkways and jogging paths. Installation began on Monday, October 2 and was completed on Wednesday, October 4. Eighty-four people were employed by A. L. Huber and Son, a Kansas City building contractor, to install the material. Among others, there were thirteen construction workers and four professional seamstresses. The cloth was secured in place by 34,500 steel spikes (7 inches by $5/16$ inches) driven into the soil through brass grommets in the fabric and by 40,000 staples in wooden edges on the stairways. After over 52,000 feet of seams and hems were sewn in a West Virginia factory, professional seamstresses, using portable sewing machines and aided by many assistants, completed the sewing in the park. The Contemporary Art Society of the Nelson Gallery, which was instrumental in getting the construction permits, sponsored an exhibition of "Wrapped Walk Ways" documentation at the Nelson Gallery-Atkins Museum.

The project remained in Loose Park from October 4 to October 16, 1978, after which the material was removed and given to the Kansas City Parks Department.

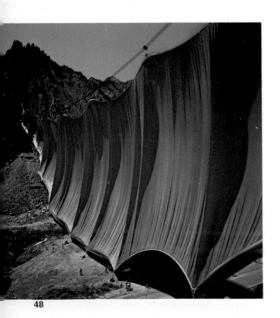

48

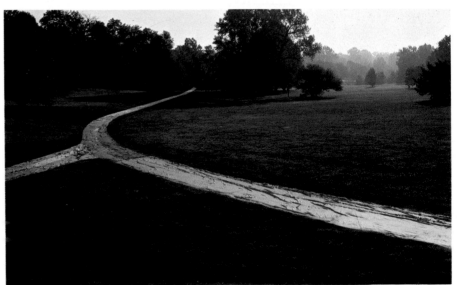

49

43

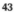43

LOUISE NEVELSON PLAZA, LOWER MANHATTAN
New York, New York

ARTIST: Louise Nevelson, "Shadows and Flags," seven black-painted weathering steel sculptures, one piece is 71' high and six others are 16 to 22', 1978. (The Plaza is located at Legion Memorial Square at William St., Liberty St., and Maiden Lane in the Wall Street district and was financed by private donors.)

44

POLICE MEMORIAL BUILDING, INTERIOR CORRIDOR
Jacksonville, Florida

ARTIST: Original designs by second-grade students, enlarged and painted on eight banners, each 8' high × 4½' wide, by artist, Anne Williamson, 1977. Banners were colored with hand-applied thickened procion dyes on 100 percent cotton duck fabric, a process that allows strong, bright colors. (Funding by NEA and Fine Arts Council of Florida.)
ARCHITECT: William Morgan Architects
INTERIOR DESIGNER: Ed Heist, Jr.

45

POLICE MEMORIAL BUILDING, PLAZA
Jacksonville, Florida

DESIGNER: William Morgan, untitled, fountain, textured concrete, 1977.
ARCHITECT: William Morgan Architects

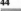44

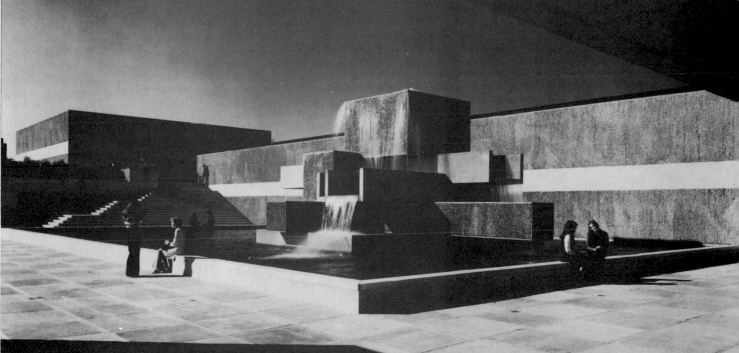

45

46, 47

CIVIC AUDITORIUM, FORECOURT
Portland, Oregon

LANDSCAPE ARCHITECT: Lawrence Halprin and
Associates, 1970.

48

PORTLAND MALL
Portland, Oregon

ARTIST: Robert Maki, untitled, sculpture fountain, metal
on oval granite base, 1978.
ARCHITECTS: Skidmore, Owings, and Merrill
LANDSCAPE ARCHITECTS: Lawrence Halprin and
Associates

49

PORTLAND MALL
Portland, Oregon

ARTIST: Lee Kelly, untitled, sculpture fountain, stainless
steel, 1977.
ARCHITECTS: Skidmore, Owings, and Merrill
LANDSCAPE ARCHITECTS: Lawrence Halprin and
Associates

Dominating an entire city block, this "people park," to use Halprin's words, consists of a sculptured terrace-garden where people can escape from the bustle of the city. It was designed to complement the auditorium as an informal outdoor theater and activity area divided into an upper and lower level. On the upper level, rivulets originate and thread their way down through a maze of rocklike concrete tiers until, supplemented by additional water, they cascade down 10 to 18 feet into a massive waterfall 80 feet across. There is a well-lighted grotto behind this waterfall area where people may sit and look through the falls toward the entrance to the auditorium. This curtain of water also forms a background for the amphitheater in the lower level. From the steps of the auditorium, the viewer looks across to a sculptured park framed in green and planted with a variety of trees, both deciduous and evergreen. Berms, or raised areas, on the three sides help to shut out the traffic and other city noises. Moving across the street from the auditorium entrance, the viewer can descend steps on either side of broad terraces 8 to 10 feet below the street level to the amphitheater, which is 100 feet wide.

The amphitheater offers a stage where outdoor events can be held or where people can congregate before performances or during intermissions. Seating is provided by the terraces and the steps. Because the amphitheater is below ground level, passing traffic is screened from view, the 13,000 gallons of water cascading over the falls each minute further drown the sound of traffic. A remote control center contains equipment to reduce the flow of water during performances and to adjust the lights.

*From a release by the Portland Development Commission.

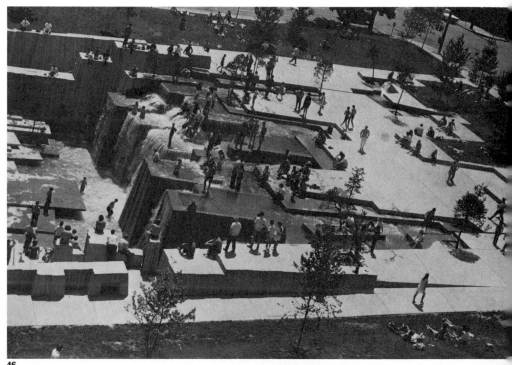

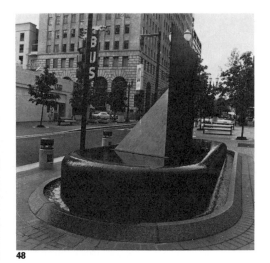

48

46

47

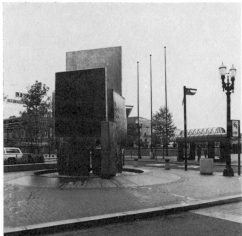

49

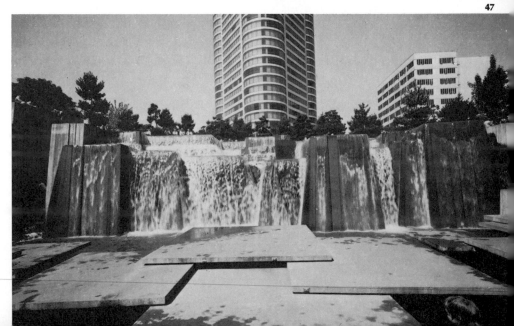

Architect's statement:

The twenty-two-block long Portland Transit Mall superimposes three distinct layers of vehicular circulation, pedestrian walkways, and landscape improvements on eleven blocks in the heart of Portland. Working within the orthogonal grid of the city, a system of coordinated signals, street lights, bollards, widened sidewalks, and reduced street widths establishes an exclusively one-way circulation corridor. As the hub of a regional transit system, the mall provides convenient transfers between bus routes and serves as a link between suburban transit stations and future light rail lines now being designed.

Shape, color, and texture direct and focus pedestrians along the corridor to bus stops. Red brick paving banded by cut grey granite curb borders the system of bus shelters, information kiosks, vendors' booths, fountains, and sculpture that enrich the pedestrian experience. The intersections of pedestrian traffic and bus circulation systems are marked by large granite circles at each street intersection. Trees, tubs of flowers, and overhead banners mark the change of seasons and introduce a natural element into this sophisticated transit corridor.

The project won the 1979 American Institute of Architects Honor Award. The jury comments were: "It is honored because of its contribution to the public life of its city and region. It is an outstanding example of the integration of architecture and other design professions, including traffic engineering, landscape architecture, and graphic design. The design is an example of architecture as a temporal, as well as a spatial experience in everyday life. That is, the transit mall is a discontinuous structure, but it is a continuous experience made more vivid by its architectural design. In addition, it is an example of excellence of design detailing, especially the kiosks, fountains, benches, curbs and paving, signs, and pamphlets. Finally, it exemplifies architecture's contribution to the ecological as well as visual values of life through the encouragement of the use of public transportation and the conservation of energy."

50

TRANSIT MALL
Downtown Portland, Oregon
Sculptured fountain, 1978

ARCHITECTS AND LANDSCAPE ARCHITECTS: Skidmore, Owings, and Merrill and Lawrence Halprin and Associates

51

TRANSIT MALL
Downtown Portland, Oregon
Walk-through bus station, 1978.

ARCHITECTS AND LANDSCAPE ARCHITECTS: Skidmore, Owings, and Merrill and Lawrence Halprin and Associates

50

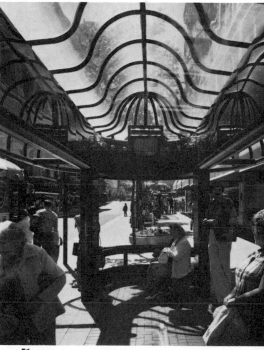

51

52

TRANSIT MALL

Downtown Portland, Oregon
Banners, 1978.

ARCHITECTS AND LANDSCAPE ARCHITECTS: Skidmore, Owings, and Merrill and Lawrence Halprin and Associates.

53

TRANSIT MALL

Downtown Portland, Oregon
Sculpture, fountain, 1978.

ARCHITECTS AND LANDSCAPE ARCHITECTS: Skidmore, Owings, and Merrill and Lawrence Halprin and Associates

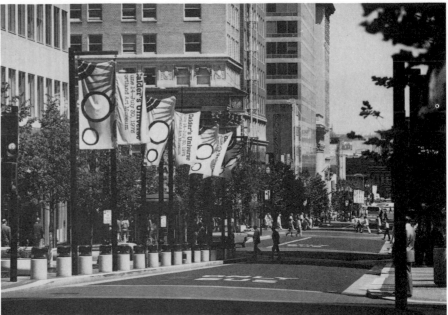

52

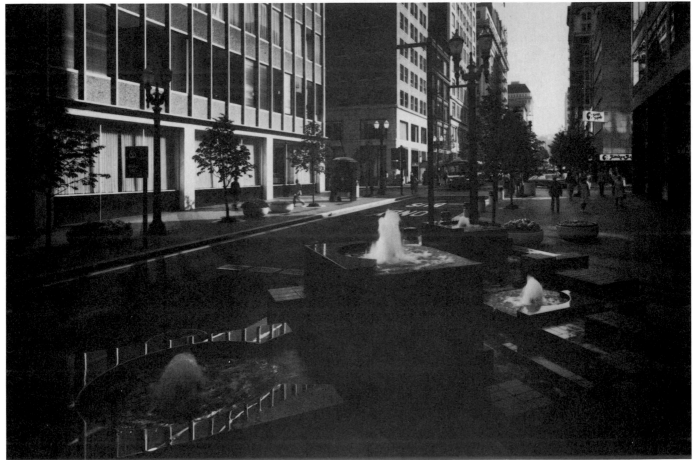

53

Seattle, Washington reclaimed 5½ acres of freeway airrights as a public park, challenging the notion that freeways can only violate a city. Seattle Freeway Park is an innovative solution to integrate a vital transportation corridor into the city's urban fabric; to provide much needed urban open space in an increasingly dense downtown; and to utilize the "free" airspace over a freeway that bisects the city.

Freeway Park resulted from three main goals: (1) the desire of the Seattle community as a whole to reunite neighborhoods severed by the construction of Interstate 5 in the 1950s; (2) the concerted effort of private citizens to seek support and funding; and (3) the longstanding commitment of the designer to reconcile transportation needs in urban environments.

This complex project demonstrates what the coordinated efforts of citizens, public officials, private enterprise, and planning and design professionals can achieve. The park is the first project in the country on which city, state, and federal agencies have joined with private investors to convert a freeway wasteland into a major element of a central city greenbelt.

Seattle Freeway Park, therefore, is the result of intricate planning and coordination. Almost 8 years ago Seattle undertook a significant park development program. "Forward Thrust" was a voter-approved bond issue for open space acquisition and park improvement in the city of Seattle and surrounding Kings County, and among the projects considered under this program was a linear strip along Interstate 5. As pieces were collected and related projects began to emerge during the planning stages—such as a major muncipal parking garage adjacent to the freeway—the opportunity arose to expand a few isolated visual improvements along the roadway into a really innovative way to return lost and alien space to people's use.

Integrating these projects required cooperation and collaboration among individual project sponsors. For instance, the Washington State Department of Highways built the bridge linking the city's garage with the garage and plaza of H. R. Hedreen's new Park Place office building across Interstate 5, and the Department of Housing and Urban Development made a federal open space grant to Seattle to provide a "pedestrian walkway" over the freeway. The Park Designer was also responsible for coordinating the related complex structural and architectural aspects of the project that were being undertaken by other design firms and agencies during the park's construction.

54, 55

FREEWAY PARK
Downtown Seattle, Washington

LANDSCAPE ARCHITECT: Lawrence Halprin and Associates, fountain, concrete, 1976. This 5.4 acre park is actually a roof garden built atop two parking garages and a bridge structure which spans the freeway. In terms of the urban fabric, the park knits together two parts of downtown that the freeway had torn apart. Within the park are several fountains, green spaces, plazas, and a series of large terraced planters, all of which combine to form a beautiful setting for a variety of activities.

56

WOODLAND PARK ZOO
Seattle, Washington

ARTIST: David Gilhooly, "Seattle's Own Ark," ceramic sculpture, 1979.

56

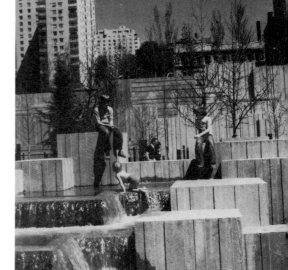

55

54

PHILIP A. HART PLAZA, HORACE E. DODGE & SON FOUNTAIN, CIVIC CENTER

Detroit, Michigan

DESIGNER FOR PLAZA AND FOUNTAIN: Noguchi
Fountain Plaza, Inc. Fountain is 30' high stainless steel
"floating" above a walled circular pool, 1979.
ASSOCIATE ARCHITECTS AND ENGINEERS: Smith,
Hinchman & Grylls Associates, Inc.

The 8-acre Hart Plaza accommodates a wide variety of uses by both large and small groups of people, many of which can meet simultaneously. The various activity areas within the plaza space allow maximum public participation, and it is well suited for the colorful ethnic summer festivals. The lower level includes a tourist information center, public washrooms, security offices, dressing rooms for the amphitheater activities, restaurants, a mechanical equipment room, and provisions for shops and boutiques.

According to Noguchi:

The design develops a functional relationship between the fountain, the plaza, and what goes on below. The plaza, viewed as a whole will present a series of pyramidal shapes: that of the fountain, that of the stepped pyramid of the theater, the blue exhaust stack of the underground road, and the greater pyramid of the festival amphitheater as it rises to the plaza plane. The whole will be seen as a low mound with the bend in the road and the river beyond. I like to think that the effect will be American, unlike anything elsewhere.

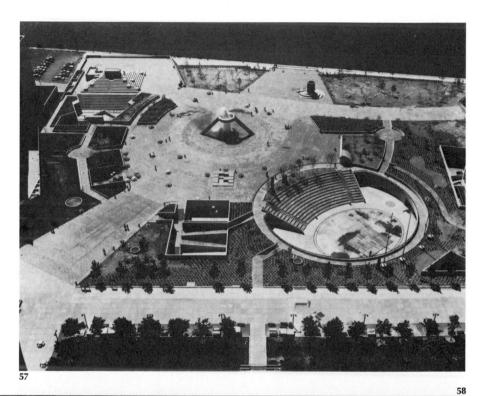

57

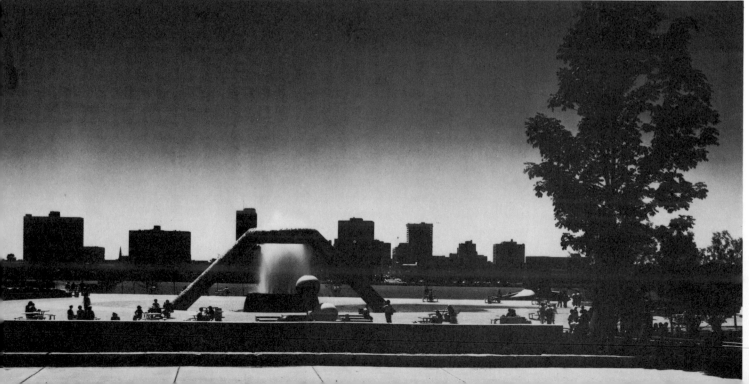

58

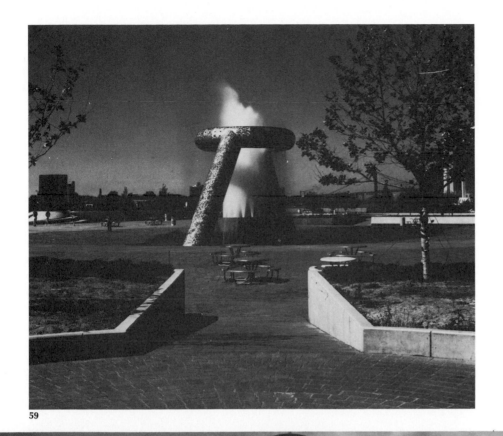

59

60

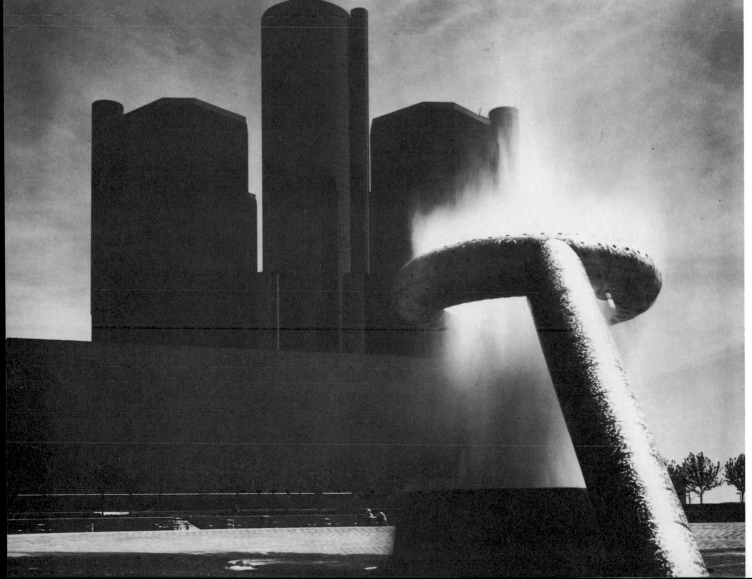

61

MARYLAND SCIENCE CENTER, PROMENADE
Baltimore, Maryland

ARTIST: Kenneth Snelson, "Easy Landing," stress/tension sculpture, 30' × 85' × 65' tubular stainless steel, wire rope, and three reinforced concrete pedestals, 1978. (Commissioned by the city of Baltimore, William Donald Schaefer, Mayor. This piece was made possible through municipal grants and selected by the Charles Center–Inner Harbor Advisory Committee on Public Sculpture.)
ARCHITECT: Charles Tomlinson of the firm WMRT in Philadelphia.

62

FEDERAL BUILDING
Charlotte Amalie, St. Thomas, U.S. Virgin Islands

ARTIST: Ned Smyth, "Reverent Grove," venetian glass and ceramic tiles on concrete, 10'6" high in 20' diameter pool, 1978.
ARCHITECT: Thomas Marvel

63

PIAZZA d'ITALIA
Old City Renewal Area, New Orleans, Louisiana

FOUNTAIN DESIGNER: Charles Moore, Urban Innovations Group, 1978.
ARCHITECT: August Perez & Associates

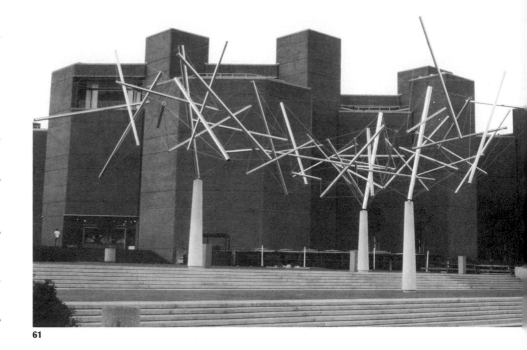

61

62

63

As work on this square was part of the Wilkes-Barre Downtown Urban Renewal Program's public improvements, the funding was provided by HUD and the Pennsylvania Department of Community Affairs after the flood caused by Hurricane Agnes in 1973.

64

DOWNTOWN PUBLIC SQUARE
Wilkes-Barre, Pennsylvania

ARTISTS: Annie Bohlin, Peter Bohlin, and William Gladish, "People Seats," painted bent steel, 1976.
ARCHITECTS: Bohlin Powell Brown

65

DOWNTOWN PUBLIC SQUARE, DETAIL OF SPECIAL PAVING BLOCKS
Wilkes-Barre, Pennsylvania

ARTISTS: Peter Bohlin, Eric Oliner, William Gladish, David Wilson, Frank Grauman in collaboration with Regis Melioni, "Petroglyph" (defined as "a drawing or carving on rock made by prehistoric or primitive people"). In all over 300 petroglyphs were set, 1977.

66

DOWNTOWN PUBLIC SQUARE
Wilkes-Barre, Pennsylvania

ARCHITECTS: Bohlin Powell Brown

67

DOWNTOWN PUBLIC SQUARE
Wilkes-Barre, Pennsylvania

ARTISTS: Regis Melioni in collaboration with Peter Bohlin, "Beast," segmented marble play sculpture, 1977.
ARCHITECTS: Bohlin Powell Brown

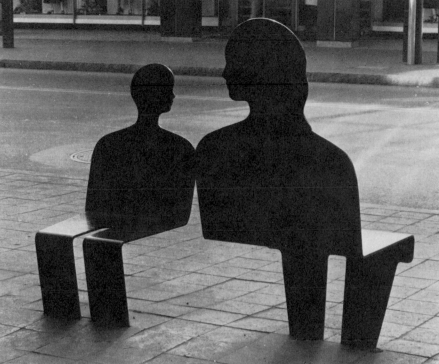

64

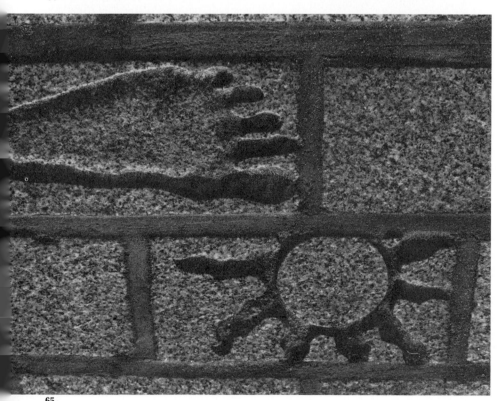

65

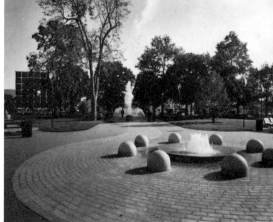

66

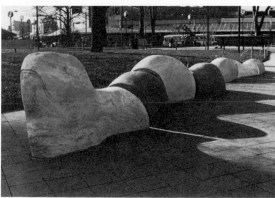

67

Public Art in the Educational and Civic Environment

All schools—from primary schools to universities—provide an ideal opportunity for presenting works of art which reflect the searching efforts of talented artists. A campus is an ideal place for a student to be introduced to art in all its forms, and an atmosphere of art thus becomes a natural and enjoyable part of daily life. There is a good possibility that college students, many of whom will become future leaders, will provide strong influences in their communities for the creation of similarly enriching environments.

To stimulate interest in public art, a number of universities have promoted public exhibitions on campus. In many cases, some of the works remain permanently, purchased by private donors. Another way of introducing public art on campus is through a symposium, such as the first one organized by the University of California at Long Beach in 1965. Since then some other universities, such as the University of Oregon in 1974, have successfully conducted major symposia, with many excellent works remaining on campus and in the community as a result. Details of symposium organization are presented in this chapter. As for funding, most campus art is funded by donors, with a number of gifts matched by funds from the National Endowment for the Arts. In a few cases, such as at the University of Houston, the university earmarks a percentage of its construction budget for art.

The fact that so few examples of art are seen at the primary-school level indicates the lack of attention shown by educators to this important aspect of cultural values. It is only by laying the groundwork at the elementary level that we can prepare a new generation to become receptive to the enjoyment of art in everyday life.

This chapter includes significant examples of public art incorporated into the design of civic center plazas. Important works of public art are displayed in many of the transportation facilities, including airports and subway stations. Also featured are exterior wall murals, a comparatively recent development that adds color and interest to the drab surroundings in the older sections of cities.

An interesting aspect that bodes well for the future is the experimental work by the many talented young as well as the established artists. These works are being created in a multiacre park that serves as huge outdoor studios and as a training ground for the creation of works on a monumental scale (see Artpark).

This chapter highlights various directions public art can take. It is the hope of the authors to further stimulate and encourage this very vital role in our life.

1
KENSICO PLAZA
Valhalla (Westchester County), New York

ARTIST: Robert Fink, "Flame," 14' high painted marine
plywood, 1976.

2
OREGON STATE BUILDING, NEW WING
Salem, Oregon

ARTIST: Jan Zach, "Drapery of Memory," 7' high
laminated pine wood, 1977.
ARCHITECTS: Zimmer-Gunsul-Frasca

In 1974 Westchester County, under the leadership of Alfred B. Del Bello, county executive, established a publicly owned sculpture park at the foot of Kensico Dam, a massive stone construction which serves as a fitting background.

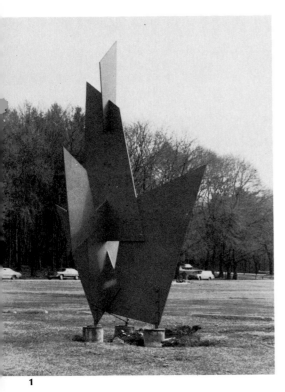

1

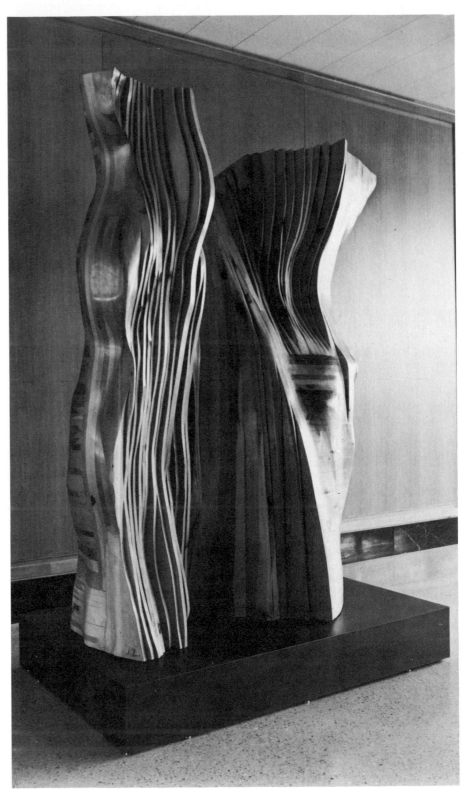

2

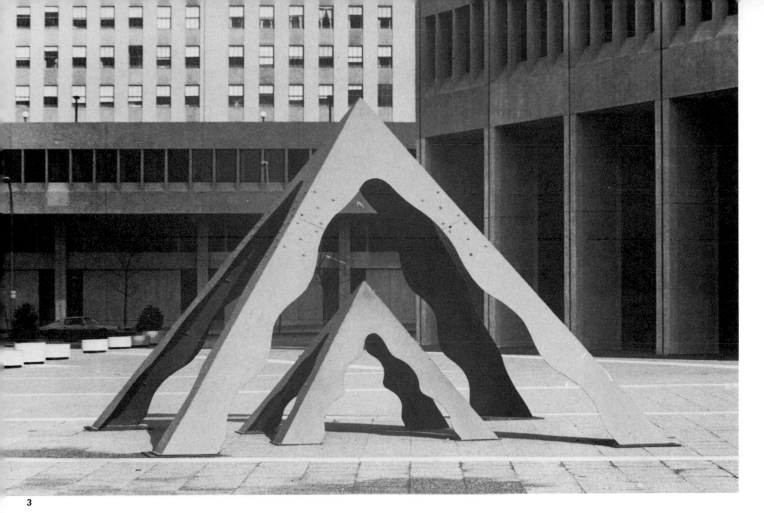

3

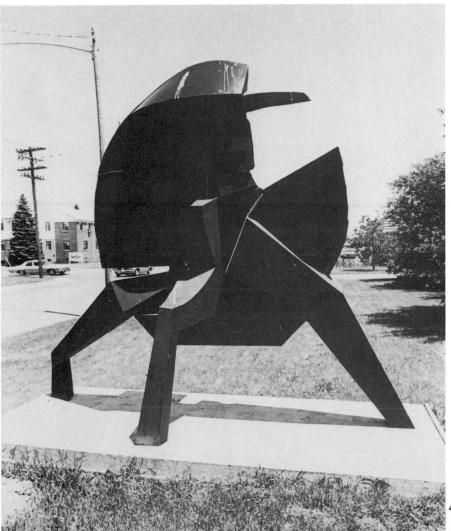

4

3

WESTCHESTER COUNTY COURTHOUSE, PLAZA

White Plains, New York

ARTIST: Penny Kaplan, "The Queen's Chamber," two pyramids, the larger 22' high × 15' wide, the inner pyramid 10' high × 8' wide red painted steel, 1978.

4

FRANKLIN AVENUE BRANCH, PUBLIC LIBRARY, FRONT LAWN

Des Moines, Iowa

ARTIST: Tom Gibbs, "Broken from Whole," black steel, 1977.

5

LA GUARDIA PLACE
New York, New York

ARTIST: Alan Sonfist, "Time Landscape," planting stage,
April 1978.

6

LA GUARDIA PLACE
New York, New York

ARTIST: Alan Sonfist, "Time Landscape," completion of
first planting stage, September 29, 1978.

Culminating almost ten years of effort, Alan Sonfist dedicated the first stage of "Time Landscape" on September 29, 1978. Community leaders, project supporters, and the mayor, Ed Koch, attended the dedication.

In April 1978 the process of planting a precolonial forest within urban Manhattan began. Ecologists, botanists, and historian consultants had researched and selected native species that once grew on the site of La Guardia between Houston and Bleeker. Ground was shaped to natural contours and the forest began its first stage—wild flowers and grasses. Further down the site, small shrubs and saplings appeared as the second stage was planted. Nearby residents and church groups helped in the planting. Public texts explained soil preparation and ecology as the planting proceeded.

When completed, "Time Landscape" will demonstrate all three stages of a natural forest. New Yorkers will be able to stroll past a permanent exhibition of the life cycle of a forest—a span of 100 years. They will also be able to go back in time several centuries, to experience the indigenous species of this island as did the Indians and forest settlers.

Artist Alan Sonfist said, "The 'Time Landscape' is the new type of environmental sculpture, being made of natural elements, its form growing out of the actual history of an urban setting."

The "Time Landscape" is being supported by the National Endowment for Art in Public Places, the Chase Manhattan Bank Foundation for Art in the Environment, United Mining Corporation, and the National Shopping Centers Incorporated, which is planning a similar historical sculpture for its suburban centers. It is also being supported by Mayor Ed Koch, the Municipal Arts Society Public Arts Council, the Central Park Historical Society, the Arts and Business Council, the New York State Council Creative Artists Program, the New York Horticultural Society, and local Planning Board 2, in which the project is located.

5

6

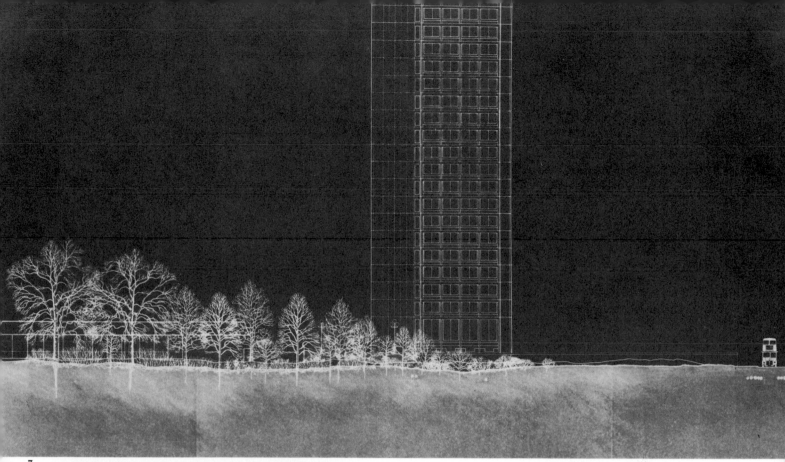

7

7

LA GUARDIA PLACE
New York, New York

ARTIST: Alan Sonfist, "Time Landscape," three stages of a forest created as a sculptural environment. The landscape re-creates nature as it would have been observed during colonization of the land. This is a pilot project for a series of historical re-creations of different periods in the evolution of the land. Dedication in September 1978.

8

LA GUARDIA PLACE
New York, New York

ARTIST: Alan Sonfist, "Time Landscape," detail of first planting stage, September 29, 1978.

8

9, 10

WATERFRONT PARK, BOARDWALK OVERLOOKING PUGET SOUND
Seattle, Washington

ARTIST: Douglas Bennett, "The Spirit of Christopher Columbus," 13' high bronze made up of twenty separate parts mounted on black terrazzo base, 1978.

11

FEDERAL OFFICE BUILDING, ENTRANCE PLAZA
Seattle Washington

ARTIST: Philip McCracken, "Freedom," 5' bronze, 1976.
ARCHITECT: Fred Bassetti

The sculpture was commissioned as a gift to the city of Seattle by the Italian-American community, which felt that the statue, as a memorial to Columbus, should communicate historically recognizable aspects of the subject and the conditions surrounding him. The sculptor considered this to be a legitimate aspiration and endeavored to express the spirit of persistence and courage that led Columbus to prevail over frightful odds; he also undertook as a creative challenge the idea that the work should be a personal and unique statement, and unlike any other Columbus statue.

The Italian-Americans initially envisioned a more traditional concept, but as the work progressed, they came to understand the sculptor's concept and were pleased with the final results. The general public's response has been overwhelmingly positive.

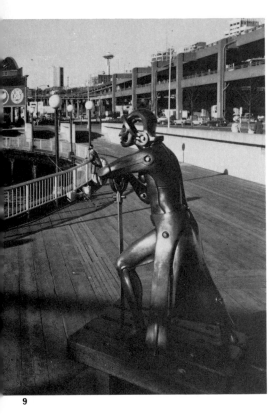

9

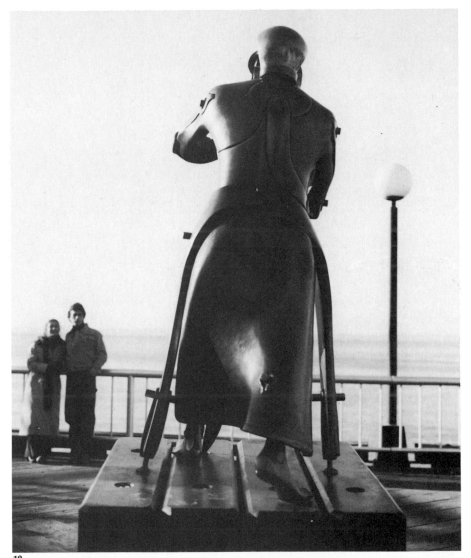

10

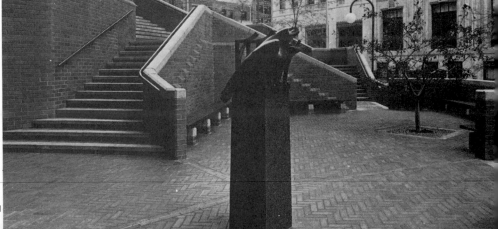

GASWORKS PARK
Seattle, Washington

LANDSCAPE ARCHITECTS: Richard Haag Associates

12

13

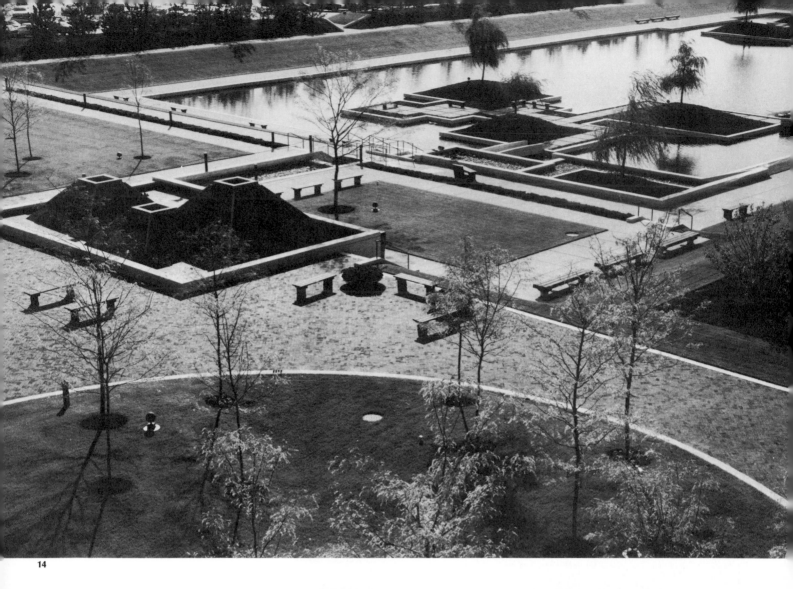

14

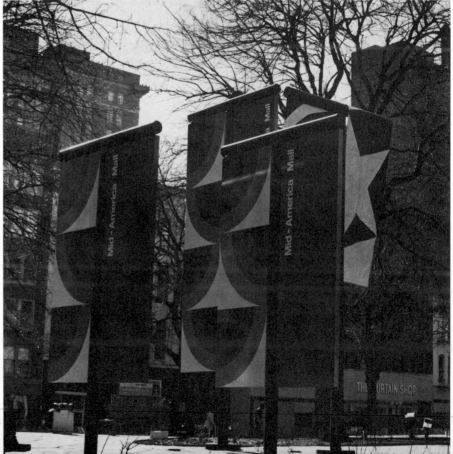

15

M. Paul Friedberg comments: "The significance of the sculpture at Nielsen was to provide a visual expression of the recirculation of the water. It is a punctuation point in the landscape echoing the planted forms of the islands."

Architect James A. Evans (a member of the firm) comments:

Our design goal was to unify the disparate elements into a single composition which would, above all else, create a pervasive sense of place. The length of the "place" was to be enormous; we needed to balance enough variety with the overriding demand for unity to avoid monotony. Brick paving is carried throughout to establish a continuous base plane. It is overlaid with custom designed repetitive elements such as light standards, identifying banners, kiosks, benches, and trash containers. We wrote a sign ordinance, and the projecting signs came down.

By the act of design, we have hoped to provide a physical environment in which the early stirrings of a renewed perception of urban life can take root. We believe that design can strengthen these perceptions and give them a place to flourish.

14

NIELSEN PLAZA
Chicago, Illinois

DESIGNER AND LANDSCAPE ARCHITECT: M. Paul
 Friedberg and Partners, 1975.
ARCHITECT: Welton Becket

15

MID-AMERICA MALL, COURT SQUARE, DOWNTOWN BUSINESS DISTRICT
Memphis, Tennessee

GRAPHIC DESIGNERS: Rinaldi and Associates, aluminum
 banners 25' high × 15' wide on steel columns, 1976.
ARCHITECTS: Gassner Nathan and Partners

16

U.S. FEDERAL BUILDING PLAZA
New York, New York

ARTIST: Oded Halahmy, "Talisman," 5'5" × 17'7" × 14'
 painted red aluminum, Bicentennial exhibit, 1976.

17

FITCHBURG PUBLIC LIBRARY, COURTYARD
Fitchburg, Massachusetts

ARTIST: Michio Ihara, untitled, sculpture, 28' high × 10'
 wide × 10' deep stainless steel and steel, 1974. (This
 project was funded by the Massachusetts Council for the
 Arts and Humanities in an open competition.)

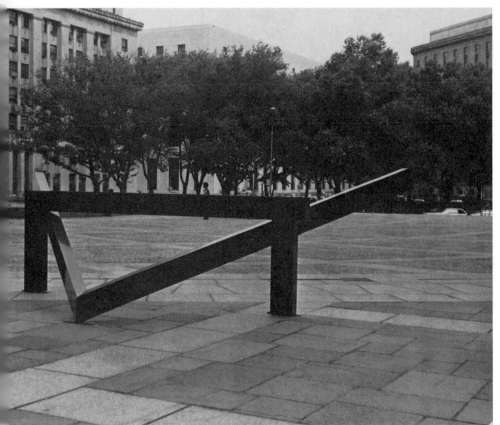

16

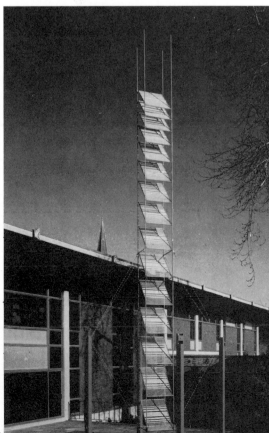

17

18

MID-AMERICA MALL, DOWNTOWN BUSINESS DISTRICT
Memphis, Tennessee

ARTIST: Richard Hunt, "Martin Luther King Memorial," sculpture, 10' high welded weathering steel, 1977.
ARCHITECTS: Gassner Nathan and Partners

19

EMPIRE STATE PLAZA
Albany, New York

ARTIST: Clement Meadmore, "Verge," 16'6" × 36' × 24' weathering steel, 1970.
ARCHITECT: Harrison and Abramowitz

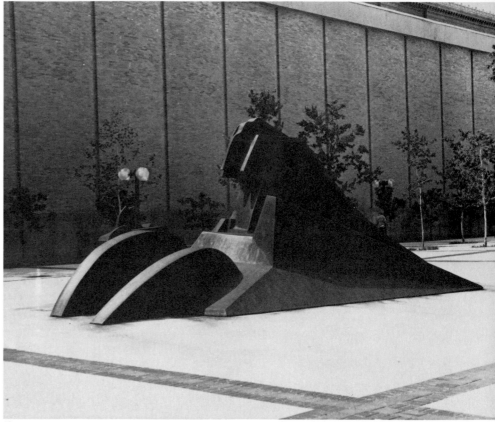

18

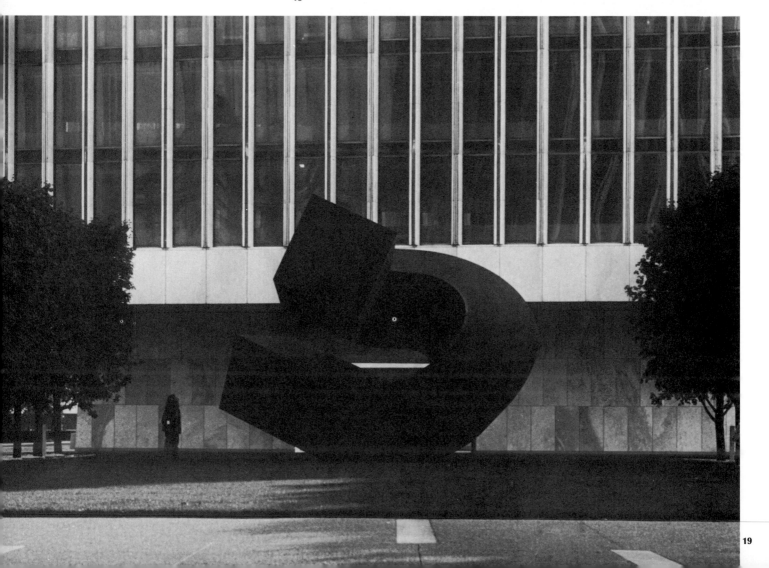

19

NEW JERSEY PORT AUTHORITY,
New Jersey

ARTIST: Anthony Padovano, "Spherical Division," 13½' × 17' stainless steel, 1975.

DOWNTOWN
Kansas City, Kansas

ARTIST: George Rickey, "Two Planes Vertical Horizontal, Var. I," 21' 5½", high stainless steel, planes 78½" × 78½", clearance above base 9'2", 1972. (Sculpture owned by Kansas City.)

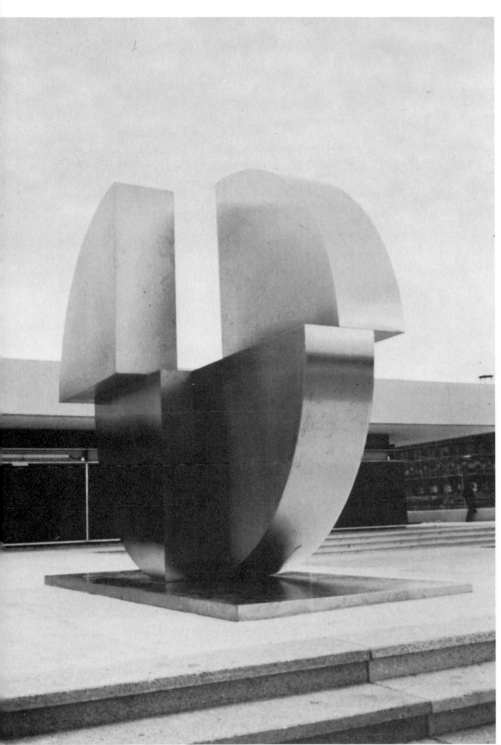

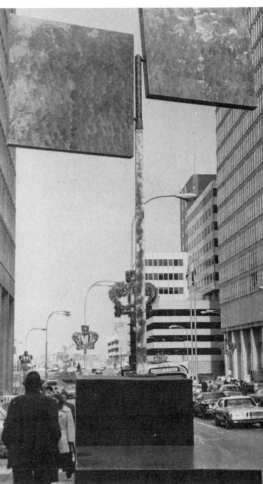

20

21

HONOLULU INTERNATIONAL AIRPORT, GATES 9–11 AND 25–28
Honolulu, Hawaii

ARTIST: Group coordinated by Ruthadell Anderson: Margaret Robinson, Diane Van Dyke, Conrad Okamoto, Donette Gene-Wilson; untitled, banners of batik, stichery, weavings, each 6' × 3'.
ARCHITECT: Ossipoff, Snyder, Rowland, and Goetz

23

HONOLULU INTERNATIONAL AIRPORT, MAIN ENTRANCE TO PARK GARAGE
Honolulu, Hawaii

ARTIST: Mamoru Sato, "Dyad," 2' × 24' terrazzo sculpture.
ARCHITECT: Ossipoff, Snyder, Rowland, and Goetz

24

HONOLULU INTERNATIONAL AIRPORT, THIRD LEVEL SHUTTLE BUS ENTRY
Honolulu, Hawaii

ARTIST: Edward Brownlee, "The Clouds of Pele," 8' × 60' cast aluminum.
ARCHITECT: Ossipoff, Snyder, Rowland, and Goetz.

In 1967 the Hawaii Legislature enacted the nation's first law setting aside 1 percent of capital improvement (public works) funds for the acquisition and commissioning of works of art for installation and display in state buildings.

At Honolulu International Airport there are fifteen works of art in the lobbies and departure and arrival areas that were commissioned under this program. There are, in addition, 144 weavings, stitcheries, and batiks that were commissioned and are on display in the passenger holding rooms.

The art was selected by the State Foundation on Culture and the Arts in conjunction with the Airport Environmental Control Committee.

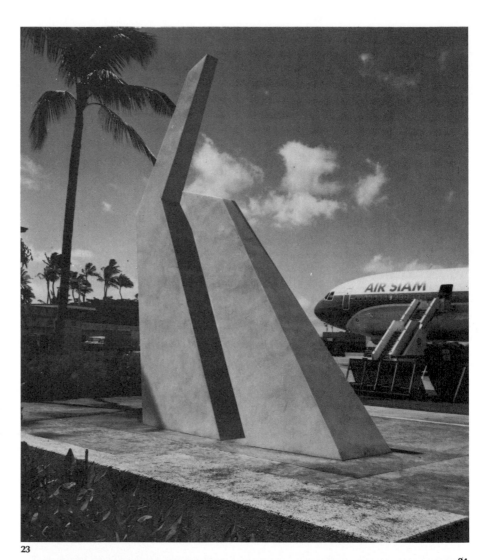

22

23

24

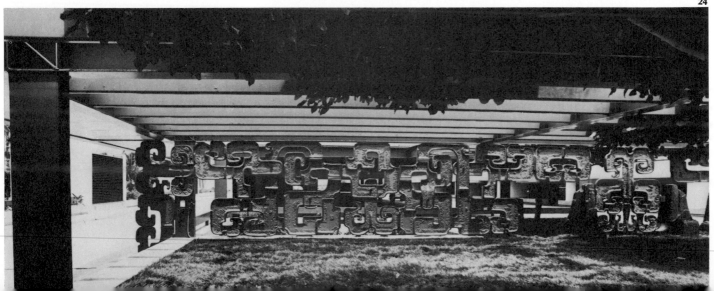

This mural is a collage painting by Romare Bearden—a combination of abstract and photographic elements, symbolizing the past, present, and future possibilities of the city. The imagery presented depicts the many lifestyles and ethnic constituencies that comprise Berkeley. This project, developed by the Civic Arts Commission, was funded through a matching grant of $8000 from the National Endowment for the Arts, Civic Art Foundation ($4420), Zellerbach Family Fund ($750), and the city of Berkeley ($2780).

CITY COUNCIL CHAMBERS
Berkeley, California

ARTIST: Romare Bearden, "Berkeley, The City and Its People," mural above city council rostrum, $10\frac{1}{2}' \times 16'$, 1973.

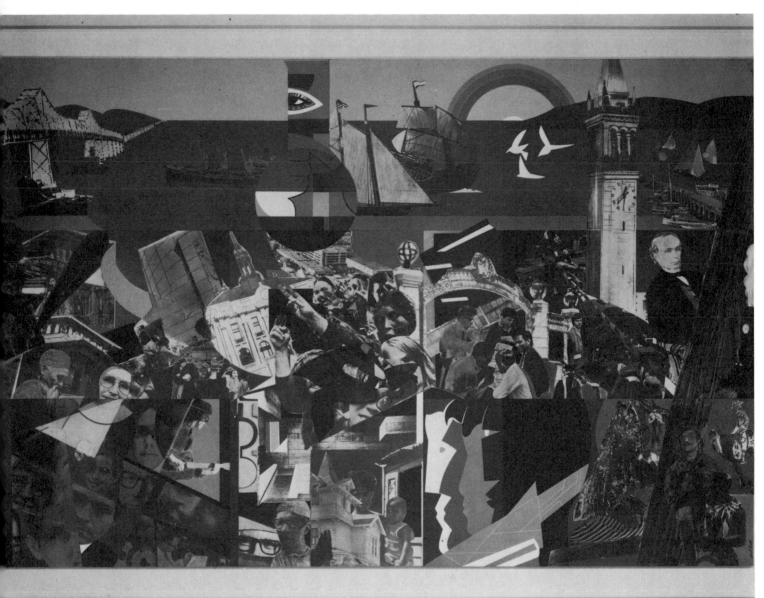

25

26

JEWISH COMMUNITY CENTER, MAIN ENTRANCE

West Bloomfield, Michigan

ARTIST: Louis G. Redstone, "Eternal Hope," brick mural, 25' high × 40' wide, 1976.
ARCHITECT: Louis G. Redstone Associates, Inc.

27

MICHAEL BERRY INTERNATIONAL TERMINAL, DETROIT METROPOLITAN WAYNE COUNTY AIRPORT

Romulus, Michigan

ARTIST: Robert Youngman, untitled, bas-relief frieze and twenty-six columns 32" × 32" × 13½' high precast concrete, 1972.
ARCHITECT: Louis G. Redstone Associates, Inc.

28

MICHAEL BERRY INTERNATIONAL TERMINAL, DETROIT METROPOLITAN WAYNE COUNTY AIRPORT

Romulus, Michigan

ARTIST: Robert Youngman, untitled, bas-relief frieze and twenty-six columns 32" × 32" × 13½' high precast concrete, 1972.
ARCHITECT: Louis G. Redstone Associates, Inc.

Architect's comments:

The use of brick as a material for art expression in the form of sculptural bas-reliefs goes as far back in history as the Babylonian period 575–530 B.C. The ancient technique of using pre-formed shapes molded from unbaked clay was successfully used by Henry Moore in his brick mural for the Rotterdam Bouwcentrum building in 1955.

In contemporary design, the factor of energy conservation has resulted in large exterior unbroken wall surfaces. Wherever brick is the material used, there is a great opportunity to integrate art forms as part of the structure, thereby adding the element of human interest.

The mural "Eternal Hope" expresses two symbolic ideas of Jewish life. On the right side the broken Menorah symbolizes the Holocaust; on the left side the two growing stems reaching upward symbolizes the eternal striving for Jewish survival. The design of the lower portion is derived from segments found in the floor design of an ancient synagogue in Israel.

The design unifies all the elements of the mural to become an integral part of the architecture.

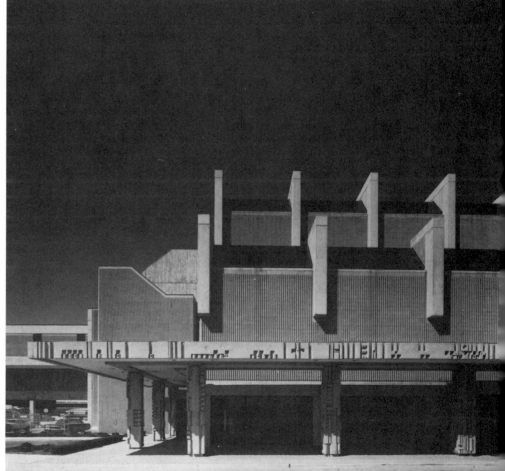

27

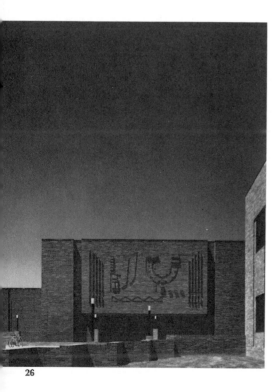

26

28

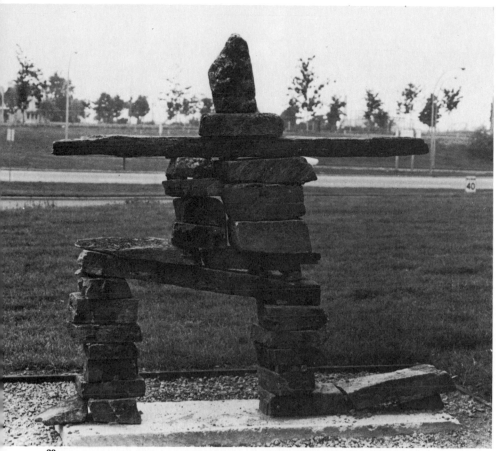

29

29

LESTER B. PEARSON BUILDING, DEPARTMENT OF EXTERNAL AFFAIRS
Ottawa, Ontario, Canada

ARTIST: Oseotuk from Cape Dorset, "Inukshook" ("like a person"), 6'6" high stone sculpture, 1973.
ARCHITECT: Webb Zerefra Menkes Howsden Partners

30

LESTER B. PEARSON BUILDING, DEPARTMENT OF EXTERNAL AFFAIRS, CAFETERIA, COURTYARD
Ottawa, Ontario, Canada

ARTIST: Arthur Handy, untitled, 15' × 23'6" × 6' red enameled weathering steel, 1973.
ARCHITECT: Webb Zerefa Menkes Howsden Partners

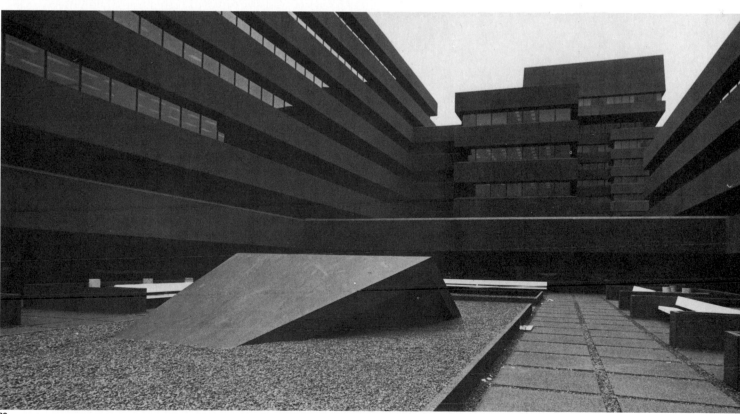

30

PERFORMING ARTS THEATER OF QUEBEC
Quebec City, Canada

ARTIST: Jordi Bonet, three walls entitled "Death," 40' × 180', "Space," 40' × 120', and "Liberty," 40' × 80', cement plaster, 1970.
ARCHITECT: Victor Prus

Comments by Guy Beaulne, director-general of Le Grande Théâtre de Québec:

The man is standing alone, silent and gazing at infinity. He is waiting for a message: He would like to understand it all at one glance. But he is used to formulas, to slogans, to digests and now he is puzzled and confused.

His eyes measure the dimension of the work. How he would like to understand but he has forgotten how to read. And suddenly lines form a pattern and the man is on safe ground. He will seek other patterns and soon find that the details are the clue to the ensemble. He is now initiated into the pleasures of meditation.

We have wished this house to be alive with people. So many theaters are but box-offices. Here is also the oasis, the pause, the silent abode. Man in the center and around him his eternal tragedy: death, infinity, and liberty.

Here, as in the theater, man's quest will bring answers—if he still has the courage to look at himself.

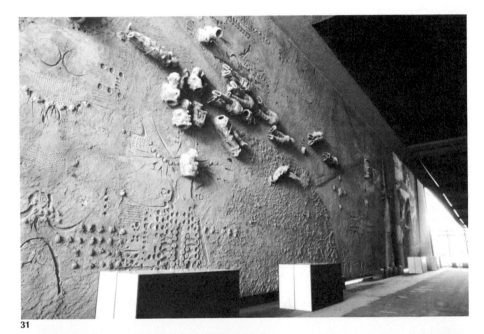

31

32

33

34

PELHAM PARKWAY IRT SUBWAY STATION
Bronx, New York

DESIGNER: Peter Bradford and Associates, 1976.

Peter Bradford wanted the Pelham Parkway station to become a "portal to the Bronx Zoo." Working with his media design class at the School of Visual Arts, Bradford conceived of poster designs dramatizing lesser-known details and images of various zoo species, set against a simple, rolling hill landscape painted in neutral colors. Bradford explains:

> The Pelham Parkway station in the Bronx connected two city institutions, the Bronx Zoo and the subway line that serves it. The total visual experience is zoo-related, with enough to see and read to provoke and hopefully prolong the passenger's interest regardless of his intentions to visit the zoo.
>
> The typical New York subway station is a pit. It is dirty, dim, depressing, and maybe a little frightening. But always a bore. The visual gratifications are few. Subway stations are among the classic urban spaces. I think they need not be profitless experiences. They could, with care, some ingenuity, and a little money, become stimulating, energizing, and perhaps even informative places to spend time. Most of all, they could become symbols of this city's determination to reshape its institutions around the needs of the users.

81ST STREET IND SUBWAY STATION
New York, New York

ARTIST-ARCHITECTS: Mayers and Schiff, color posters for station serving the American Museum of Natural History, 1976.

New York subway cars may be notable for their bursts of colorful graffiti, but the subway stations are remarkably drab and dull, lagging behind the underground glories of Montreal, Paris, and Moscow transit stops. In an effort to improve the visual surroundings of New York stations, Exxon Corporation, in cooperation with the Arts and Business Council and the Public Arts Council/Municipal Art Society, funded a "Platforms for Design" program. Four designers were chosen for the project. Working with limited budgets and different media, the designers came up with four unique, visually lively design solutions.

Mayers and Schiff used a paper solution, huge, colorful posters of fantasy dinosaurs which parody museum-style classification. Appropriately enough, since the station is located at the American Museum of Natural History, the posters serve as an attraction to the museum.

"These posters of fantastical dinosaurs are humorous, and elaborately contrived," says Robert Mayers. The humorous copy describes the fantasy animals and also provides a graphic counterpoint to the dense animal forms.

"We wanted to do something fun, and paper was an inexpensive medium. The colors are intense, and we intended the series of posters, seen from a moving train, to appear as a film in reverse. In a film, the audience is stationary, while the frames move."

(*Note:* The posters have to be periodically replaced, because of the limitation of the material and because of vandalism.)

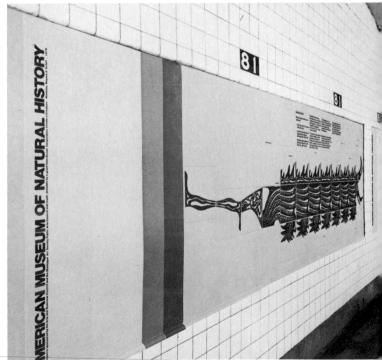

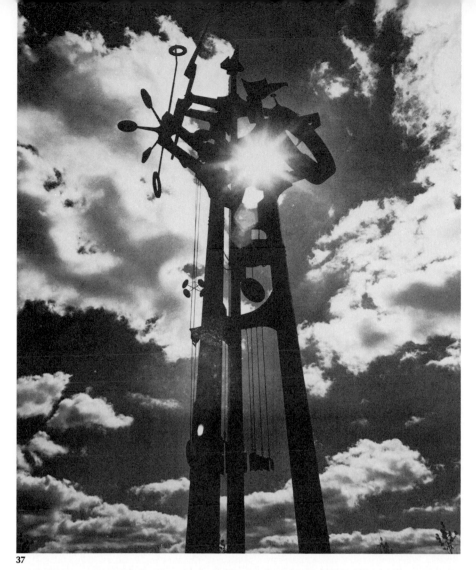

37

37, 38

METEOROLOGICAL BUILDING
Toronto, Ontario, Canada

ARTIST: Ron Baird, "Wind Machine," 110' high self-
 weathering steel, 1971.
ARCHITECT: Boigon and Armstrong Architects/Planners

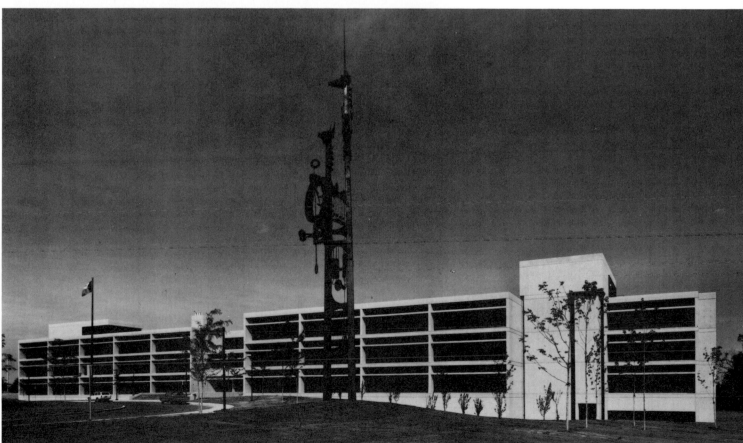

38

39, 40

SMITHSONIAN NATIONAL AIR AND SPACE MUSEUM, SCULPTURAL POOL
Washington, DC

ARTIST: Alejandro Otero, "Delta Solar," triangular grid sculpture, 27' high × 48' wide, stainless steel rotary sails, which turn in the breeze, 1977. (Sculpture is Bicentennial gift from government of Venezuela.)

41

YM–YWHA (YOUNG MEN'S AND YOUNG WOMEN'S HEBREW ASSOCIATION) PLAZA
Toronto, Ontario, Canada

ARTIST: Nathan Rappoport, "Jacob Wrestling with the Angel," 12' to 14' high bronze, 1978.

Otero belongs to the group of artists who have tried through their work to express the process of change that man has been living since the beginning of this century.

His fundamental idea is that of the object's total mobility in the purest kinetic sense, since every work leans on the principle of alternation of movement and the changing of shapes. The attitude is reflected in his own works: "I continuously question everything. It is my drama."*

*Excerpted from an article by Ray Ponte, *Daily Journal,* Caracas.

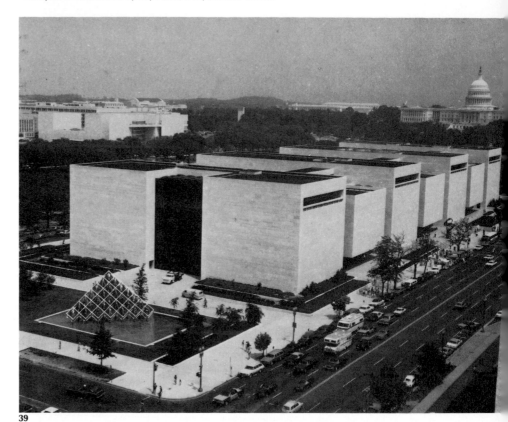

39

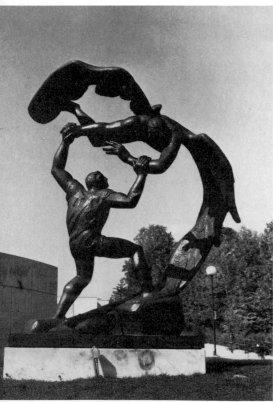

41

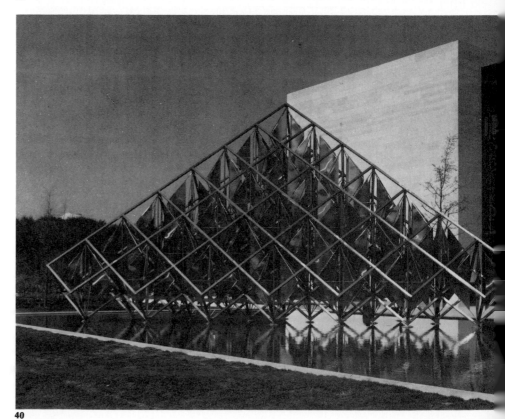

40

Andrews's water sculptures are part of a continuing exploration into new ways of using water as an expressive medium. Most contemporary fountains are derived from forms developed in the seventeenth and eighteenth century in France and Italy. The fountains of this period were usually expressions of civic pride or fanciful diversions for royal entertainment. Since the source of water was usually a diverted stream, the idea was to make the water do as many things as possible before allowing it to continue downstream and out of town. The climax of the typical seventeenth-century waterwork was a grand gushing of ingeniously directed water spouts.

In our present area of misused energy, polluted streams, and dire water shortages, a baroque display of hydraulic energy appears to the artist to be unseemly. He explains:

> I want to suggest a more contemplative feeling for water, based on the reflecting pools of northern Spain, the gardens of Japan, and an ancient tradition coming out of the deserts of North Africa and the Near East, where the imaginative preservation of water is a matter of life and death. Water sculpture designed for contemporary needs should offer cooling relaxation in the midst of turmoil, and should restore tempers eroded by the scraping of feet and tires on the pavement. Those who allow themselves this peace will find a renewed sense of playful awareness in the presence of these water columns of light and energy. The water flows over the lip at the top and envelops the sculpture completely; there is quite a variation in the amount of water that can be used, from a thin film to a gushing cascade. There is a high wind in this place, so we used a wind control to cut back or turn off the water if the blow gets too wild. However, water sticks to the surface surprisingly well in a moderate wind. This is a function of the lip design (rounded) and the texture of the surface (not too slick).

Oliver Andrews died in an automobile accident in 1978. His brilliant and innovative talent will be missed.

42

FEDERAL RESERVE BANK, PLAZA
Cincinnati, Ohio

ARTIST: Oliver Andrews, "Column and Prism," fountain, 12' × 9' × 3' and 6' × 6' × 18' stainless steel, 1972. (Water flows over the top of the column and down the sides.)
ARCHITECT: Harry Hake, Jr.

43

LOS ANGELES TIMES-MIRROR NEWSPAPER COMPANY, COURT
Costa Mesa, California

ARTIST: Oliver Andrews, "Water Blade," fountain, 24' high × 6' wide × 1' thick stainless steel, 1971.
ARCHITECT: William Pereira, Associates

42

43

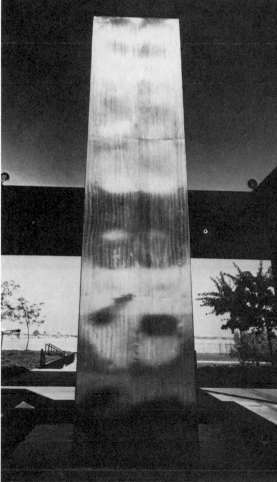

44

ARTPARK
Lewiston (Niagara Falls), New York

ARTIST: Robert Rohm, "Untitled 1977 (Artpark Shelf)," 8'
high × 60' wide × 75' long, 2" × 6" lumber, six 14-
gauge 24" diameter corrugated aluminum culvert pipes,
1977.

45

ARTPARK
Lewiston (Niagara Falls), New York

ARTIST: Robert Rohm, "Untitled 1977 (Artpark Small
Shelf)," 12' high × 3' wide × 29' long, 2" × 6" lumber,
one 14-gauge 18" diameter corrugated aluminum culvert
pipe, 1977.

Artpark is an ongoing summer program of the National Heritage Trust under the juris-
diction of the New York State Office of Parks and Recreation.*

Each summer since 1974 some twenty-five visual artists are invited to Artpark for overlapping
residencies averaging four weeks.

As a nonprofit state institution, it has established another mode of patronage by providing
artists funds and services with which to create new works, to realize an idea, to try new tech-
niques and explore new contexts; experimentation is encouraged. Artists are invited from all
over the United States and Canada, and they visit the park prior to residency to select a site.

Here are 200 acres of land, approached along highways that are wrought through industry
and hydroelectric technology, along the dramatic gorge of the Niagara River, land embedded
with evidence of remote millennia and twentieth-century debris, remnants of its former uses and
functions: a natural embankment for travelers who wish to bypass the Niagara Falls, an Indian
settlement and burial ground, a railroad bed, a quarry, a winery, a dumping place for local
highway construction. In addition, the area includes a wood, barren uninflected landfill fields,
and the imposing layered walls of a rock gorge carved out over thousands of years by the
Niagara Falls (now 7 miles to the south). The territory of Artpark is an honest synthesis of the
natural and the artificial, the historic and the new, the planned and the incidental.

As an open-air recreational and cultural attraction, Artpark has challenged a wide public
audience (of visitors) in an informal manner. The works executed outdoors at Artpark have been
impressively varied. The artists range in age and background. Their materials have run the gamut
from videotape systems to poured concrete to smoke. The works have been theatrical, primitiv-
istic, architectural, ephemeral, whimsical, perceptual, and more.

Fostering the (ongoing outdoor) process of making art and the visitors' immediate experience
of participating in the works are Artpark's chief goals. The artist is visible and accessible to the
tens of thousands of visitors as he or she goes through the stages of realizing an idea—a valuable
resource for making new art and new ideas freely accessible to the public.

None of the projects is permanent and none remains after the summer season. The artists are
given the option of removing their own works, salvaging the materials, or simply permitting the
park to clear the land for the next season.

Artpark has proven that meaningful results can be achieved by integrating the working artist
into our everyday lives and our leisure activities. It is a pioneering model for a new breed of
public park.

*This text has been excerpted and synthesized from the following sources:
Sharon Edelman (Ed.), *Artpark, The Program in Visual Arts,* Lewiston, NY, 1976, p. 3.
 Nancy Rosen, "Introduction." In S. Edelman (Ed.), *Artpark 1977, The Program in Visual Arts,* Lewiston, NY,
1977, pp. 2–3.

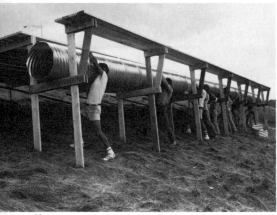

44

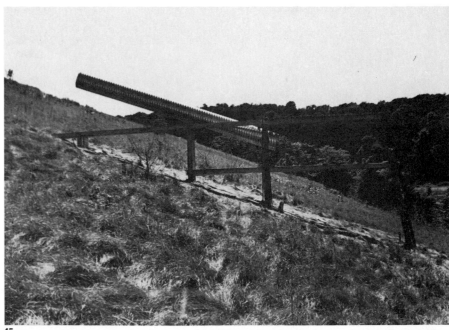

45

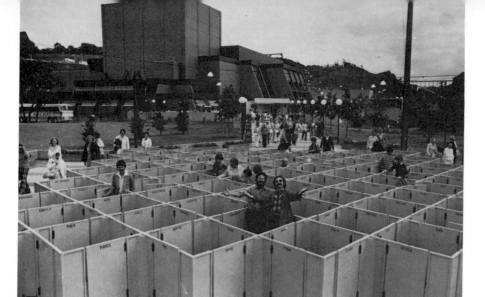

46

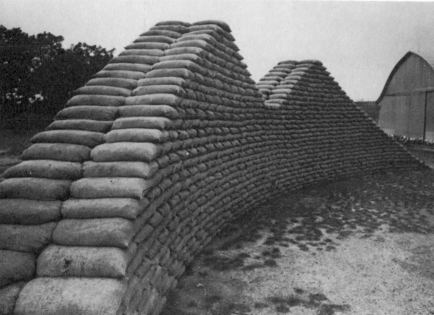

47

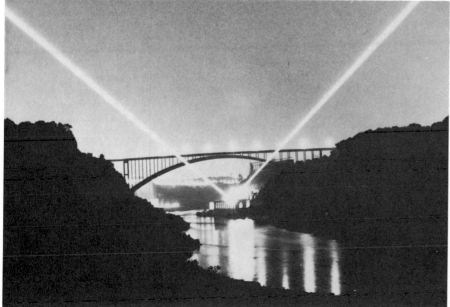

48

46

ARTPARK

Lewiston (Niagara Falls), New York

ARTIST: Phillips Simkin, "Choices Prototype," maze as a format of public participation, 40' × 40' lumber and steel, 1976.

47

ARTPARK

Lewiston (Niagara Falls), New York

ARTIST: Lloyd Hamrol, "Soft Wall for Artpark," 9'9" high × 37" wide × 56' long burlap bags and soil, 1976.

48

ARTPARK

Lewiston (Niagara Falls), New York

ARTIST: Rockne Krebs, "Green Isis," green laser configuration radiating from a single 8-watt unit, located in Canada on the Ontario Hydro-Electric Plant, 1975.

49

ARTPARK

Lewiston (Niagara Falls), New York

ARTIST: Lyman Kipp, "Lockport," 18' high × 10'6" wide 12' long painted blue aluminum, 1977. In background, "Tonawanda," 10' high × 4' wide × 11' long painted red aluminum, 1977.

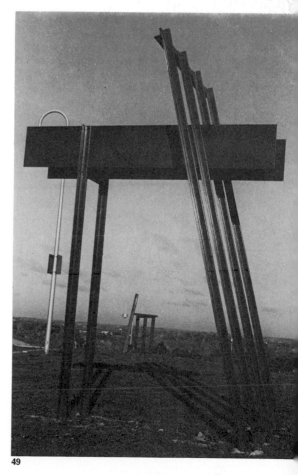

49

MURAL PAINTING, WALL, CHICAGO LAWN COMMUNITY

(southwest area), Chicago, Illinois

ARTISTS: Caryl Yasko, Lucyna Radycki, assisted by local workers, contractors, and volunteers, "Roots and Wings," 115' long cast concrete mural with painting above, 1976.

In southwest Chicago, Chicago Lawn is a conservative working-class community. Youngsters have little opportunity to develop imaginative skills because of the absence of artistic programs. The mural project was initially regarded with suspicion. Many people felt that murals are created only for ghettos, and ghetto means blacks. The migration of blacks into the southwest neighborhoods seemed to threaten the life-style of many residents.

In spite of such sociological handicaps, Caryl Yasko and Lucyna Radycki succeeded in gaining support and goodwill from a large segment of the community for Chicago's first concrete relief mural. This "new" mural is the first attempt of the Chicago Mural Group to work in the permanent material of cast concrete. This experiment makes use of a common and accessible material to obtain lasting and maintenance-free murals. Yasko and Radycki opened up a new and significant area of community involvement. They made wide use of the resources of the area by inviting local laborers and contractors to work on the wall.

The lower portion of the mural is a cast concrete relief depicting aspects of life in Chicago Lawn. The mold for the 115-foot casting was carved over a two-month period by community residents of all ages in an empty store near 63rd and Talman. They worked with extruded foam plastic industrial insulation material. The casting was poured in three sections. The concrete is composed of buff-tone cement and Merrimac pea-gravel. The painting above the casting took less than a month to complete. The lower portion consists of portraits of early settlers of the community worked into the base of a tree. These include John Eberhart, who was the community's founder, a World War I hero, an Indian, the community's first teacher, an old man, and the coal man. Growing from the roots are intertwined figures who symbolize the family and the community rising out of the past. Above these, the figure of Pegasus, the mythical winged horse, symbolizes the spirit of freedom and the wings of the mind.

MURAL PAINTING, WALL OF THE SALVATION ARMY'S OLD HAT NEIGHBORHOOD CENTER

Clybourn Avenue at Sheffield (north side area), Chicago, Illinois

ARTISTS: Barry Bruner, Catherine Cajandig, Paula Gee, four students, CETA workers from Waller High School, and local youth volunteers from the Old Hat Center, "Break Away," 1200 ft² to 2400 ft², 1976. (Financed by NEA, the Intercraft Neighborhood Foundation, and local donations.)

In the fall of 1975 the Chicago Mural Group was contacted by Lou Gugliuzza of the Intercraft Neighborhood Foundation (INF) concerning the possibility of painting a community mural. The INF was formed by an executive of the Intercraft Industries, a large picture frame plant at 1800 North Clybourn Avenue, and was set up to be of assistance to youths in the surrounding community. During the ensuing months John Webber and Barry Bruner met with Mr. Gugliuzza several times and discussed a worthwhile site for the mural. A natural site was the Old Hat Neighborhood Center, 1743 North Clybourn, a summer recreation spot for youngsters in the Clybourn area.

INF pledged their financial support for the entire project, and several conferences with Dorothea Weatherby, director of the Old Hat, followed. Dr. Cusick, principal of Waller High School, promised his support to obtain student artists for the project. The groundwork for the mural had been laid.

Introductory letters to over thirty neighborhood businesses and industries in the community were written in hopes of obtaining some new funding. In a month's time more than $250 was raised.

"Break Away" is the result of feelings experienced in the impoverished Clybourn community. The center provides a form of recreation and escape, a break from the problems and pressures of ghetto living. Relief from the surrounding high rises, overcrowding, elevated trains, and oppression is symbolized in the athletic activities depicted in the Old Hat mural. Two weeks were spent tarring the roof, and wire-brushing, tuck-pointing, and generally preparing the wall. Graffiti, consisting of the names of local youths, was transfered to an adjacent wall, and the four remaining weeks were spent in spirited painting.

Completion of the mural was celebrated at an outdoor dedication with food, music, and speech-making. Hundreds of neighborhood kids attended as well as sponsors and supporters of the mural. The small, rather dismal neighborhood of Clybourn has been left with a mark of color and meaning. The kids had shown their appreciation with an overwhelming sense of pride in their wall at a place where they could come and "Break Away."

50

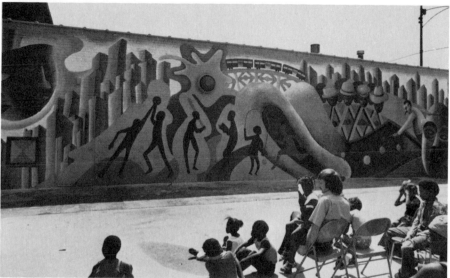

51

52

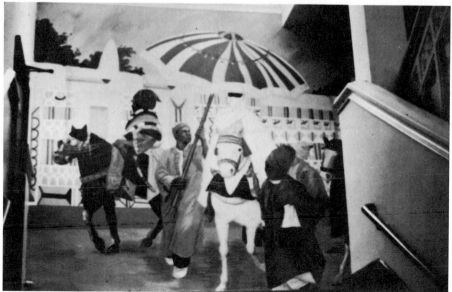

53

52

HIGHLAND PARK COMMUNITY COLLEGE, HALLWAY
Highland Park, Michigan

ARTISTS: Barbara Hill and Sherman Williams, "N'debele Wall Replication," mural, 1973.

53

HIGHLAND PARK COMMUNITY COLLEGE, HALLWAY
HIGHLAND PARK, MICHIGAN

ARTIST: Dennis Orlowski, "Nigeria Street Scene," mural, 1973.
ART DIRECTOR: Cyril Miles

ARTIST: Richard S. Beyer, "Waiting for the Interurban," sculpture, life-size figures on 4' × 10' base, cast aluminum, 1978. (Project was sponsored by the Fremont Community and the Fremont Arts Council. The Seattle Arts Commission hired through its CETA Artist-in-the-City program Bruce Crowley, a sculptor-apprentice, to work with Richard Beyer in completing the project.)

55

FREMONT
Washington

ARTIST: Richard S. Beyer, "Waiting for the Interurban," sculpture, life-size figures on 4' × 10' base, cast aluminum, 1978.

According to Salvador Ramos, chairperson for the Fremont Arts Council:*

"Waiting for the Interurban," by Richard Beyer, is a sculpture promoting the efforts of Fremont and the Fremont Arts Council. The uniqueness of this project is the great amount of neighborhood involvement and financial support given by Fremont residents and businesses to help pay for the completion of the project.

Fremont's past has been represented by the clamor of trains, the insistent ring of trolley bells, and the whistle of tugs piloting lumber schooners. These sounds once formed a lively accompaniment to the busy activities of Fremont's working people. The interurban gave way to the automobile and Fremont's central street became a busy thoroughfare for automobiles, while some buildings settled into decay.

The sculpture idea began when "Forward Thrust" money was allocated to upgrade street facilities in Fremont. One of its projects was the resurfacing of the triangle, at which time the community suggested that a sculpture might be considered for the triangle. Richard Beyer designed a life-size sculpture depicting six people and a dog waiting for the interurban. Donations of money for materials came from Fremont residents, businesses, and the state arts commission. As a measure of its support, the Seattle Arts Commission hired Bruce Crowley, a sculptor/apprentice, through its CETA Artist-in-the-City program to work with Mr. Beyer in completing the project.

*Excerpted from *Fremont Public Association,* Seattle, Washington, June 17, 1978.

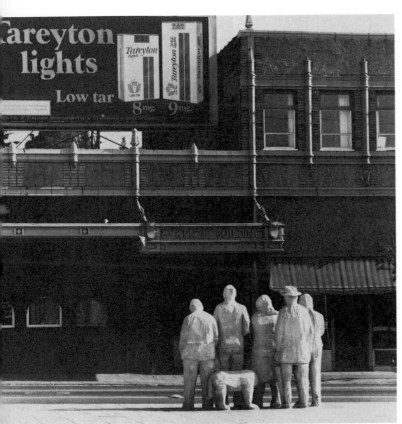

54

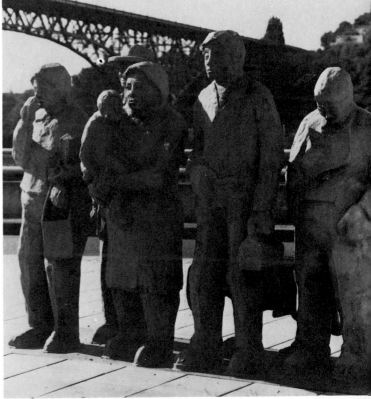

55

In 1979 Michigan Artrain celebrated its eighth anniversary. Since its grand opening in Traverse City, this art museum in six railroad cars—the only one of its kind in existence—has traveled throughout Michigan to over 200 communites and to nineteen additional states. In its relatively short life, more than 2 million people have come aboard.

Artrain was designed to take art to the people with special emphasis on areas not served by major art institutions. It was also designed to serve as a catalyst for continuing art development. Artrain, as a catalyst, has given impetus to numerous annual art festivals, artist-in-residence programs, and community arts councils.

Artrain's success is one of "total community involvement," not from the established arts community alone, but from business, industry, and educational institutions as well.

A visit by Artrain spurs people—throughout Michigan and the nation—to establish and realize their own goals. New local arts councils, artist-in-residence programs, and ongoing festivals are often left in Artrain's "tracks." Artrain is the vehicle used to move toward these goals.

A broad base of funding keeps Artrain rolling. The Michigan Council for the Arts grants annual funds through the state legislature for Michigan tours. National tours have been coordinated through the National Endowment for the Arts (NEA). Transportation of Artrain is generously provided by railroads throughout Michigan and the nation. The Herbert H. and Grace A. Dow Foundation has endowed Artrain with a $1 million matching grant to be matched over a period of five years through Artrain's development program. The Charles Stewart Mott Foundation supports Artrain's community arts development program, and most recently a gift from the Richard H. and Eloise Jenks Webber Foundation has made possible the acquisition of an expanded studio car and electrical generator facility.

As a museum, Artrain is an entertaining and educational experience which makes the most of a challenging and obviously mobile gallery space. Major works of art from America's finest museums, galleries, and private collections fill the walls and cases. Picasso, Renoir, Matisse on one hand and the exquisite renderings of folk artists on the other exemplify the diversity of the treasures carried literally to "people's front doorsteps."

Michigan Artrain is a celebration of the creative American spirit in all of us—witnessed not only by the wide-eyed wonder of children viewing the many-faceted exhibits but by people of all ages joining forces to create an Artrain visit which celebrates their community's creativity.

Mrs. William G. Milliken, Michigan's First Lady, is honorary chairman of the board of directors and Mrs. Gerald R. Ford is honorary chairman of the development committee.

56, 57, 58

ARTRAIN, STATE OF MICHIGAN
Michigan Artrain, Inc., Detroit, Michigan

57

58

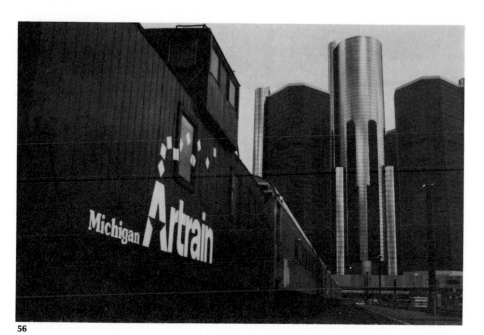

56

59

ROTHKO CHAPEL, PLAZA
Houston, Texas

ARTIST: Barnett Newman, "The Broken Obelisk,"
 26' weathering steel, 1968.
ARCHITECTS: Howard Barnstone (formerly Barnstone and
 Aubry)

60

ROTHKO CHAPEL, INTERIOR
Houston, Texas

ARTIST: Mark Rothko, fourteen paintings on the eight
 walls, 1971.
ARCHITECTS: Howard Barnstone (formerly Barnstone and
 Aubry)

"The Broken Obelisk," situated in a reflecting pool opposite the Rothko chapel entrance has been called by some art critics "the greatest American sculpture of the twentieth century." It is dedicated to the memory of Dr. Martin Luther King, Jr.

Barnett Newman was a friend of Mark Rothko and was one of the most influential of the New York abstract expressionists. Like Rothko he was beset by profound religious and philosophical concerns which he struggled throughout his life to translate into visual form.

This obelisk is one of three in existence, another being in the upper courtyard of the Museum of Modern Art, New York, the third in the quadrangle of the University of Washington, Seattle. It is 26 feet high and made of weathering steel. It consists of a square base plate beneath a four-sided pyramid whose tip meets and supports that of the up-ended broken obelisk. The two tips have exactly the same angle (53 degrees, borrowed from that of the Egyptian pyramids, which had long fascinated the artist) so that their juncture forms a perfect X.

Rothko had these comments: "A picture lives by companionship, expanding and quickening in the eyes of the sensitive observer. It dies by the same token. It is therefore risky to send it out into the world. How often it must be impaired by the eyes of the unfeeling and the cruelty of the impotent."

Mrs. John de Menil, in her address at the dedication, said:

At first we might be disappointed at the lack of glamour of the paintings surrounding us. The more I live with them, however, the more impressed I am. Rothko wanted to bring his paintings to the greatest poignancy they were capable of. He wanted them to be intimate and timeless. Indeed they are intimate and timeless. They embrace us without enclosing us. Their dark surfaces do not stop the gaze. A light surface is active—it stops the eye. But we can gaze into the infinite.

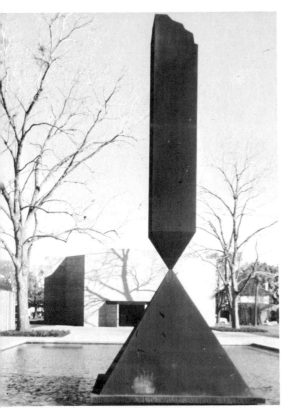

59

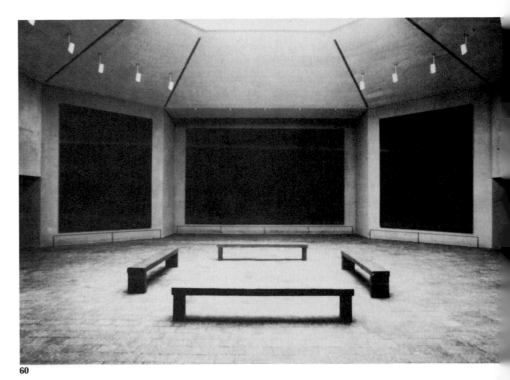

60

Statement by Gerhardt Knodel:

Like a glass of water to a lake, or a breath of fresh air to the sky, the elements which compose the work called "Gulf Stream" embody the essence of that of which they are a part, but they are aspects of something larger. These forms were conceived to be part of their surroundings and to interact by giving and receiving. The forms are aware of the presence of one another and those that are beyond.

In the work I find energy, light, and life. Its origins are unclear, but it has been formed with vitality and purpose, which it transmits as it moves. In many ways "Gulf Stream" is a metaphor for the university as a source of inspiration and insight, and the library is an ideal location for this expression.

61

UNIVERSITY OF HOUSTON, LIBRARY

Houston, Texas

ARTIST: Gerhardt Knodel, "Gulf Stream," room-size fabric sculpture, 22' high, 100' wide, 30' long of Mylar and wool material with stainless-steel rods, cables, hardware, 1977. (This work was commissioned by the regents of the University of Houston.)
ARCHITECT: Kenneth Bentsen
INTERIORS: IDS

62

UNIVERSITY OF HOUSTON, CONTINUING EDUCATION CENTER, ENTRANCE PLAZA, CENTRAL CAMPUS

Houston, Texas

ARTIST: Clement Meadmore, "Split Level," 6' × 14'9" × 6'9" weathering steel, 1974.

63

UNIVERSITY OF HOUSTON, EAST ENTRANCE SCIENCE AND RESEARCH BUILDING

Houston, Texas

ARTIST: Richard Miller, "Sandy in Defined Space," bronze sculpture 6'3" high, 3'10" wide, 3'2" deep.
ARCHITECTS: Pierce and Pierce

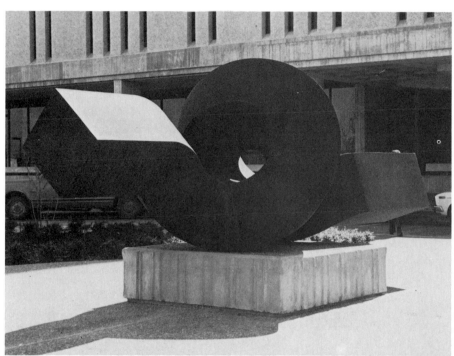

62

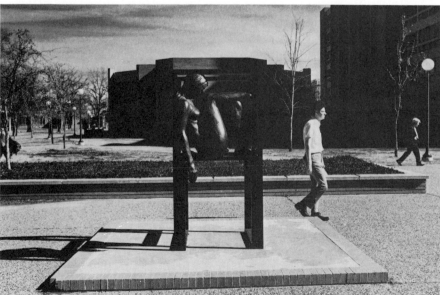

63

61

64

UNIVERSITY OF HOUSTON, ARBOR OF UNIVERSITY CENTER

Houston, Texas

ARTIST: Bob Fowler, untitled, sculpture, high-core steel
with blue patina, 23' high.
ARCHITECTS: Pierce and Pierce

65

UNIVERSITY OF HOUSTON, LOBBY OF McELHINNEY HALL

Houston, Texas

ARTIST: Francisco Zuniga, "Woman with Shawl," bronze
sculpture, 22' high.
ARCHITECTS: Pierce and Pierce

The sculpture in the University of Houston university center courtyard is the result of an eight-month collaboration between Bob Fowler, the sculptor, and the office of Pierce and Pierce, Architects. It was specifically designed to be a focal point within an extremely powerful, enclosed composition. The university center courtyard contains three tiers of blunt concrete, a suspended stairway, waterfall, and small garden, the forms of which are in mostly straight lines. The sculpture was designed to repeat the force of these forms while relieving them in awkward curves of metal.

The subject matter, deliberately chosen, is a commentary on student life. While it contains no definite meaning, the sculpture is calculated to stimulate a wide assortment of responses from viewers.

According to Patrick J. Nicholson, Vice President of University Development, University of Houston System, "Our own 1 percent program originated with our Board of Regents in December 1966, on joint recommendations to our Office of the President by this office and the Office of Facilities Planning and Construction, which had at that time an interlocking Landscaping Committee."

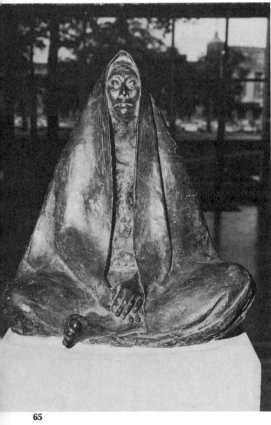

65

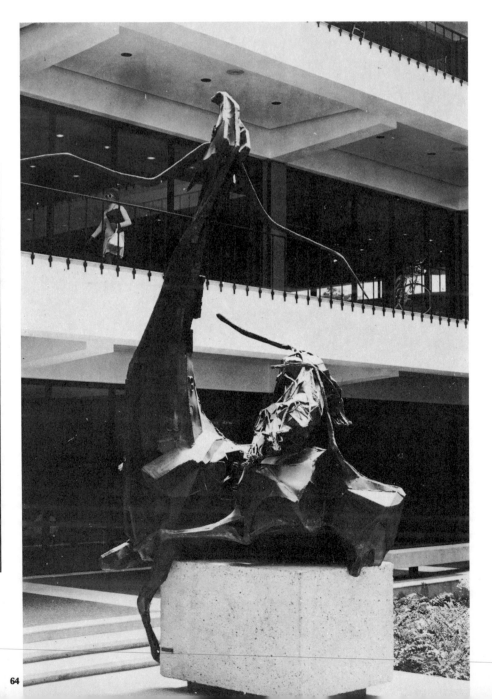

66

 66

UNIVERSITY OF HOUSTON, CULLEN FAMILY PLAZA

Houston, Texas

ARTIST: Lee Kelly, "Waterfall, Stele, and River," four pieces, 15' × 12' reverse L shape with water flow, 4' curve flow, pool 30' × 30'.
ARCHITECTS: Pierce and Pierce

67

UNIVERSITY OF HOUSTON, COLLEGE OF OPTOMETRY

Houston, Texas

ARTIST: Linda Howard, "Round About," 16' × 16' spun aluminum bars, 1978.
ARCHITECTS: Pierce and Pierce

68

CAPITOL PARK

Detroit, Michigan

ARTIST: Morris Brose, "Sentinel X," 12' × 4½' × 3½', weathering steel, 1979. (Funded by the Detroit Council of the Arts.)

67

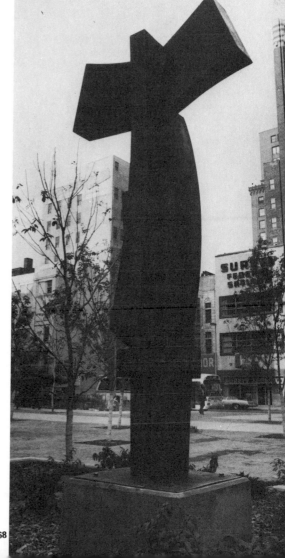

68

69

BENTLEY LIBRARY, GARDEN, UNIVERSITY OF MICHIGAN

Ann Arbor, Michigan

ARTIST: Richard Hunt, "Historical Circle" and "Peregrin Section," approximately 12' high weathering steel, 1975. (These two related pieces were commissioned by Hobart Taylor, Jr., as a memorial to his father, a leader in Texas civil rights.)

70

UNIVERSITY OF IOWA, MUSEUM, WEST LAWN

Iowa City, Iowa

ARTIST: Lila Katzen, "Oracle," 17' high × 11' × 5' weathering and stainless steel, 1974. (Funded by NEA and private contributions of Friends of the Museum.)

Artist's comments quoted from dedication:
"Historical Circle" sits at the center of the Bentley Library's garden court with the taller "Peregrine Section" overlooking it from the low hill to the northeast. Abstract in character, the two works appear to carry on a visual dialogue from their places on the hill and in the court, as if between nature and man's manipulation of nature—or perhaps between man's apparent freedom and his necessity for self-discipline.

"I am not an engineer; I feel the steel," Katzen has commented about her work with steel sculpture. "My interest in steel got quite intense . . . I wanted to be able to suspend this intractable material, to be able to swing it into the air, to have it practically dance."

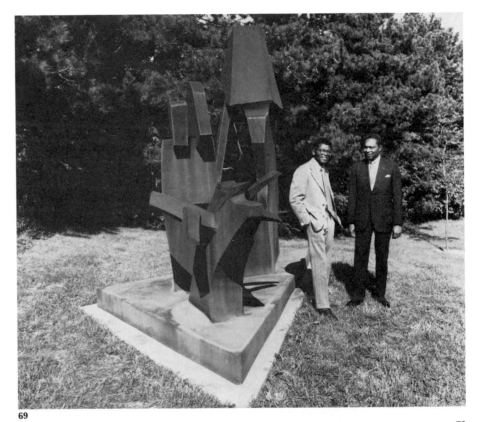

69

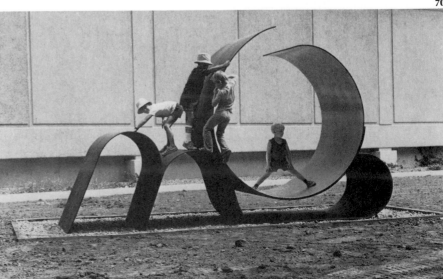

70

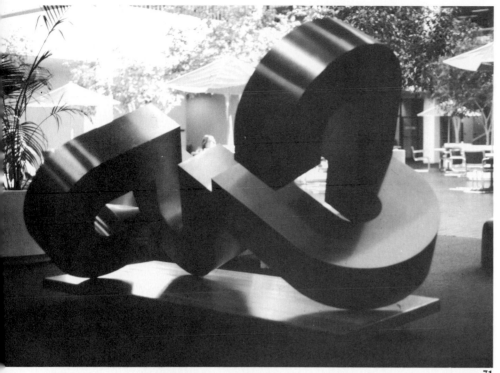

71

UNIVERSITY OF HOUSTON, FIRST FLOOR NEAR ATRIUM
Clear Lake City, Texas

ARTIST: Richard Crovello, "Steel Study," 5½' high × 6' wide × 7½' long, 1977.

72

UNIVERSITY OF HOUSTON, SECOND FLOOR OF ATRIUM SURROUNDED BY SEATING ARRANGEMENTS
Clear Lake City, Texas

ARTIST: Masaru Takiguchi, "Ocean," 3'8" × 4' marble, 1975.

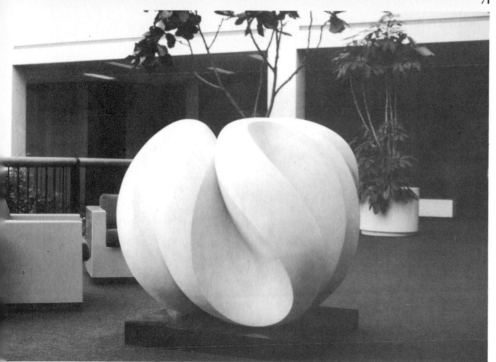

72

73

NATIONAL AIR AND SPACE MUSEUM, SMITHSONIAN INSTITUTE, THE MALL PLAZA

Washington, DC

ARTIST: Richard Lippold, "Ad Astra—'To the Stars,'" 115' high.
ARCHITECTS: Hellmuth, Obata, Kassabaum

74

NATIONAL AIR AND SPACE MUSEUM, SMITHSONIAN INSTITUTE, THE MALL PLAZA

Washington, DC

ARTIST: Richard Lippold, "Ad Astra—'To the Stars,'" 115' high (tallest sculpture in Washington), gold-colored stainless steel plus clear polished stainless steel, 1976.
ARCHITECTS: Hellmuth, Obata, Kassabaum

75

LEHIGH UNIVERSITY, SAUCON VALLEY ATHLETIC COMPLEX

Allentown, Pennsylvania

ARTIST: Menashe Kadishman, "Trees," eight 10' × 20' metal tree cutouts making a 20-ton sculpture. (Donated by Mr. and Mrs. Philip I. Berman.)

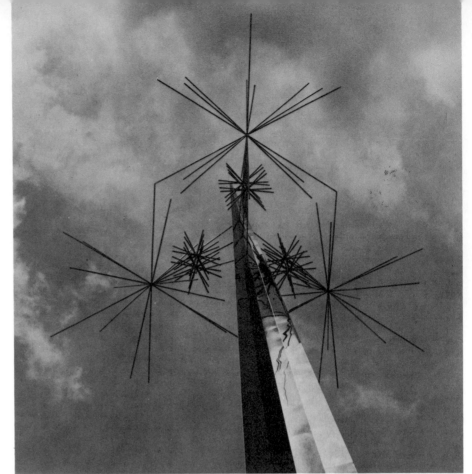

73

74

75

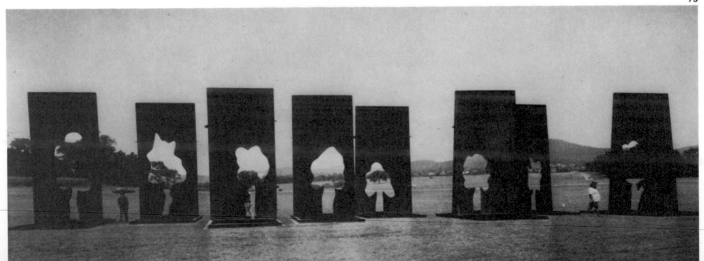

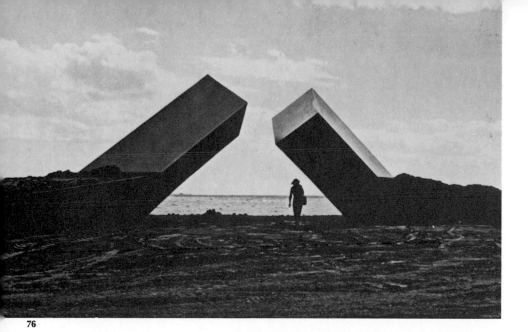

76

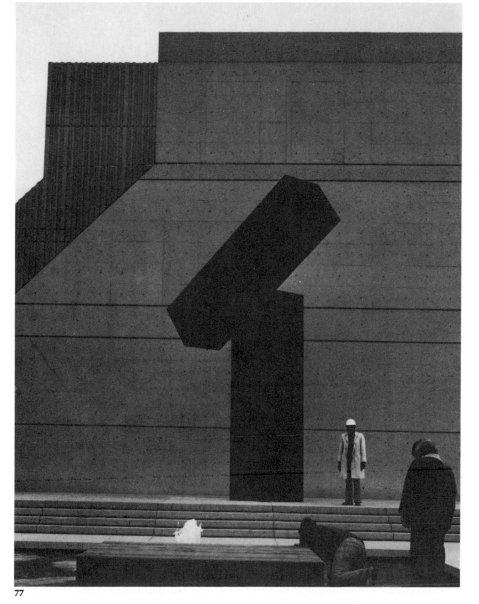

77

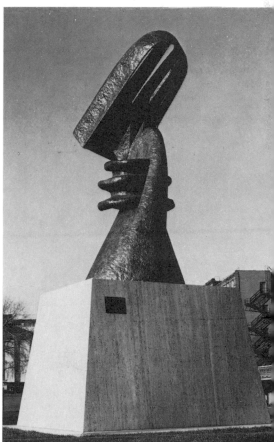

78

76

QUEEN'S UNIVERSITY GROUNDS
Kingston, Ontario, Canada

ARTIST: Kosso Eloul, "Time," 21' high × 125' long aluminum and concrete, 1973.

77

HAMILTON ART MUSEUM, PLAZA
Hamilton, Ontario, Canada

ARTIST: Kosso Eloul, "Canadac," 24' high weathering steel, 1977. (Plaza is above the underground parking facility of the art museum.)

78

MILWAUKEE CENTER FOR PERFORMING ARTS, FRONT LAWN
Milwaukee, Wisconsin

ARTIST: Seymour Lipton, "Laureate," 12½' high on 7' high pedestal, nickel-silver on monel metal, 1970.
ARCHITECT: Harry Weese

79, 80

SCHOOL OF LAW, COLUMBIA UNIVERSITY, OVER MAIN ENTRANCE
New York, New York

ARTIST: Jacques Lipchitz, "Bellerophon Taming Pegasus," approximately 60' high bronze, 1977.

81

BOSTON UNIVERSITY, CAMPUS
Boston, Massachusetts

ARTIST: Igael Tumarkin, "Reflecting Wall No. 1," 15' × 5' × 48' painted weathering steel and umber-tinted relfecting glass, 1976.

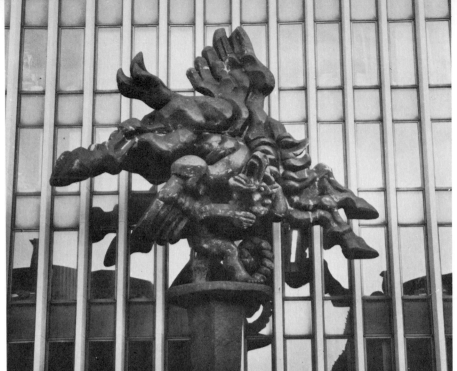

79

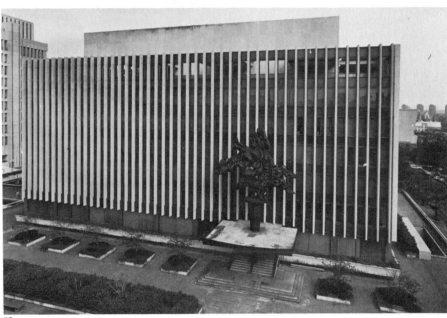

80

81

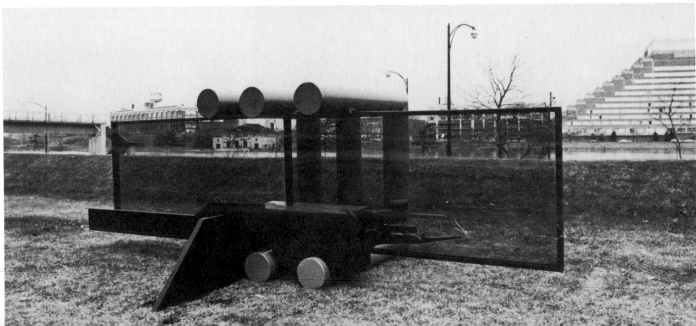

The pieces on various levels suggest water—the artificial lakes which farmers make for watering their animals and the little glacial lakes which dot the northeast landscape as seen from an airplane.

"The Sculptor, the Campus, and the Prairie," a campus exhibit of major works of seven outstanding sculptors, honored the founding President of Governors State University, William E. Engbretson, upon his retirement in 1976. Participating artists whose works are not shown here were Jerald Jacquard, Mark Di Suvero, Edoins Strautmanis, John Payne, and Richard Hunt.

82

MACOMB COUNTY COMMUNITY COLLEGE, SOUTH CAMPUS
Warren, Michigan

ARTIST: Ivy Sky Rutzky, "Glacial," 5' × 10" plate and 4' and triangle, stainless steel, 1978.

83

CAMPUS EXHIBITION, GOVERNORS STATE UNIVERSITY
Park Forest South, Illinois

ARTIST: John R. Henry, "Illinois Landscape #5," 36' × 134' × 24' painted steel, 1976.

84

CAMPUS EXHIBITION, GOVERNORS STATE UNIVERSITY
Park Forest South, Illinois

ARTIST: Jerry Peart, "Falling Meteor," 18' × 22' × 14' painted welded aluminum, 1975.

82

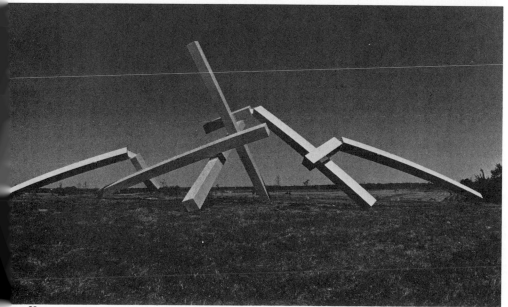

83

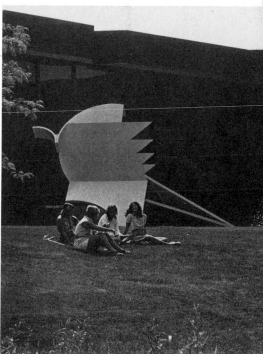

84

TEXAS HEALTH SCIENCE CENTER, LOBBY, GOOCH AUDITORIUM UNIVERSITY OF TEXAS

Dallas, Texas

ARTIST: David Novros, untitled, fresco mural, 22' high × 100' long nine-section wall.
ARCHITECTS: Fisher and Spillman, Inc.

UNIVERSITY OF NORTHERN IOWA

Cedar Falls, Iowa

ARTISTS: Anthony Padovano, "Probe," 40' long painted steel, 1972.

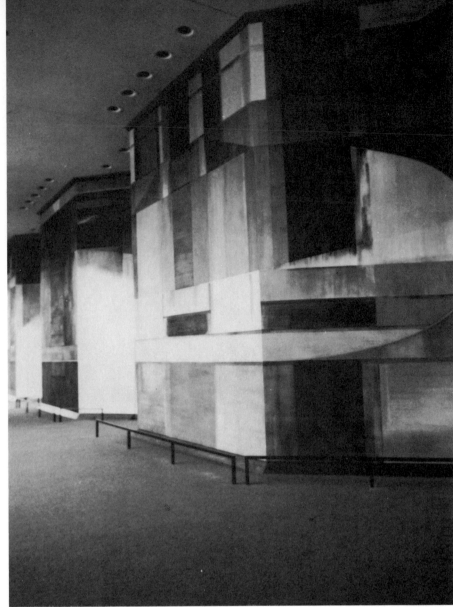

85

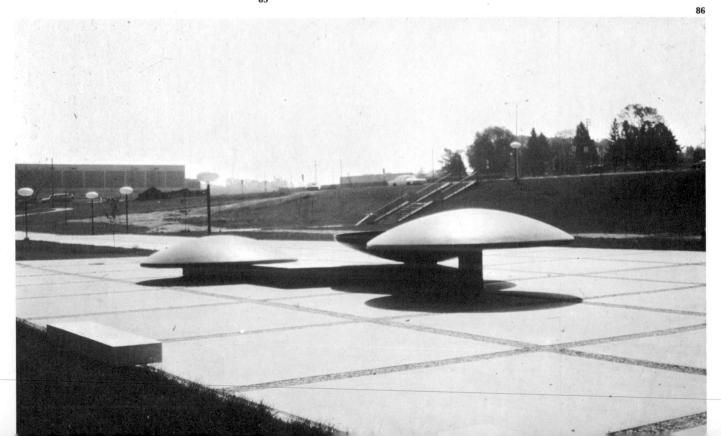

86

BATEMAN HALL, SAN FRANCISCO COLLEGE
San Francisco, California

ARTIST: Jacques Overhoff, "Socio Sculpture Garden," 80' long × 40' wide × 30' high concrete with inlaid mosaic, 1979. The sculptural forms are designed to be a part of the architectural complex and are integrated with the surrounding environment. The shapes are designed for seating, making an attractive gathering place for students.
ARCHITECT: Milton Pfleuger

87

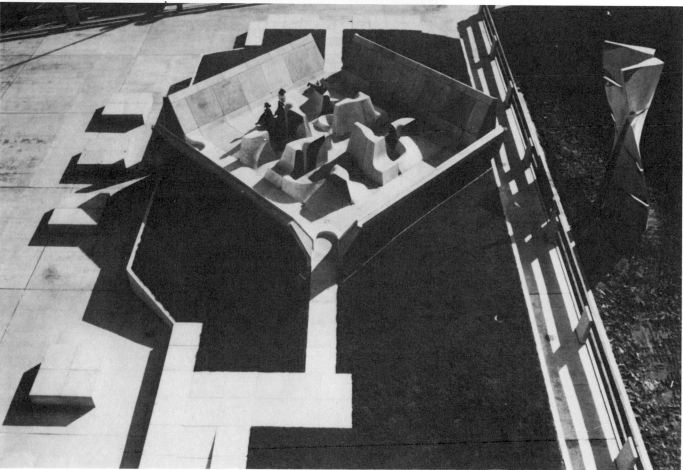

88

CINCINNATUS CONCOURSE AND FORUM, URBAN RIVERFRONT PARK

Cincinnati, Ohio

ARCHITECT: Louis Sauer Associates, 1978.

The new park is tied back to the central business district at several points, but most importantly by a combined pedestrian and vehicular bridge that spans the expressway. Pedestrians arrive at a broad elevated plaza that overlooks the river while automobiles are collected in a 200-car parking garage under the plaza. From the plaza, pedestrians descend into an enchanting urban garden of trees and shrubs, of sculptured concrete masses, of terraces and stepping stones, of waterworks developed in a variety of ways. These are "people spaces" of a sophisticated character; spaces that almost demand the viewer's active participation; spaces that are designed to seem incomplete, like an empty stage set, without that participation.

Water, of course, is a remarkably adaptable design medium and Sauer has used it in a range of expressions from static and serene to active—even aggressive. At the lively end of this spectrum is a huge water cannon that fires volleys of spray in changing patterns through an adjustable cluster of nozzles.*

*Excerpted from Cincinnatus Concourse and Forum, *Architectural Record,* June, 1979, pp. 107–102.

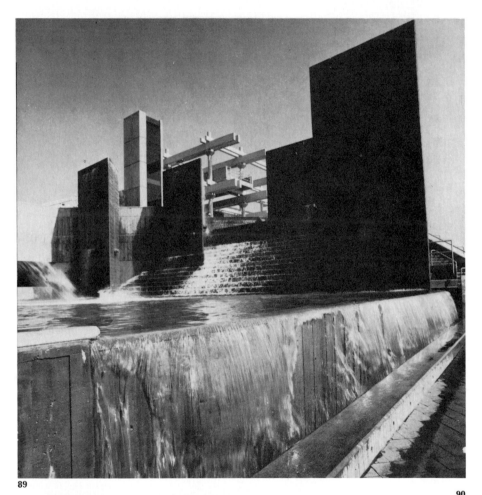

89

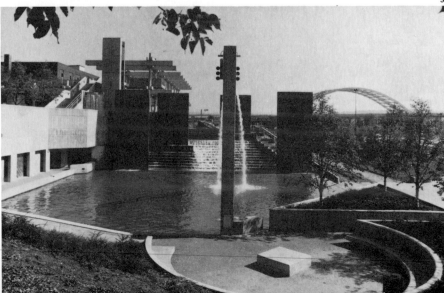

90

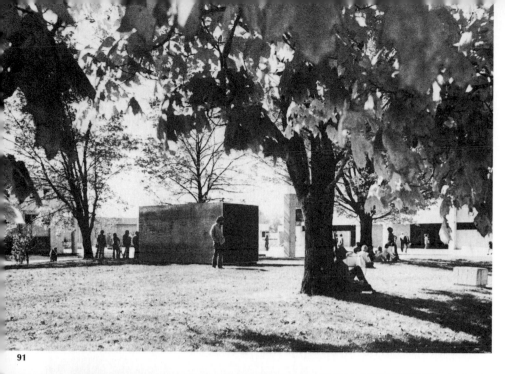

91

91,92

NORTHERN KENTUCKY UNIVERSITY, PLAZA
Highland Heights, Kentucky

ARTIST: Donald Judd, "Box," sculpture, 8' × 8' × 16' one-inch thick aluminum plate, 1977. (Funded by the Kentucky State Legislature with a matching grant by National Endowment for the Arts.)

93

MERCY COLLEGE, CAMPUS
Dobbs Ferry, New York

ARTIST: David Durst, "Max," 10' × 16' weathering steel, 1978.

94

MERCY COLLEGE, CAMPUS
Dobbs Ferry, New York

ARTIST: Bill Barrett, untitled, 8' × 6' aluminum, 1976.

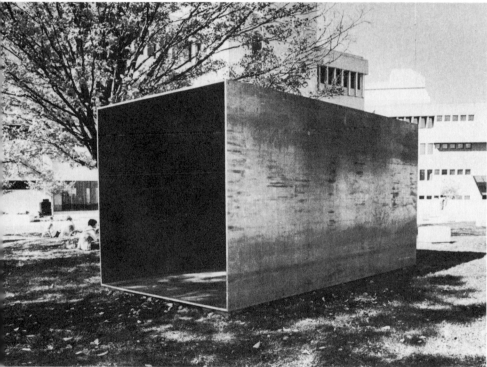

2

94

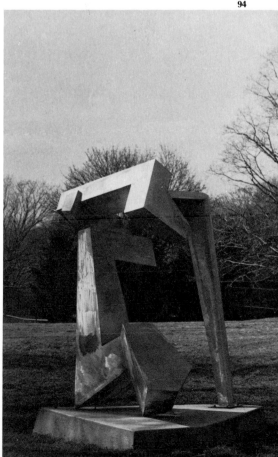

93

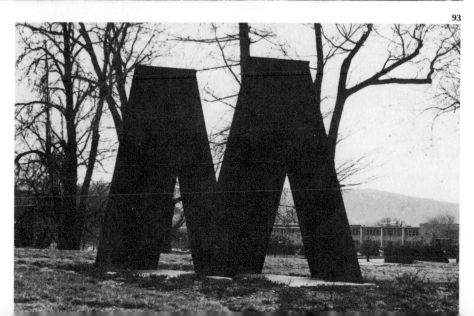

95, 96

UNIVERSITY OF CALGARY, CAMPUS

Calgary, Canada

ARTIST: George Norris, untitled, sculpture, polished
stainless steel, 1975.
SITE PLANNING: University of Calgary Campus Planning
Department, Vic Swanberg, project officer

97

BOTANICAL GARDENS

Vancouver, British Columbia, Canada

ARTIST: George Norris, fountain, large boulder 31′ × 5′
diameter, small boulder 3′ high × 2′3″ × 3′, 1976.

The sculpture by artist George Norris is a focal point of the mall, visible from all four main entrances to the campus core. It is situated on a 13-foot promontory at the north end of the mall corridor.

Several years ago, the board of governors established a policy that 0.5 percent of the capital building budget would be reserved for works of art for the public spaces on campus. The art and architecture committee, chaired by Dean W. T. Perks of the faculty of environmental design, felt the main mall, a central pedestrian thoroughfare on campus, would be a suitable place to display major works.

According to George Norris,

The aims are twofold: (1) to reflect, within the quadrangle, the character of the greater local landscape by bringing the foothills (of the Rocky Mountains) into the quadrangle, and (2) to encourage, through design, more student activity within the quadrangle. A hill was created in an area visible from all building entrances. The earth for this hill comes from the excavation for the future center block. The grade is within the 1 to 5 limitation specified. New grades have been established for sidewalks in order to eliminate as many stairs as possible, but conform to the 4 percent sidewalk grade limitation. An area almost the size of a regulation hockey rink was excavated to allow winter flooding and outdoor skating.

Every effort was made to preserve existing trees and only about seven are relocated. It is suggested that a future planting program aim for more dense groupings of a more limited variety of species. These groupings would serve as windbreaks, snow fences, and visual screens, as well as relating the quadrangle to the local landscape.

Regarding the sculpture concept, Mr. Norris says:

A large stainless steel sculpture rises from the top of the hill and acts as a rallying point for student events. It is a vantage point from which speakers, actors, and musicians may perform, or a background to student activity on the hill, for example, sliding in winter, sunbathing in summer, or watching events below in any season. Its strong overall shape avoids visual confusion with planting or buildings. Its unfolding and expanding gesture is oriented toward the sun and suggests revelation, enlightenment. Its supporting members rise from the soil and at the same time form a gateway. Images of ritual and celebration come to mind—the plumage of a prairie chicken in full array, the dance costume of a Blackfoot Indian. . . .

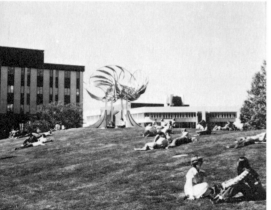

95

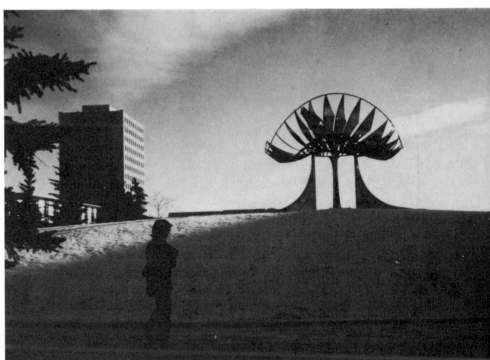

96

The sculpture was inspired by Carl Sandburg's poem of the same name.

Monies for the sculpture were provided by the B. F. Ferguson Fund of the Art Institute of Chicago. The fund was established in 1905 to beautify Chicago's streets and public spaces.

98

UNIVERSITY OF ILLINOIS AT CHICAGO CIRCLE, CENTRAL CAMPUS
Chicago, Illinois

ARTIST: Richard Hunt, "Slabs of the Sunburnt West," 3' to 9' high, 27' long, 30' wide welded bronze plate, 1975.
ARCHITECTS: Skidmore, Owings, and Merrill

99

UNIVERSITY OF AKRON, GUZZETTA HALL MUSIC, SPEECH AND THEATRE ARTS BUILDING, INTERIOR ATRIUM
Akron, Ohio

ARTIST: Harry Bertoia, untitled, sculpture, steel rods, 1976.
ARCHITECTS: Thomas Zung Architects, Inc.

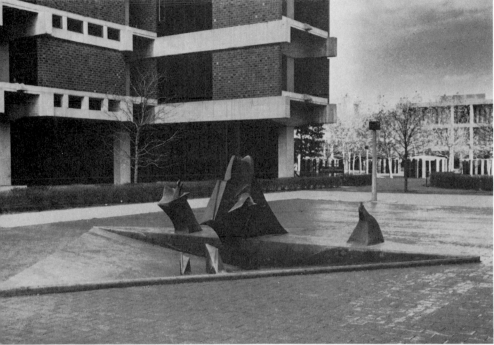

98

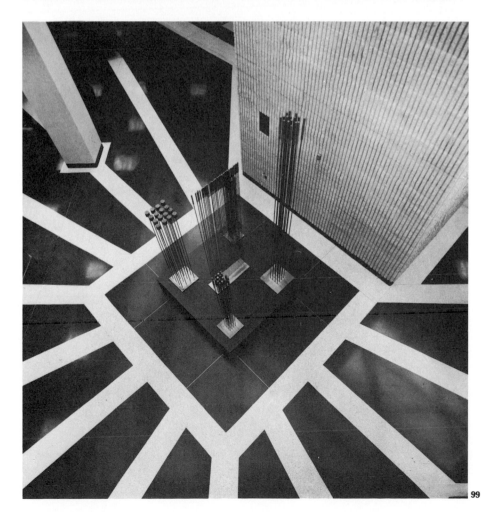

99

100

CRANBROOK ACADEMY OF ART, GROUNDS
Bloomfield Hills, Michigan

ARTIST: Alice Aycock, "And the World Takes Shape," wood construction, 1978.

101

CRANBROOK ACADEMY OF ART, GROUNDS
Bloomfield Hills, Michigan

ARTIST: Alice Aycock, "Ups and Downs or Hanging and Oscillating Spring," wooden construction, 1978.

Roy Slade, president of the Cranbrook Academy of Art, comments:

At Cranbrook Academy of Art, there has been an attempt to use the arts with architecture to create a visual enrichment of totality and unity. Writing in the New Republic, Wolf Von Eckardt states that an "intense group of artists . . . under Saarinen's direction created one of the most enchanted and enchanting settings in America." And that "the dormitories, faculty houses, museums, and workshops are earthy, rustic, direct, and a delightful adventure of pathways, enclosed gardens, open malls and meadows, and constant surprises. The place abounds, inside and out, with art and decoration . . . beautiful wrought iron work, handsome lamps and benches . . . specially designed rungs and wall hangings, furniture, light fixtures, ceramics, and woodwork. . . . All harmonizes in one visual symphony."

Within this visual harmony, the works of art are all-important, and that is particularly true of the sculpture. Cranbrook was conceived by the architect Eliel Saarinen fifty years ago, and he immediately involved other artists in the project, prominent amongst them the sculptor Carl Milles. Over the years, Carl Milles created many major works which now adorn the grounds. That tradition is continued by Michael Hall, who, as head of sculpture, encourages his students and fellow artists to place work within the grounds. As an artist his concerns are with changing our perception and involvement with place and space.

The temporary works have been recently installed by Alice Aycock, Robert Stackhouse, and Siah Armajani. Alice Aycock in her work creates a city of buildings based upon medieval and traditional forms and set in the pathway and woods above Jonah Pool. As the visitor wanders through the woods seeing the sculpture at a distance and then close up, the constant surprises of discovery give enrichment to the landscape and great enjoyment to the viewer.

That feeling of involvement is very characteristic of the work of Robert Stackhouse. The work grows out of the actual form and articulation of a hilly woodside, which he has encompassed with a 180-foot running wooden wall. More than that, he invites us to walk through the sculpture to enjoy the changing textures of light and pattern through the wooden laths of his piece. The changing seasons and lights also greatly enhance the work, and it, in turn, complements its surroundings. The placement of these sculptures makes us more aware of the landscape as well as of the works themselves.

There are five pieces by Alice Aycock placed near one another in the wooded area of the academy grounds. The collective title is "On the Eve of the Industrial Revolution, a City Engaged in the Production of False Miracles."

100

101

CRANBROOK ACADEMY OF ART, GROUNDS
Bloomfield Hills, Michigan

ARTIST: Robert Stackhouse, "Cranbrook Dance," 180'
long wooden frame passageway supported by V-shaped
metal pipes.

102

103

THE OREGON INTERNATIONAL SCULPTURE SYMPOSIUM
Eugene, Oregon

ARTIST: Roger Bolomy, "Sculpture for Meditation," assisted by W. Greene, 12' high and 10' high cedar and fir wood, 1974. Permanently placed at Lane County Public Services Building.

THE OREGON INTERNATIONAL SCULPTURE SYMPOSIUM
Eugene, Oregon

ARTIST: Hugh Townley, "Eugene Group," assisted by J. Dudd and B. Baker, 8'9" cast concrete. Placed in Alton Baker Park.

THE OREGON INTERNATIONAL SCULPTURE SYMPOSIUM
Eugene, Oregon

ARTIST: Bruce Beasley, "Red Welded Sculpture," assisted by D. Loppnow and D. Dykes, 18' high × 40' long red painted carbon steel. Placed in a park in Eugene, Oregon.

The following is from a report by Jan Zach and Hope Hughes Pressman;*

The Oregon International Sculpture Symposium was held at Eugene, Oregon, from 15 June to 1 August 1974. Jan Zach's idea for such a symposium was based on the experience of the International Sculpture Symposium organized by the Austrian sculptor Karl Prantl at St. Margarethen near Vienna in 1959. Israeli sculptor Kosso Eloul has described Prantl's event as follows: "In an abandoned stone quarry in Austria, the first International Sculpture Symposium began with a few sculptors who realized that sculpture and space are inseparable. These sculptors worked for the experience of creating forms outside a studio environment. They worked, not for commission, not for a client, but only for the opportunity to relearn how sunlight and space combine with form to create the environment of the monumental. The sculpture was carved from the quarry stone and left in the quarry as a collection."

Zach's first effort was to organize the Symposium under the auspices of the University of Oregon, but in 1969 he learned that the University could not provide the necessary money. After the gradual enlistment of a number of supporters of the project, however, by 1974 they were able to collect $145,000. The following four sponsors provided $20,000 each, for which each chose one of the sculptors, whose work made during the Symposium, each could place at a public location: the city of Eugene, Eugene Renewal Agency, Lane Community College, and the University of Oregon. A grant of $45,000 under the Works of Art in Public Places program, National Endowment for the Arts, made it possible for Mt. Hood Community College near Portland, Oregon, and Alton Baker Park in Eugene, Lane County, to choose a sculptor whose work they would place. Additional funds, facilities, materials, and services were also contributed by private donors.

Administrative and business matters were handled by the planning committee of the Northwest Sculpture Advocates (NSA), Inc., with Hope Hughes Pressman as project director. With the help of a volunteer attorney, NSA entered into contracts with the participating artists and with the sponsors who were to receive a work executed during the symposium.

The primary site for the work of the sculptors was at an underdeveloped portion of the Alton Baker Park. Sculptors requiring indoor facilities and special industrial equipment worked at Lane Community College. The sculpture department at the University of Oregon also provided additional facilities and equipment.

Each sculptor invited to participate in the symposium was offered an honorarium of $15,000, a per diem of $25 for six weeks, materials and tools needed, and assistants to help with the execution of his work. The material selected for a work by a sculptor was subject to approval by the sponsor who was to receive the work and by Northwest Sculpture Advocates.

In 1969 an Advisory Committee was appointed by Jan Zach to draw up a list of sculptors from any country who might be invited to participate in the symposium. It consisted of F. Barraclough (UK), Editor-Publisher, *Sculpture International;* F. J. Malina (US), Founder-Editor, *Leonardo;* T. Messer (US), Director, The Solomon R. Guggenheim Museum, New York; F. Newton (US), Director, Portland Art Museum, Portland, Oregon (Chairman); J. Schnier (US), sculptor; J. Taylor (US), Director, National Collection of Fine Arts, Smithsonian Institution, Washington, DC, and E. Tefft (US), Director, National Sculpture Center, University of Kansas, Lawrence, Kansas.

Of the forty-five sculptors on the committee list, about twenty-five agreed to participate in the symposium, if invited. From the list of twenty-five the committee recommended nine to be given first priority.

Due to the fact that the grant from the National Endowment for the Arts could only be used for American citizens, only one of the sculptors finally invited was from outside the US. The six sculptors were: Bruce Beasley (US), Roger Bolomey (US), John Chamberlain (US), Dimitri Hadzi (Italy and US), Bernard Rosenthal (US), and Hugh Townley (US). The following sculptors were invited as assistants or consultants to the "six": Brian Baker (Kentucky), Jerry Dodd (New York), Wayne Green (Texas), Fred Loopstra (Wisconsin), Duane Loppnow (California), Shirley Stark (New Mexico). These assistants were paid an honorarium of $750 and were provided with free lodging.

The six sculptors were expected to complete their works within six weeks at a location where interested citizens and students could observe them at work. Furthermore, each was to give an evening public lecture at the Council chambers of the Eugene City Hall, participate in informal discussions, and be available for interviews by the press.

The general feeling of those who organized and participated in the symposium is that the venture was well worthwhile in spite of the large effort that had to be made to obtain the support and cooperation of national and local organizations in order to have the funds and other necessities required. The "six" were given the opportunity of making monumental works of sculpture without restrictions as to artistic tendency. Several of them obtained experience with locally available materials that they had not used before. The assistants to the sculptors and the student helpers gained valuable experience both in the development of a conception and in the execution of a work of sculpture.

A considerable number of the citizens of Eugene and of the students and faculty of the University of Oregon and of Lane Community College observed the work of the "six" and attended public lectures and informal discussions. There was good press coverage of the symposium in Oregon, although on a national and international level little note was taken of the event.

Finally, and most important, the cultural life of Oregon has been enriched by the sculptures erected in public places—the tangible record of the Symposium.

*Jan Zach and Hope H. Pressman, *Leonardo*, 8:332–334, Pergamon Press, 1975.

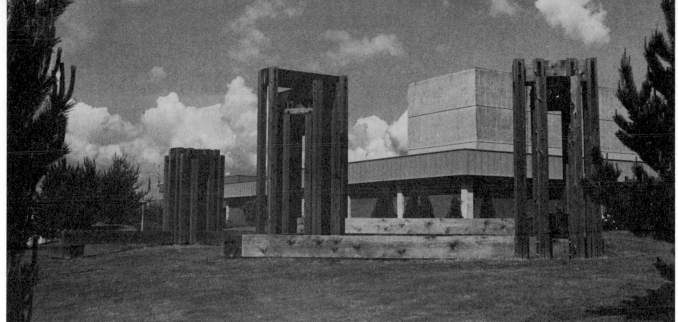

104

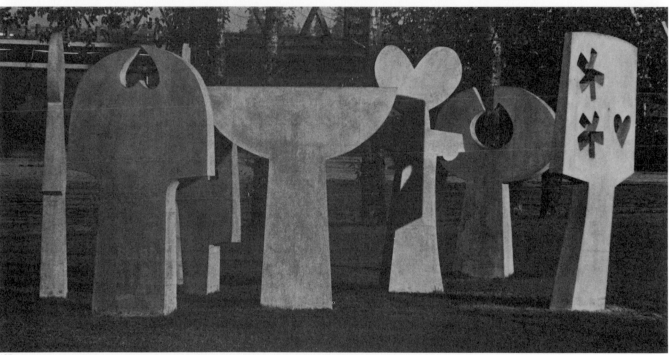

105

106

THE OREGON INTERNATIONAL SCULPTURE SYMPOSIUM
Eugene, Oregon

ARTIST: Dimitri Hadzi, "Basalt Forms," assisted by S. Stark, B. Goldboom, L. Johnston, and sculptor consultant M. Tzobanakis, 6' to 10' high Oregon basalt, 1974. Placed at Lane County Public Services Building.

108

THE OREGON INTERNATIONAL SCULPTURE SYMPOSIUM
Eugene, Oregon

ARTIST: Bernard Rosenthal, "Turning Piece," assisted by J. Hughes (welder) and D. Dykes, 12' × 12' welded weathering steel. (Renewal Area, Center of Eugene, Oregon.)

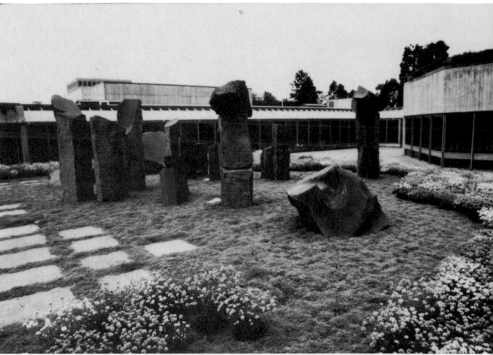

107

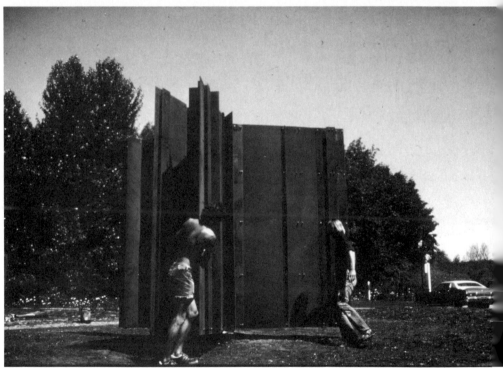

108

The wall is a sculptured chronicle of Chicago architecture since 1836. On its bas-relief surface are images of forty-five of the city's significant buildings.

ROSARY COLLEGE, CAMPUS
River Forest, Illinois

ARTIST: Henri Azaz, "The Form Makers," sculptured freestanding wall, 12.5' high × 86' long concrete, 1976.
ARCHITECTS: Perkins and Will

110

OAKLAND UNIVERSITY, CAMPUS FOUNTAIN
Rochester, Michigan

ARTIST: Marshall M. Fredericks, "Saints and Sinners," seven figures 10' high, 50' long, and 25' wide bronze on granite bases in granite basin, 1976.

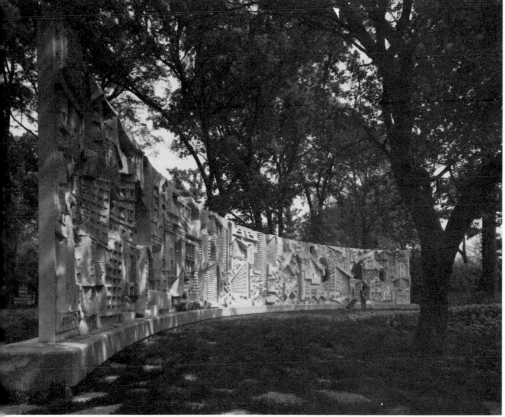

109

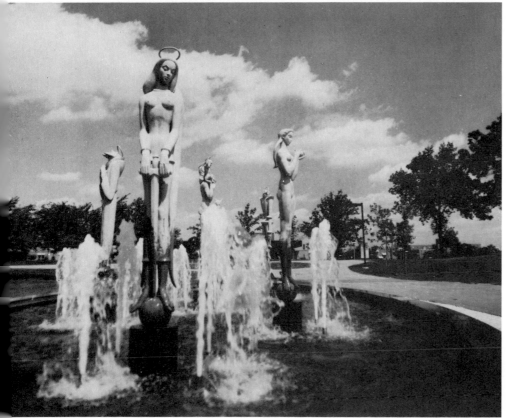

110

Public Art in the Commercial and Corporate Environment

It is difficult to think of a more active place than the suburban shopping centers where people come to shop and browse. From the very inception of the first major centers, Northland and Eastland, by the J. L. Hudson Company in suburban Detroit in the mid-1950s, it has been the policy to include significant works of art. It is not an exaggeration to say that this policy set the standards for many other major centers throughout the United States and Canada, and this policy has continued throughout the 1960s and 1970s. Public art finds its fullest expression when the architect is aware of the proportion, scale, and character of the various courts where artworks will be placed. These include sculpture, murals, fountains, paving designs, plantings, seating arrangements, lighting, and graphics.

Public art continues to receive increasing support from businesses, banks, and corporations. It is encouraging to see many important corporations include art in their building programs. It is of interest to know that in 1967 leaders of businesses organized the Business Committee for the Arts (BCA), whose purpose is to stimulate corporations to contribute to community projects of an artistic or cultural nature.

Not only does such an interest in art create a favorable image for a community; it also makes a visible contribution to a community's cultural life. Economics should not be the only interest of business. As John Kenneth Galbraith, professor of economics at Harvard University, says, "We must explicitly assert the claims of beauty against those of economics. That something is cheaper, more convenient, or more efficient is no longer decisively in its favor." The truth of this statement is borne out by the fact that the business community has gained in sales and popularity through the subsidization of beauty.

FIRST NATIONAL BANK OF CHICAGO, PLAZA

Chicago, Illinois

ARTIST: Marc Chagall, "The Four Seasons," freestanding three-dimensional mosaic mural wall 14' high × 70' long × 10' wide, 128 panels in all, each 4'11" × 3'3" and 1½" thick, 1974. (Colors are yellows, blues, reds, pinks, greys, greens, blacks and whites, with colored stones and glass marbles among the 350 shades and hues of mosaic materials.)
ARCHITECTS: C. F. Murphy Associates and Perkins and Will Partnership, joint venture.
LANDSCAPE ARCHITECTS: Novak and Carlson
FOUNTAIN DESIGN: Samuel S. Hamel

For his great Chicago mosaic, Chagall chose the theme of the four seasons. "There will be many people going through this plaza in the heart of the city of Chicago," he said. "In my mind, the four seasons represent human life, both physical and spiritual, at its different stages."

The Chagall mural is located in a large plaza adjoining the ten-story First National Bank of Chicago. The tri-level First National Plaza begins at street level at four strategic corners. Seven steps lead down to the second level where there are seats, planters, and walkways. On this level is the Chagall mosaic. From here twenty-six more steps lead to the lowest level where the fountain designed by Samuel S. Hamel of San Diego serves as a focal point. Elevators are also provided.

"The Four Seasons" was planned for this plaza by the architects of the bank building: C. F. Murphy Associates and Perkins and Will. The cost of the freestanding mosaic mural was underwritten by Mr. and Mrs. William Wood Prince through the Prince Foundation. The mosaic is maintained by Art in the Center, Inc., a nonprofit organization serving the needs of public art.

The popularity of the plaza is attested by the fact that over 3000 people visit it daily, enjoying the pleasant and invigorating surroundings of the 400-jet fountain, the colorful mosaics, and the rich landscape design interwoven in the total concept (4300 hawthornes and evergreens, 57 fully grown honey locusts, several thousand colorful annual flowers and plants).

1

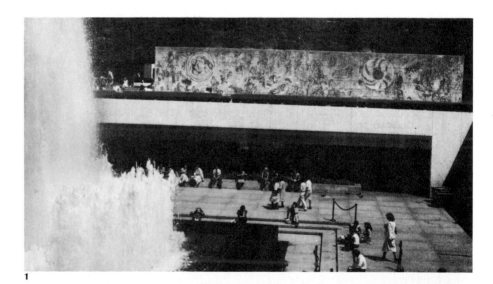

2

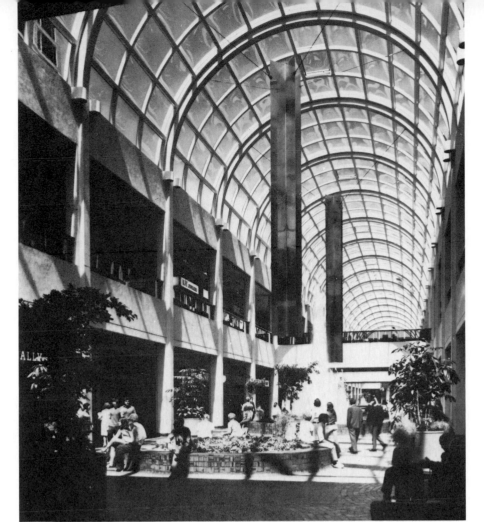

3

WORCESTER CENTER, DOWNTOWN COMMERCIAL COMPLEX, CENTRAL MALL
Worcester, Massachusetts

ARTIST: Paul Von Ringelheim, "Continum III," three 35' polished stainless steel pieces suspended by cables from the 60' high dome, 1971.
ARCHITECT: Welton Becket and Associates

4

SEARS TOWER, WACKER DRIVE LOBBY
Chicago, Illinois

ARTIST: Alexander Calder, "Universe," kinetic wall sculpture of seven elements—three flowers, a spine, helix, sun, and pendulum. Each is driven by its own motor and moves at its own speed, varying from 4 r/min for the spine and sun to 9 r/min for the helix and 10 r/min for the flowers. Total composition in metal painted in primary colors of red, yellow, orange, blue, and black spreads over the lobby wall, 33' high × 55' long, 1974.
ARCHITECTS: Skidmore, Owings, and Merrill

3

4

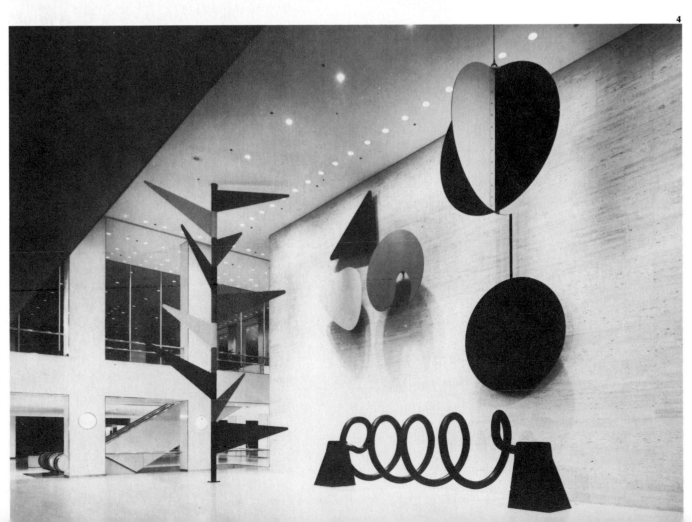

STANDARD OIL COMPANY (INDIANA) AND AMOCO SUBSIDIARIES, PLAZA POOL

Chicago, Illinois

ARTIST: Harry Bertoia, "Sounding Sculpture," for pool, copper rods in rectangular groupings ranging in height from 4' to 16' with the spacing between the rods ranging from 12" to 20", and the width of the individual sections from 16" to 11', 1975.
ARCHITECT: Edward Durell Stone

The variable height, as well as the position and arrangement of each unit, determines the sounding qualities of the sculpture. The sound that will be produced when the wind sets the metal rods into motion will never twice be exactly the same.

"The pleasing and subtle variations of tone, in addition to the flowing patterns of swaying metal rods, have an appeal to many senses," Richard J. Farrell, Standard Oil vice president, stated at the press briefing. "It is truly 'art for the public,' art which can be seen and heard, art which can reach every level of understanding," he continued.

The sculpture is situated in a 4000-square-foot reflecting pool, surrounded by an open-air plaza with honey locust trees and a 190-foot-long waterfall.

5

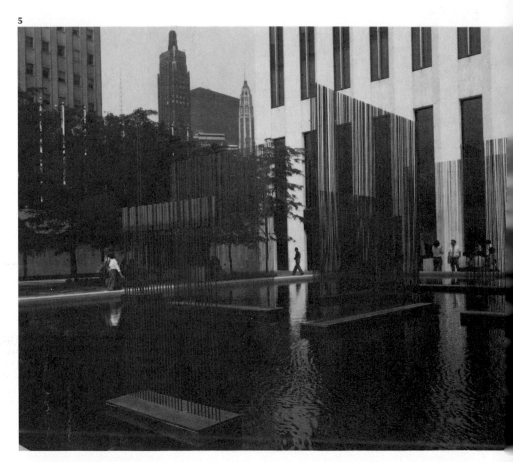

6

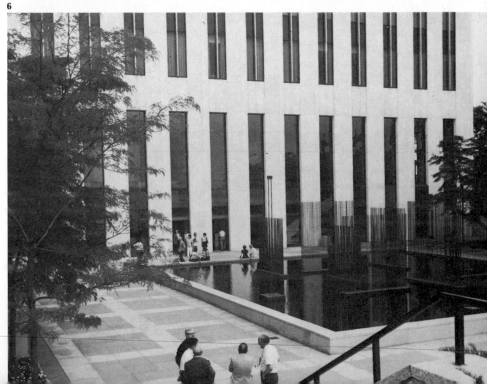

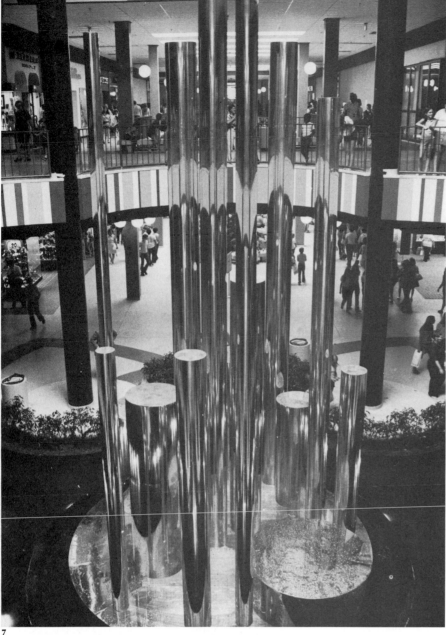

7

SUNRISE MALL, CENTRAL COURT
Massapequa (Long Island), New York

ARTIST: Alexander Liberman, "All," 36' high polished aluminum, 1973.
ARCHITECT: Lathrop Douglass
PROJECT DESIGNER: Louie G. Lindiakos

8

CIBA-GEIGY CORPORATION HEADQUARTERS ENTRANCE
Greensboro, North Carolina

ARTIST: Herbert Ferber, "Oval and Triangle," 10' × 6' × 6' painted steel within brass structure, 1976.

8

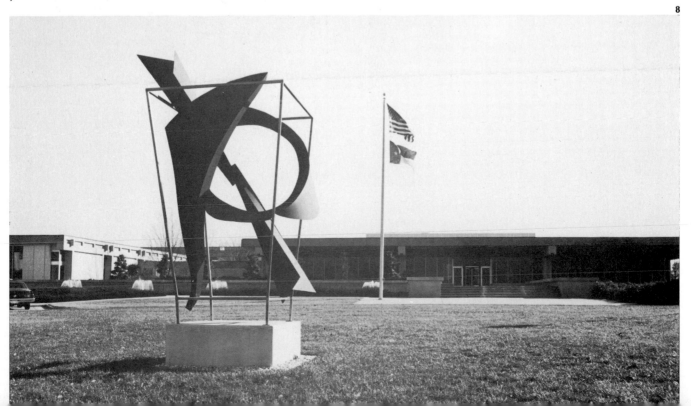

9

FIDELITY BANK PLAZA
Oklahoma City, Oklahoma

ARTIST: Lin Emery, "Aquamobile," fountain, sculpture, 20'
 high naval brass, 1972.
ARCHITECTS: Sorey, Hill, Binnicker

10

SOUTH CENTRAL BELL
COMPANY, INTERIOR ATRIUM
Birmingham, Alabama

ARTIST: Lin Emery, "Magnetmobile," kinetic sculpture, 29'
high × 10' wide welded aluminum "C-Flex", cold-cast
aluminum (aluminum flake and polyester resins), and
ceramic magnets. Magnets mounted on flywheels
concealed in the ceiling and floor sporadically attract
magnets in the mobile forms and start them swinging.
The momentum is transferred from one form to another;
each in turn tends to move in an ever-wider arc as it
reaches its natural frequency or responance. However,
since the movement of one form acts as a damper to the
others, the cycle of movement is constantly altered.

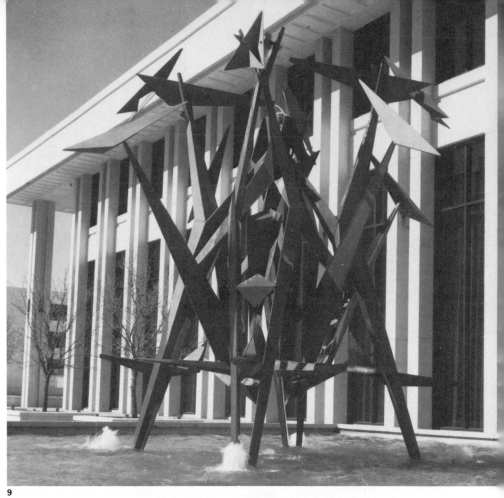

9

10

Comments by David von Schlegell:* "These pieces have a specific alignment relative to the earth. Reflecting light, they change with the earth's time and with the flux of its weather. They force a particular awareness of the most basic element of nature, the sun.

"If sculpture is kept open and quiet, it can clarify man's concepts and re-form his continuity with nature."

*Arts Magazine, May–June, 1973.

PepsiCo, Inc. purchased the first pieces of sculpture in 1970 and these became the nucleus of its permanent collection of the present twenty-four works of internationally known sculptors. They are an integral part of the design of the sunken garden, mall, natural lake, and terrace areas.

11

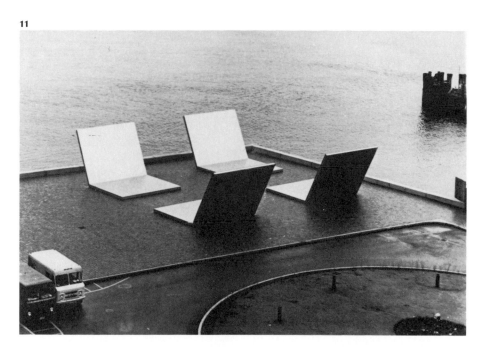

12

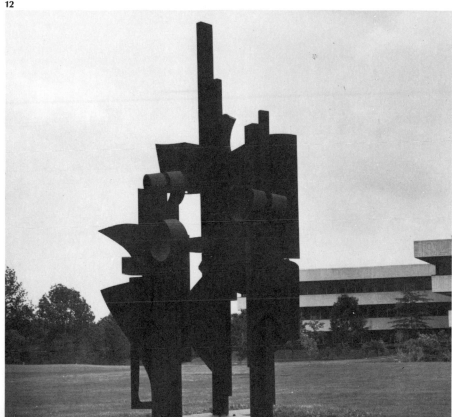

11

INDIA WHARF AT HARBOR TOWERS
India Street and Atlantic Avenue, Boston, Massachusetts

ARTIST: David von Schlegell, untitled, 20' wide, 16' deep, 16' high stainless steel, 1973.
ARCHITECT: I.M. Pei

12

THE PEPSICO WORLD HEADQUARTERS, SUNKEN GARDEN, MALL AND TERRACE AREAS
Purchase, New York

ARTISTS: Louise Nevelson, "Celebration II," 28' × 16½' weathering steel, painted black, 1977.
ARCHITECT: Edward Durell Stone
LANDSCAPE ARCHITECT: Edward Durell Stone, Jr.

13

OFFICE BUILDING ENTRANCE, PLAZA
New York, New York

ARTIST: Herbert A. Feuerlicht, "Embrace," 22' × 4' × 4' weathering steel painted red, 1973.

13

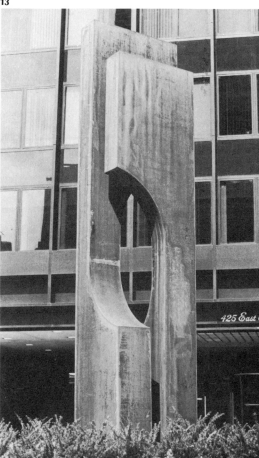

14

FIRST NATIONAL BANK, FIRST LEVEL PLAZA
Tulsa, Oklahoma

ARTIST: Harry Bertoia, fountain, 20' bronze.
ARCHITECT: Murray Jones Murray

15

THEATER FOR THE PERFORMING ARTS, FOYER
Las Vegas, Nevada

ARTIST: Don Snyder, "Sorcerer's Apprentice," 52' high × 26½' wide stainless and neon, 1976.

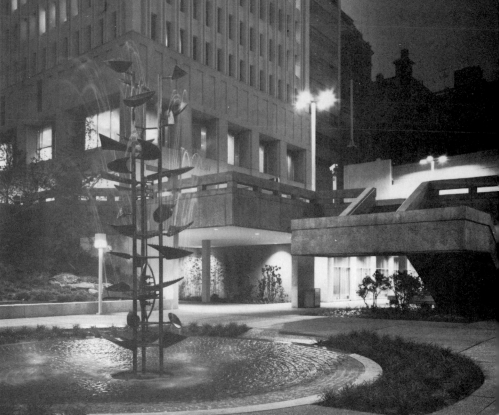

14

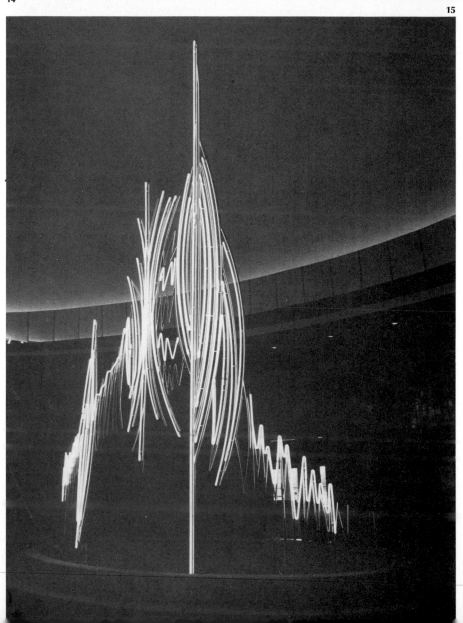

15

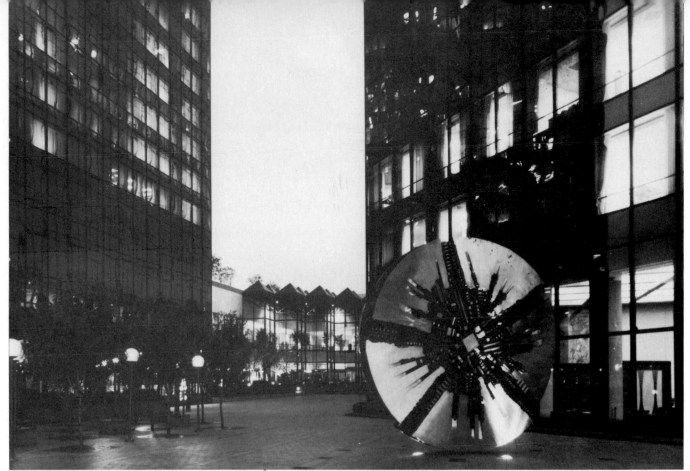

16

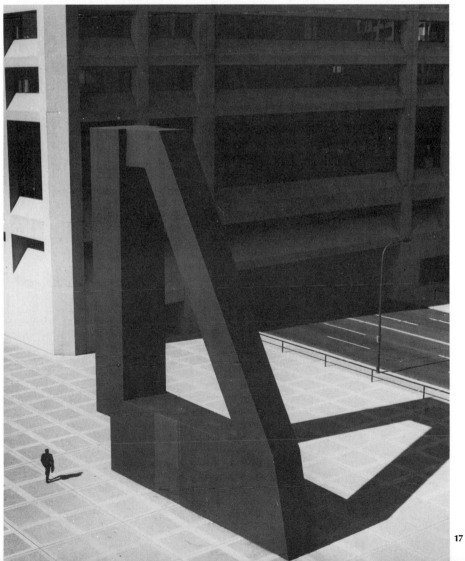

16

NORTH CAROLINA NATIONAL BANK PLAZA, INDEPENDENCE SQUARE
Charlotte, North Carolina

ARTIST: Arnaldo Pomodoro, "Grande Disco," 16' high ×
2½' wide bronze disc mounted on ball bearing post,
pivots in the wind on a steel axle, 1976.
ARCHITECT: Thompson, Ventulett, Stainback, and
Associates, Inc.

17

MARINE MIDLAND CENTER HEADQUARTERS FOR MARINE MIDLAND BANKS, INC., PLAZA
Buffalo, New York

ARTIST: Ronald Bladen, "Vroom-Shhh," 60' high steel,
1974.
ARCHITECTS: Skidmore, Owings, and Merrill

17

18

THE MANUFACTURERS NATIONAL BANK OPERATIONS CENTER, LOBBY

Detroit, Michigan

ARTIST: Samuel Cashwan, untitled, suspended stainless
 steel sculpture 30' high, 1971.
ARCHITECT: Louis G. Redstone Associates, Inc.

19

TOWER 100, THE MANUFACTURERS NATIONAL BANK

Renaissance Center, Detroit, Michigan

ARTIST: Glen Michaels, untitled, assemblage, bronze in the
 lost-wax process, shale, stone, ceramics, different woods,
 brass, and ivory.
ARCHITECTS: for Manufacturers National Bank interior,
 Louis G. Redstone Associates, Inc.
ARCHITECTS: for Renaissance Center, John Portman
 Associates, Inc.

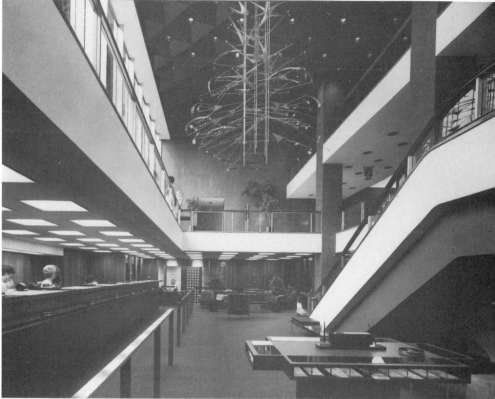

18

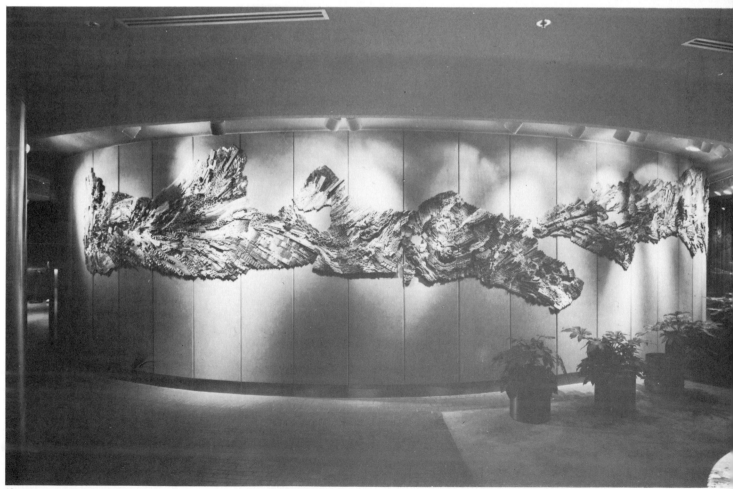

19

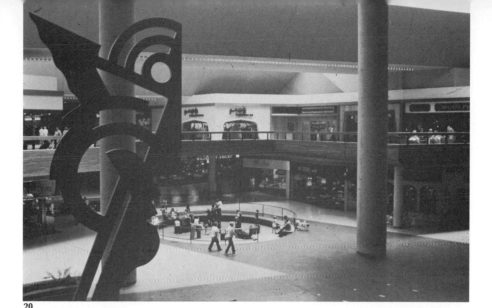

20

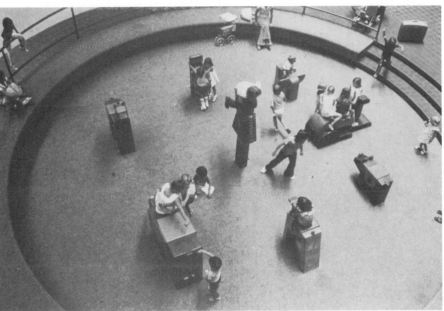

21

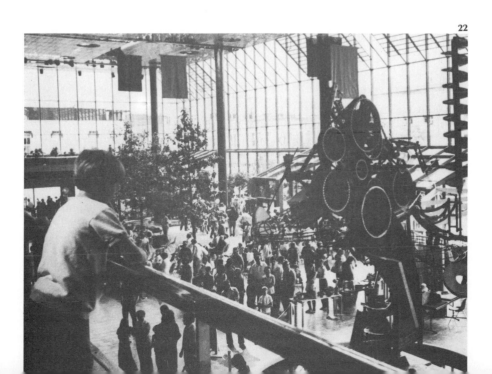

22

20

SANTA ANITA FASHION PARK REGIONAL SHOPPING CENTER, CENTRAL MALL COURT
Arcadia, California

ARTIST: Roy Lichtenstein, untitled, 30' high, fabricated in wood, covered with a bright blue plastic skin.
ARCHITECT: Gruen Associates, Inc.

21

SANTA ANITA FASHION PARK REGIONAL SHOPPING CENTER, CENTRAL MALL COURT
Arcadia, California

ARTIST: Pamela Weir Quinton, untitled, eight contemporary wooden animal play sculptures (elephant, alligator, cow, giraffe) ranging from 2' to 4' high and up to 5' long, 1974.
ARCHITECT: Gruen Associates, Inc.

22

THE COMMONS AND COURTHOUSE CENTER, INTERIOR OF THE COMMONS
Columbus, Indiana

ARTIST: Jean Tinguely, "Chaos No. 1," a 30'-high machine with wheels, gears, a large auger bit, and racing metal spheres, all moving at varying speeds, and the entire sculpture slowly rotating on its massive base of steel, 1976.
ARCHITECT: Gruen Associates

23

GIRARD BANK AND THE FIDELITY MUTUAL LIFE INSURANCE COMPANY, PLAZA
Philadelphia, Pennsylvania

ARTIST: Robert Engman, "Triune," 26' high (includes 6½'
 concrete base) × 18' wide bronze, 1974.
ARCHITECT: Vincent Kling and Partners

24

SHERATON AIRPORT INN, ENTRANCE
Philadelphia, Pennsylvania

ARTIST: Art Brenner, "Atlas X," 19' high steel painted
 orange with sculpture base 10 ft² concrete block, 1974.
ARCHITECT: Emery Roth and Sons

Robert Engman comments: "The sweeping bronze surfaces of 'Triune' curve into three lobes that interlock and describe a circle. The three lobes represent the interdependence of people, government, and private industry who must work together in harmony for the achievement of their common goals and the betterment of society."

Art Brenner comments: "In the creation of 'Atlas X,' I was concerned with two very separate areas: (1) the plastic aspects of the forms as sculpture and my preoccupation with solid and transparent planes as well as (2) the interference (moire) patterns that produce a kinetic effect from two perforated sheets or two grills."

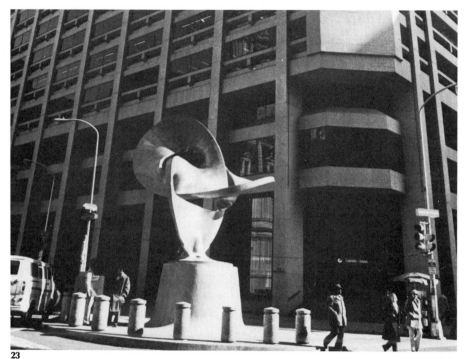

23

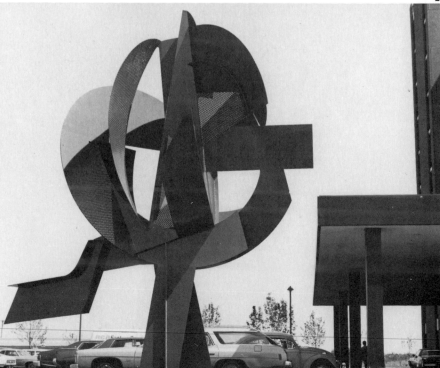

24

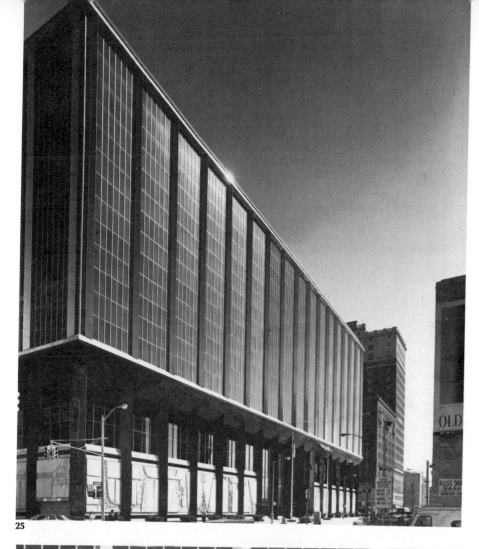

25

25, 26

**THE MANUFACTURERS BANK
OPERATIONS CENTER, FRONT
FACADE**
Detroit, Michigan

ARTIST: Robert Youngman, "Industrial Images," twenty-
four precast concrete bas-relief panels, 19′ × 21′ each,
1970.
ARCHITECT: Louis G. Redstone Associates, Inc.

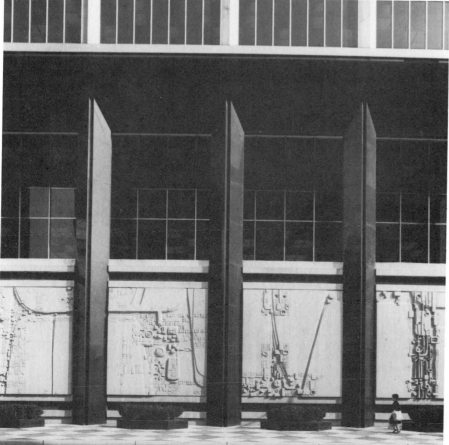

26

HAMDEN PLAZA, SHOPPING CENTER, PARKING LOT

Hamden, Connecticut

ARTIST: James Wines, "Ghost Parking Lot," twenty used automobiles, bloc band, asphalt, 1978.
ARCHITECTS: SITE, Emilio Sousa, Alison Sky, Michelle Stone, and James Wines, project directors.

This project utilizes existing physical and psychological circumstances in the development of an urban art project. Contrary to the traditional use of "object art" as a decorative accessory to buildings and spaces, this concept is neither "placed" nor "integrated" in any formal sense. Instead, it fits its context because of certain subconscious connections between shopping center rituals and the mythology of the American automobile. Also, unlike standard public art, SITE's "Ghost Parking Lot" cannot be isolated from its environment without a total loss of meaning.

The "Ghost Parking Lot" incorporates two essential ingredients of the suburban mall—cars and asphalt—and transforms them into another frame of reference. Twenty discarded automobiles are enveloped by the paving surface on various graduated levels, from full exposure of the body contours to complete burial. The concept deals with a number of factors in the American mobilized experience—the blurred vision of motion, the fetishism of the car, the indeterminacy of place and object—and exaggerates them as the raw material of public art.

27

28

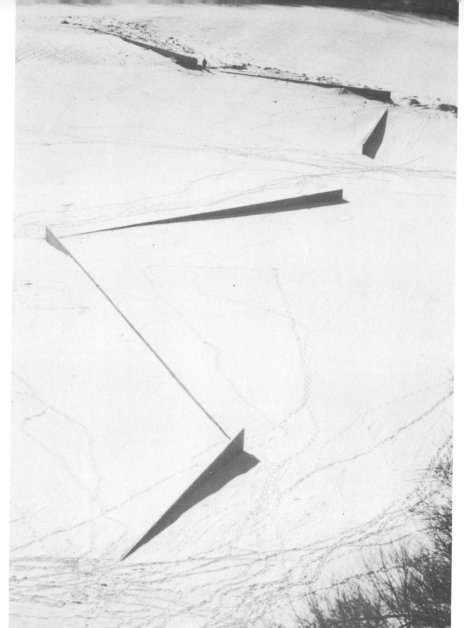

ON PROPERTY OF ROGER DAVIDSON (OPEN TO PUBLIC)

King City, Canada

ARTIST: Richard Serra, "Shift," environmental earth sculpture, 1972. Six rectilinear cement sections 5' high and 8" thick. The fall of the slope determines the shape and length of each section. The placement was determined by the shortest contour interval (most critical slope) at 5'. The placement was point-to-point. The sections span two hills that are 1500' apart. The sections step downward at 5' falls on the opposite contours. There are three sections on each side of the valley. There is a total drop to the center of 15' feet. The land was contoured by backhoe and then the cement was framed and poured in place. Each section was reinforced with rebar.

ANDERSON PARK, CHILDREN'S PLAYGROUND

Aspen, Colorado

ARTIST: Mathias Goeritz, "The Big Dipper," painted concrete, 1973.
ARCHITECT: Herbert Bayer

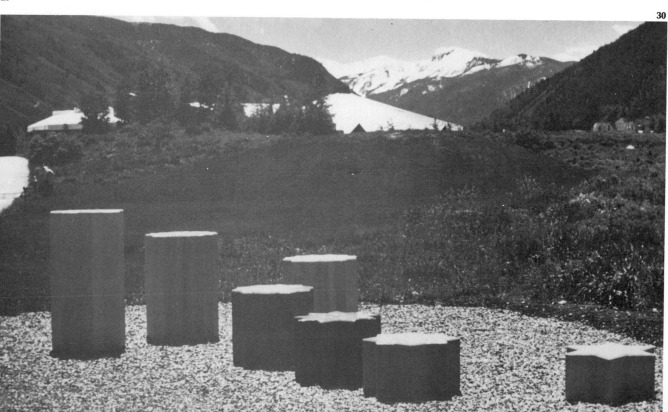

31

LARRY SEFTON MEMORIAL FOR THE UNITED STEELWORKERS OF AMERICA, PARKETTE BEHIND CITY HALL
Toronto, Ontario, Canada

ARTIST: Jerome Markson, untitled, sculpture, 12' high ×
 9' wide × 6' deep weathering steel, 1977.
ARCHITECT: Jerome Markson Architects
LANDSCAPE ARCHITECT: Johnson, Sustronk, Weinstein,
 and Associates, Ltd.

32

DRESDNER BANK, MAIN LOBBY
Chicago, Illinois

ARTIST: Ruth Duckworth, "Clouds over Lake Michigan,"
 ceramic mural, 9'7" high × 24' long, 1976.
ARCHITECTS: Perkins and Will

Union contributions provided funds for the Memorial Parkette honoring Larry Sefton, a prominent leader of the United Steelworkers of America. The city provided a site near city hall and maintains the parkette.

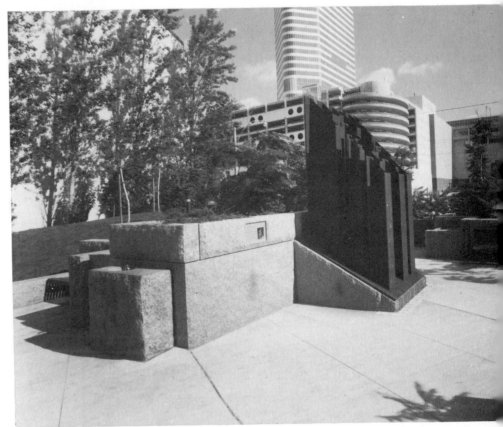

31

32

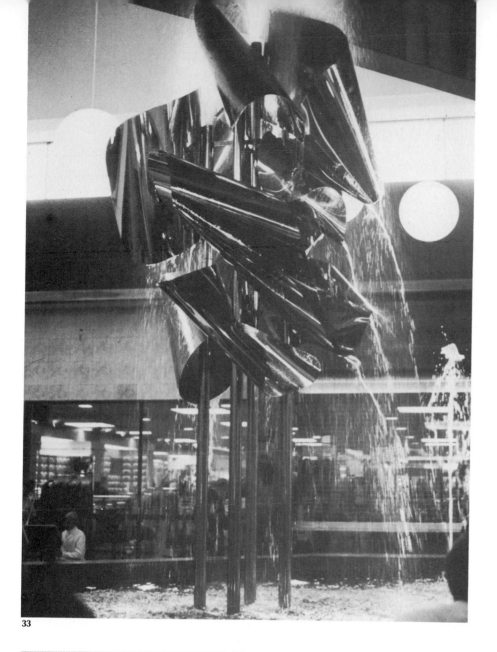

33

33

JANESVILLE SHOPPING CENTER, MALL

Janesville, Wisconsin

ARTIST: Joseph Anthony McDonnell, "Again," fountain, 22' high mirror stainless steel.
ARCHITECT: William Dorsky

34

THE SPITZNAGEL PARTNERS OFFICE BUILDING, FRONT LAWN

Sioux Falls, South Dakota

ARTIST: Chris Martens, "Centripeton," 9½' × 7' painted steel tubing, 1977.

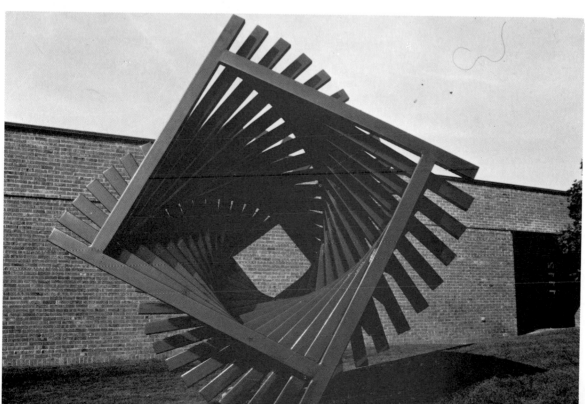

34

35

OMNI INTERNATIONAL MEGASTRUCTURE, INTERIOR COURT

Atlanta, Georgia

ARTIST: Rockne Krebs, "Canus Major," laser sculpture for night effect; also "Atlantis," a sun piece composed of 100 prisms placed around the atrium of the interior court for day effect, 1976.
ARCHITECT: Thompson, Ventulett, Stainback, and Associates, Inc.

36

COMMERCE PLACE, LOBBY

Nashville, Tennessee

ARTIST: Jon Reis, untitled, mural.
ARCHITECT: Thompson, Ventulett, Stainback, and Associates, Inc.

Krebs was commissioned by Maurice Alpert, the Omni developer, to do both pieces before all the drawings for the megastructure were set. Because of this timing, Krebs had an opportunity most artists rarely have: He was able to work with the architects and make suggestions about the skylighted roof on behalf of his sun piece, an unusual example of the artist influencing structural considerations.

He started working on "Atlantis" in 1973 and began by studying the movement of the sun for a full year, noting to the half-hour how it would strike the megastructure every day of the year. Based on this knowledge, he designed the sun piece in two parts.

The first part, which he compares to traditional sculpture, was to determine how he wanted to let the shafts of sunlight enter and be cast around the megastructure's interior. Hence his interest in the design of the skylighted roof, where the glass would go, and how clear and tinted panes of glass would be spaced in the roof.

The second part of "Atlantis," which Krebs compares to painting, involved the establishment on the megastructure's inner surfaces of rainbow patterns which appear, move, and disappear, only to be replaced by others. The rainbows are formed by the sun's rays striking some 1000 prisms which Krebs placed around Omni International.

The laser piece, "Canus Major," is described by the artist as essentially a collage—an interplay of space, structures, and light. He views it as drawing through space with light. In the evening, the laser's pure blue-green beams are directed through the megastructure's interior court toward the hotel and then deflected back in other directions by mirrors in several locations.

Laser light, unlike ordinary white light, is coherent: it is emitted as a tight beam and travels great distances through space with a minimum of dispersal. Because the artist does not consider the apparatus to be part of the work of art, he completely conceals it from view. But it is located in a large, deep purple-brown enclosure which is in itself a sculptured piece and has been designed by the artist with proportions identical to those of the complex's vast interior space. This enclosure is located two levels above Omni International's ice rink.

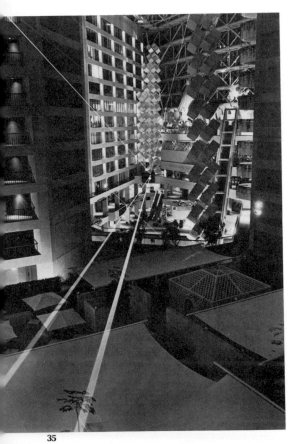

35

36

The inspiration for the sculpture comes from Jock's experience as a member a mountain rescue team. During technical evacuations, extremely complex rope systems must be engineered to rescue injured climbers.

"These systems have real excitement and beauty, their elegance resulting from the pure functionalism and problem-oriented design," says de Swart. "I hope to capture this for people not able to participate in actual operations.

" 'Belay on' means to a climber or mountain rescue person that his partner is ready to accept the responsibility of the climber's life, and that it is time to begin the climb," says de Swart. This sculpture was erected by de Swart's mountain climbing friends.

37

WESTMINISTER MALL
Westminister, California

ARTIST: Jock de Swart, "Belay On," 40' × 120' sculpture of rope, laminated beam, and hardware connected with mountain climbing rescue systems, 1974.
ARCHITECT: Architectonics, Inc.

38

LINCOLN MALL, MAIN COURT
Chicago, Illinois

ARTIST: Jan de Swart, "Lincoln Tower," 40' high laminated wood, 1973. The sculpture consists of four major curves of arches of laminated wood that twist skyward. Between the curves are flat, sculptural pieces of 1"-plywood in various rectangular and triangular shapes.
ARCHITECT: Daverman Associates

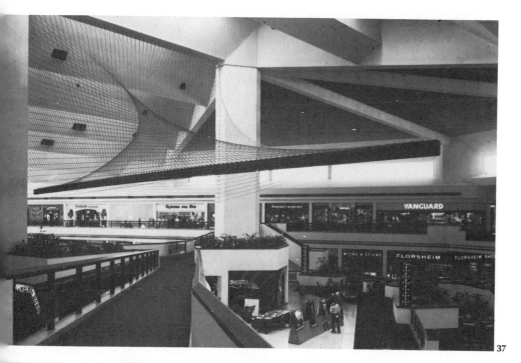

37

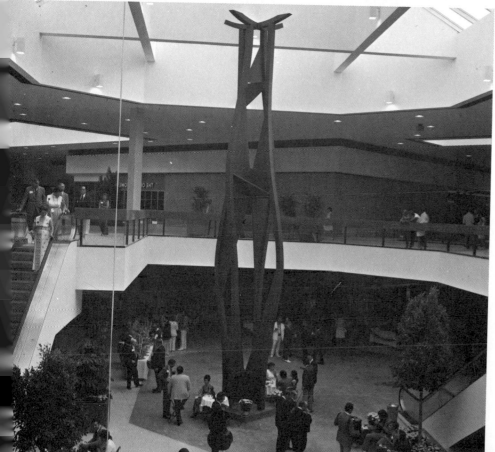

38

39

GENESEE VALLEY CENTER, MAIN COURT

Flint, Michigan

ARTIST: Harry Bertoia, untitled, hanging sculpture, 35'
high brass and bronze rods, 1970.
ARCHITECTS: Gruen Associates and Louis G. Redstone
Associates, Inc.

40

SOUTHLAND CENTER, MAIN COURT

Taylor, Michigan
Concrete fountain, 1970.

ARCHITECTS: Gruen Associates and Louis G. Redstone
Associates, Inc.

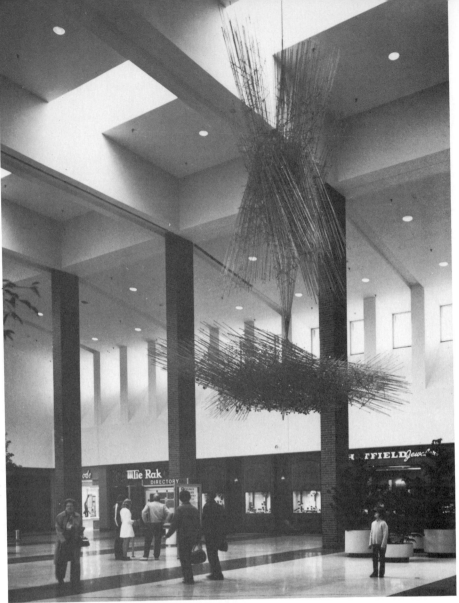

39

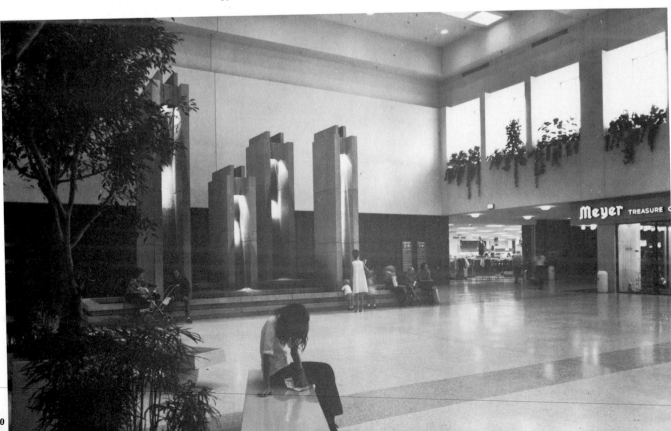

40

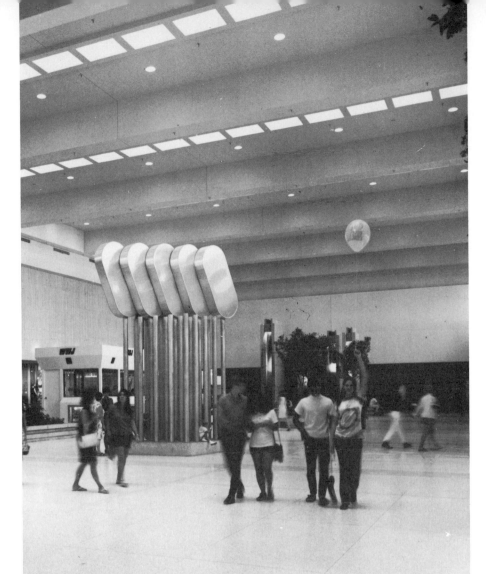

41

SOUTHLAND CENTER, EAST COURT
Taylor, Michigan

ARTIST: Hubert Dalwood, untitled, aluminum sculpture, 15' high, 1970.
ARCHITECT: Gruen Associates and Louis G. Redstone Associates, Inc.

42

SOUTHLAND CENTER, WEST COURT
Taylor, Michigan

ARTIST: Elsie Crawford, untitled, painted bas-relief wood forms on painted plaster 16' high × 80', 1970.
ARCHITECT: Gruen Associates and Louis G. Redstone Associates, Inc.

41

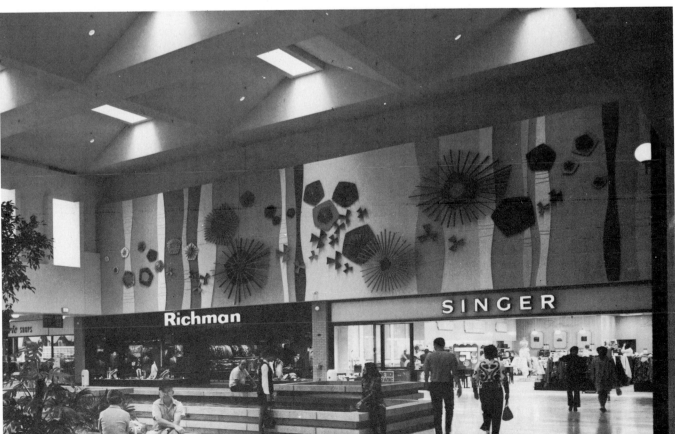

42

43

WAYNE STATE UNIVERSITY HEALTH CARE INSTITUTE, ONE OF SIX INTERIOR COURTS

Detroit, Michigan

ARTIST: Joseph E. Kinnebrew IV-III/4K spun aluminum
 spheres, 65' high, 1979.
ARCHITECT: William Kessler and Associates, Inc.; Zeidler
 Partnership, Inc.; Giffels Associates—Associated
 Architects and Engineers

44

GENESEE MALL SHOPPING CENTER

Flint, Michigan

ARTIST: Marshall M. Fredericks, "Friendly Frog," play
 sculpture, 5' high × 8' long marble terrazzo, 1970.
ARCHITECT: Gruen Associates and Louis G. Redstone
 Associates, Inc.

45

OAKLAND MALL SHOPPING CENTER

Troy, Michigan

ARTIST: Samuel Cashwan, "Hippopotamus," play
 sculpture, 4' high × 8' long cast terrazzo, 1971.
ART CONSULTANT: Louis G. Redstone Associates, Inc.
ARCHITECT: for Center, Daverman Associates

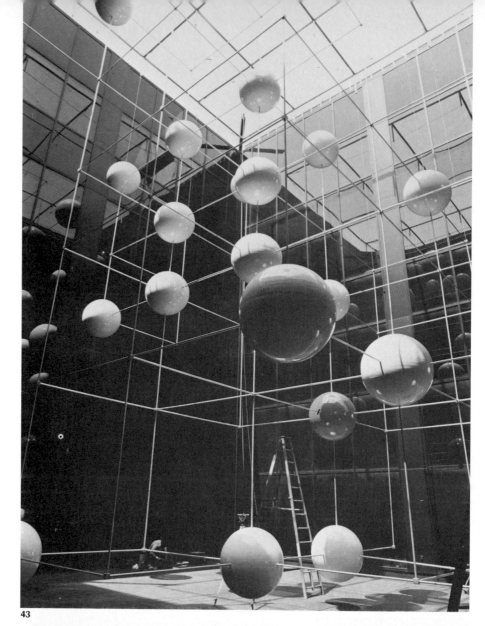

43

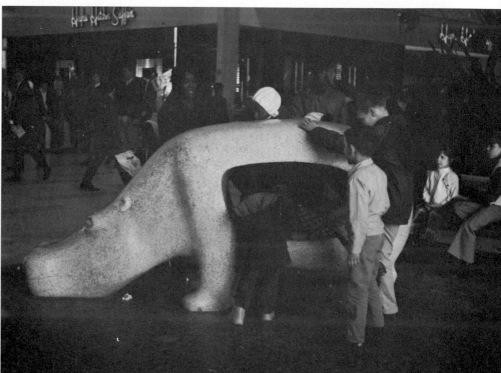

44

45

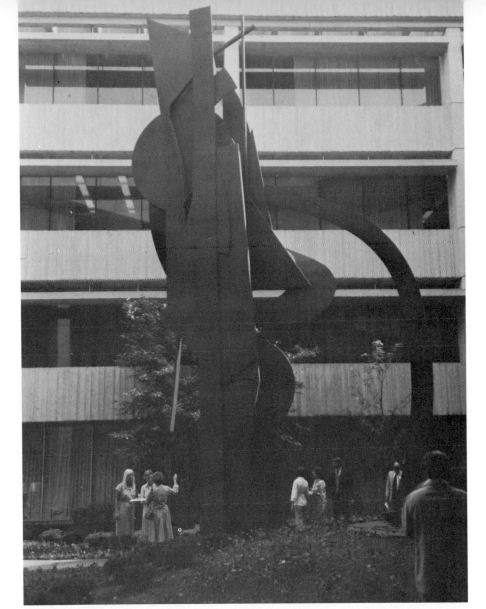

46

THE BENDIX CORPORATION HEADQUARTERS, EXTERIOR COURTYARD AND INTERIOR ATRIUM

Southfield, Michigan

ARTIST: Louise Nevelson, "Trilogy," three structures of painted black weathering steel and aluminum. In exterior court are a vertical sculpture 44' high and a horizontal sculpture 12' in diameter. In the interior atrium, separated from the exterior piece by a three-story glass wall, is another vertical sculpture 30' high, 1979.
ARCHITECT: Rossetti Associates

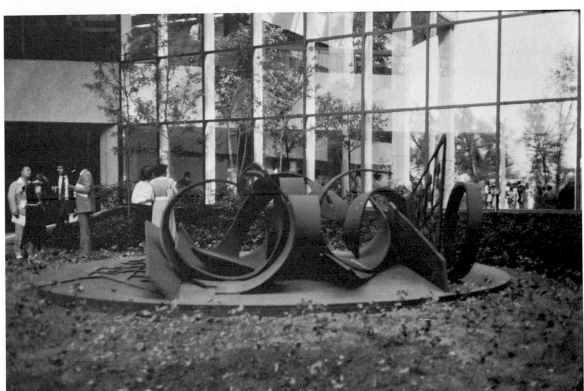

47

48

WOODFIELD SHOPPING CENTER, COURT
Schumburg, Illinois

ARTIST: Kenneth Snelson, untitled, stainless steel, 1971
ARCHITECT: The Taubman Company, Inc., Architectural
 Department
DEVELOPER: The Taubman Company, Inc.

49

WOODFIELD SHOPPING CENTER, COURT
Schumburg, Illinois

ARTIST: Robert Engman, stainless steel and bronze, 1971.
ARCHITECT: The Taubman Company, Inc., Architectural
 Department
DEVELOPER: The Taubman Company, Inc.

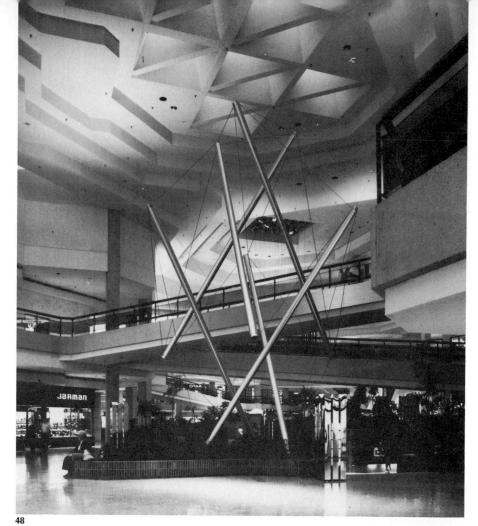

48

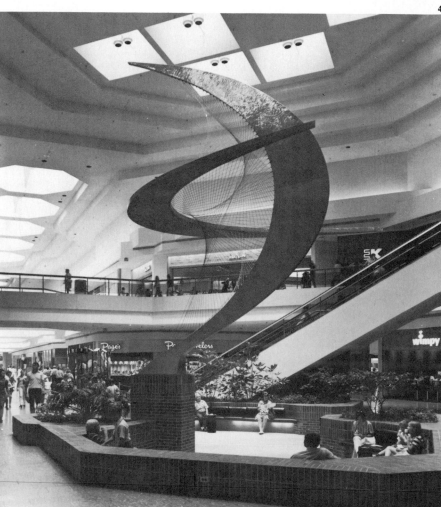

49

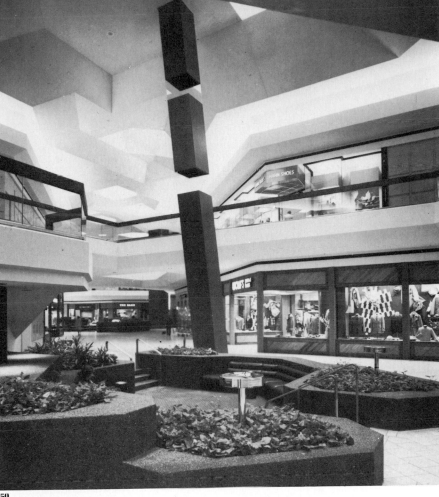

50

LAKEFOREST SHOPPING CENTER
Gaithersburg, Maryland

ARTIST: Buky Schwartz, untitled, painted black steel and
 mirror, 1978.
ARCHITECT: The Taubman Company, Inc., Architectural
 Department
DEVELOPER: The Taubman Company, Inc.

51

LAKEFOREST SHOPPING CENTER
Gaithersburg, Maryland

ARTIST: William Crovello, untitled, stainless steel, 1978.
ARCHITECT: The Taubman Company, Inc., Architectural
 Department
DEVELOPER: The Taubman Company, Inc.

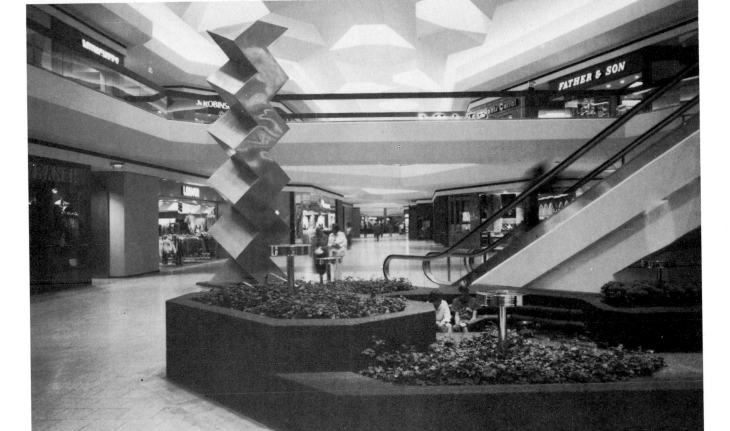

51

52
LAKESIDE SHOPPING CENTER
Sterling Heights, Michigan

ARTIST: Harry Murphy, untitled, mirrorized plexiglass and stainless steel, 1976.
ARCHITECT: The Taubman Company, Inc., Architectural Department
DEVELOPER: The Taubman Company, Inc.

53
FAIRLANE TOWN CENTER
Dearborn, Michigan

ARTIST: Richard Lippold, untitled, stainless steel and brass, 1976.
ARCHITECT: The Taubman Company, Inc., Architectural Department
DEVELOPER: The Taubman Company, Inc.

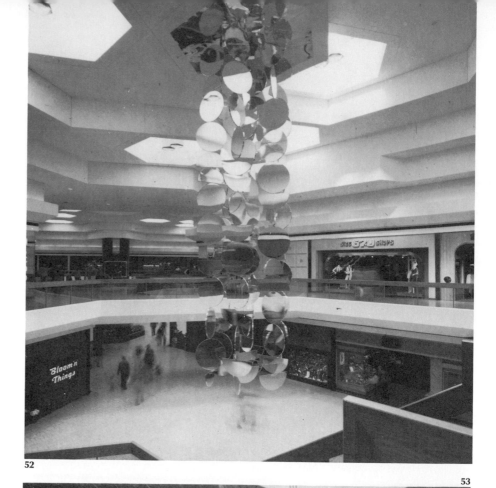

52

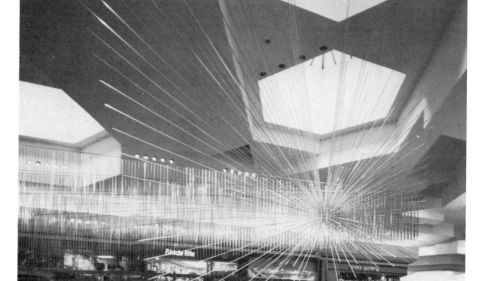

53

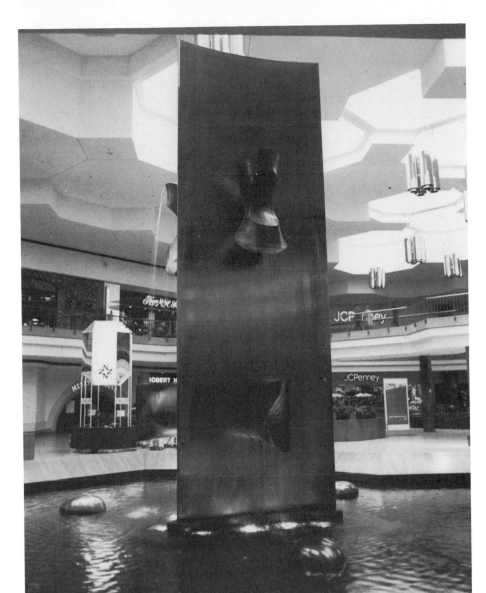

NORTHRIDGE SHOPPING CENTER
Milwaukee, Wisconsin

ARTIST: Harold Paris, untitled, stainless steel and bronze, 1972.
ARCHITECT: The Taubman Company, Inc., Architectural Department
DEVELOPER: The Taubman Company, Inc.

55

FAIRLANE SHOPPING CENTER
Dearborn, Michigan

ARTIST: David Barr, untitled, steel painted brown and blue, 1977.
ARCHITECT: The Taubman Company, Inc., Architectural Department
DEVELOPER: The Taubman Company, Inc.

54

55

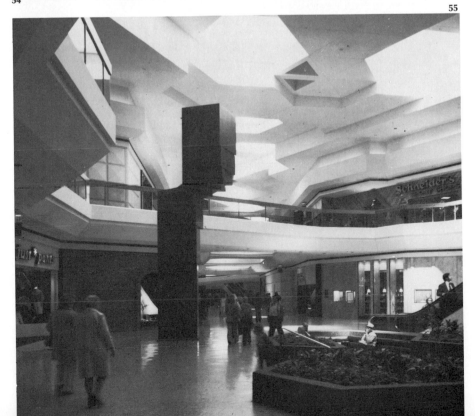

TWELVE OAKS SHOPPING CENTER, CENTRAL COURT
Novi, Michigan

SCULPTOR: Paul Slepak, "Pumping for Sedgwick," wall 4'
high × 22' long, large triangular unit 24' long, 6' at
widest point, large triangular unit jets: 3" to 6" jets with
4" to 4½" hollow core, 1977.
ARCHITECT: Gruen Associates, Inc.

57

TWELVE OAKS SHOPPING CENTER, HUDSON COURT
Novi, Michigan

SCULPTOR: Paul Slepak, "Pumping for Sedgwick," wall 4'
high × 22' long, large triangular unit 24' long, 6' at
widest point, large triangular unit jets: 3" to 6" jets with 4"
to 4½" hollow core, 1977.
ARCHITECT: Gruen Associates, Inc.

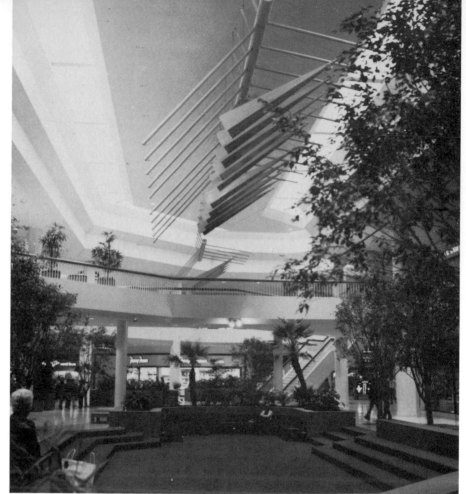

56

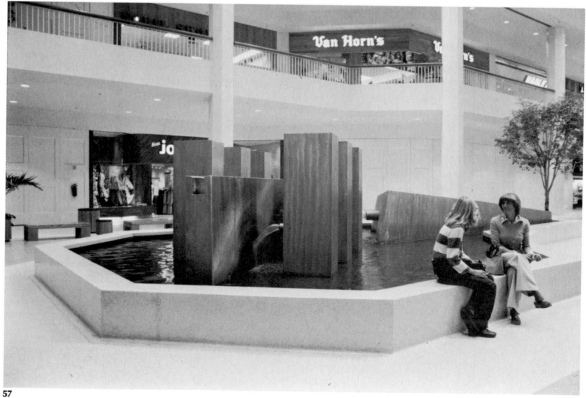

57

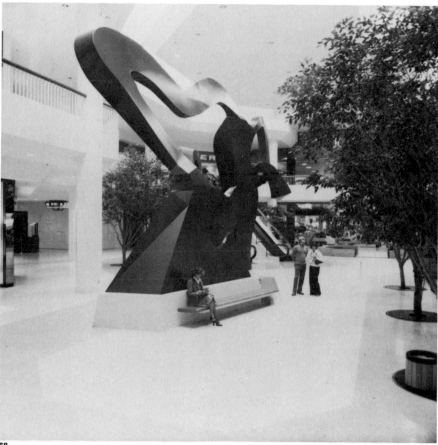

58

TWELVE OAKS SHOPPING CENTER, J.C. PENNEY COURT
Novi, Michigan

SCULPTOR: Jerry Peart, "Devil's Heart," 26' high × 22' long × 10' wide painted aluminum, 1977.
ARCHITECT: Gruen Associates, Inc.

59

TWELVE OAKS SHOPPING CENTER, LORD AND TAYLOR COURT
Novi, Michigan

SCULPTOR: Barry Tinsley, "The Arch of Prometheus," 22½' high × 38' wide painted steel, 1977.
ARCHITECT: Gruen Associates, Inc.

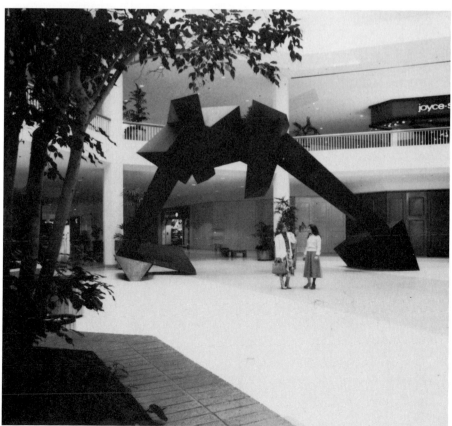

59

SONOMA AND MARIN COUNTIES, CALIFORNIA

ARTIST: Christo, "Running Fence," 1977.

"Running Fence," 18 feet high and 24½ miles long, extended east–west near Freeway 101, north of San Francisco, on the private properties of fifty-nine ranchers, following the rolling hills and dropping down to the Pacific Ocean at Bodega Bay, and was completed on September 10, 1976.

The art project required forty-two months of collaborative efforts, the ranchers' participation, eighteen public hearings, three sessions at the superior courts of California, the drafting of a 450-page environmental impact report and the temporary use of the hills, the sky, and the ocean. Conceived and financed by Christo, "Running Fence" was made of 165,000 yards of heavy, woven white nylon fabric hung from a steel cable strung between 2050 steel poles (each 21 feet long and 3½ inches in diameter) embedded 3 feet into the ground—using no concrete—and braced laterally with guy wires (90 miles of steel cable) and 14,000 earth anchors. The top and bottom edges of the 2050 fabric panels were secured to the upper and lower cables by 350,000 hooks. All parts of the structure were designed for complete removal, leaving no visible evidence of "Running Fence."

As had been agreed with the ranchers and with county, state, and federal agencies, the removal of "Running Fence" started fourteen days after its completion and all materials were given to the ranchers. "Running Fence" crossed fourteen roads and the town of Valley Ford, leaving passage for cars, cattle, and wildlife, and was designed to be viewed by following 40 miles of public roads in Sonoma and Marin counties.

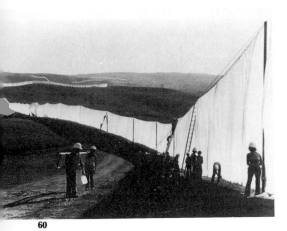

60

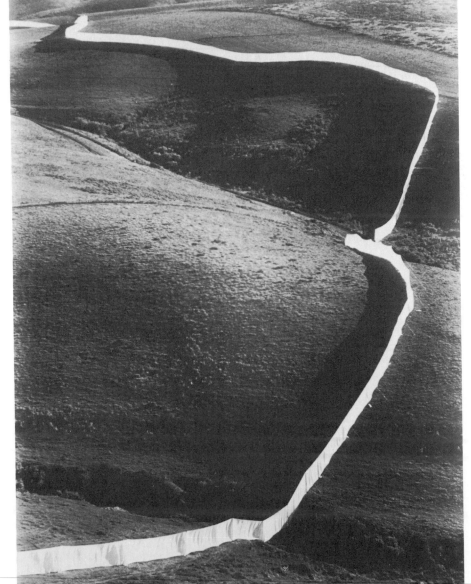

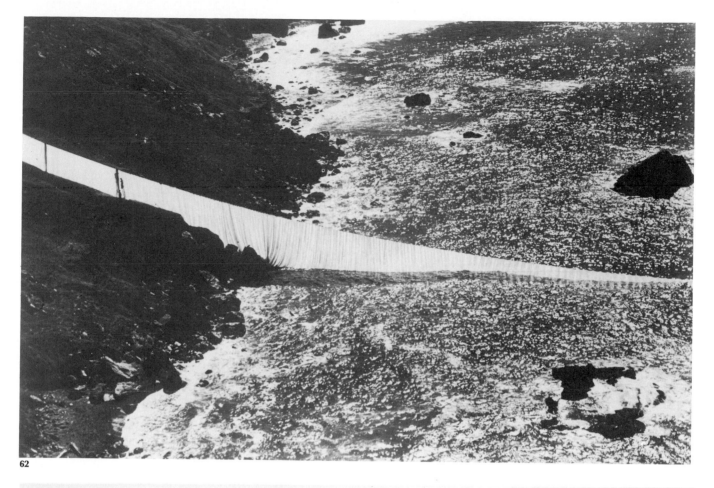

62

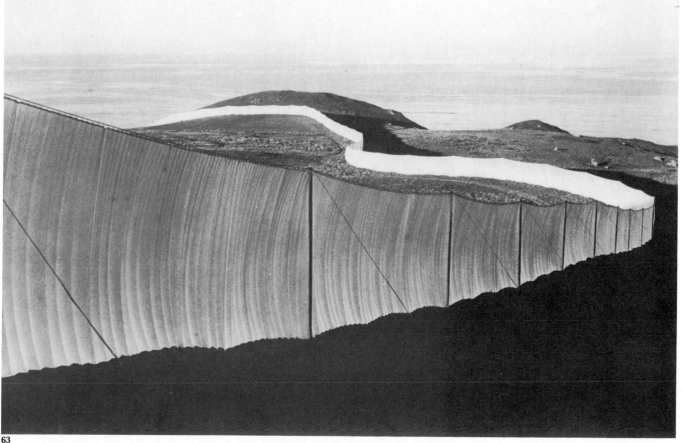

63

64, 65

OCEANIC PLAZA OFFICE BUILDING, LOBBY

Vancouver, British Columbia, Canada

ARTIST: Jordi Bonet, "Resurgence," mural, 11' × 19' colored cast aluminum, 1978. The significance of the figure moving in front of the other is to show the "interior" man, who is immutable.
ARCHITECT: Charles T. Paine

66

EDMONTON PUBLIC LIBRARY, LOBBY

Edmonton, Alberta, Canada

ARTIST: Jordi Bonet, untitled, 10' × 20' cast iron mural, 1966.
ARCHITECT: A. M. Holland

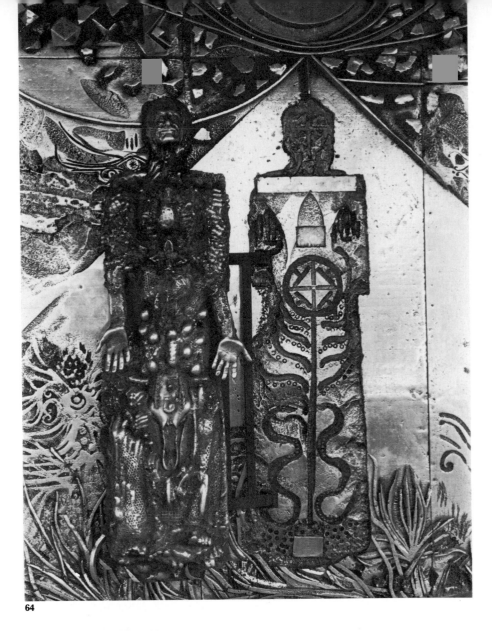

64

65

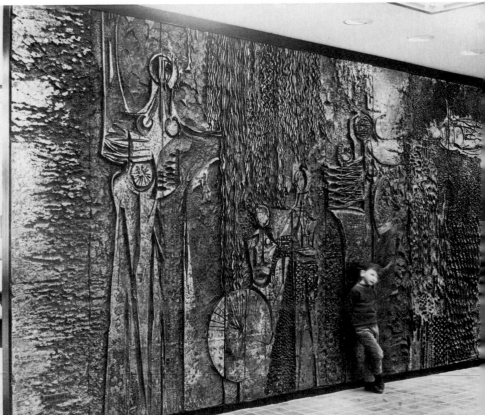

66

67

MAYO CLINIC, 16TH FLOOR
Rochester, Minnesota

ARTIST: Marjorie Kreilick, untitled, mosaic mural 8'
high × 35' long, 1970.
ARCHITECT: Thomas F. Elerby

68

OSTEOPATHIC HOSPITAL,
CHAPEL
Garden City, Michigan

ARTIST: Don Snyder, stained-glass sculptured window, 7'
× 4'. Circular cast stainless steel sculpture, untitled, 37"
high × 2' in diameter set in a revolving cast acrylic
base. Sculpture represents symbols of all faiths.

69

MANUFACTURERS BANK OF
SOUTHFIELD, LOBBY
Southfield, Michigan

ARTIST: Narendra Patel, "Detroit Panorama," mural, 5'
high × 40' long, multicolored copper forms achieved by
application of the torch and chemicals, 1974.
ARCHITECT: Louis G. Redstone Associates, Inc.

68

69

ONTARIO PLACE
Toronto, Ontario, Canada

ARTIST: Michael Hayden, "Ice Wedge," 16' high, 8' wide at base and 5' wide at top, stainless steel, 1978.

COLLECTION: VIRGINIA DWAN AND MICHAEL HEIZER
Central Eastern Nevada

ARTIST: Michael Heizer, "Complex One/City," 23½' high × 110' deep × 140' wide concrete, steel, earth, 1976.

A refrigeration unit (ice maker) is housed in a single geometric shape made from stainless steel. Once an hour, this assemblage produces a sheet of ice, 48 inches by 30 inches by ½ inch, that is forced up out of the top of the piece. This sheet topples over and smashes, shatters, or at least cracks where it falls, and the ice begins to melt. An hour later, another sheet of ice is produced and it tumbles down either on top of the first sheet or to the other side of the piece. Eventually there is a pile of ice sheets, some almost completely melted away, some in their crystalline state.

Dichromatic lamps are installed at the base of the piece and change slowly from one color to another. This light diffuses through the pile of shattered ice.

Over twenty-eight subcontractors from various disciplines were involved in the design fabrication and installation of this sculpture. These include hydraulic, refrigeration, civil, mechanical, pneumatic, structural, and electronic engineers.

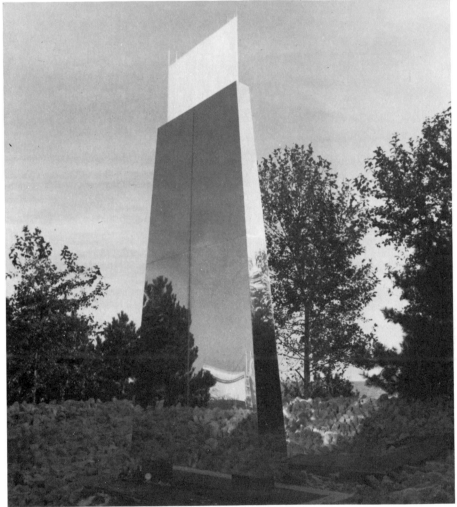

70

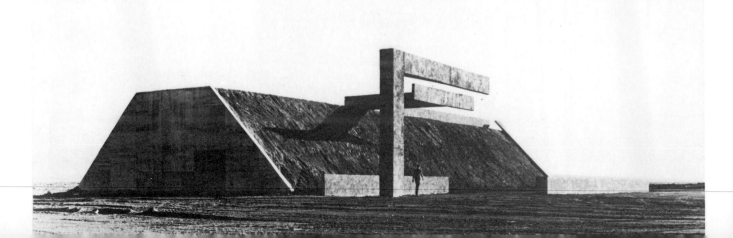

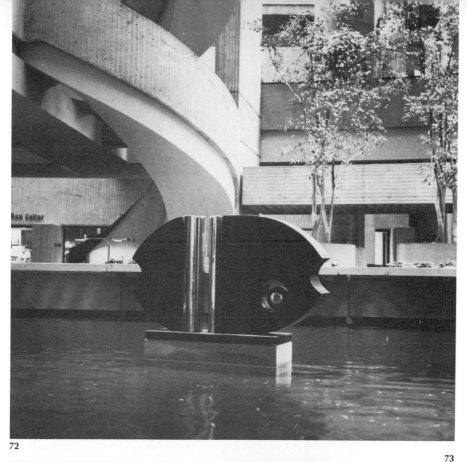

72

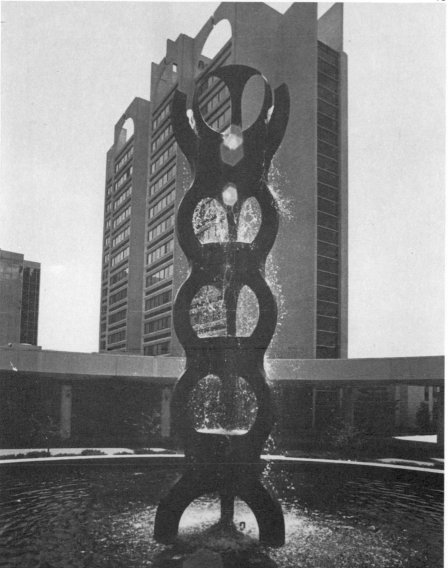

73

72

PLAZA HOTEL RENAISSANCE CENTER, LOBBY POOL
Detroit, Michigan

ARTIST: Hanna Stiebel, "Source II," 3' × 6' × 8" bronze, 1977.
ARCHITECT: John Portman Associates

73

SOMERSET INN, PLAZA ENTRANCE
Troy, Michigan

ARTIST: George Tsutakawa, "Spirit of Spring," fountain, 27' high bronze, 1974.
ARCHITECT: Volk and London
LANDSCAPE ARCHITECT: Mort Alger

74

FIRST FEDERAL BANK OF DETROIT, COURT
Troy, Michigan

ARTIST: Louis G. Redstone, untitled, brick mural, 30' × 60', with ceramic inserts by John Stephenson, 1976.
ARCHITECT: Louis G. Redstone Associates, Inc.

74

75

PROGRESSIVE INSURANCE CORPORATION HEADQUARTERS
Mayfield Heights (Cleveland area), Ohio

ARTIST: David E. Davis, "Harmonie Grid IX," 23' high × 18' wide × 6' deep aluminum painted with chlorinated rubber paint, 1978.
ARCHITECT: Jack Bialosky

76

COMBUSTION ENGINEERING CORPORATION, COURT
Stamford, Connecticut

ARTIST: Roy Gussow, "Two Forms," 6' × 6' × 6' stainless steel, 1976.

77

AMERICAN MOLDING PLASTIC CORPORATION, LOBBY
Mount Vernon, New York

ARTIST: John Costanza, mural, 9' × 20' white glazed ceramic, 1974.
ARCHITECTS: Rouse, Dubin, and Ventura

Comments by David E. Davis:

Regarding chlorinated rubber paint, I became aware of it when I investigated coating systems, as the project director for the "Portal," the Isamu Noguchi commission for the Justice Center here in Cleveland. I was so impressed with its qualities that I used it on a commission for the Beck Cultural Center, which I did in 1976, and several other pieces since then. After three years of exposure in the field, there isn't any evidence of deterioration of the surfaces, only a slight amount of oxidation which I do not find objectionable. The undercoating on steel must be on bare metal, using inorganic zinc, sprayed, and on aluminum, after cleaning with lacquer thinner, it must be sprayed with an "acid-wash" undercoat, before applying the top coat.

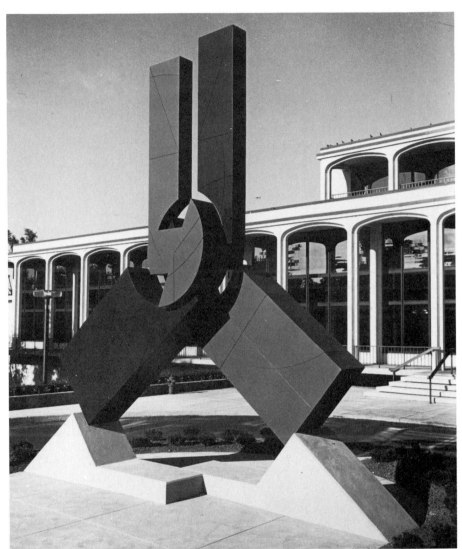

75

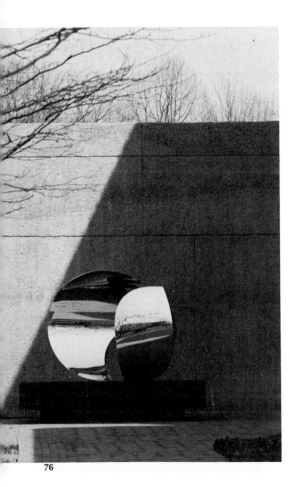

76

77

Artists' Comments:

The interior perpendicular lines and the exterior curvilinear lines of these monoliths rise from the great block and mass of the sculpture to form slender spires. The strongly patterned surfaces were created by beating the weathering steel with a 90-pound bronze pointed jackhammer. Between the monoliths, a grate in the plaza floor covers an uplit underground fountain. Water bubbles to the surface and recedes. The fountain is an integral part of the sculpture and landscaping coordination. In sight and sound, it provides an unexpected and pleasant "happening." There is a quality of constant change as the sun creates shadow patterns on the plaza and highlights the surfaces of the sculpture throughout the day.

Artist's Comments:

Straight and bending units define the three rectilinear and curvilinear columns which rise upward from a quiet lake in front of the building. The solid mass of the sculpture stands in contrast to the reflective surface of the building.

The sculpture has specific meanings to the people of Blue Cross Blue Shield. The forms are derived from computer connectors, symbolizing an efficient communication system.

78

MARTIN LUTHER KING MEMORIAL STATION, METROPOLITAN ATLANTA RAPID TRANSIT AUTHORITY
Atlanta, Georgia

ARTISTS: William Severson and Saunders Schultz, "Aspirations," sculpture, three towers 36' × 10", 38' × 11", 46' × 10" high × 2'6", natural patina surface repoussed with a bronze tipped jackhammer, 1979.
ARCHITECT: Aeck Associates

79

BLUE CROSS BLUE SHIELD, FRONT OF BUILDING
Chapel Hill, North Carolina

ARTISTS: Saunders Schultz and William Severson, "Computer Connectors," 3 towers 46' high, 5' wide × 2'6" long, polychromed with epoxy, 1973.
ARCHITECT: Arthur Gould Odell

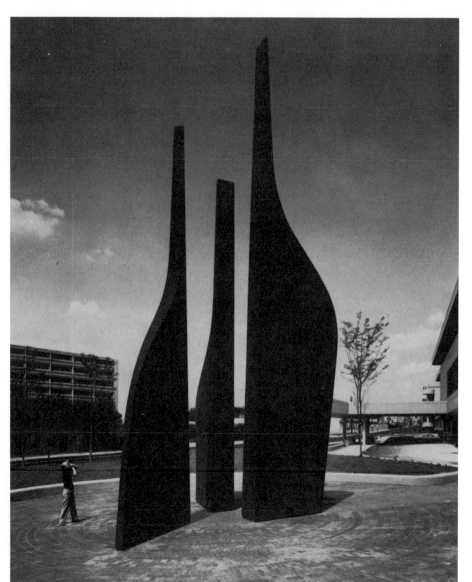

78

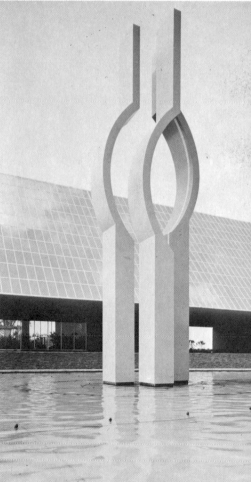

79

200 EXECUTIVE HILL OFFICE BUILDING, LOBBY

West Orange, New Jersey

ARTIST: John Costanza, untitled, ceramic wall mural, 1978.
ARCHITECT: Rouse, Dubin, and Ventura

HEADQUARTERS OFFICES FOR CHAS. T. BAINBRIDGE AND SONS, Inc.

Edison, New Jersey

ARTIST: Marvin Horowitz, untitled, cast concrete sculpture, 10' high × 15' long, 1978.
ARCHITECT: Rouse, Dubin, and Ventura

80

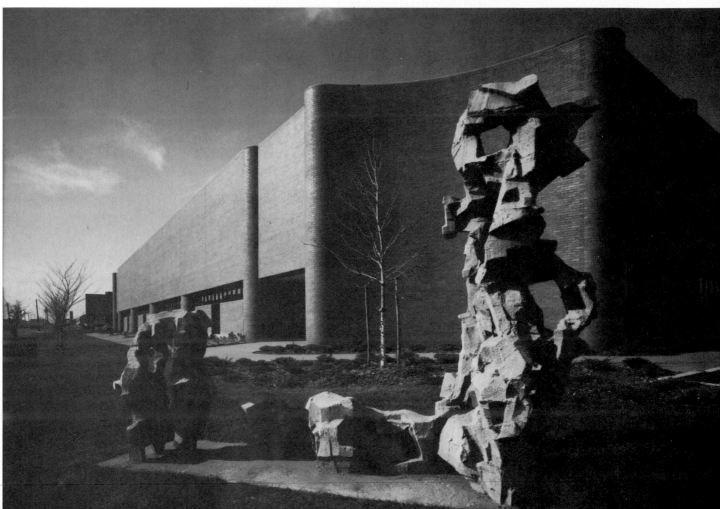

81

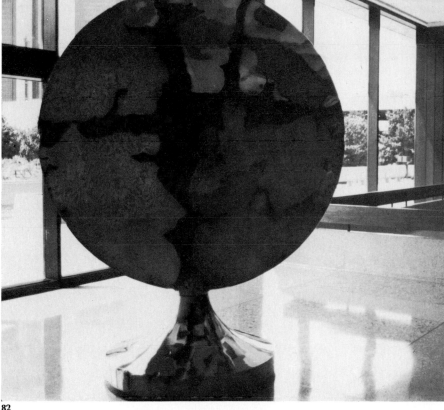

82

BLUE CROSS BLUE SHIELD OF MICHIGAN, THE SERVICE CENTER, FOYER
Detroit, Michigan

ARTIST: Tom McClure, "Universe," sculpture, 8' cast-bronze disc that pivots on a 2'-high pedestal-type base; rotates by touch of hand. Each side has unequal sections of mirror-polished finish divided by sunken channels of rough surface into which have been cast names, dates, references to local history of the site, 1974.
ARCHITECT: Giffels and Rossetti

83

BLUE CROSS BLUE SHIELD OF MICHIGAN, HEADQUARTERS, EXTERIOR COURT
Detroit, Michigan

ARTIST: John Nick Pappas, untitled, procession of thirteen figures in three groupings, the largest of which is 30' long. Most figures are freestanding, approximately 10' tall, bronze, 1977.
ARCHITECT: Giffels and Rossetti

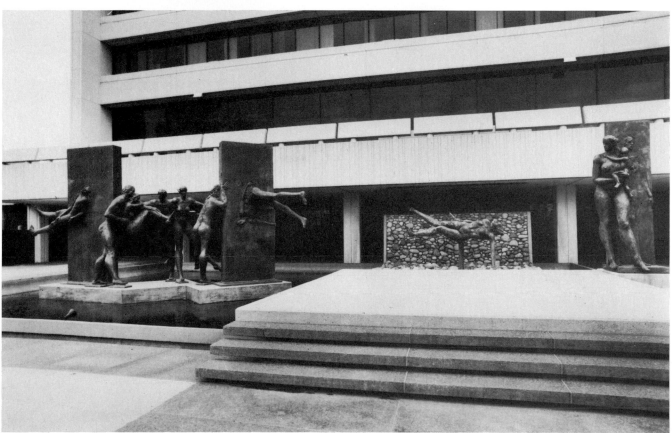

83

MERCANTILE TOWER, NORTH PATIO

St. Louis, Missouri

ARTISTS: William Conrad Severson and Saunders Schultz, "Synergism," 20' polished stainless steel on a 6" base, 1976.
ARCHITECTS: Thompson, Ventulett, Stainback, and Associates, Inc.

Artists' Comments:

"Synergism" brings the design elements of the tall building down to pedestrian level. It is almost as though pieces that had been cut to form the triangles of the building had fallen out and been reassembled to form the three intercontained cubes of the sculpture.

People pass "Synergism" going to and from work and see themselves mirrored in its polished surfaces. On pleasant days they enjoy lunch on the plaza, and often there may be a speaker, a musical group, or a fashion show scheduled at noon. At such times, the sculpture becomes alive with the color and activity it reflects.

84

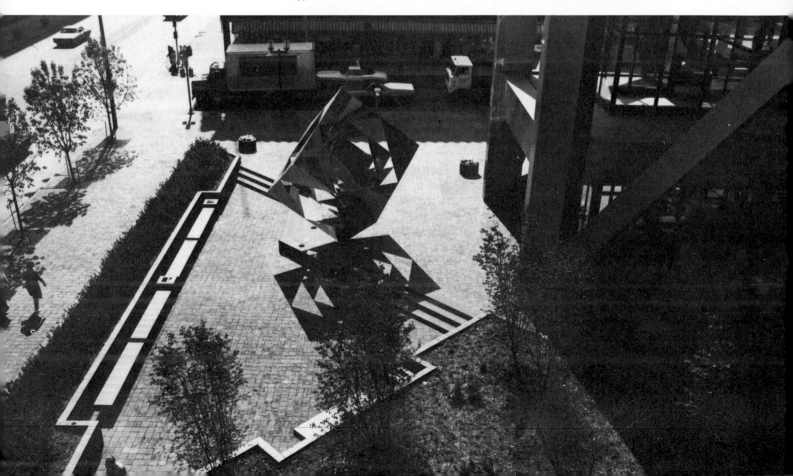

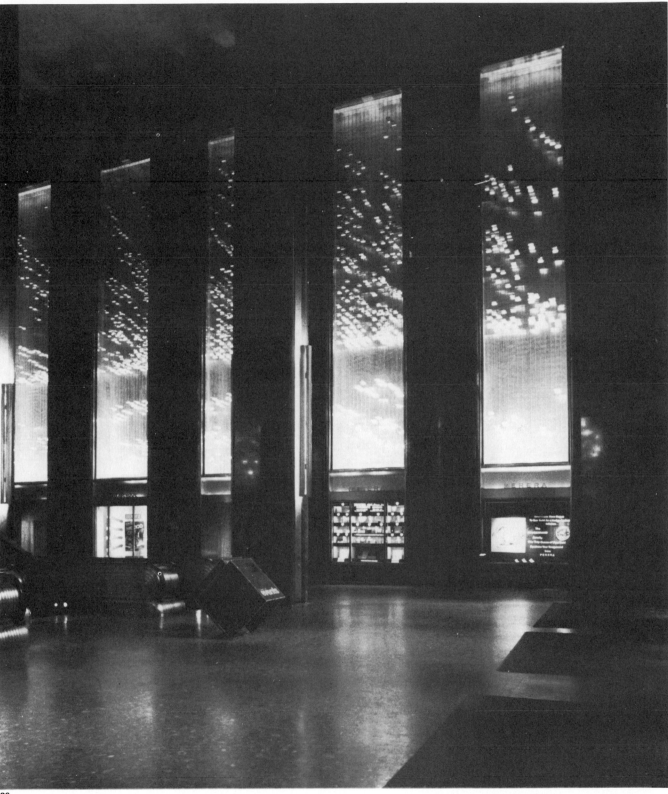

86

INTERNATIONAL BUILDING, LOBBY

Rockefeller Center, New York City, N.Y.

ARTIST: Michio Ihara, 10 panels 35' high, 7' wide,
 depth 2', stainless steel, copper, brass, and gold
 plating, 1978.
ARCHITECTS: Harrison and Abramovitz Associates

PART TWO

Foreign Countries

Photographers' Credits

Chapter 4

1 Courtesy J. Crowther, Australian Information Service
2–3 Jan Dalman, A.I.P.
4 J. M. Miller
5 Courtesy Herbert Bayer
6–7 Courtesy Mathias Goeritz
8–11 J. J. Beljon
12 Courtesy Lydia Okumura
13–14 Courtesy Carlos Gustavo Tenius
15 Courtesy Lydia Okumura
16 Bubi leite Garcia
17–18 Sydney Waissman
19–20 Courtesy Oscar Niemeyer
21–24 Thomas Pederson and Poul Pederson
25 Simo Rista
26 Fox-Waterman Photography Ltd., Copyright © by Pentagram
27 Keith McCarter
28 Courtesy Franta Belsky
29 Photographer: Raimo Miekka: Photo: Courtesy Nokia Rubbel Works Company
30 Seppo Hilpo
31 Simo Salmi
32 Lauri Kanerva
33–34 Seppo Hilpo
35–36 Dietrich Mohr
37 Philippe Delaporte
38 Courtesy Lathrop Douglass
39 Pamir
40 J. P. Coqueau
41 Courtesy French Embassy Press and Information Division
42 Pierre Joly et Vera Cardot
43 Serge Lemoine
44–45 Pierre Joly et Vera Cardot
46 Corinne Piquot
47 Pierre Joly et Vera Cardot
48 D. Planquette
49–50 Courtesy Comby
51–52 Courtesy Marie Zoe Greene-Mercier
53–56 Jean Biaugeaud
57 Courtesy Claude Viseux

58–60 Jacques Verrier
61–62 Louis G. Redstone
63 Courtesy Stichting "Kunst en Bedrijf"
64 Courtesy Mathieu Ficheroux
65 Courtesy Stichting "Kunst en Bedrijf"
66–67 Cor Von Weele
68–71 Hans Petri
72 Rob Meijer, Mike Toner
73–76 Rob Meijer
77 Courtesy Stichting "Kunst en Bedrijf"
78–79 Lucien A. M. den Arend
80 Courtesy Leo Castelli Gallery
81 Courtesy Stichting "Kunts en Bedrijf"
82 John-David Biggs
83 Pieterse Davison International Ltd.
84–85 Courtesy Department of Architecture, Chandigarh, India
86–88 John Donat
89–90 Ran Erde
91 Studio Alfred Bernheim, Ricardo Schwerin
92 R. Milon
93–96 Paul Gross, Ltd.
97 Keren-Or
98–99 Courtesy Nathan Rapoport
100–101 Courtesy Hadassah Medical Association, Inc., which owns all rights in and to the sculpture. Permission to publish by HMRA, Inc.
102 Israel Sun Litd.
103–104 Louis G. Redstone
105–106 R. Reilinger
107–109 I. Tumarkin
110 A. Barler
111–112 Courtesy James Wines
113–114 Stephen Tonelli
113–114 Stephen Tonelli
115–116 Foto d'Arte, G. Fini
117 Courtesy Alberto Biasi
118–119 Osamu Murai
120 Masako Yuhara
121 Yoshihisa Ara
122 Courtesy Kazuo Yuhara

123–124 Michio Ihara
125–126 Makoto Yoshida
127 Copyright © by Masahiko Tanaka
128 Isao Terada
129–130 Ursula Bernath
131–132 Courtesy Manual Felguerez
133 E. Bostelmann
134 Sebastian
135–136 Andrea Di Castro
137 Courtesy Helen Escobedo
138 Photographer: Trevor Ulyatt; Photo: Courtesy National Publicity Studios, Wellington
139 Courtesy Halfdan Wendt
140–141 Courtesy Oslo Kommunes Kunstsamlinger
142 Arturo R. Luz
143 Courtesy Portuguese Embassy
144 Courtesy L. V. Locsin and Associates
145 Arturo R. Luz
146 Antonio Drumond
147 Eduardo Nery
148 Pergstrelos Photographos, Lda.
149 Courtesy Artur Rosa
150 Courtesy Hannatjie Van Der Wat
151 Courtesy George Boys
152 Jean Du Plessis
153 Courtesy Esme Berman, Director, Art Institute of South Africa
154 Courtesy Mrs. Liliana Daneel, President, Human Sciences Research Council
155–156 M. G. Muniz
157 Vaquero Turcios
158 Courtesy Yugoslav Press and Cultural Center
159 Ediciones ABACO
160–162 Vaquero Turcios
163–165 F. Engesser
166–167 R. E. Hopfner
168 Jonsson bilder ab. Bo Ingrar Jonsson
169 Daniel Germann
170 Prof. Dr. Justus Dahinden
171 Courtesy Josef Egger
172 Courtesy Wilfred Moser
173 Reinhard Friedrich
174 Robert Hausser
175 Wolfgang Schackla

176 Gebhardt and Lorenz
177–178 Cor Van Weele
179 Courtesy George Rickey
180 Reinhard Friedrich

Color Section

50–52 Jan Dalman
53–56 Courtesy Royal Danish Embassy
57–58 Thomas Pederson and Poul Pederson
59 Roda Reillnger
60–62 Louis G. Redstone
63–65 Courtesy Cliché Régie Autonome des Transports Parisiens
66 Robert Hausser
67 Peter Oszvald
68 Courtesy Christo
69–70 Courtesy Stichting "Kunst en Bedrijf"
71 Jos. Fielmich
72–73 C. Stauthamer
74 Pieterse Davison International Ltd.
75–76 John Donat
77 Igael Tumarkin
78–79 Louis G. Redstone
80 E. Bostelmann
81–83 Louis G. Redstone
84 Manuel Rodriguez, Jr.
85 Eduardo Nery
86 Louis G. Redstone
87 Courtesy Mrs. Liliana Daneel, President, Human Sciences Research Council
88 Courtesy Division of Art and Architecture, Human Sciences Research Council
89 Courtesy Mrs. Liliana Daneel, President, Human Sciences Research Council
90–97 Courtesy Dr. Thomas Matthews, Rhodes University, Grahamstown, South Africa
98–102 Courtesy AB Storstockholms Lokaltrafik

Public Art Around the World

T he acceptance of public art has reached a new dimension as a result of the wide range of artists' concepts and techniques that can be seen in many countries around the world. Equally significant are the popular general positive response, interest, and support.

It is refreshing to see how the term "public art" has slowly broadened in meaning. The individual piece of artwork, however excellent by itself, may no longer create the impact that public art should generate. Recent developments are seen in the large plazas with sculptured forms, bright colors, and computerized water configurations in fountain design kinetics as well as in lighting and graphics. They are also seen in the artist's effort to combine the shaping of natural and man-made materials to create an enviroment with which people will feel a special empathy.

One of the most encouraging developments in many countries has been the government's role in funding art in government and educational institutions. Leading the way on the federal level are France, Sweden, West Germany, Norway, Holland, Switzerland, and Denmark. In most cases, the government allows 1 percent of the construction costs of all new government buildings for the commissioning of art to be used both inside and outside public areas. (In some cases, the allocation is as high as 2 percent.) In several instances, city governments have their own ordinances of mandating funds for art.

To assemble the material for this chapter, the embassies of all countries represented in Washington were contacted, and the national architectural societies in the various countries were asked to notify their members through their publications. Although the responses have generally been positive and enthusiastic, some countries did not respond. It is also regrettable that because of lack of information, limited space, and timing, the works of many fine artists in the public domain are not represented here.

1

TREASURY BUILDING, COURTYARD
Canberra, Australia

ARTIST: Norma Redpath, untitled, bronze fountain.
ARCHITECT: Fowell, Mansfield, Jarvis, and MacLurcan.

2

ADELAIDE FESTIVAL CENTRE, TERRACE LEVEL
Adelaide, South Australia

ARTIST: Bert Flugelman, untitled, seven linked tetrahedral forms, stainless steel, 1978. (Art is funded by Adelaide Festival Centre Trust, public subscriptions, and private gifts.)
ARCHITECT: Hassell and Partners, Pty. Ltd.

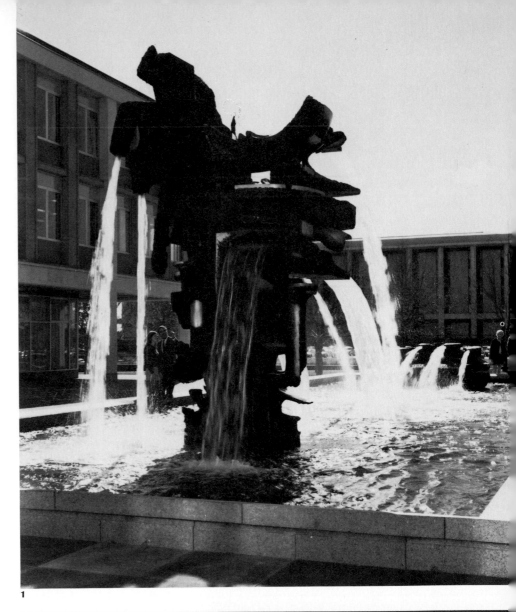

1

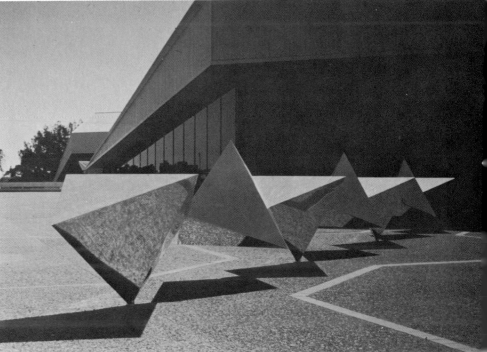

2

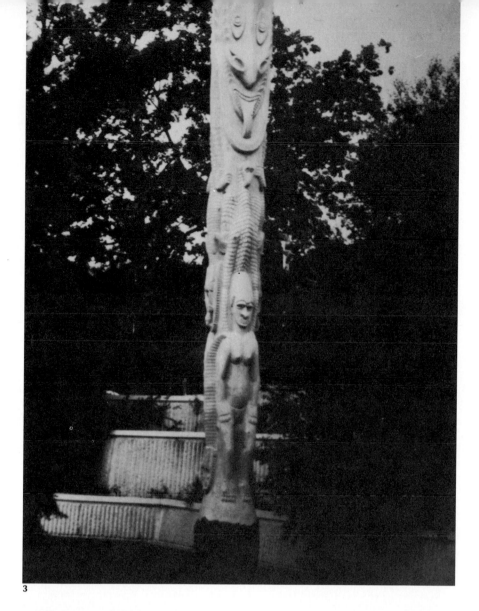

3

ADELAIDE FESTIVAL CENTRE, GROUNDS
Adelaide, South Australia

ARTIST: Students from the Papua/New Guinea School of Art, untitled, house post (totempole), carved on site, 1978.
ARCHITECT: Hassell and Partners, Pty. Ltd.

4

ADELAIDE FESTIVAL CENTRE, GROUNDS
Adelaide, South Australia

ARTIST: Milton Moon, "Glover Memorial Fountain," ceramic domes, 1976.
ARCHITECT: Hassell and Partners, Pty. Ltd.

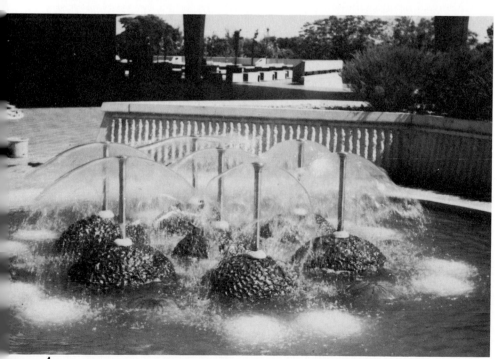

4

5

BRUCKNER CONCERT HALL, ENTRANCE PLAZA
Linz, Austria

ARTIST: Herbert Bayer, "Organ Fountain," seventeen stainless steel columns in a fountain basin 22½' in diameter, 1977. (Commissioned by the city of Linz within the sculpture program of "Forum Metalle 1977.")

6, 7

PARK AT MIDDELHEIM
Antwerp, Belgium

ARTIST: Mathias Goeritz, "The Milky Way," constellation of fifty "stars," each 4' in diameter, painted white steel, 1971.

Comments by Herbert Bayer:

Seventeen stainless steel columns, polished to a dull matte surface, form a counterclockwise spiral standing in a circular water basin of dark grey local granite. They grow according to a mathematical progression from thin-low to thick-high and return from thin-high to thick-low. Water ripples down from the tops of the cylinders along their surfaces. Water inflow for each cylinder is individually controlled. The cylinders are slightly raised from the floor of the basin to allow invisible outflow of water. The basis is surrounded by an octagonal walkway of granite to which a path of the same stone leads.

The fountain is located in a lawn area surrounded by tall chestnut trees at the entrance of the Bruckner Concert Hall. It has been suggested that the balanced relationships and tension of this sculpture are similar to those of a musical composition.

The cylinders are illuminated at night by floodlights set in the water basin, which gives the composition a metallic glow. This particular fountain design was proposed because of its independence as a sculpture during the winter months when the water is shut off.

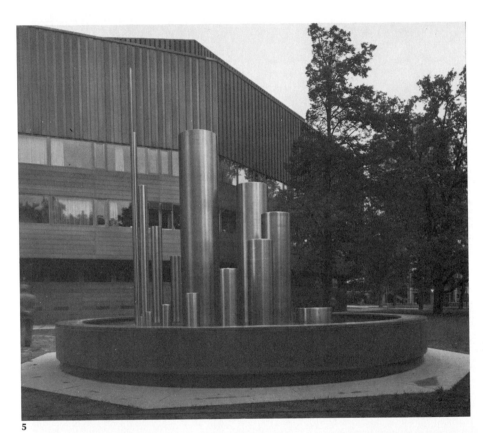

5

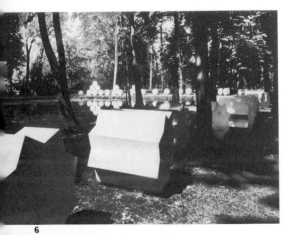

6

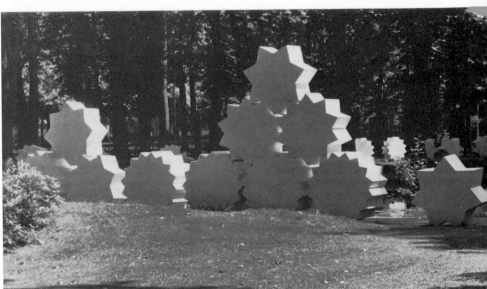

7

Comments by J. J. Beljon:

The most important thing in such an experiment is that the student get an opportunity to work on a big scale, on the scale of the landscape itself, one to one. That is possible with materials like textile or reed.

For the experiment in Kortrijk, I gave them special training for this material for about three months in the studios and the gardens of the Royal Academy in The Hague. In Kortrijk we worked in the open air for two weeks. The task was to bring the constructions into a visual relationship with the buildings, to take advantage of the environment, to obey the laws of materials, and to work in a group. The students had to help each other in the completion (implementation) of their designs. They had to learn to live in a group. I was with them all the time.

The event was made possible by a Belgian organization called "Intérieur," organizers of a biennial for interior furniture. They asked me to do a temporary environment for their exposition in 1978, and I changed my commission into a student project. My main source of help within that organization was the well-known art historian, Jan Pieter Ballegeer. All my material and the cost of living in Belgium were paid for by his organization.

EXPOSITION GROUNDS
Kortrijk, Belgium

ARTISTS: Nine students from the Royal Academy, The Hague, Holland, under the direction of Director-Sculptor J. J. Beljon, "Temporary Environmental Happenings," project for the International Sixth Biennial of Interior Design (furniture and textiles), reed sculptures, 7½' × 36' high.
ADVISOR: Jan Pieter Ballegeer

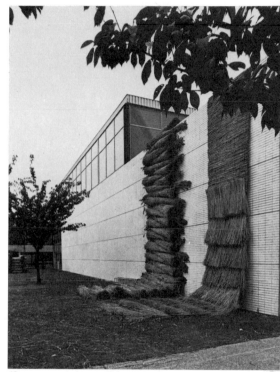

8

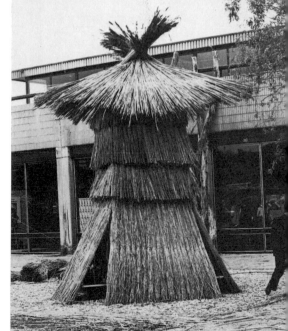

10

9

11

MUSEUM OF CONTEMPORARY ART, ANNUAL EXHIBITION, LAWN

Campinas, São Paulo, Brazil

ARTIST: Lydia Okumura, "Disappearance of Perspective," 108″ × 4″ × 8″ wood pole, 500″ painted 8″ grass band, 1972.

13

CITY PLAZA, GROUP SCULPTURE

Porto Alegre, Brazil

ARTIST: Carlos Gustavo Tenius, "Monument to Acorianos," 42′ high × 72′ long steel, 1974. (Commissioned by the mayor of Porto Alegre.)

In the mid-1970s, Lydia Okumura was working in group projects in connection with the International São Paulo Biennial. Her coworkers were Genilson Soares and Francisco Inarra, who were allotted garden area for their experimental prize-winning works. This led to an invitation to exhibit at the Cranbrook Academy of Art, Bloomfield Hills, Michigan, in 1979.

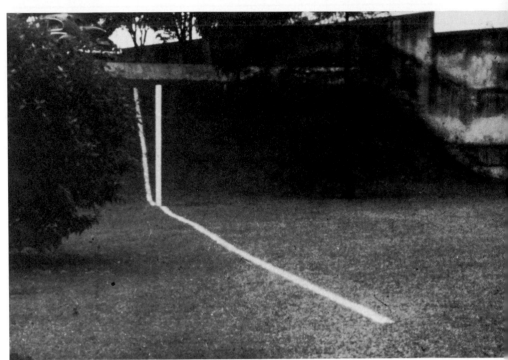

12

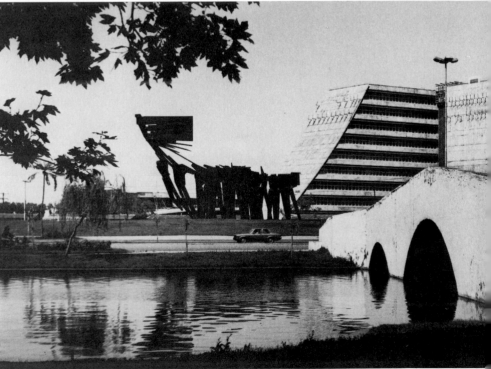

13

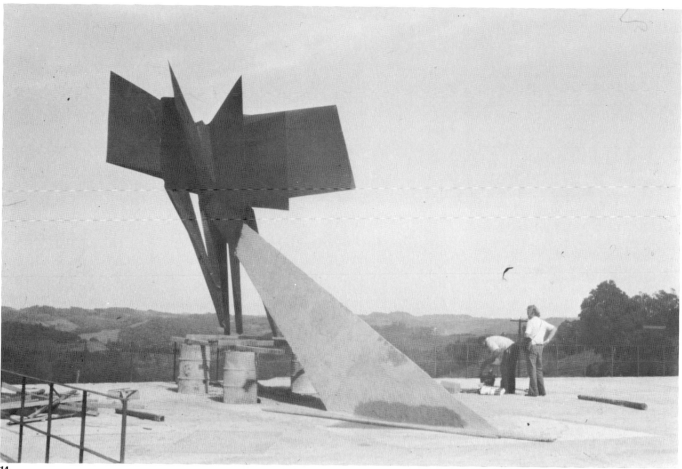

14

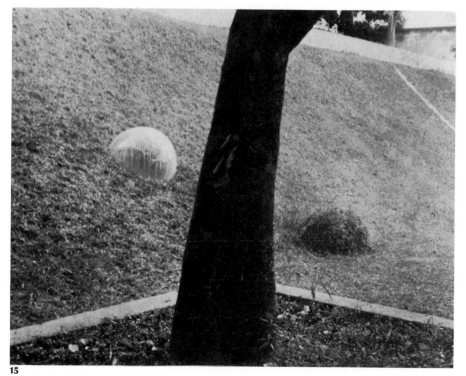

15

14

FEDERAL ROADSIDE
Nova Milano, Brazil

ARTIST: Carlos Gustavo Tenius, "Monument to Italian
Immigration Centennial," weathering steel, 1975.

15

MUSEUM OF CONTEMPORARY ART, ANNUAL EXHIBITION, LAWN
Campinas, São Paulo, Brazil

ARTIST: Lydia Okumura, "Positive and Negative—Breath
of Earth," 32" plexiglass dome, dirt, grass excavation,
and elevation, 1972.

16

SHOPPING CENTER RIO DE JANEIRO, MALL
Niteroi, Brazil

ARTIST: Haroldo Barroso, untitled, stainless steel, 1972.
ARCHITECT: Elias Kauffman

17, 18

MONUMENT TO YOUTH, CULTURE, AND SPORT AND PRESIDENT MEDICI SQUARE BETWEEN THE STATE UNIVERSITY OF RIO DE JANEIRO AND THE MARACANA STADIUM
Rio de Janeiro, Brazil

ARTIST AND DESIGNER OF SQUARE: Haroldo Barroso, 60' high on a 6' × 6' base, prefabricated modules of concrete, 1974.

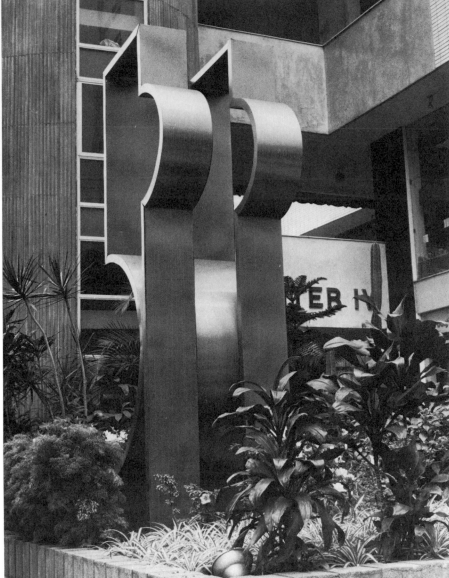

16

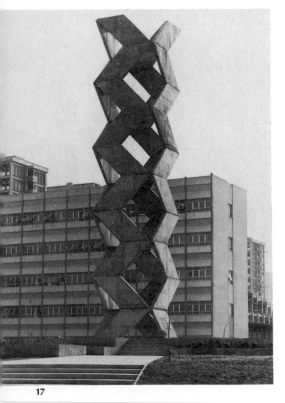

17

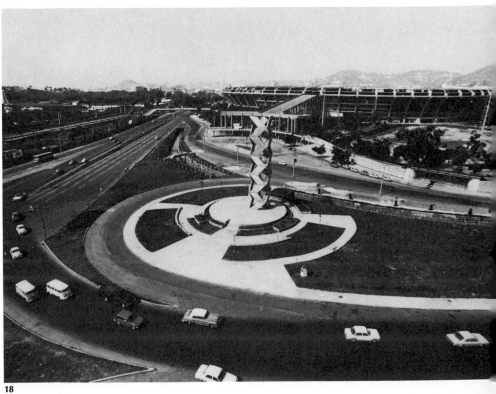

18

19

19

HOTEL NACIONAL
Rio de Janeiro, Brazil

ARCHITECT: Oscar Niemeyer, 1970

20

CATHEDRAL OF BRAZIL
Brasilia, Brazil

ARCHITECT: Oscar Niemeyer, 1970.

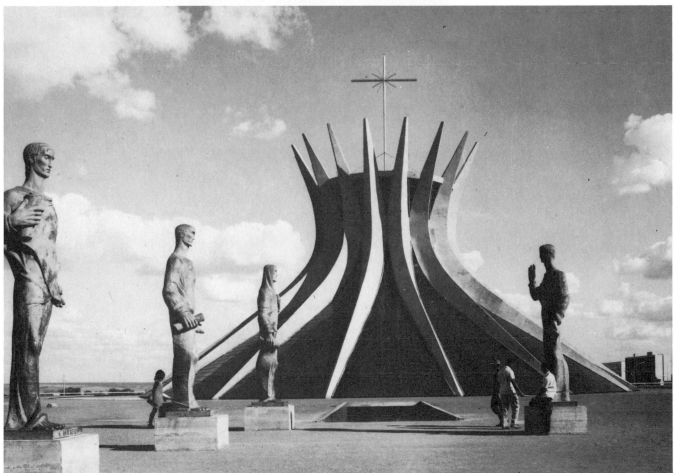

20

UNIVERSITY OF AARHUS, FOYER OF PHYSICS BUILDING
Aarhus, Denmark

ARTIST: Svend Wiig Hansen, untitled, mural, 7' high × 14' long concrete in white and grey colors.
ARCHITECT: C. F. Mollers Tegnestue

22

RADIO AND TELEVISION HEADQUARTERS, LOBBY
Aarhus, Denmark

ARTIST: Jan Groth, "Sign," woven tapestry 9' × 21', 1974.
ARCHITECT: C. F. Mollers Tegnestue

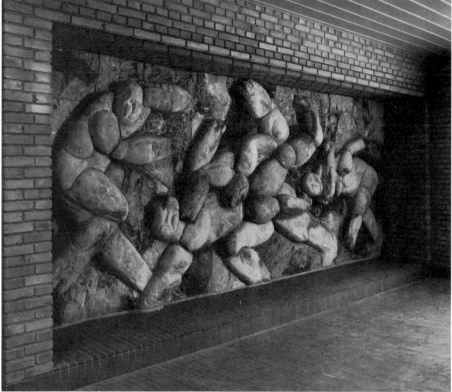

21

22

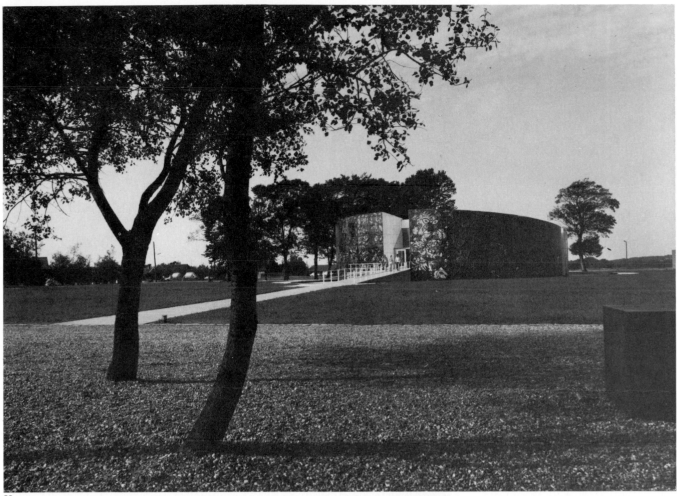

23

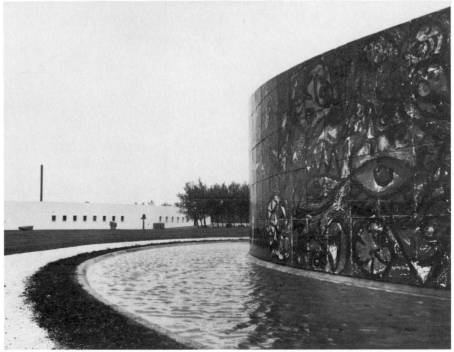

24

23, 24

CARL-HENNING PEDERSEN AND ELSE ALFELTS MUSEUM FACADE
Herning, Denmark

ARTIST: Carl-Henning Pedersen, exterior wall, glazed
 ceramic tile murals, 1976.
ARCHITECT: C. F. Mollers Tegnestue

25

WATERFRONT
Helsinki, Finland

ARTIST: Raimo Utriainen, "Outdoor Sculpture," 40' high
× 16' wide anodized aluminum and acidproof steel,
1974.

26

ROYAL EXCHANGE, FRONT OF BUILDING
London, England

ARTIST: Michael Black, statue, memorial to Paul Julius
Reuter, Cornish granite, 13' high.
LETTERING: William Brown
DESIGN: Pentagram, Theo Crosby

27

HEADQUARTERS, DEPARTMENT OF ENVIRONMENT
London, England

ARTIST: Keith McCarter, screen wall 6' × 150' precast
concrete, 1973.
ARCHITECT: Department of Environment, W.S. Bryant,
Chief Architect

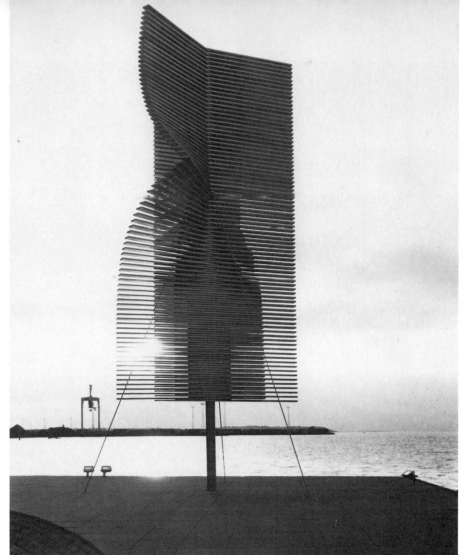

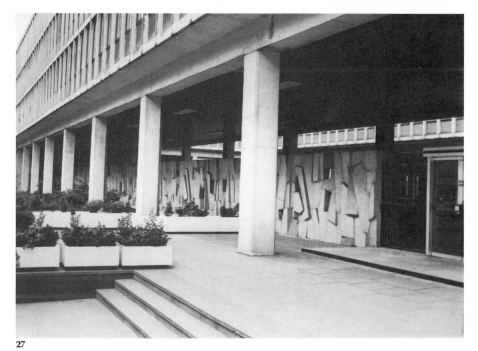

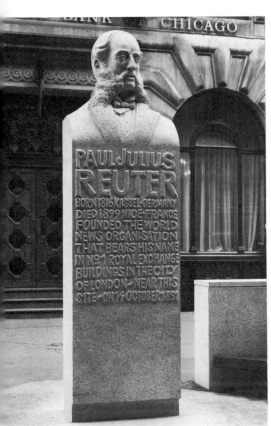

25

26

27

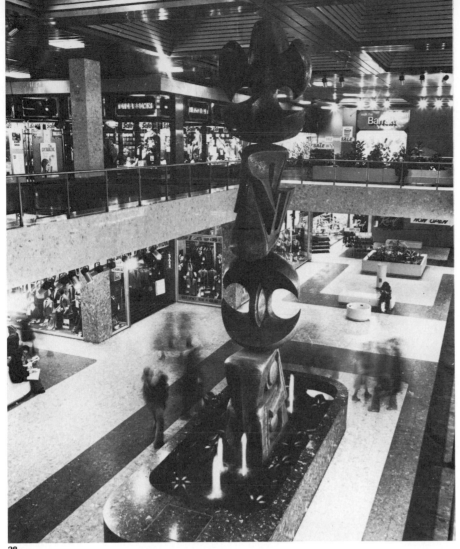

28

ARNDALE SHOPPING CENTER
Manchester, England

ARTIST: Franta Belsky, "Totem," sculpture, 32' high
aluminum filled glass reinforced resin, 1977.
ARCHITECTS: Wilson and Womersley; Ken Shone, project
architect

29

POUTUNPUISTO PARK
Nokia, Finland

ARTIST: Veikko Eskolin, "Water Sphere," computerized
fountain sculpture, 105' diameter, all metal parts of
stainless steel, 1974.

29

30

CITY HALL
Helsinki, Finland

ARTIST: Kimmo Kaivanto, "Chain (A Positive Visionary Diagonal)," 25' high × 6' wide glass fiber, with mirrors on ceiling and at the base, 10'6" × 10'6". (Commissioned by city of Helsinki.)

31

CHILDREN'S PLAYGROUND
Myllypuro, Helsinki, Finland

ARTIST: Tapio Junno, "Love on the Alert," three figures, 10' high bronze, 1976. (Commissioned by the city of Helsinki.)

32

ROVANIEMI
Finland (Lapland)

ARTIST: Kari Huhtamo, "Monument for the Rebuilding of Lapland," 45' high stainless, acid-resisting steel, 1976. (Commissioned by the city of Rovaniemi.)
ARCHITECT: Paavo Kaipainen

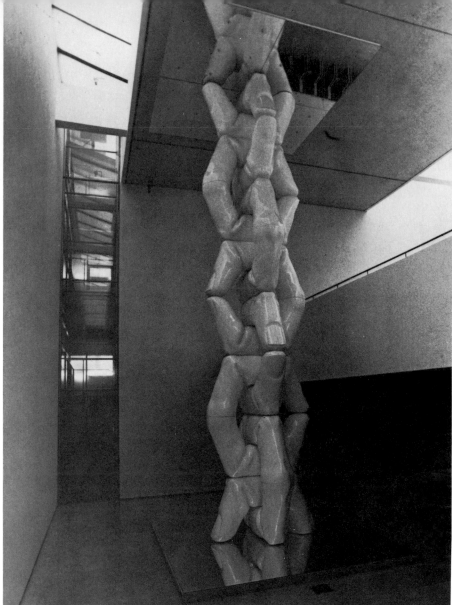

30

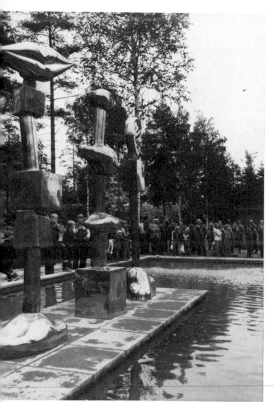

31

32

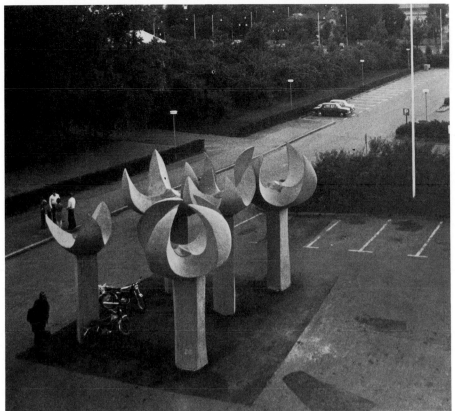

33

33

MUNICIPAL HOSPITAL, PLAZA
Lahiti, Finland

ARTIST: Liisa Ruusuvaara, "Flower Greeting," sculpture,
reinforced concrete, 9'15" high, 1973. (Commissioned by
the city of Helsinki.)
ARCHITECT: Helge Railo

34

HESPERIA HOTEL, POOL PLAZA
Helsinki, Finland

ARTIST: Fimmo Kaivanto, "Ode to the 60,000 Lakes,"
sculpture, 30' high × 21' wide steel, 1972.

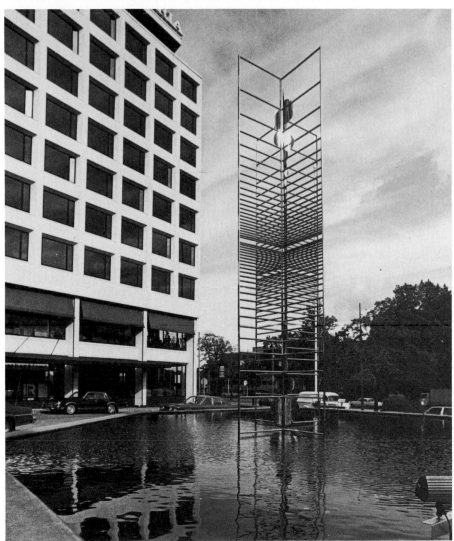

34

35

COLLÈGE D'ENSEIGNEMENT SECONDAIRE (SECONDARY SCHOOL)
Houdain, Pas-de-Calais, France

ARTIST: Dietrich Mohr, untitled, sculpture, 11' high × 12' wide weathering steel, 1975.
ARCHITECTS: Battut and Warnesson

36

PORT-GRILLE, COLLÈGE D'ENSEIGNEMENT SECONDAIRE
Bordeaux-Bègles, France

ARTIST: Dietrich Mohr, gate, 6' high × 20' long stainless steel, 1972.
ARCHITECT: Alain Danger

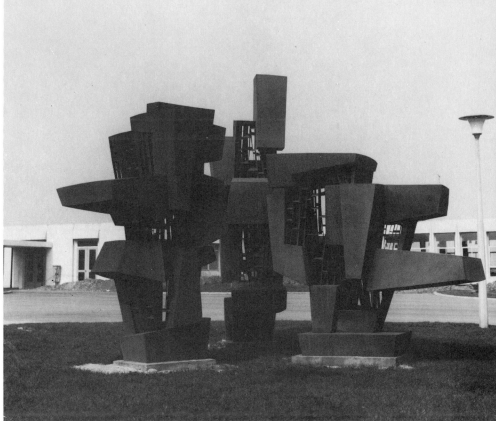

35

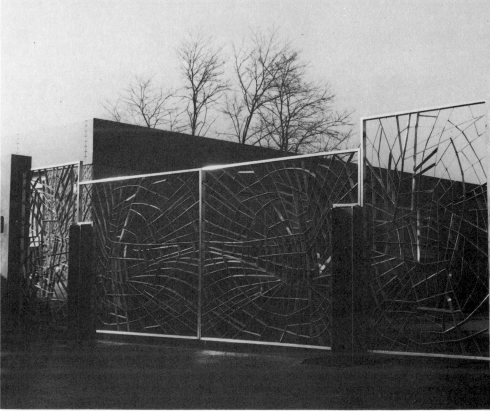

36

Selected under the percent for art law for the new cities, this project was a unifying element in the approval by both the Communist Party and the Social Democrats.

CITY HALL, LOBBY ENTRANCE
Montreuil, France

ARTIST: Shelia Hicks, "Conditioned by Life and Death," fabric curtain composed of 3000 worn cotton nurses' blouses, 24' × 36'. The line of fabric can be lowered, removed for laundering, and returned to place easily.

38

BELLE ÉPINE SHOPPING CENTER, COURT
Near Paris, France

ART: Untitled, wire sculpture.
CONSULTING ARCHITECT: Lathrop Douglass

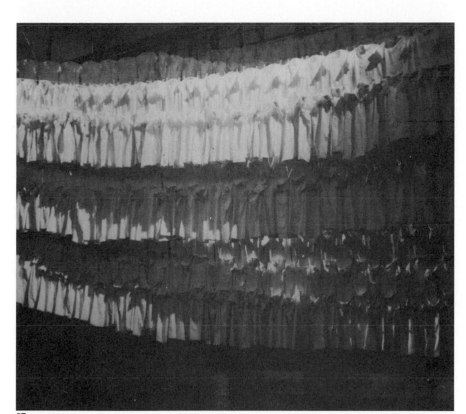

37

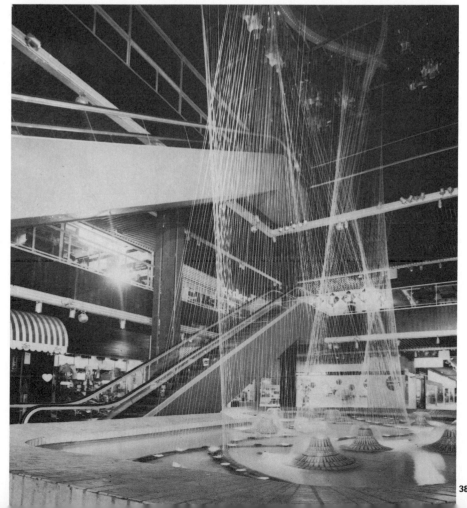

38

39

HIGH SCHOOL MARCELLE-PARDE, COURT

Dijon, France

ARTIST: Berto Lardera, "Déesse Antique," 12' high × 8' wide stainless steel and weathering steel, 1977.

40

UNIVERSITY CAMPUS, BETWEEN THE LAW SCHOOL AND THE LIBRARY

Dijon, France

ARTIST: Gottfried Honegger, "Homage to Jacques Monod," 12' high × 12' long black painted steel, 1974.

41

GRIGNY-LA-GRANDE BORNE HOUSING PROJECT, PLACE AUX HERBES

Essonne Department, Paris, France

ARTIST: Fabio Rieti, "Tobacco Pots," mosaic masking ventilation outlets from underground parking lot.
ARCHITECT: Emile Aillaud

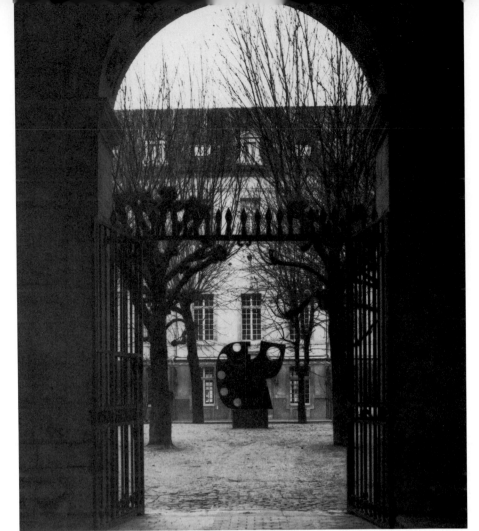

39

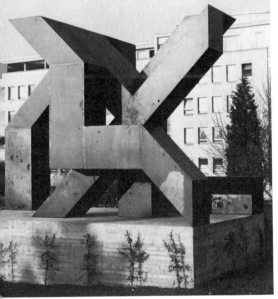

40

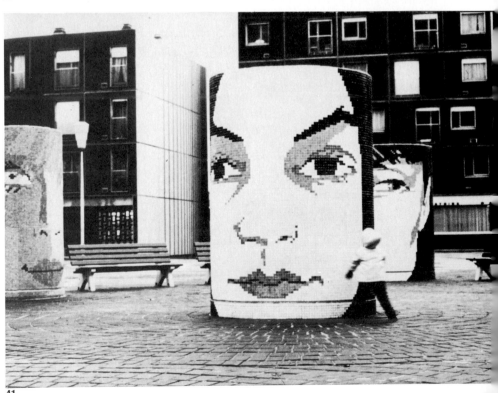

41

Comments by the artist:

In my view, sculpture is not a complement to architecture, since an object without utilitarian function is not necessary in a construction. I would say that it is an indispensable part of the vital function that art plays in every aspect of human life. The architecture of the past gives evidence of this organic and vital contribution which gives to cities their spirit and spell. Why are ancient cities, which contain so many sculptures in buildings and streets, still places of pilgrimage that give us spiritual nourishment? These sculptures are like music and poetry: they do not perform any complementary function, but they mingle with our lives and make us forget, precisely, death and the merely utilitarian. If sculpture is linked to and in harmony with architecture, it makes use of it, just as music seems to be in tune if the acoustics are good; it finds a proper context to deploy all its suggestiveness and mystery. Architecture must be in tune as a good musical instrument is.

In Roche fountain, a series of forms cross the pool from one side to the other with a rhythm that must enchant the onlooker.

42

ROCHE, S. A. HEADQUARTERS
Neuilly, France

ARTIST: Alicia Penalba, untitled, fountain, 5' high × 37' long × 8' wide dark green patina bronze, 1971.
ARCHITECT: Dr. Rohn

43

COLLÈGE PAUL-PORT
Is-sur-Tille, France

ARTIST: Marcelle Cahn, "Spatial C," 7½' × 7½' painted polyester, 1976.

43

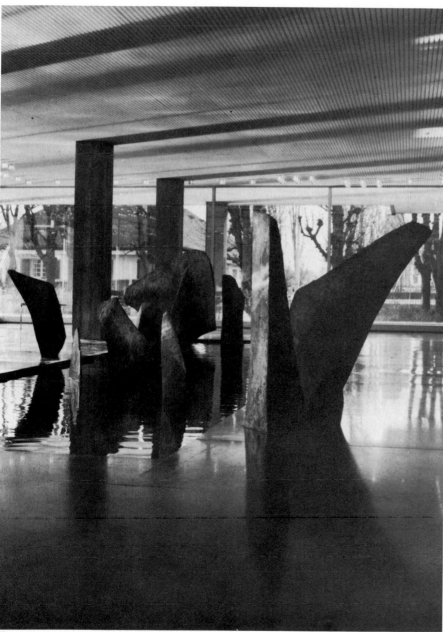

42

PLAZA
Vitry-sur-Seine, France

ARTIST: Pierre Szekely, "La Boule," cosmic clock
sculpture with electric motor, 18' high on a 36' × 36'
base, 1972.

45

MONUMENT AT LA DÉFENSE, MÉTRO STATION

Paris, France

ARTIST: Pierre Szekely, "L'Homme Libre," sculpture
dedicated to Amnesty International, 15' high polychrome
granite, blue, pink, and grey.

46

SCHOOL, RESIDENTIAL GREEN AREA

St. Geneviève des Bois (near Paris), France

ARTIST: Pierre Szekely, "Observatoire à Einstein,"
sculpture, grey granite, 1974.

Comments by Pierre Szekely:

This project was funded through an ordinance of the municipality of Vitry-sur-Seine by which every new building is to have artwork. To date the city has commissioned about fifty works.

The plaza sculpture is located in the plaza (Place de l'Horloge) between new buildings in the town.

An electronic motor is included in the center of the clock, so the sphere (boule) turns slowly, once in twenty-four hours. The motor is regulated automatically. The lights in the base are programmed to go on during the night hours. The central motor can be reached through a small special door included in the sculpture. This revolving chromatic form always presents itself differently for the people who are viewing it. The little white sphere, or globe, indicates the time in connection with the surrounding numbered cones.

Pierre Szekely comments: "This project, funded by the percentage for art, was built by the sculptor together with his students from Japan, Holland, Australia, Italy, and France. This work received first prize in the Second International Street-Art Biennial in 1978."

44

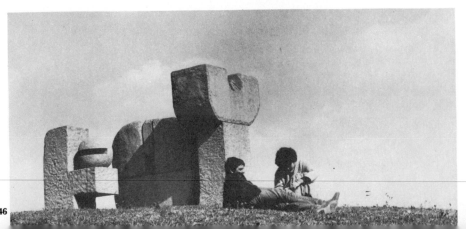

45

46

Comments by Pierre Székely:

The social dimension seems to be the most important one to be reached in the present relationship between art and the city.

The example of Granville is in France. The sculptural environment called "Variation sur les Armes" is located not far from the cliffs of Normandy. Made of granite sculpted by fire and of cyclopean concrete, this work is the result of the active collaboration of all the citizens of the town. My work group, founded in 1977, was open to all 32,000 inhabitants of the town. To produce a homogeneous result, I had to evolve new techniques of collective work. This is why we practiced "improved democracy" and "harmonious anarchy." The official inauguration on October 13, 1978, turned into a popular festivity, and it was a happy occasion to see the inhabitants wanting to take an active part in the creation of their cultural environment.

The sculpture was designed for training techniques in mountain climbing. Awarded "Grand Prix de la Première Biennale Internationale des Arts de la Rue" by the Ministry of Culture and Communication in 1978.

47

CAMPUS SCULPTURE
Granville, Normandie, France

ARTIST: Pierre Székely, "Variation sur les Armes," sculpture, 21' high, base length 300', concrete and gray granite, 1978.

48

CITY OF EVRY
France (near Paris)

ARTIST: Pierre Székely, "La Dame du Lac," sculpture 51' high, concrete, 1975.
STRUCTURAL ENGINEER: Bernard Metzle

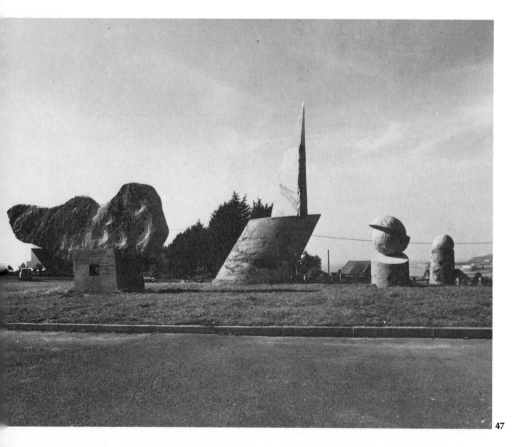

47

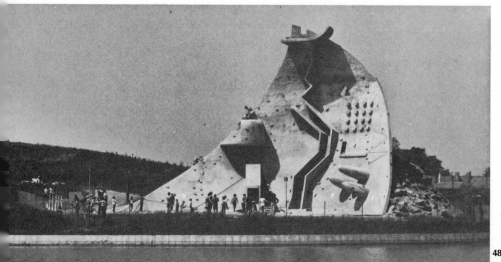

48

49

LYCÉE TECHNIQUE D'ÉTAT LOUIS VINCENT, CAMPUS

Metz, France

ARTIST: Comby, "Clearsange," 12' high wood and
aluminum, 1974. (Funded by 1 percent government
allowance of state building costs.)
ARCHITECT: J. L. Rauzier

50

AUDITORIUM DE LA PARK DIEU

Lyon, France

ARTIST: Comby, "The Croncelhorbe," 12' high × 9' wide
aluminum, 1978. (Paid for by the city of Lyon and
chosen by a committee of artists and art critics.)

51

ST. NICOLAS-LES-ARRAS, COURT

France

ARTIST: Marie Zoe Greene-Mercier, "Composition with
Twenty Cubes," sculpture, 10' × 25' in two units of
painted steel, 1977.
ARCHITECTS: Battut and Warnesson

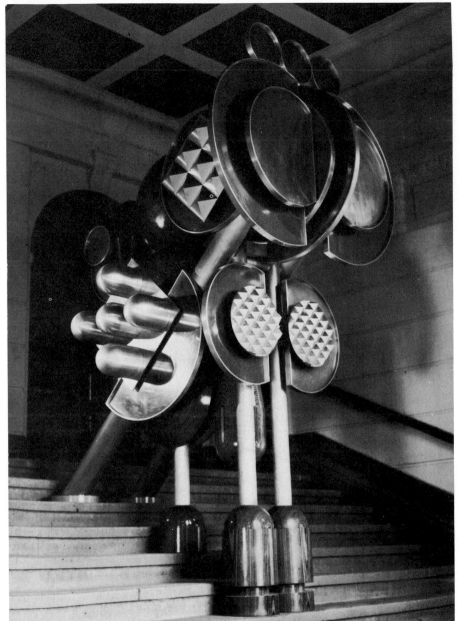

49

50

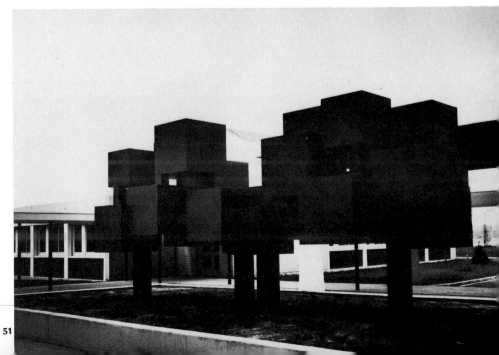

51

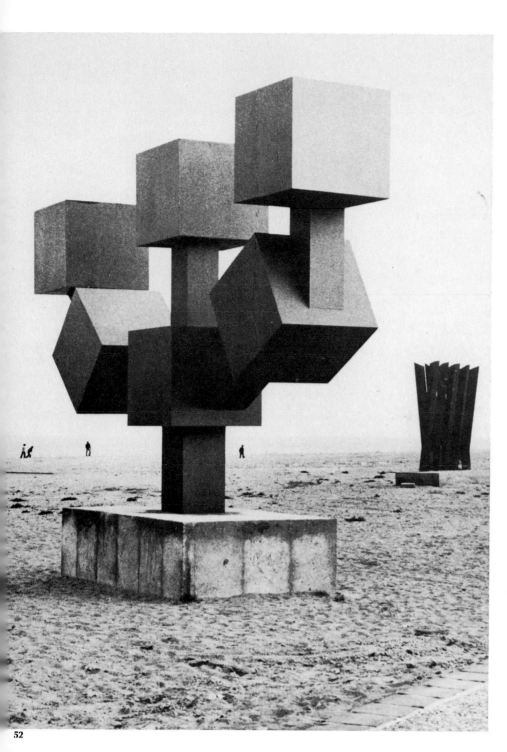

LEUCATE, BARCARÈS
Mediterranean Shore, France

ARTIST: Marie-Zoe Greene-Mercier "Arboreal Form," sculpture, 15' high steel, 1971. (Sculpture on right is by Gina Pane.)

52

53

SUBWAY STATION HAVRE-CAUMARTIN, SALLE HAUSSMANN

Paris, France

ARTIST: Claude Viseux, "Structure Suspendue," sculpture, 6' × 15' × 30' stainless steel, 1972.
ARCHITECT: Andre Wogensky

54

ÉCOLE NATIONALE D'ADMINISTRATION, CENTRAL PATIO

Paris, France

ARTIST: Claude Viseux, sculpture, 30' high polished stainless steel, 1978.

55

LES OLYMPIADES BUILDING COMPLEX, PLAZA

Paris, France

ARTIST: Claude Viseux, "Clepsydre," mobile fountain, 21' high × 3" wide stainless steel sculpture, 1973.
ARCHITECT: Michel Holley

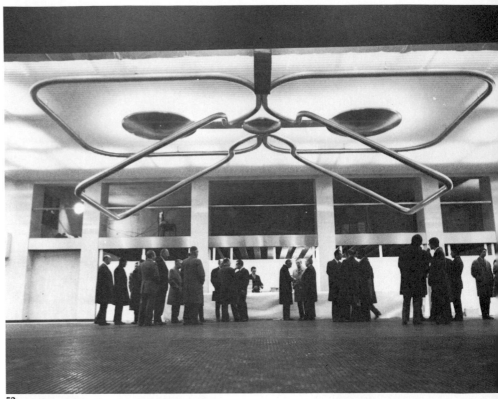

53

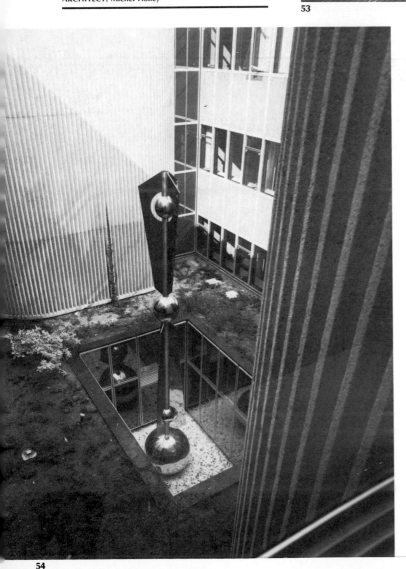

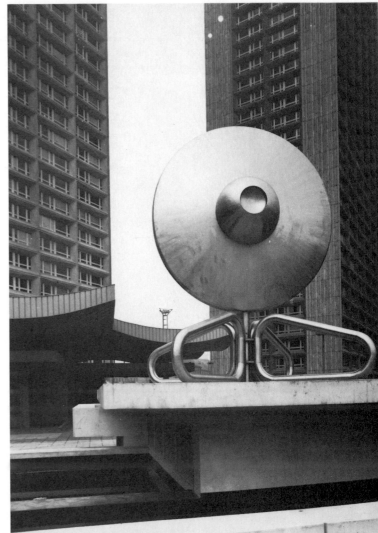

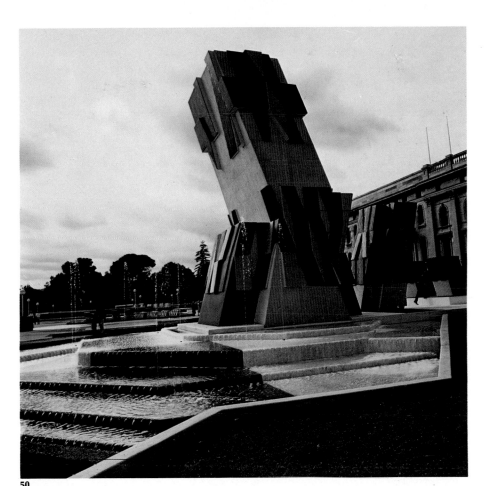

50

ADELAIDE FESTIVAL CENTRE, SOUTHERN PLAZA
Adelaide, South Australia

ARTIST: O. H. Hajek, plaza 360′ × 260′ color concrete, water, and light. Sculpture sign 36′ high concrete, 1977.
ARCHITECT: Hassell and Partners, Pty. Ltd.

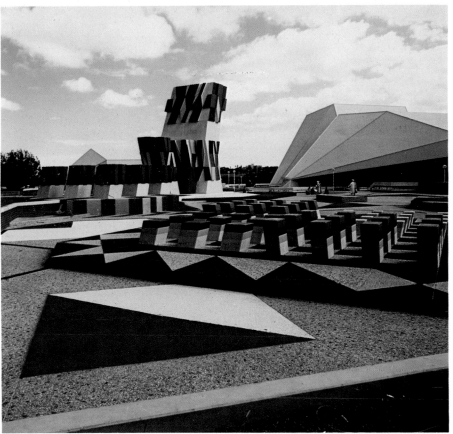

51

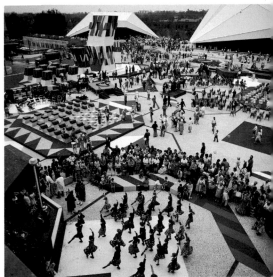

52

Plate 53

COPENHAGEN COUNTY HOSPITAL

Herlev, Denmark

ARTIST: Else Fischer-Hansen, "Complimentary Sun," stained glass 17' × 11'. (The State Art Foundation's Committee on Decoration finances 100 percent of the cost of artworks for state institutions and 75 percent of the cost of artworks for municipal or other nonprofit institutions.)

Plate 54

CITY LIBRARY

Lyngby, Denmark

ARTIST: Willy Orskov, untitled, 4 sculptures, maximum height 7', painted stainless steel. (The State Art Foundation's Committee on Decoration finances 100 percent of the cost of artworks for state institutions and 75 percent of the cost of artworks destined for municipal or other nonprofit institutions.)

Plate 55

COPENHAGEN COUNTY HOSPITAL

Herlev, Denmark

ARTIST: Paul Gernes, untitled, alkydgloss painted enamel, 450 yd². (The State Art Foundation's Committee on Decoration finances 100 percent of the cost of artworks for state institutions and 75 percent of the cost for artworks destined for municipal or other nonprofit institutions.)

Plate 56

RANUM TEACHERS TRAINING COLLEGE

Denmark

ARTIST: Frede Christoffersen, "Sol-efter-Billeder," 5' high × 32' wide. (The State Art Foundation's Committee on Decoration finances 100 percent of the cost of artworks for state institutions and 75 percent of the cost of artworks destined for municipal or other nonprofit institutions.)

53

54

Comments by Else Fischer-Hansen:

In painting the stained glass, the same technique has been used as in antique stained glass paintings. The glass is approximately 3 millimeters thick. It has been dyed to match the model at a glass factory. Some glass is double so as to leave on one side a blue film and on the other side a layer of green, white, etc., in order to obtain many different shades. After the glass has been dyed, it is cut and mounted in lead by Studio Jacques Simon in Reims; after that I paint it with "Grisaille" (grey in grey), a powder, which creates light and shade with strokes of the brush. In addition some places on the glass are treated with acid to remove the blue color in order that the green underneath may appear. In olden times pumice was used instead of acid.

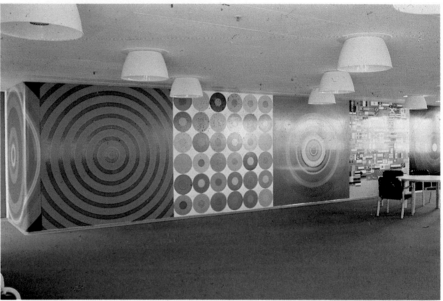

55

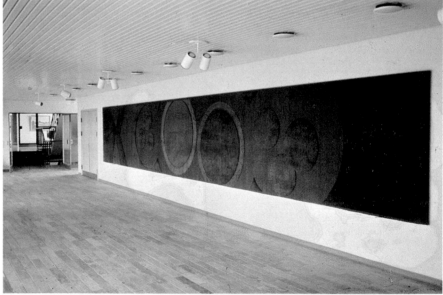

56

57

SKJOLDHOJ KOLLEGIET, COLLEGE CAMPUS, SHOPPING, HOUSING, AND COMMUNITY FACILITIES

Brabrand, Denmark

ARTIST: Kasper Heiberg, environmental atmosphere.
ARCHITECT: Friis and Moltke

Plate 59

PUBLIC SQUARE

Aalborg, Denmark

ARTIST: Roda Reilinger, "Noah's Ark," (sculpture in honor of the rescue of Danish Jews by the Danes during Nazi occupation, 19' high concrete, 1976.)

58

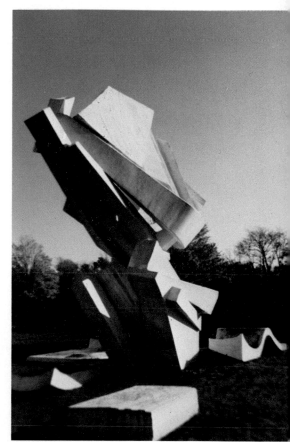

59

LA DÉFENSE
Paris, France

ARTIST: Yaacov Agam, untitled, fountain with color
mosaic basin; sixty-six water nozzles gush water upward
48', and it then cascades down over an accordian-
pleated waterfall 240' long and 20' high, 1978.
(Government sponsored.)

The fountain is set on a concrete esplanade with a background of steel and glass tower buildings and combines computer technology with sophisticated pump systems, music, and art. The water dances with an infinite variety of movements to music broadcast onto the esplanade from hidden quadriphonic speakers. Each of the sixty-six jets can gurgle in low, bubbling action or shoot upward to form columns of varying heights or hesitate mid-flight just long enough to create a precalculated pyrotechnical explosion. Because each nozzle is autonomous, balletlike effects with extraordinary sensitivity of crescendo, rhythm, and mood can be orchestrated.

The artist intended that the spectator "participate" in the fountain's movements and aid in its constantly changing artistic effects. Movement and transformation are employed to dematerialize the pictorial image, to dissolve form and matter so that the spectator becomes a source of potential dynamism. The accordion pleats of the cascade change from a colorful composition to a study in black and white as one walks or drives from one exit to the other. More directly participatory is the "jukebox," which the public is invited to play. The potential "composer" descends beneath the fountain to a hidden, lower water basin housing the pumps and the adjacent control room. There, one is faced with a typewriter-size control panel and a closed circuit television set showing the activity of the fountain overhead. For a fee one can select from amongst ten music/water programs prerecorded on magnetic tapes (Gershwin's "Rhapsody in Blue," a Ravel waltz, and Karl Orff's "Carmina Burana" are among the choices). One can also manipulate the sixty-six water jets, recording for replay, if one wishes.*

*Excerpted from a release by Barbara Silvergold.

60

61

62

The close relationship between art and the Paris subway goes back to 1900. Today there are eighty-seven subway entrances designed by Architect Hector Guimard that are registered as historical monuments of France. In the interceding decades, the wars negated art interest in subways until 1968 when the Louvre station was built in the form of an antechamber of the museum. In 1976 the station of the Saint Denis Basilica, burial place of the kings of France, was designed, and the Varenne station acquired the copies of sculptures evoking the Rodin Museum nearby. The entrance to the station at Gobelins shows reproductions of ancient and modern tapestries woven in the Gobelin factory. The Paris subway system in the large regional stations has promoted the integration of the arts . . . with the cooperation of the architects and engineers . . . as evidenced by the choice of significant artists to execute significant commissions (Tremois, Signori, Locret, Mathieu-Bachelat, and Delumeau among others), as well as by the choice of materials (stainless steel, marble, ceramics, etc.).

Consultant architects involved in the planning by the architectural staff of the Regie Autonome Des Transports Parisiens (RATP) were Blanchet (Chatelet-Les Halles and Saint-Germain-en-Laie), Vicariot with Gautier-Delage and Van Hout (La Defense); Wogensky (Auber); Dufaut (Etoile); Arsac (Nanterre-Prefecture); Bourbonnais (Nation). Thus the RATP hopes to create conditions for a better climate for public contemporary art.*

*"L'Esthétique des Stations," press release of Régie Autonome des Transports Parisiens, December 1977.

Plate 63

MÉTRO STATION, CHATELET-LES-HALLES
Paris, France

ARTIST: Pierre-Yves Tremois, "Énergies," bas-relief 9' high × 24' long bronze, 1977.
ARCHITECTS: Marius Jean Belin and Pierre Crevoisier; Consultant, André Blanchet

Plate 64

MÉTRO STATION, LA DEFENSE
Paris, France

ARTIST: Adam Tessier, "Le Cosmos," mural.
ARCHITECTS: Vicariot with Gautier-Delage and Van Haut

Plate 65

MÉTRO STATION, CHATELET-LES-HALLES
Paris, France

ARTIST: Herve Mathieu, untitled, fresco mural, 9' high × 10' long.
CERAMIST: Teresa Timmerman
ARCHITECTS: Marius Jean Belin and Pierre Crevoisier; Consultant, André Blanchet

63

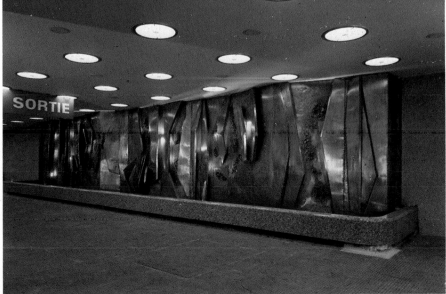

64

65

Plate 66

REGIONAL HEADQUARTERS, CITY PLAZA WITH SYMBOL
Schwelm, West Germany

ARTIST: O. H. Hajek, plaza, 120' × 110'; sculpture, 12'
high steel, 1978.
ARCHITECT: Klaus Kafka

Plate 67

MINISTRY OF HEALTH, PLAZA
Bonn, West Germany

ARTIST: O.H. Hajek, "Environmental City Symbol," plaza
150' × 150', stone, colored concrete, and water;
sculpture, 20' high steel, 1977.
ARCHITECT: City Planning Department of Bonn

Artist's comments:

Creative artists are taking their art into factories so that they can meet people who regard art as a luxury. In doing this the artist doesn't simply want to bring an art object into the work place, but rather to raise up the creative strengths in each person and thereby make it clear that work is also a creative process.

The work environment can and should be seen as an aesthetic milieu from which work can arise. Work tools, cupboards, tables, machines, machine arrangements, and the structure of the work itself become the means by which a person at work can look around and see a world which holds more value than before. These factors constitute the world when one is at work.

Artists are going into prisons in order to work with men and women who live isolated from society, and the force of creative action is applied to the inmates' problems. This kind of program helps prisoners to recognize their social heritage and become conscious of their visual surroundings.

Artists are going into hospitals and working with people who are in pain. One should not forget pain when one talks of creativity. Creativity helps to conquer pain and to redirect people's strength.

Artists are going into schools. Schools are well-equipped for enhancing verbal communication, and they operate under the assumption that the future earnings of their students will be proportional to the amount of education they have had. Schools do not operate under the principle that more education can redirect people's behaviour. Artists go into schools in order to give visual communication and verbal communication the same value.

Artists go to the streets in order to bring art to the public thoroughfare. Here it is not a question of the decoration of buildings. Art must ask questions about the impoverishment of our artificial world. How we modify the landscape for human use is a key to the shape of our city and it involves question of form. Art asks about the value of a building as a place. Here the artist takes up a position from which most architects have withdrawn. Artists justifiably try to overcome the impoverishment of our streets and squares. It is known that the nature of the surroundings have a profound psychological effect—they shape us.

Through sensitive perception, a person's surroundings become more important. How in fact do environment and form communicate themselves?

In this work there must be no architecture or art separate from one another. They must, on the contrary, complement one another. Art must not be an attribute but an integral part of architecture and must be integrated in social space.

Architectural art takes the measure of man. In the Federal Republic of Germany there is a regulation which states that up to 2 percent of the building cost of public high-rise buildings must go toward architectural art. We are trying with this stipulated percentage to bring artistic activity to the streets so that they become a livable landscape and a place of relaxation.

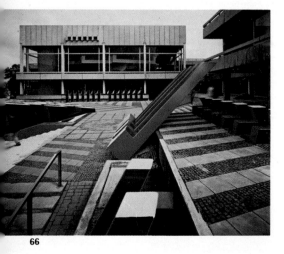

66

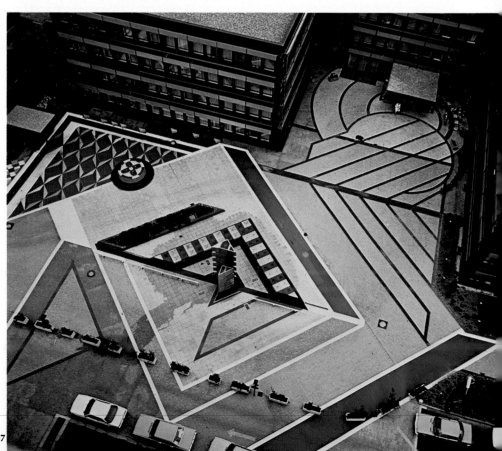

67

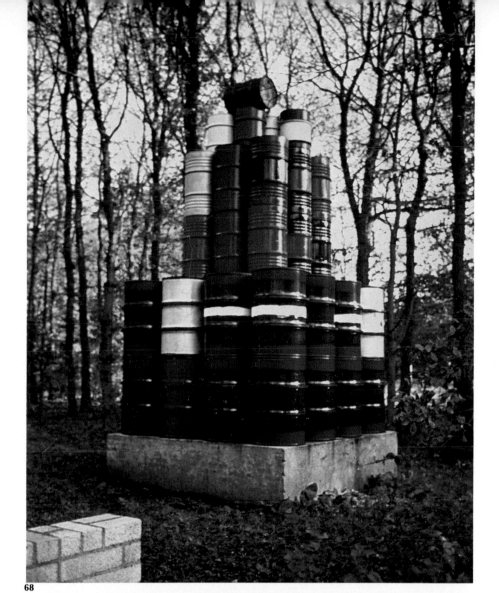

68

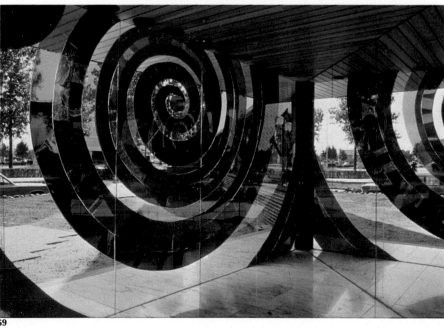

69

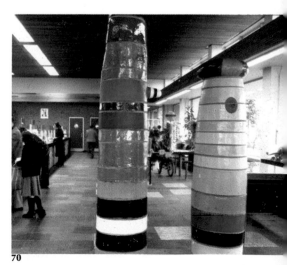

70

Plate 68

KROLLER-MULLER MUSEUM, GARDEN
Otterlo, Holland

ARTIST: Christo, ''56 Barrels,'' painted steel barrels, 1977.

Plate 69

COORDINATION BUILDING
Naarden, Holland

ARTIST: Joost van Santen, 9' × 42' glass applique, 1971.
ARCHITECT: Tauber

Plate 70

POST OFFICE
Oss, Holland

ARTIST: Jan Snoeck, pillars, ceramic tiles, 1972.

Plate 71

DRAWBRIDGE CONNECTING HEEMSTEDE WITH SCHALKWIJK

Haarlem, Holland

ARTIST: Louis C. Roling, painted steel span, 1972.
ARCHITECT: Louis C. Roling, W. Bernson

Plate 72

ZEIST INSURANCE COMPANY, ENTRANCE

Amsterdam, Holland

ARTIST: Josje Smit, supporting concrete wall, 9' × 6'
relief-ceramic and pebbles.
ARCHITECT: J. B. Grunsven DeBilt

Plate 73

HEAD OFFICE, NEDERLANDSCHE MIDDENSTANDS-BANK, RECEPTION-HALL

Amsterdam, Holland

ARTIST: Josje Smit, untitled, wall design, 21' × 9' ceramic,
glass, pebbles, and brick.
ARCHITECT: de Vlaming, Salm, Fennis

The magnificent landscape of river and polder can tolerate only a very sober "technical" bridge.

Artistic trappings would be out of place and would aggravate rather than improve the situation. The only refinement applied is a painting on the underside of the span which is visible from the road when the bridge is open and from boats passing under the closed bridge.

The steel beams on the underside of the bridge produce an interplay of shadows. By using different tones of grey, which combine with the moving shadows of the beams as the bridge opens, a gradually changing image is achieved with some lines remaining and others fading out. The "rising sun" emerges first in the shape of a cross, then an ellipse, and finally a big red ball (by coincidence the symbol of the Haarlem artists' group). In the evening as the sun sets and the bridge opens there are two red suns in the west. The opening of the bridge is thus transformed from an annoying factor of delay into a pleasant occurrence.

"What a pity the bridge isn't open, we have to drive through and miss the rising sun." Is not this reversal of values the "highest that art can achieve"?

71

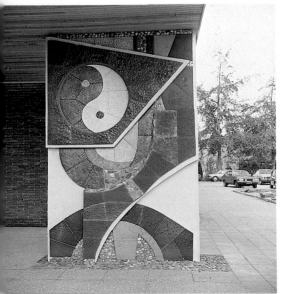

72

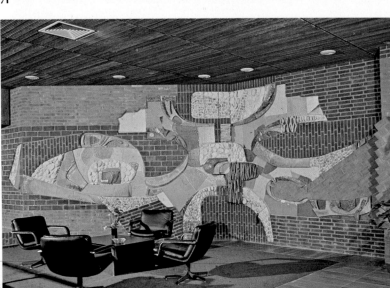

73

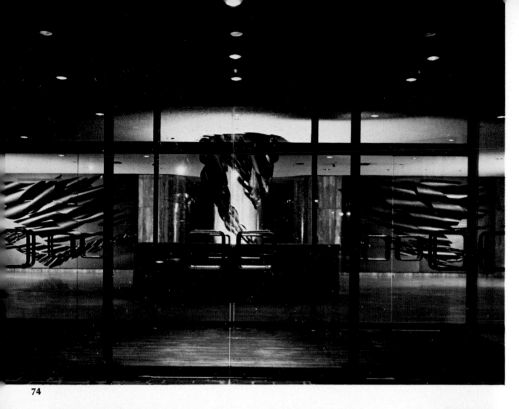

74

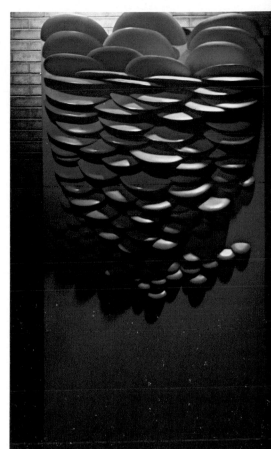

76

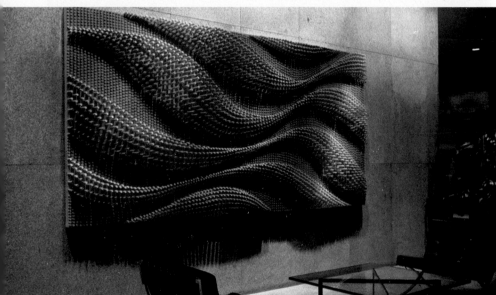

75

Plate 74

IRISH LIFE HEADQUARTERS, LOBBY
Dublin, Ireland

ARTIST: Alexandra Wejchert, untitled, wall and column
 sculpture, 12′ × 15′ anodized aluminum, 1977.
ARCHITECT: Robinson, Keef, and Devan

Plate 75

BANK OF IRELAND, GROUND FLOOR
Dublin, Ireland

ARTIST: Alexandra Wejchert, "The Flowing Relief," timber
 dowels on board with sprayed acrylic finish, 6′ × 13′,
 1972.
ARCHITECT: Scott Tallon Walker

Plate 76

UNIVERSITY COLLEGE, INTERIOR OF ARTS BUILDING
Dublin, Ireland

ARTIST: Alexandra Wejchert, untitled, 10′ × 5′ wood
 elements, mixed media, acrylic, 1971.
ARCHITECT: Andrzej Wejchert Associates, Robinson,
 Keefe, and Devane.

Plate 77

MARINA
Tel Aviv, Israel

ARTIST: Igael Tumarkin, "Earth," beach monument, 200' × 72' × 45' earth, acrylic, polymer, and steel, 1978.

Plates 78, 79

CITY HALL PLAZA
Tel Aviv, Israel

ARTIST: Igael Tumarkin, "Monument for the Holocaust and Revival," 63' × 63' × 24' weathering steel, glass, and concrete, 1975. (This sculpture won first prize in a national competition.)

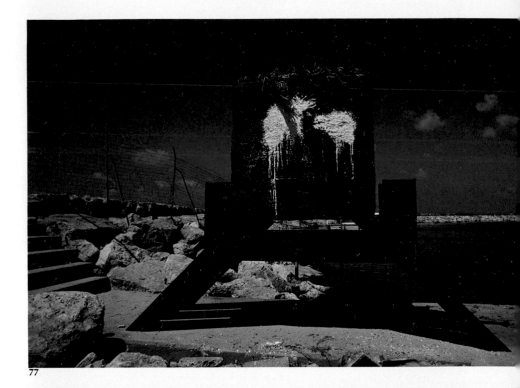

77

78

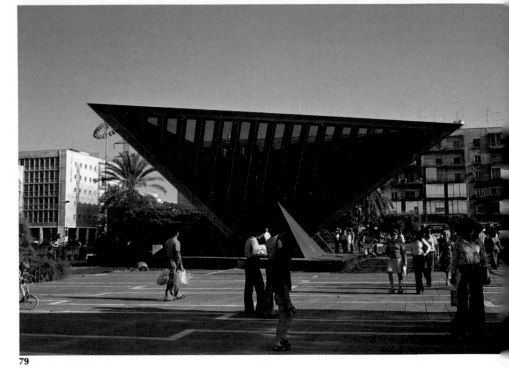

79

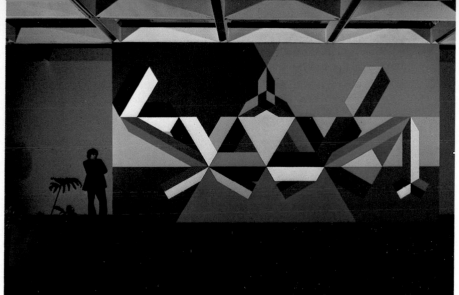

80

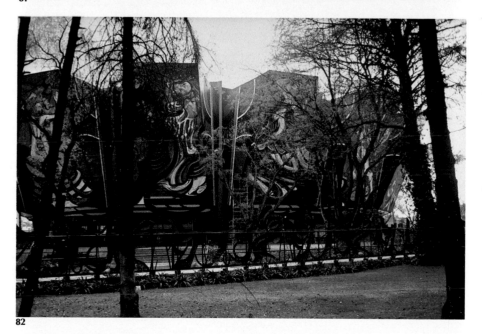

81

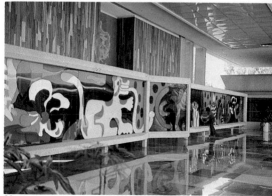

82

83

Plate 80

COLLEGE OF CIVIL ENGINEERING, FOYER
Mexico City, Mexico

ARTIST: Sebastian, untitled, mural, 21' × 12' metal painted with lacquer, 1974.
ARCHITECT: Rafael Aburto

Plate 81

HOTEL CAMINO REAL, LOBBY
Mexico City, Mexico

ARTIST: Tamayo, untitled, mural.

Plate 82

POLYFORM BUILDING
Mexico City, Mexico

ARTIST: Siqueros

Plate 83

CUBAN EMBASSY BUILDING
Mexico City, Mexico

ARTIST: Mariano, untitled, freestanding mural screen in front of main entrance, 1977.
ARCHITECT: Javier Valverde

Plate 84

WALL PAINTING, ROXAS BOULEVARD
Manila, Philippines

ARTIST: Manual Rodriguez, Jr., "Antoinette's Dream," painted wall, 1976–1977.

Plate 85

TODOS-OS-SANTOS (MEDICAL CLINIC), FIRST FLOOR
Lisbon, Portugal

ARTIST: Eduardo Nery, exterior grate facade, 9½' × 40¼' steel and colored glass, 1971.
ARCHITECT: Florivaldo Florentino

Plate 86

THE NEW UNIVERSITY OF LISBON, SCIENCE AND TECHNOLOGY DEPARTMENT
Municipality of Almada, Portugal

ARTISTS: Eduardo Nery, Cristina Leiria, A. Morais, and F. Silva, environment painted murals, 1979.
ARCHITECT: Arnaldo Brito

Comments by Manuel Rodriguez, Jr.:

In 1976, First Lady and Metro Manila Governor Madame Imelda R. Marcos appointed me project director for her project entitled "Kulay anyo ng Lahi" (literally, faces of our land). The idea was to bring art to the people, and in this project we utilized the artworks of about twenty-one artists and painted vacant spaces in various buildings strategically located in Metro Manila to enable ordinary people to appreciate Filipino artwork.

The idea of street art is not new—it has been tried in Paris, New York, and Mexico. This undertaking was proposed by local artists a long time ago. Not until now, however, has art gained such community acceptance as to be given the support needed to execute a project of this dimension, for which the costs can be staggering. As a barometer of a community's consciousness, "Kulay anyo ng Lahi" is a colorful monument to the city's cultural renaissance.

Comments by Eduardo Nery:

The facade of "Todos-os-Santos" Clinic is divided into three distinct sections, closely related either by pattern or color. On the left side is an entrance to the public main hall and an opaque wall in the middle; on the right side, an emergency entrance.

This structure is composed of iron tubes with a square section of 4 by 4 centimeters and by large aesthetically pleasing plates. I also employed other materials such as grey nonthermic glass and colored opaque glass, which play an important part in the ensemble's color.

The general structure is subdivided into several rectangular panels, each fitting the other vertically, some movable (the doors) and others fixed, as those in the central zone.

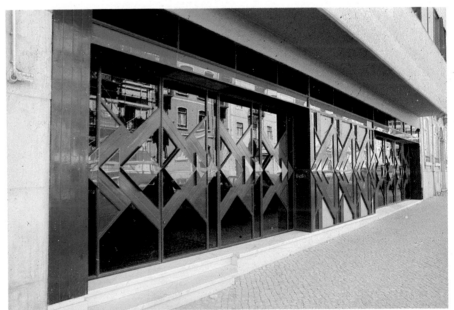

85

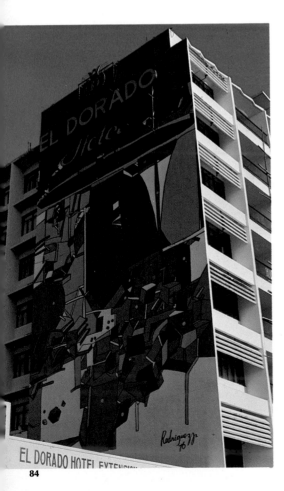

84

86

The artist considers her work to be an integral part of the architecture of a building. By combining color, texture, and design, she endeavors to create warmth and atmosphere. She feels that her leather hangings are especially suitable for monumental-size walls and full-hanging screens.

The required design is initally drawn roughly on a linen backing. The abstract shapes of leather and suede are then matched to size and cut and neatly fitted; the tapestry would hang badly if the joints were not neat and flat. She then glues each piece into place on the backing, irons the reverse side to spread the glue evenly, and finally sews every piece into place with a zigzag stitch.

Plate 87

STELLENBOSCH UNIVERSITY, LANGENHOVEN STUDENT CENTRE

Stellenbosch, South Africa

ARTIST: Beatrix Bosch, "Knowledge in Motion," 20' high × 3' wide sculptured leather wall hanging, 1975.
ARCHITECT: Holm, Beyers, and Holm

Plate 88

NICO MALAN THEATRE CENTRE, OPERA FOYER

Cape Town, South Africa

ARTIST: Eleanor Esmonde-White, "Orpheus with His Lute," tapestry, 33' × 13' loomed shades of red- and purple-colored wool with sparkling gold and silver threads through fabric, 1970.
ARCHITECT: Kent, Miszewski, Hockly, and Partners; Partnership Van der Merwe, Jordan, Truter, and Partners

Plate 89

JAN SMUTS AIRPORT, INTERNATIONAL DEPARTURE HALL

Kemptonpark, Near Johannesburg, South Africa

ARTIST: Armando Baldinelli, untitled, 21' × 12' glass and mosaic mural.
ARCHITECT: Daneel and Smit and Partners; Erik Todd, Auston, and Sandilands

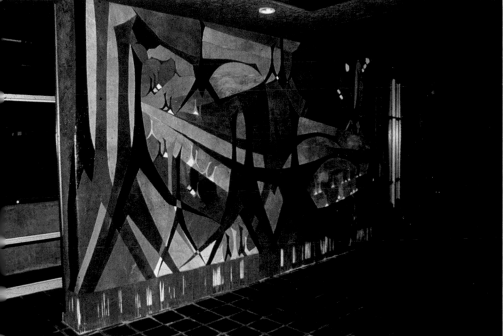

87

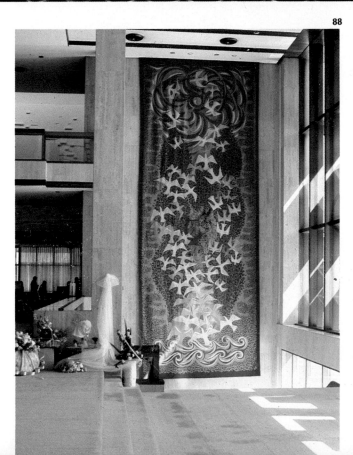

88

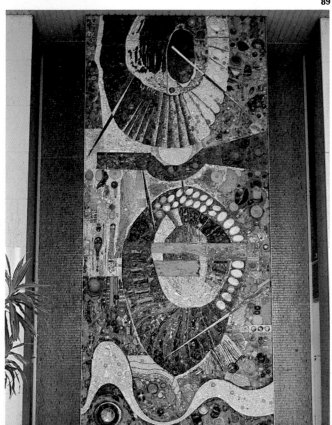

89

Plates 90, 91, 92, 93

N'DEBELE VILLAGE
Near Pretoria, Republic of South Africa

Native mural paintings on homes and buildings.

Plates 94, 95, 96

SOTHO VILLAGE
Near Welkom, Republic of South Africa

Native mural paintings on homes and buildings.

Plate 97

XHOSA VILLAGE
Near Grahamstown, Republic of South Africa

Native mural paintings on homes and buildings.

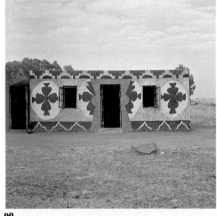

90

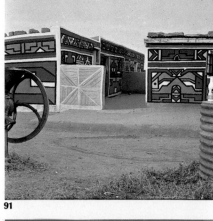

91

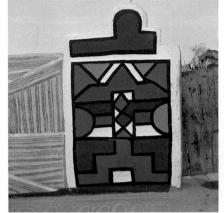

92

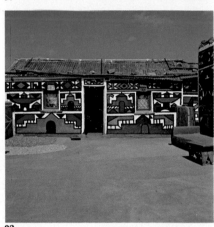

93

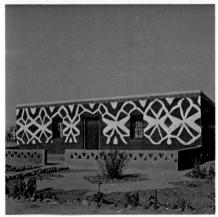

94

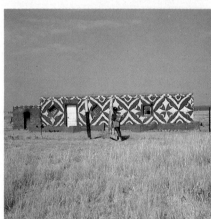

95

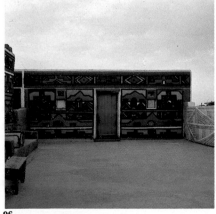

96

97

In Sweden during the past decade the National Arts Council has been responsible for an allocation representing roughly 1 percent of the state building budget. This sum includes art purchases for older buildings and rented premises. Some county and city authorities have a 1 percent allocation for public art (a national art archive is maintained by the Arts Council and the Museum of Sketches at the University of Lund in the south of Sweden. Housing complexes, schools, hospitals, and civic buildings are the beneficiaries.)

One of the earliest to plan for subway art was Stockholm. The County Council Public Transport Board with its advisory committee on art planned the art for the eleven stations between Central Station and Hjulsta.

According to the chief architect of Storstockholms Lokaltrafik (SL), Michael Granit, the stretch between Central Station and Hjulsta, with its eleven stations, is one continuous cave 14 kilometers long and between 20 and 30 meters below the earth's surface.

After blasting, a 7-centimeter-thick layer of cement was sprayed onto the rock. By reinforcing this and, when necessary, draining it, a satisfactory surface treatment of the rock was obtained. Moreover, this results in a coarse uneven surface which gives an exciting contrast to the smooth easily cleaned surfaces of the terrazzo used to cover the floors and dadoes. In order to compensate to some extent for the loss of direct contact with the landscape, the whole space formed by blasting the rock has been transformed by the artists. The resulting works of art give each station its identity and help the passengers to find their way in it.

Plate 98

SUBWAY STATION, "KTH"
Stockholm Sweden

ARTIST: Lennart Mork
ARCHITECT: Michael Granit

Plate 99

SUBWAY STATION, "SOLNA CENTRUM"
Stockholm, Sweden

ARTIST: Anders Aberg, Karl Olov Bjork
ARCHITECT: Michael Granit

Plate 100

SUBWAY STATION, "VASTRA SKOGEN"
Stockholm, Sweden

ARTIST: Sivert Lindblom
ARCHITECT: Michael Granit

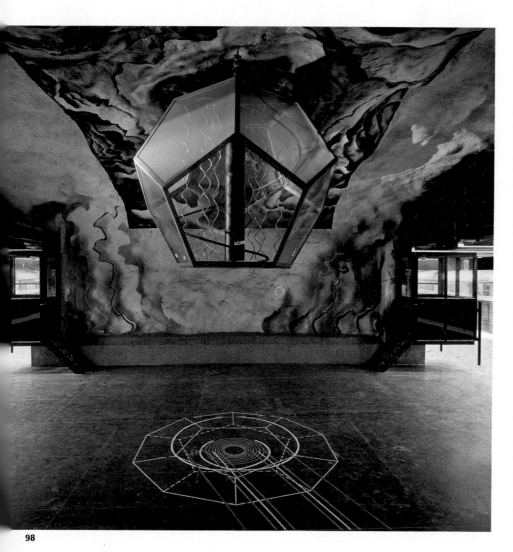

98

99

100

Plate 101

SUBWAY STATION, "T-CENTRALEN"

Stockholm, Sweden

ARTIST: Per Olof Ultvedt
ARCHITECT: Michael Granit

Plate 102

SUBWAY STATION, "RADHUSET"

Stockholm, Sweden

ARTIST: Sigvard Olsson
ARCHITECT: Michael Granit

Artist's statement:

The motif for the whole decoration is a country parish church turned inside out. I have always admired the old whitewashed vaults of such churches, with their decorative *al secco* paintings, and have thought how exciting it would be to paint such a church myself. An old church and underground railway tunnel have many similarities: a branch of a tunnel seems almost like a transept. The technique I used is, in principle, the same as the old church painters used: painting *al secco* directly on the plastered walls. They used lime paint; I have painted with silicate.

Artist's statement:

During excavations for the subway tunnel, some of the remains of previous generations became evident. By an extraordinarily fortunate coincidence, the tunnel came out through a richly decorated seventeenth-century gateway. It is through this area that the line going north emerges. What is so remarkable is that all these remains, the old as well as the more recent, have already become fossilized and have taken on the pale, perfumed rose color of the rock, the same tint that is found deep in the Atlas Mountain. Thus the rock contains fragments from previous epochs as well as all the new technical contraptions—lifts, escalators, and electric cables—all painted in glistening colors.

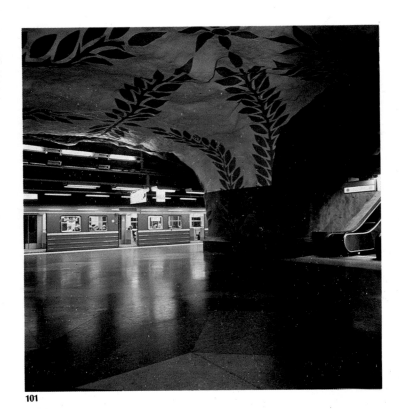

101

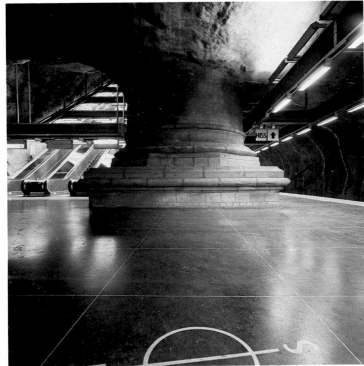

102

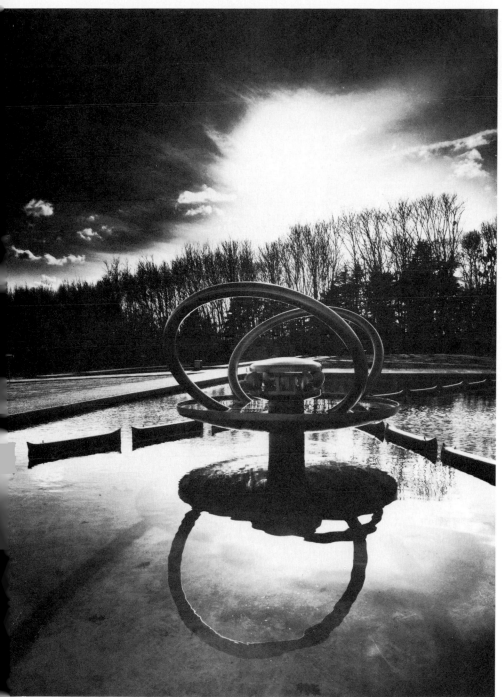

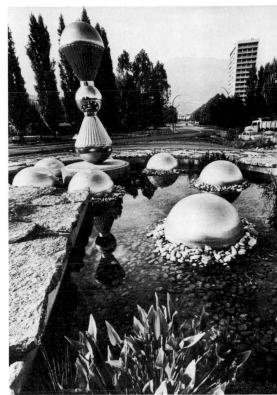

57

56

GRADUATE SCHOOL OF COMMERCE, PLAZA
Lyon, France

ARTIST: Claude Viseux, untitled, fountain, 7' × 10' × 22'
stainless steel, 1972.
ARCHITECTS: Olivier Vaudou and Raymond Luthi

57

UNIVERSITY OF GRENOBLE, ENTRANCE AT INTERSECTION
Grenoble, France

ARTIST: Claude Viseux, "Sablier," sculpture, stainless steel
mirrored sheets, 18' × 5' × 5', 1977. (Ordered by
the city of Grenoble.)

56

58

FRONT LAWN OF COMMUNITY BUILDINGS
Saint-Quentin-en-Yvelines, France

ARTIST: Klaus Schultze, "Reclined Man," 18' high x 28' long colored and standard brick, 1976.

59

NEW CITY OF CERGY-PONTOISE, SCHOOL ENTRANCE COURT
France

ARTISTS: Bernard Alleaume and Yvette Vincent-Alleaume, brick, 1977.
ARCHITECT: Maneval

60

SCIENCE BUILDING, COURT OF THE AMPHITHEATERS
Marseille, (St. Jerôme), France

ARTIST: Victor Vasarely, untitled, geometric pattern of 6000 ft² with luminous kinetic sculpture composed of duraluminum cubes in center, 1970.
ARCHITECT: Egger

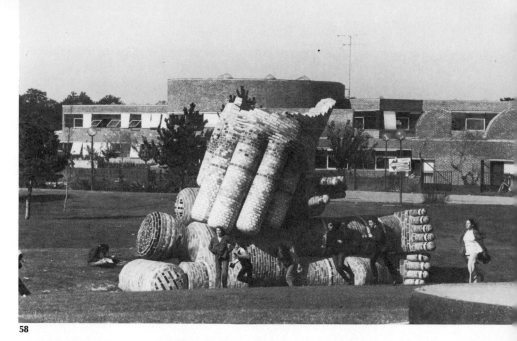

58

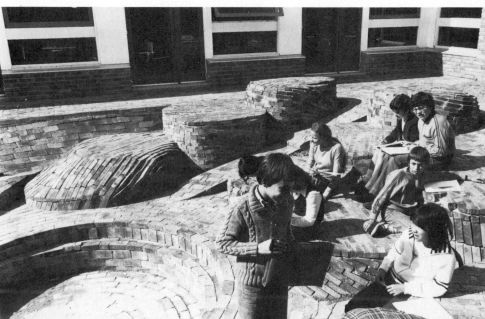

59

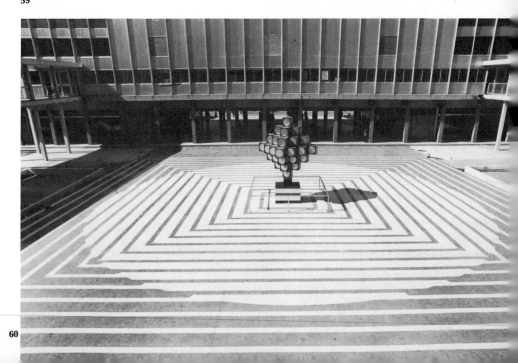

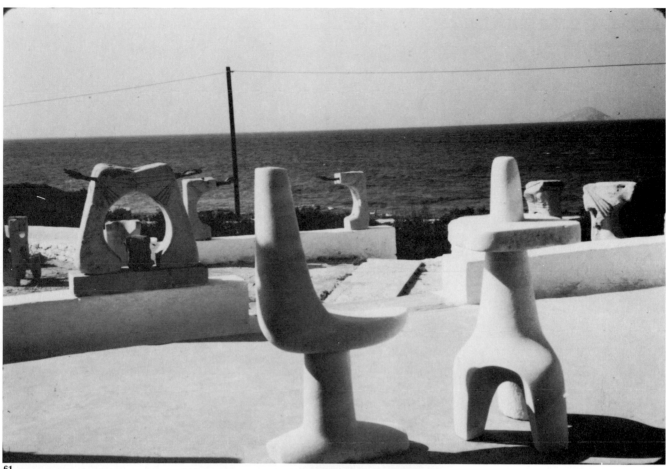

61

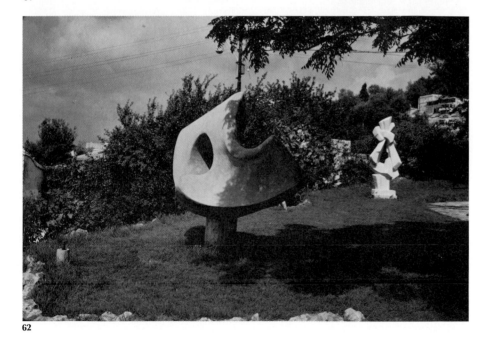

62

61

CAPRALOS RESIDENCE, FRONT PATIO
Aegina Island, Greece

ARTIST: Christo Capralos, untitled, stone sculpture grouping.

62

SCULPTURE GARDEN, ARTISTS' QUARTERS
Safed, Israel

ARTIST: Moshe Saflr, nine large outdoor pieces, stone and concrete. This terraced sculpture garden is the result of eighteen years of creative work. It was dedicated in 1977 to the city.

63

PRINSES CHRISTIANASCHOOL
Zoetermeer, Holland

ARTIST: Christa van Santen "Faces," 3' × 30' area, wood
with metal rings, 1973.

64

WALL PAINTING
City Street, Rotterdam, Holland

ARTIST: Mathieu Ficheroux, portrait of famous Dutch
writer Multatuli (1820–1887), 20' × 11', 1975.

65

INTERPOLIS INSURANCE
COMPANY, LOBBY
Tilburg, Holland

ARTIST: Arie Janema, untitled, sculpture wall, 9' × 21'
chromium-plated brass balls between gold anodized pins,
1970.
ARCHITECT: Kraayvanger

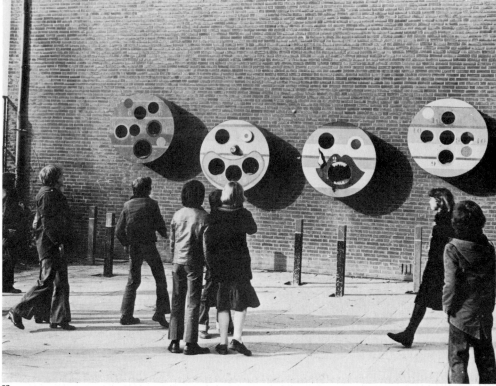

63

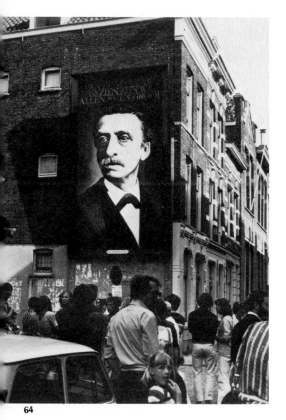

64

65

70

71

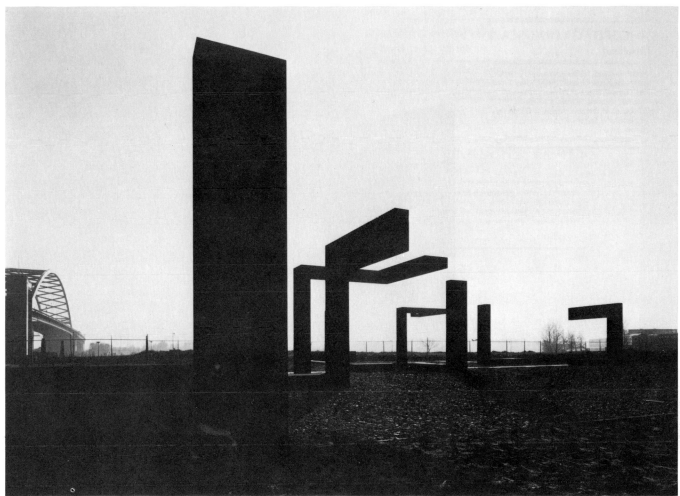

66

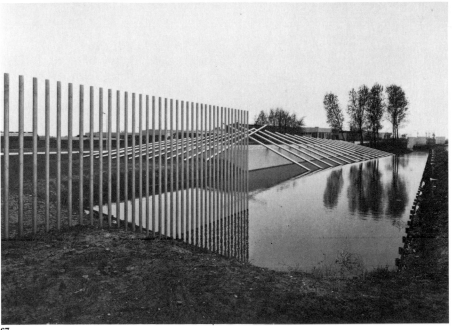

67

66

WATERWORKS
Kralingen near Rotterdam, Holland

ARTIST: Andre Volten, sculpture, eight elements 15′ high, weathering steel on gravel base, 120′ × 120′, 1977. (Financed by the city of Rotterdam.)

67

WATERWORKS
Weesperkarspel, near Amsterdam, Holland

ARTIST: Andre Volten, entrance sculpture comprising earthwork, trees, concrete retaining walls, twenty-three stainless steel tubes each 40′ long and 3″ in diameter. The sculpture encompasses an area of 175′ × 600′, 1978. (Financed by the city of Amsterdam.)

68, 69

REFAJA
Dordrecht,

ARTIST: Hans
highest 36', 1
fountain cone
Dordrecht—t
Public Works
the rest of env
pavement, bus
ARCHITECTS: I

77

ESPLANADE
Vlissingen, Holland

ARTIST: Group called Mass and Individual Moving, "Sound Stream," wind organ made of bamboo pipes, 15' high × 36' long, 1976.

78, 79

OUTSKIRTS, CITY OF ZWIJNDRECHT
Holland

ARTIST: Lucien A. M. den Arend, "Walburg, Project," environmental sculpture on 1.12 acre, 473' long parcel of land, bronze 4' × 4' × 6' form balancing on a 62' diameter asphalt convex disk, 1973.
ARCHITECT: City Architect and Town Planner, A. Stroom.

The artist group, Mass and Individual Moving, made the plans for what they call "Sound Stream," wind organs to be installed all over the world to accentuate the cultural unity of the world.

The sound stream started in Cameroon and went through Africa to Europe. In August 1975 the wind organ in Vlissingen was installed. A storm in 1976 destroyed the project and it was rebuilt by order of the municipality of Vlissingen.

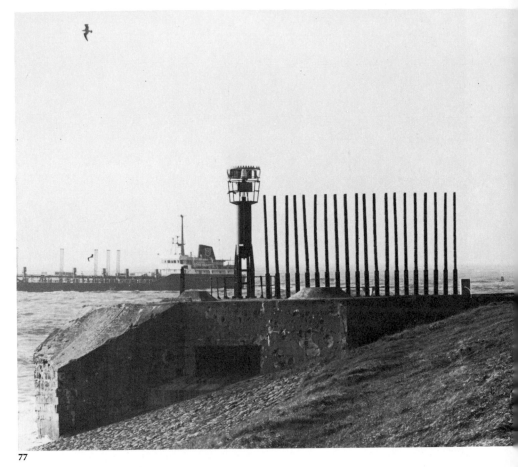

77

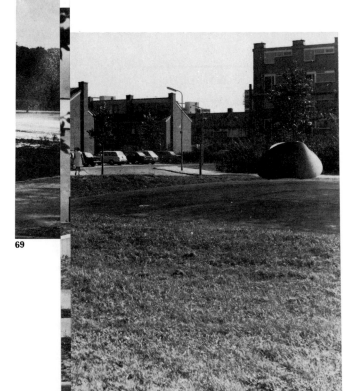

69

78

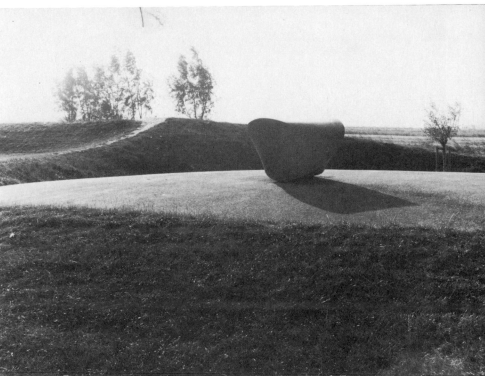

79

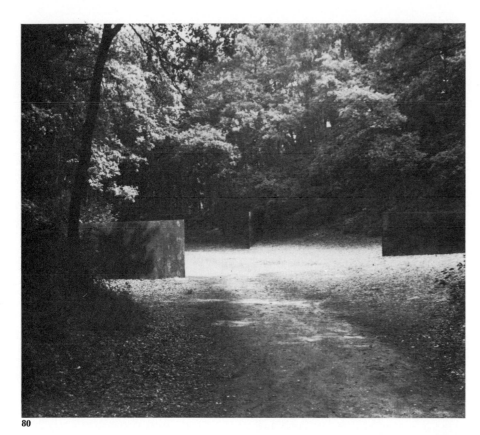

80

80

GARDEN, KROLLER-MULLER MUSEUM
Otterlo, Holland

ARTIST: Richard Serra, "Spin Out," three plates each 10'
× 40' × 1½" thick hot-rolled steel, 1973.

81

GROUNDS NEAR PROVINCIALE WATERSTAAD
Middleburg, Holland

ARTIST: Sander Littel, untitled, environmental sculpture,
30' × 111' red granite rocks, 1975.
ARCHITECT: Berghoef, Hondius, and Lamers

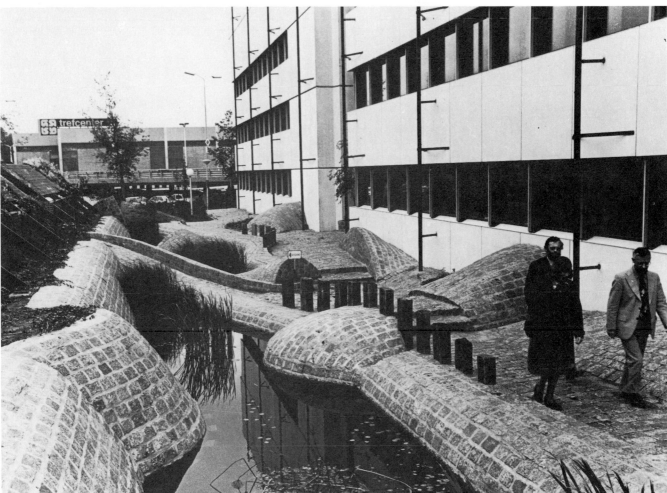

81

DUN LAOGHAIRE SHOPPING CENTER, INSIDE COURT
Suburb of Dublin, Ireland

ARTIST: Imogen Stuart, "The Scholar and His Cat," 20' × 14' area, 6'6" seated figure, pine wood, 1974.
ARCHITECTS: Costello, Murray, and Beaumont

COMMERCIAL BUILDING, LOBBY
Clonmel, County Tipperary, Ireland

ARTIST: Robert Gallagh, "People with a Modern Painting," mural, 10' × 80' plastic laminate bonded to chipboard; artwork is printed (silk-screened) and sealed under protective melanine surface, 1976.
ARCHITECT: James Furlong

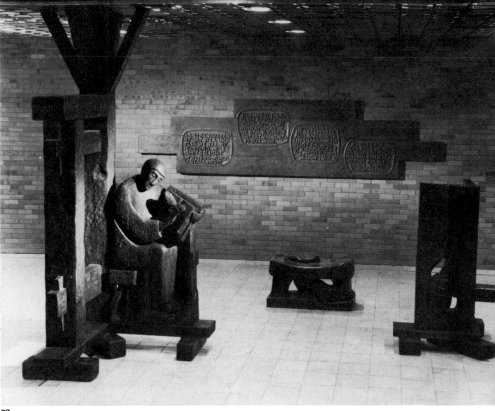

82

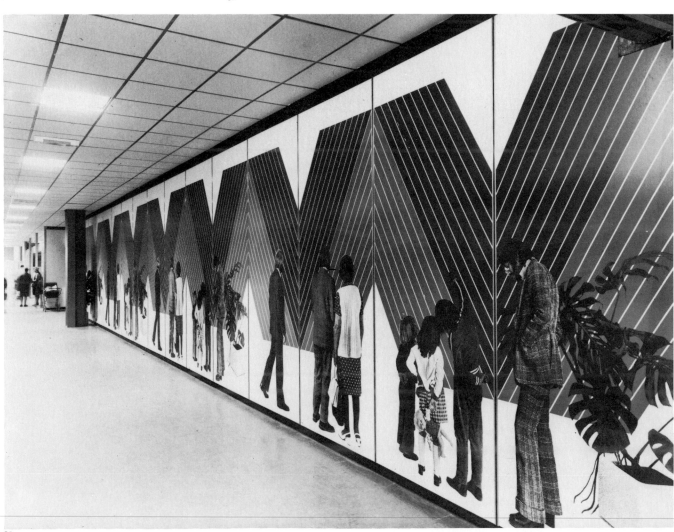

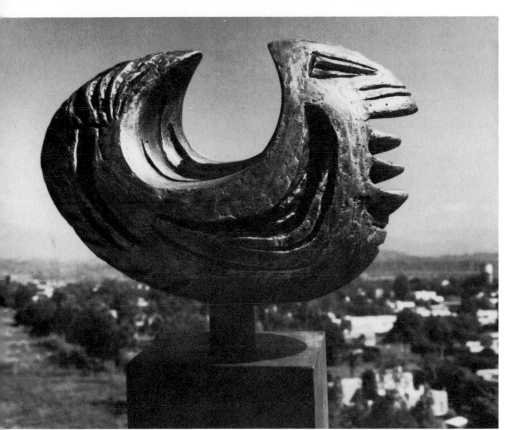

84

CITY CENTRE
Chandigarh, India

ARTIST: N. M. Sharma, fountain, 10' high concrete wall with 3' × 4' bronze sculpture (bird) spouting water to a pool 20' below, 1978.
ARCHITECT: N. M. Sharma, Chief Architect, Department Architecture Chandigarh University

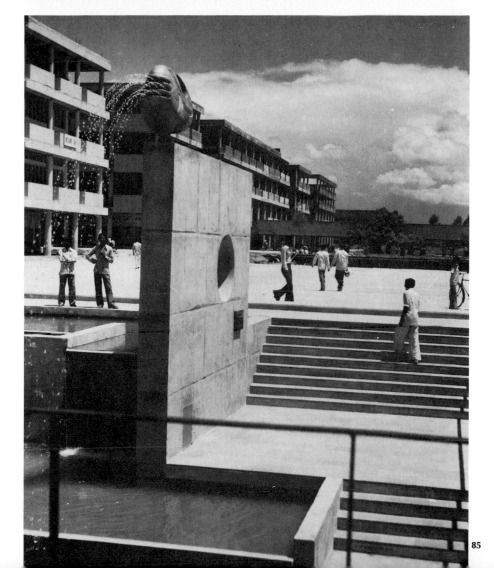

85

86

P. J. CARROLL AND COMPANY LTD., COURT POOL
Dundalk (between Dublin and Belfast), Ireland

ARTIST: Gerda Fromel, "Sails," mobile sculpture, 28' high stainless steel, 1970.
ARCHITECT: Ronald Tallon of Scott Tallon Walker/Architects

87

BANK OF IRELAND, COURT
Dublin, Ireland

ARTIST: Michael Bulfin, "Aldebar," sculpture, 19' × 18' × 16' painted steel, 1978.
ARCHITECT: Ronald Tallon of Scott Tallon Walker/Architects

88

UNIVERSITY COLLEGE, COURT
Galway, Ireland

ARTIST: Brian King, untitled, sculpture, 10' × 23' × 14' painted steel, 1973. (Financed by Arts Council and P. J. Carroll and Company Ltd.)
ARCHITECTS: Ronald Tallon of Scott Tallon Walker/Architects

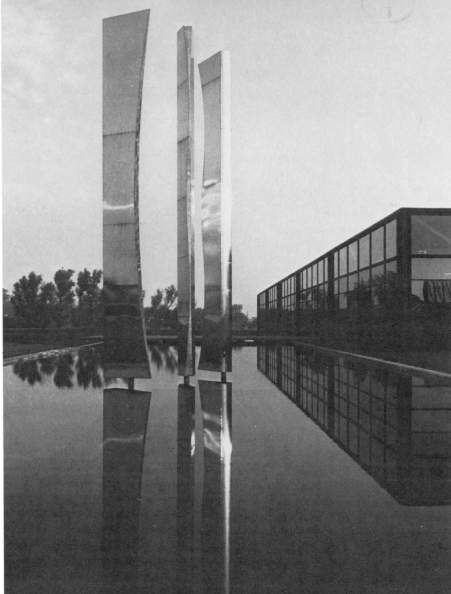

86

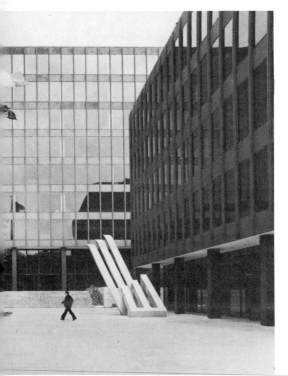

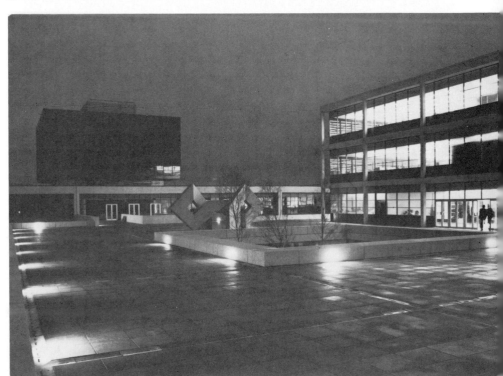

87

88

The concept of the memorial is a rock dug out of the mountain and that is the reason why the outside courtyard, the walls, and the interior floor are of the same uniform stone.

The entrance to the memorial is between two pyramids leading to the first courtyard where you find one olive tree, a stone bench, and the name of the memorial. From the courtyard, between two additional pyramids, you reach the plaza—which can house 600 people and overlooks the city of Jerusalem—viewed between vertical upright elements constituting a monument placed in a pool.

The main entrance to the memorial is at the edge of this plaza. In this space—a split pyramid forming two shells covered inside with golden sheets of anodized aluminum—are placed the names of the fallen soldiers.

The artist, Bezalel Schatz, designed special geometrical forms for those walls as well as the entrance gates, the perpetual light, the handrail, and the letters for names.

89

MEMORIAL BUILDING, SACHER PARK
Jerusalem, Israel

ARTIST: Bezalel Schatz, untitled, pool sculpture, 3' × 5' high brass pipes.
ARCHITECT: David Resnik

90

MEMORIAL BUILDING, SACHER PARK
Jerusalem, Israel

ARCHITECT: David Resnik, with A. Spector, M. Amisar, associated architects, 1978.

91

THE JERUSALEM THEATER
Jerusalem, Israel

ARTIST: Y. Shemi, untitled, sculpture, concrete.
ARCHITECT: Nadler, Nadler, Bixon

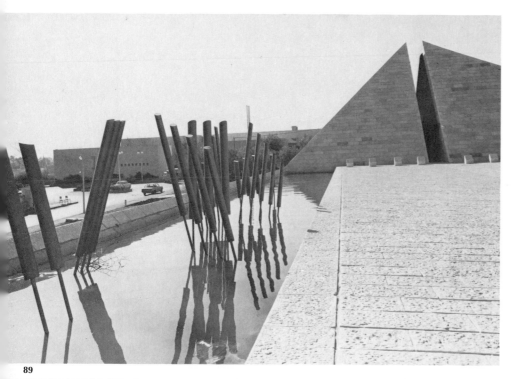

89

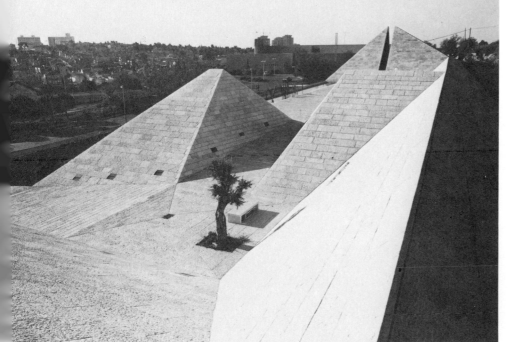

90

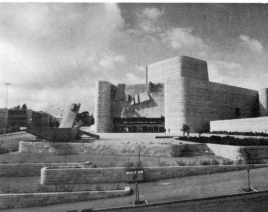

91

THE PRESIDENT'S HOUSE, GARDEN

Jerusalem, Israel

ARTIST: Menashe Kadishman, untitled, sculpture, 12' high
stainless steel, 1974.
ARCHITECT: Aba Elhanani

THE PRESIDENT'S HOUSE, GARDEN

Jerusalem, Israel

ARTIST: Dina Recanati, "Crown of Jerusalem," six bronze
columns 7' high, 1971.
ARCHITECT: Aba Elhanani

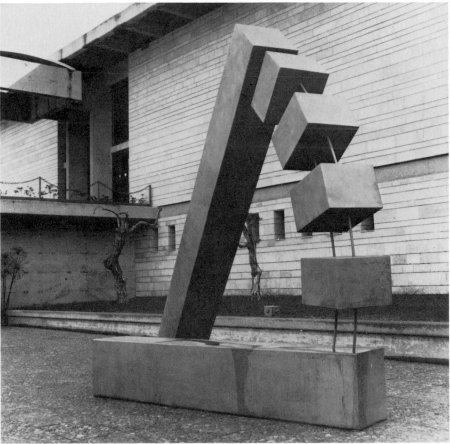

92

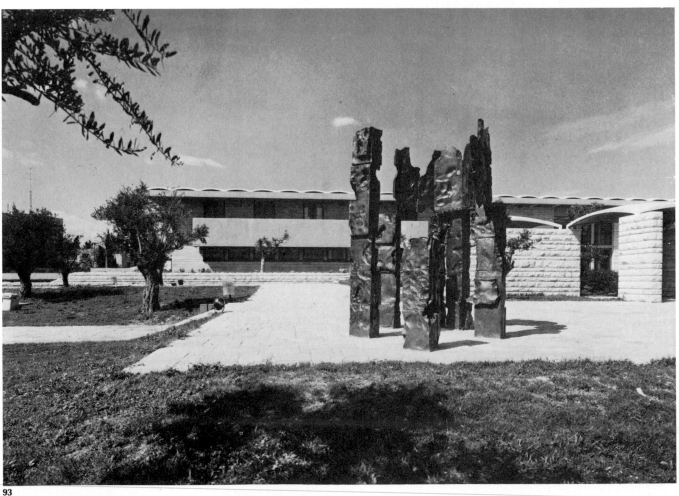

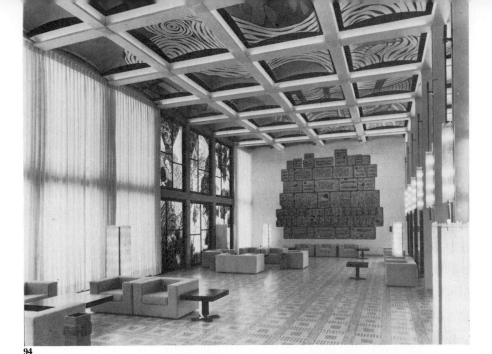

94

THE PRESIDENT'S HOUSE, RECEPTION HALL
Jerusalem, Israel

ARTISTS: Naftali Bezem, ceiling, acrylic on asbestos-cement; Moshe Castell, rear wall, bas-relief of basalt powder, 27′ × 17′; Reuben Rubin, Stained-glass window, biblical theme, six panels each 5′ × 8′, 1971.
ARCHITECT: Aba Elhanani

95

THE PRESIDENT'S HOUSE, RECEPTION HALL
Jerusalem, Israel

ARTIST: Yaacov Agam, "Hundred Gates," sculpture, 11′4″ × 17′ steel, 1971.
ARCHITECT: Aba Elhanani

96

THE PRESIDENT'S HOUSE, ENTRANCE GATES
Jerusalem, Israel

ARTIST: Bezalel Schatz, gate in three parts, each 13′ × 11′ steel painted black, 1971.
ARCHITECT: Aba Elhanani

95

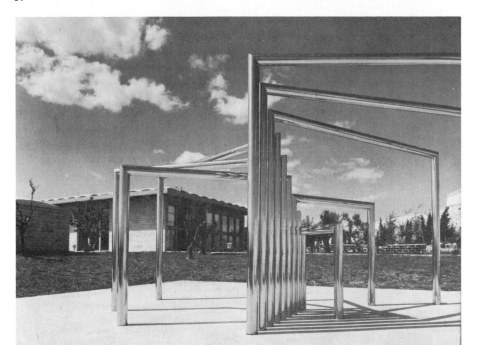

96

97

MOUNT CARMEL LEISURE CENTER AND AUDITORIUM
Haifa, Israel

ARTIST: Beni Efrat, "Mural Mutations," 1974.
ARCHITECT: Al Mansfeld and D. Eavkin

98, 99

B'NAI B'RITH MARTYR'S FOREST
Judean Hills near Jerusalem, Israel

ARTIST: Nathan Rapoport, "Scroll of Fire," two bronze
sculpture columns, 26' high, 1972. The artist depicts the
Holocaust and the birth and triumph of Israel.

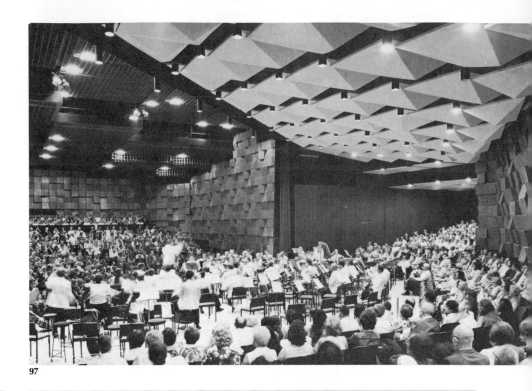

97

98

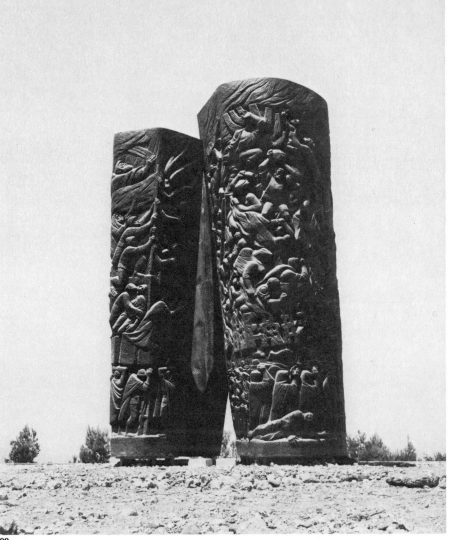

99

Lipchitz describes "Tree of Life" as the dynamics of the Judaic religion. The roots of the tree are Noah, the beginning of a new generation of Jews, after the Flood. On him stands the sacrifice of Isaac with an angel restraining Abraham. The angel serves as a support for the three patriarchs who are supporting the Burning Bush. In front of the Burning Bush is Moses. Rising from the Burning Bush is a phoenix, which is constantly nourished by and which supports the Ten Commandments.

100, 101

HADASSAH UNIVERSITY HOSPITAL, FRONT GROUNDS WITH JUDEAN HILLS AND DEAD SEA IN BACKGROUND
Jerusalem, Israel

ARTIST: Jacques Lipchitz, "Tree of Life," 20' high bronze, 1978.

102

HABIMA NATIONAL THEATER SQUARE
Tel Aviv, Israel

ARTIST: Menashe Kadishman, "Inspiration," 45' high weathering steel.

101

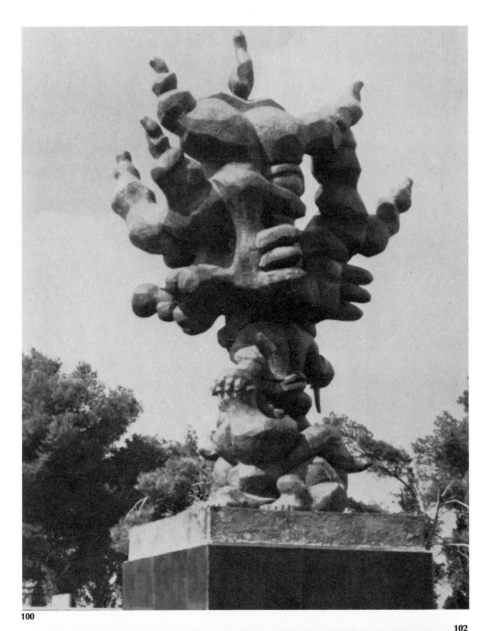

100

102

103, 104

KIBBUTZ EN SHEMER, PARK
Israel

ARTIST: Roda Reilinger "Memorial to Two Kibbutz
Members Amnon and Hanan Fallen 1967 War," 18'
high welded iron sheets with bronze and stainless
steel, 1971.

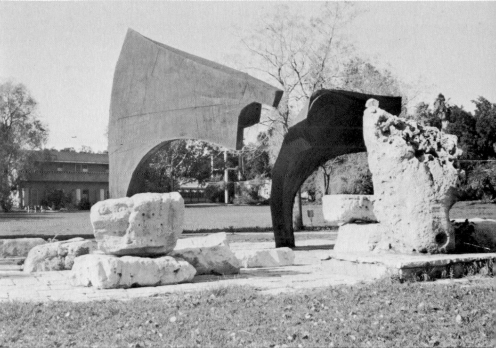

103

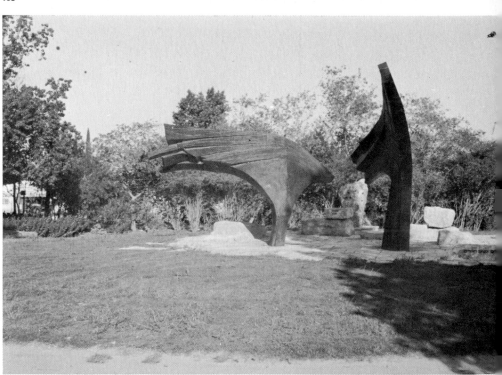

104

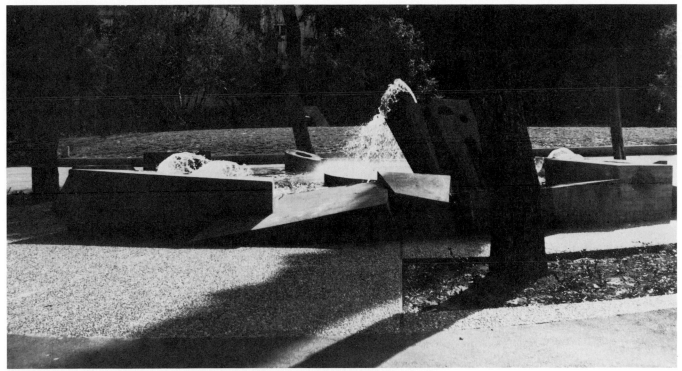

105

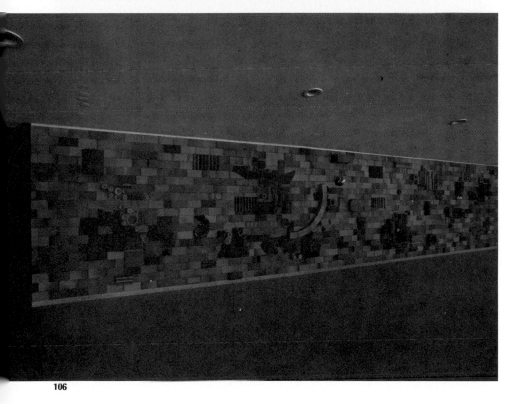

106

105

KING DAVID'S PARK
Ramat Gan, Israel

ARTIST: Roda Reilinger, untitled, fountain sculpture,
 concrete, 1972.
LANDSCAPE DESIGNER: Miller-Blum, Inc.

106

KIBBUTZ HAZOREA, FOYER OF
HALL
Israel

ARTIST: Roda Reilinger, untitled, wall mural, 7′ high × 33′
 long brick ceramic prefabricated elements, factory
 scraps, glass lumps, 1978.
ARCHITECTS: Schlomo Gilead Associates

PANORAMA
Arad, Israel

ARTIST: Igael Tumarkin, "Seats and Table," 46′ × 34′ × 24′, concrete.

Comments by Igael Tumarkin:

Soil has got me. I experiment with its sticking power, its lasting power in time and against nature. I return to textures. They are less complex, more direct, and at times colorful. The clumps grow and collide with steel and wooden frames, an attempt at expressing—not to be swept up in imitation, in oversentimentalizing, in enslavement to what has already been done (and it is stupendous, difficult to add to). For thousands of years I've been searching for a contemporary statement in the earth, so full of meaning and power.

Earth as counterpoint to the golden section: this is an exercise, an attempt to bring a lump of earth face to face with a completely different material, modular steel, and to break the golden section: $\sqrt{\dfrac{5+1}{2}} = \emptyset +$ earth $=$ an exercise in proportion, counterpoint, materials. In other words, a statement!

Can we eliminate the characteristic associations of earth—the sculpted earth beautiful, multicolored, fire- and waterproof earth, pleasant to the touch, pleasant to the sight? No, we cannot dissociate ourselves from all that earth arouses. Mother Earth who buries everything inside her with great mercy. It's all been written. It is a viewpoint: a poem on the song of the earth, a voyage, a search, and a statement.

But more important than what has been written is the statement in clay: the result.

107

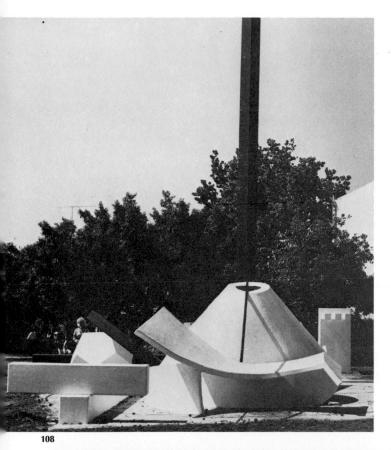

108

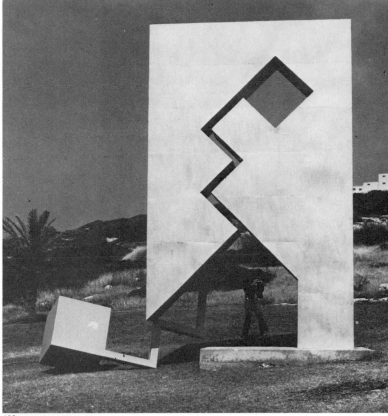

109

110

108

GARDEN
Ashkelon, Israel

ARTIST: Igael Tumarkin, "Sundial," sculpture 18½′ ×
30′ concrete and painted weathering steel.

109

SCULPTURE ALONG SEA HIGHWAY
Haifa, Israel

ARTIST: Igael Tumarkin, "Signpost," 18½′ high painted
weathering steel (needs to be painted every year to avoid
corrosion), 1971.

110

SDE-BOKER, COLLEGE GROUNDS
Negev, Israel

ARTIST: Ezra Orion, environmental art (work in progress).

PROPOSAL FOR HISTORIC RENOVATION, GUIDECCA ISLAND, MOLINO STUCKY (STUCKY MILLS)

Venice, Italy

ARTIST: James Wines, facade materials used are glass, steel structure, space frame, hydraulic pump systems, sprinkler tubes, brick stone.
SPONSOR: The Venice Biennial of Art and Architecture, 1975.

As a result of an invitation to participate in the 1975 Venice Biennial of International Art and Architecture, SITE developed a series of inconographic proposals for the abandoned Stucky Mills located on the island of Guidecca, opposite the historic center. In directing the concerns of the biennial toward the Molino Stucky, the municipality of Venice indicated a desire to focus attention on this neglected site with the ultimate purpose of revitalizing the area for housing, recreation, and student activities.

This project reverses the familiar relationship between the canals of Venice and the building facades. Contrary to the usual relationship between design elements, facade of the Molino Stucky becomes the horizontal element and the water becomes the facade. This juxtaposition is acheived by extending the promenade as an exact reproduction of the central section of the Molino and by installing a plate glass wall to bridge the gap between the two adjacent wings of the factory. Over this wall a hydraulic sprinkler system is suspended on a steel space frame, allowing a continuous cascade of water to flow over the glass. This stands in marked contrast to the traditional architectural inconography of the city and serves as an image of indeterminacy.

111

112

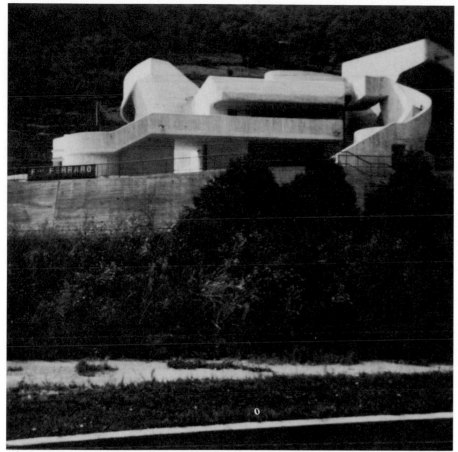

113

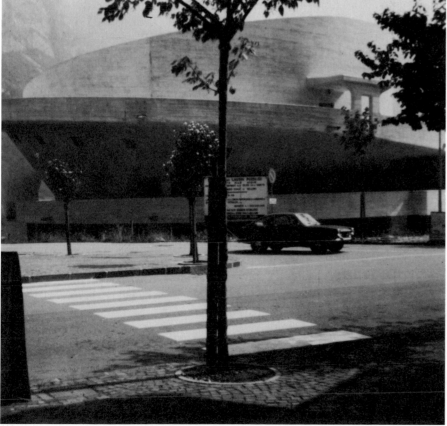

114

CHURCH OF LONGARONE
Longarone (Cadore), Italy

ARCHITECT: Giovanni Michelucci. The Church was built as a memorial to the 2000 victims of the Vajont Dam disaster of 1963. The ellipsoidal shape represents the vortex of the wave as it plunged from the dam and destroyed the town. A rose-colored cement was chosen to blend chromatically with the surrounding dolomite mountains.

115, 116

PUBLIC SQUARE, OLDEST WALL OF THE CAMPO DI NUOVO GHETTO SYNAGOGUE

Venice, Italy

ARTIST: Arbit Blatas, "The Holocaust"—"The Quarry," one of 7 bas-relief tablets, each 3'3" tall × 2½' wide × 8" deep, bronze, 1980. The bas-reliefs depict events from "The Deportations" to the "Final Solution of the Jews," the drawings of which were created for the NBC production of the TV film, *The Holocaust*.

117

ELEMENTARY SCHOOL COURTYARD WALL

Rovigo, Italy

ARTIST: Alberto Biasi, bronze sculpture plaque, 17' × 5'.

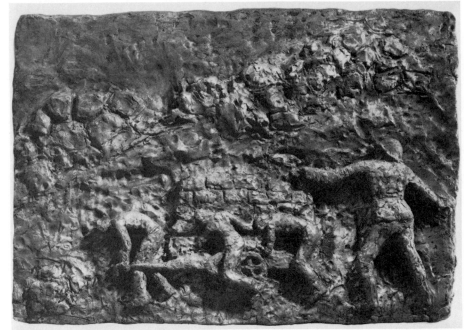

115

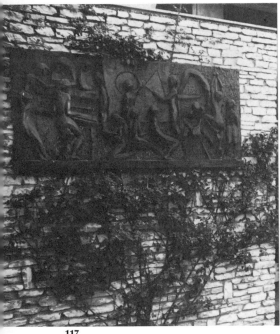

117

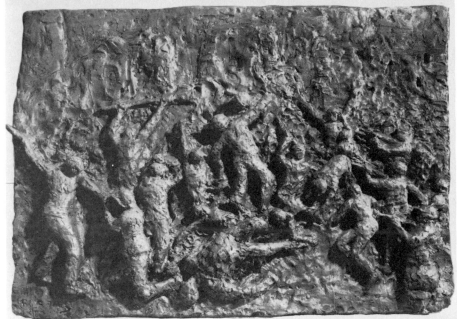

116

118

MUSEUM OF ART, ENTRANCE
City of Utsunomiya, Tochigi-prefecture, Japan

ARTIST: Yoshikuni Iida, untitled, sculpture, 30' high, each wing 21' long, stainless steel, 1973.
ARCHITECT: Professor Kiyoshi Kawasaki (faculty, Osaka University)

119

NAMEGAWA ISLAND
Chiba Prefecture, Japan

ARTIST: Yoshnikuni Iida, untitled, sculpture, 24' high × 30' long stainless steel, 1972.
ARCHITECT: Junzo Yoshimura

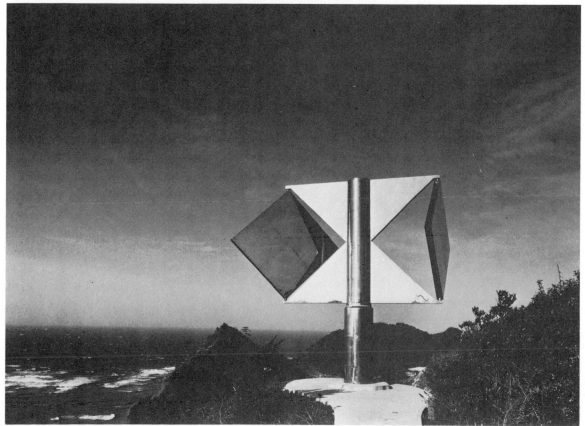

119

120

MEDICAL TREATMENT CENTER OF SETAGAYA
Tokyo, Japan

ARTIST: Kazuo Yuhara, "Sun and Verdure," 8' high × 20' long yellow color-cast aluminum, 1976.

121

OHBAYSHI HOSPITAL, LOBBY
Kagawa-ken, Japan

ARTIST: Masumi Sano, "Boy," 5' long × 2½' wide corded stainless steel cast metal, 1978.
ARCHITECT: Yasuo Uchii

122

CHIBA COLLEGE OF TECHNOLOGY, FOYER
Chiba, Japan

ARTIST: Kazuo Yuhara, untitled, 21' × 21' steel and brass, 1972.

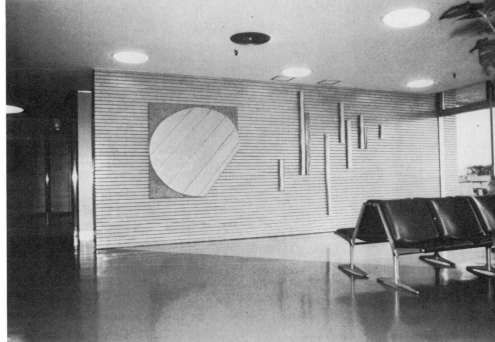

120

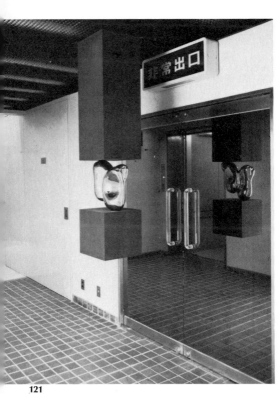

121

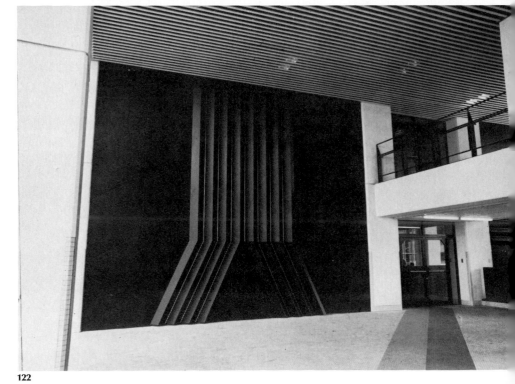

122

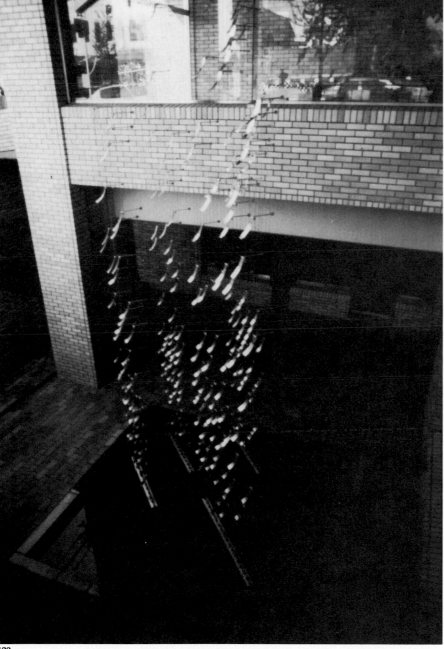

123

SAIGO HOSPITAL, LOBBY
Kumamoto, Japan

ARTIST: Michio Ihara, untitled, suspended sculpture, 28'
high × 8' wide × 3½' diameter stainless steel, 1979.
ARCHITECT: Akira Inadomi

124

CHRISTIAN PAVILION, EXPO '70
Osaka, Japan

ARTIST: Michio Ihara, untitled, sculpture, 1969–1970.
ARCHITECT: Akira Inadomi

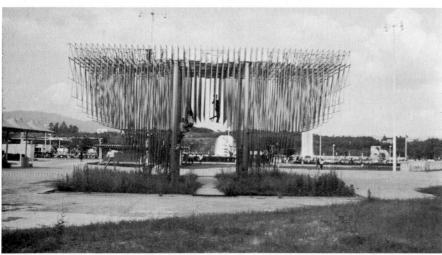

124

TOCHIGI MUSEUM, OUTDOOR PLAZA

Japan

ARTIST: Nobuo Sekine, "Cone," 3½' × 3½' × 2½' black granite, 1975.
ARCHITECT: Kiyoshi Kawasaki

MUNICIPAL OFFICE BUILDING PLAZA

Niiza City, Japan

ARTIST: Nobuo Sekine, "Walking Stones," 10' × 2' × 2', 5' × 2' × 2', 3' × 4' ×3', white granite stainless steel, 1975.
ARCHITECT: Urban Architect Design Office

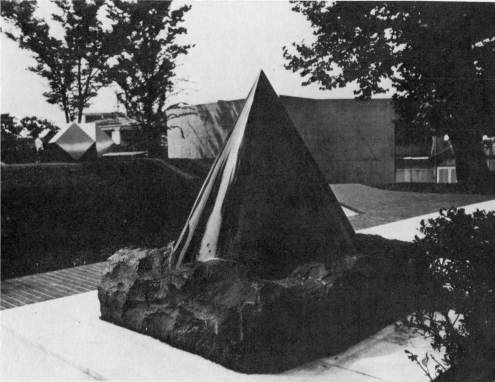

125

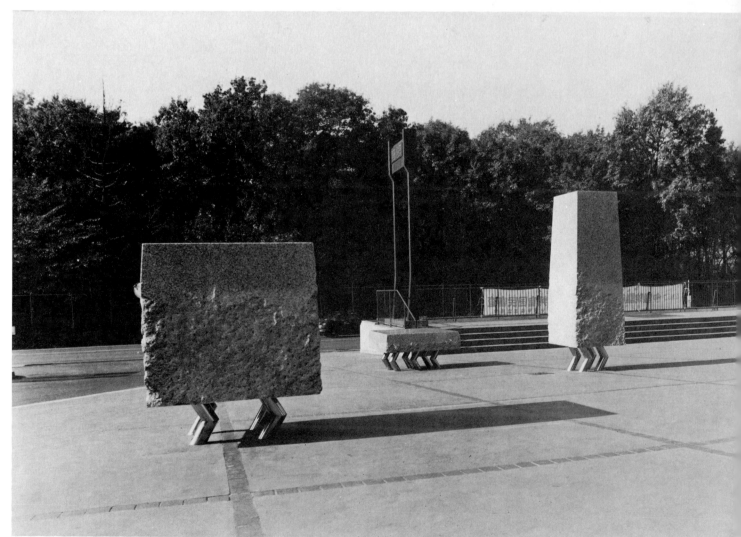

126

127

127

SAIGO KOMIKA PUBLIC BATH, INTERIOR
Osaka, Japan

ARTIST: Sadamasa Motonaga, untitled, mural, 6' × 150', waterproof enamel on concrete, 1977.
ARCHITECT: Yasutaka Yamazaki

128

SAIGO KOMIKA PUBLIC BATH, INTERIOR
Osaka, Japan

ARTIST: Sadamasa Motonaga, untitled, mural, 6' × 120', waterproof enamel on concrete, 1977.
ARCHITECT: Yasutaka Yamazaki

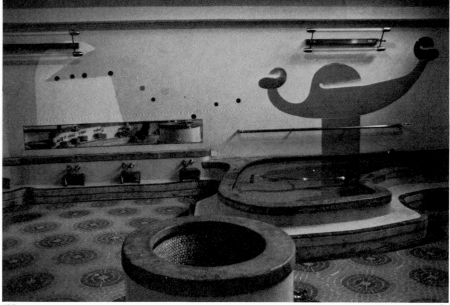

128

129

MANHATTAN TOWER OFFICE BUILDING, ENTRANCE PLAZA
Tecamachalco, Mexico City, Mexico

ARTIST: Mathias Goeritz, "Cocono," sculpture, 23'
 diameter, steel, 1977.
ARCHITECT: Abraham Zabludovsky

130

PUBLIC SQUARE, MIXCOAC
Mexico City, Mexico

ARTIST: Mathias Goeritz, "The Pyramid of Mixcoac,"
 114 prefabricated white painted concrete forms, 40'
 high, 1970.
ARCHITECT: Teodoro Gonzalez de Leon and Abraham
 Zabludovsky

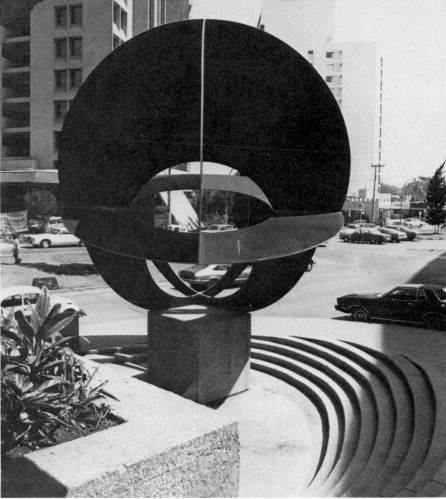

129

130

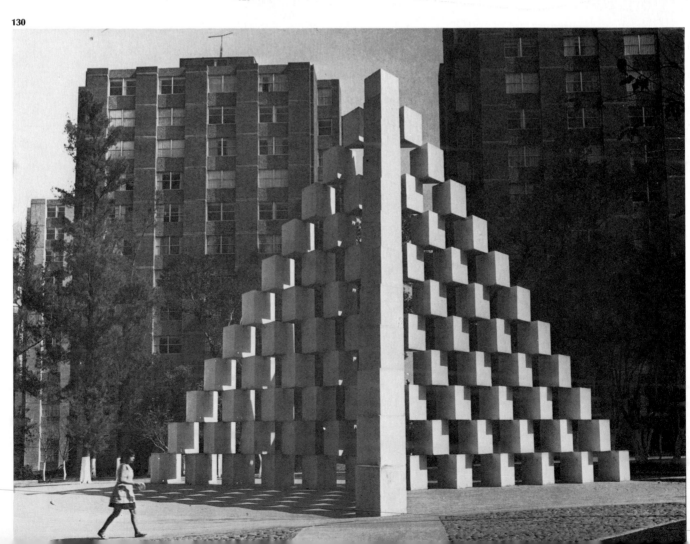

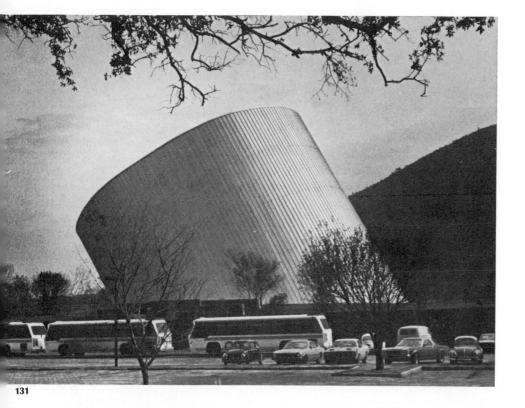

131

131

ALFA CULTURAL CENTER, AUDITORIUM, EXTERIOR VIEW
Science Museum and Planetarium, 1978.
Monterrey, Mexico

ARTIST: Manuel Felguerez

132

ALFA CULTURAL CENTER, LOBBY INTERIOR
Monterrey, Mexico

ARTIST: Manuel Felguerez, untitled, mural, relief in steel
and aluminum polychromated with industrial lacquer,
1978.
INTERIOR DESIGNER: Fernando Garza Trevino

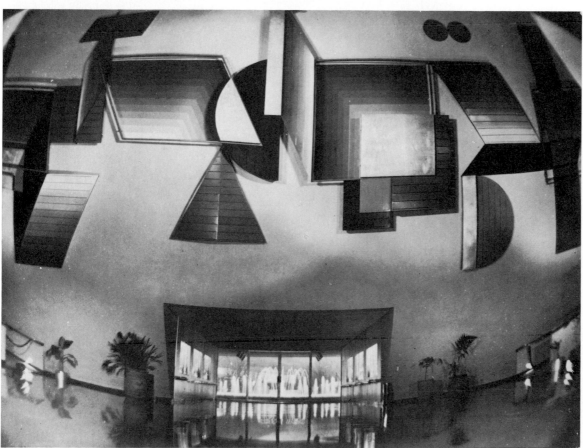

132

133

"EUGENIA" HOUSING COMPLEX, SCULPTURE PLAZA

Mexico City, Mexico

ARTIST: Sebastian, play sculpture, 15′ × 15′ × 15′ painted metal, 1977. (Master plan by Mathias Goeritz.)

134

CITY OF VILLAHERMOSA, CITY SQUARE

Mexico

ARTIST: Sebastian, untitled, city sculpture, 108′ long × 24′ high earth, concrete, and bricks, 1976.
ENGINEER: Enrique Flores

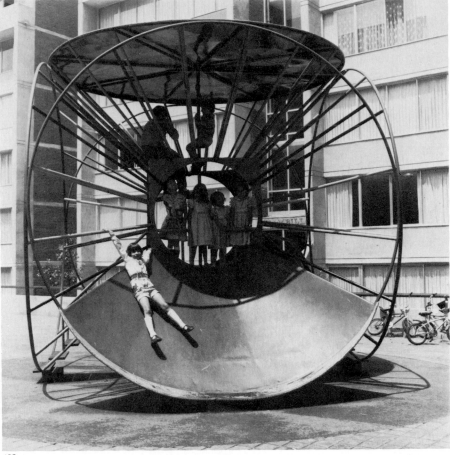

133

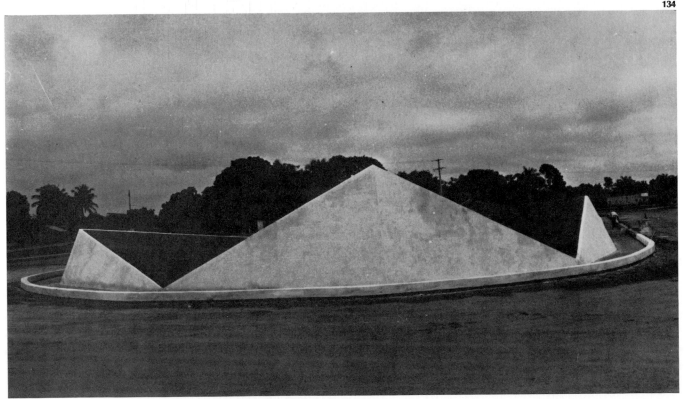

134

Comments by Joaquin Sanchez Macgregor, coordinator and director of the Center of Spacial Sculpture, National University of Mexico:

This project consists of sixty-four triangular equal prism-modules (4 meters in altitude and 9 meters in base) made of cement, which are supported by a circular platform made of volcanic lava. The exterior diameter is 126 meters, and some of the points are 8.5 meters high.

The four entrance doors correspond to the four cardinal points, and each door is 5.44 meters at the exterior and 3.78 meters at the interior. The separation between the prisms is 2.72 meters at the exterior, and 1.90 meters at the interior.

The platform and the prisms are practically completed, and the artists are now working on the interior ring, adapting its natural platforms to make them useful for cultural events.

The circular floor plan was a most ambitious model for these six sculptors to have chosen. Converging on the geometric center of the floor, each triangular segment of the circle will display the individual style of the sculptor. However, one will not necessarily be an offshoot of the others. This illustrates the idea of unity in diversity, or integrated pluralism. In this way, respect for the harmony of the whole does not demand the sacrifice of individuality. On the other hand, the circle (with access to the central crater by way of its respective triangular passages) may be drawn within a quadrangular enclosure: each intervening space will display subsurface or surface sculptings by the six sculptors.

Beyond the earthen wall (the university stadium is also earthen), which has sloping surfaces on its external face (another link with the pre-Columbian past), there will be enough space to create or display the works of other sculptors.

NATIONAL UNIVERSITY OF MEXICO, CAMPUS
Mexico City, Mexico

ARTISTS: Helen Escobedo, Federico Silva, Manuel Felquerez, Mathias Goeritz, Hersusa, Sebastian (this is the first nucleus of sculptors), "Center of Sculptural Space."

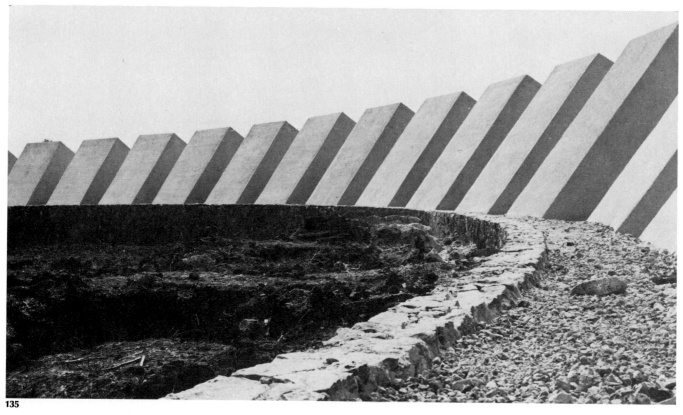

135

136

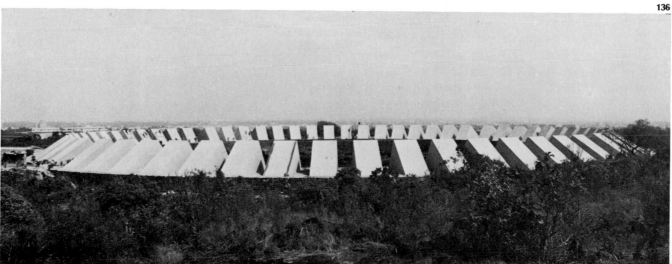

137

HARBOR
Auckland, New Zealand

ARTIST: Helen Escobedo, "Signals," 45' high tubular aluminum slotted through steel I-beams, 1971.

138

IBM HOUSE, THE TERRACE, FOYER
Wellington, New Zealand

ARTIST: Tom Taylor, untitled, sculpture, 11' high × 14' long austun rustproof metal, painted brown, 1971. (Sculpture was a winner in a competition of New Zealand and Australian artists.)
ARCHITECT: Howard Stacy of Stephenson and Turner, Architects

Artist Helen Escobedo comments:

The sculpture consists of four vertical ladders set back one from another. The ladders have a 4-foot sway at the top, which creates a moire pattern when seen from afar during the windy season. I chose a structure that can be seen through so as not to interfere with a magnificent view of ships, cranes, and harbor movement, but rather form part of it all; it is painted white with slanted bands of yellow, red, gold, and blue. "Signals" is a permanent piece commemorating Auckland's golden jubilee—the product of an international sculpture symposium for which five sculptors from the Pacific Basin were invited to build a sculpture. Mine is the Mexican contribution.

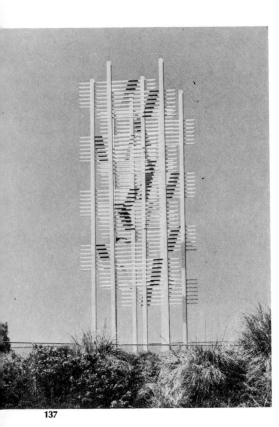

137

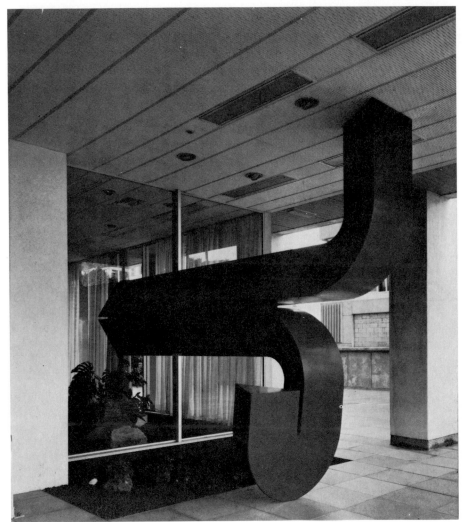

138

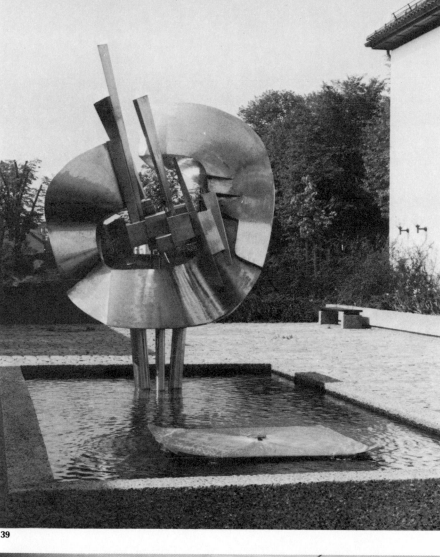

139

139

PUBLIC SQUARE
Town Hall, Mandal, Norway

ARTIST: Jorgen Uthaug, ''Expansion,'' sculpture, 12' high
 stainless steel, 1977.
ARCHITECT: Halfdan Wendt

140

STOVNER SUBWAY STATION
Oslo, Norway

ARTIST: Nils Kare Aasland, untitled, two reliefs, each
 approximately 6' in diameter, wood, 1976. (More work
 remains to be executed for mural frieze about 69' long.)

141

AKER HOSPITAL, COURTYARD
Oslo, Norway

ARTIST: Arne Vinje Gunnerud, ''Gerd and Froy,'' 9' high
 bronze, 1976.
ARCHITECT: Tore Leholt

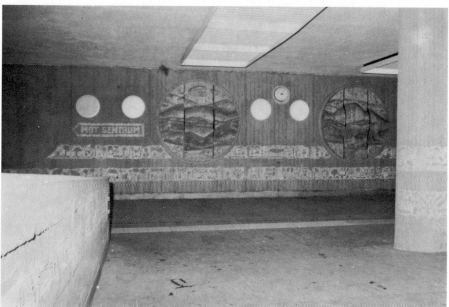

140

141

142

FAST FOOD CENTER, COURT
Makarti, Metro Manila, Phillippines

ARTIST: Arturo R. Luz, untitled, vertical sculpture, 4′ × 4′ × 17′ high; horizontal sculpture located in a pool measures 5′ × 6′ × 20′ in length.
LANDSCAPE ARCHITECTS: Ildefonso P. Santos and Associates, designers of mall and pavement pattern

143

TOWRE OF BELEM, GARDEN
Lisbon, Portugal

ARTIST: Joaquim Laranjeira dos Santos, "1° Travessa Aerea" (to the south Atlantic crossing), two main supporting stainless steel rods create the design.
ARCHITECT: Antonio Rodrigues Fernandes

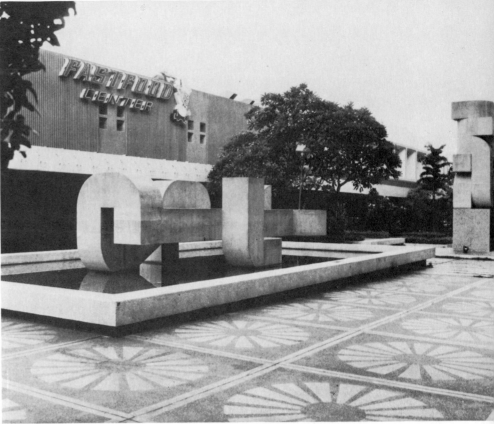

142

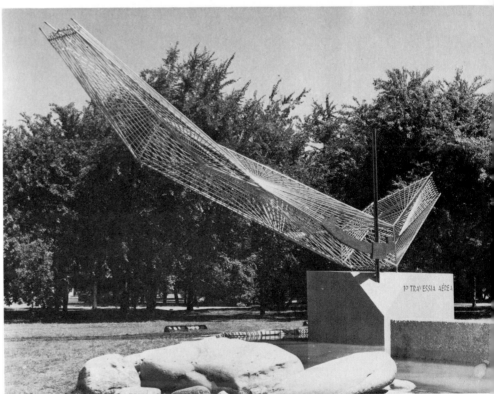

143

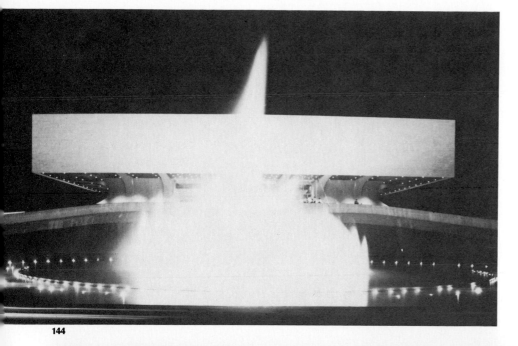

144

CULTURAL CENTER OF THE PHILIPPINES
Roxas Boulevard, Manila, Phillipines

ARCHITECT: L. V. Locsin and Associates (Dedicated to the arts, this building has a large theater, a gallery, and an art library.)

145

CULTURAL CENTER COMPLEX, PHILLIPPINE PLAZA HOTEL, LOBBY
Manila, Philippines

ARTIST: Arturo R. Luz, untitled, wool tapestry, 40' long, 1976.
ARCHITECT: L. V. Locsin and Associates

144

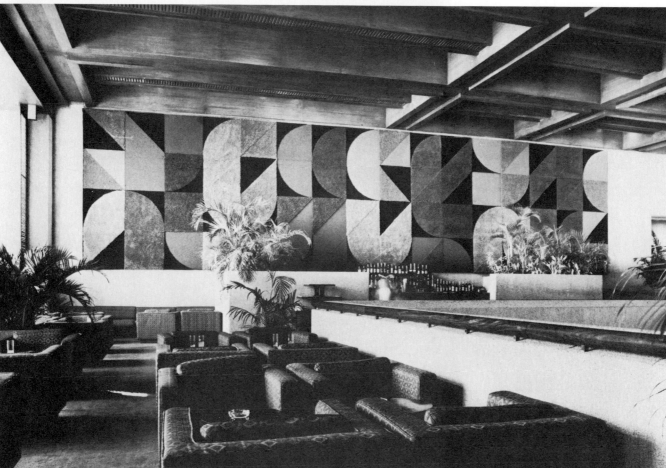

145

CENTRAL PLAZA
Aveiro, Portugal

ARTIST: Jorge Pinheiro, pavement of traditional native material, small stones of calcareous rocks and black basalt, hand placed on sand held together with molds.
ARCHITECT: Fernando Tavora

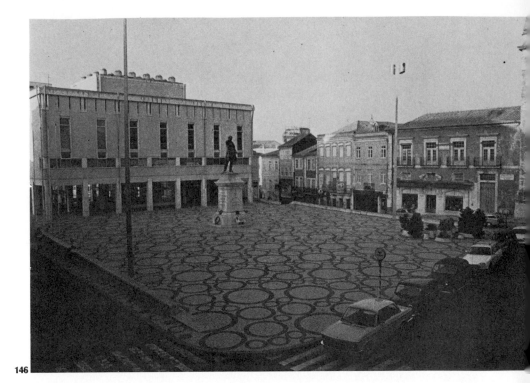

146

MAIN SQUARE, TOWN OF REDONDO
Portugal

ARTIST: Eduardo Nery, pavement, 162' × 139' black and white mosaics, 1971. (The eighteenth-century city hall building with a new court of justice building and a new fountain area for social gatherings.)
ARCHITECT AND URBAN DESIGNER: Gabinete Canon, LDA

The pavement of Praca da Republica (Republic Square) was designed in association with CANON, an architects' firm, who planned the urban setting as well as the new law court building in this square.

The mosaic pavement of black and white stones was set according to traditional Portuguese techniques. The pavement pattern exploits the asymmetry in the setting of an old square (the civic center of a small town in the center of Portugal), acting as the connecting link between the town hall building and a fountain—designed to be used for social gatherings—in a more sheltered corner of the square.

The mesh of the geometrical pattern tries to be flexible enough to accentuate the different circulation patterns of pedestrians and motorists and to integrate in the same urban space the fountain and the highly contrasting old town hall and new law court.

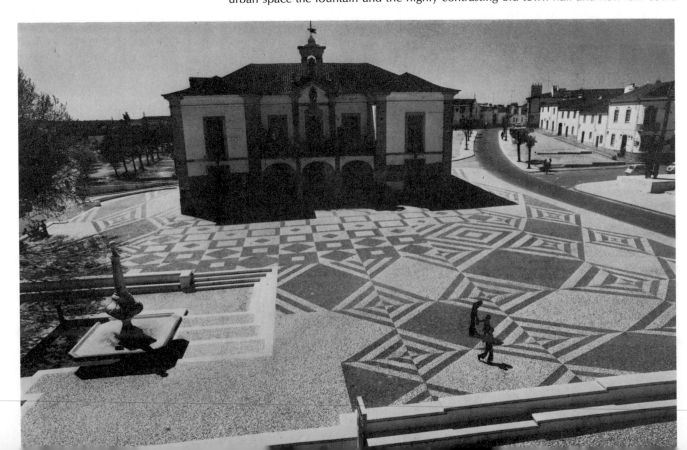

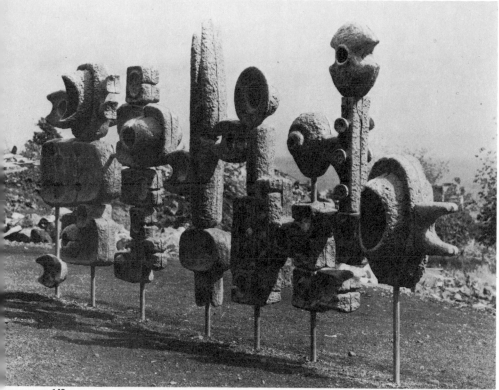

148

FUNCHAL HOSPITAL, GARDEN
Lisbon, Portugal

ARTIST: Maria Manuela Madureira, "Grito de Dor, Grito de Alegria," seven figures of ceramic material suspended in tubes of stainless steel, 1972.
ARCHITECT: Helairo

149

CALOUSTE GULBENKIAN FOUNDATION, LOBBY
Lisbon, Portugal

ARTIST: Artur Rosa, "Sculpture and Relief," 9' high × 45' long inox and plexiglas, extending on the exterior patio wall, 1970.
ARCHITECTS: Alberto Pessoa, Pedro Cid, Ruy Athouguia

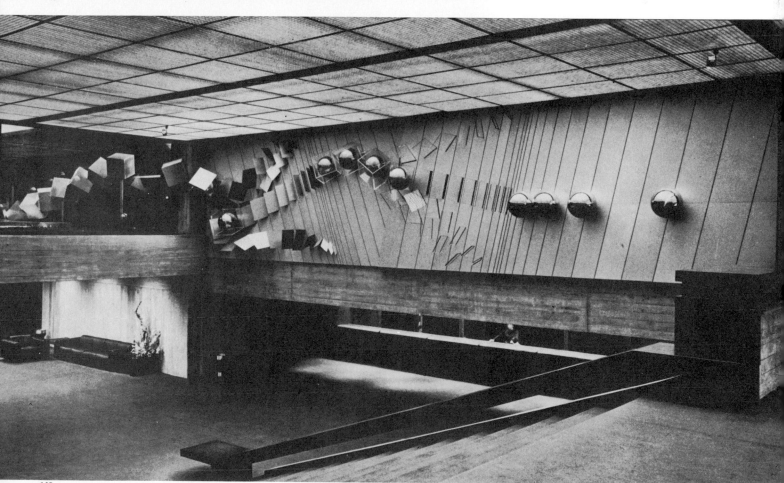

149

150

SCULPTURE PARK NEAR HIGHWAY

North Pietersburg, Transvaal, South Africa

ARTIST: Hannatjie Van Der Wat, "Abstract I '78" (homage to Pythagoras), 18' high painted tubular steel, 1978.

151

ESSELYN TOWERS, FOYER

Johannesburg, South Africa

ARTIST: George Boys, stainless steel environment, 1972.
ARCHITECT: Louis Louw and Partners

152

CONSERVATOIRE OF MUSIC, FOYER

Stellenbosch University, near Cape Town, South Africa

ARTIST: Larry Scully, "The Mandorla Murals," height varies from 11' × 20' × 150' long, oil on canvas painted in the studio and cut and collaged on site in the final composition. The shapes which receive these canvasses are in relief to a depth of 5". (Wood, chicken-wire, and then plastered.) The entire surface was covered in hessian and the cut canvasses inserted edge-to-edge to form a continuous flow.
ARCHITECT: Colyn and Meiring

Comments by the artist, George Boys:

Change and process are the basic content of my work. Figurative elements, details and perspectives of the foyer, people, and shaped polished steel planes are brought together in this metamorphic walk-through environment. At times the foyer is seen objectively, as a volume bounded by walls covered with nonfigurative shapes, and at times it is seen subjectively, as a reflection of the viewer's own image combined with aspects of the foyer. These elements are synthesized into new configurations. Static and moving figures are an integral part of the foyer situation and are therefore important elements in a changing process.

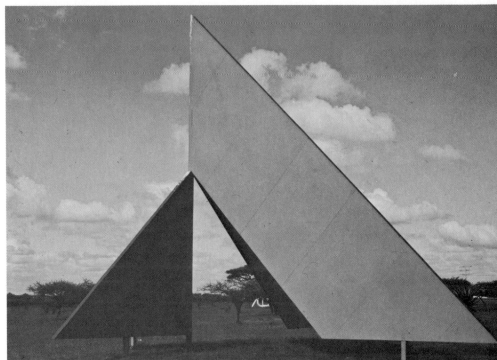

150

151

152

154

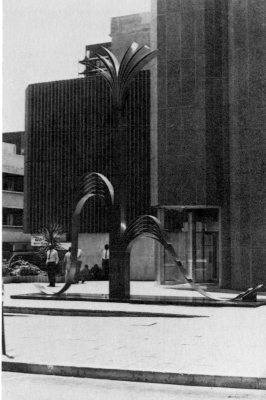

153

EXCHANGE SQUARE
Johannesburg, South Africa

ARTIST: Aileen Lipkin, "Growth," 24' high stainless steel, 1976.

According to Esmé Berman, director of Art Institute, South Africa, Villa's style has developed along a consistent organic line, governed by a rhythmical swing between two major sculptural procedures—modeling on the one hand, and assembling on the other. In his early work, Villa was much influenced by the style of Rodin. Under the influence of the strong South African sunlight, which casts black shadows and throws shapes into stark silhouette, he gradually simplified his forms. The central theme of all his work is man. To the objective image, he has added motifs extracted from the landscape and elements which speak both about the age-old mysteries of Africa and about the technological age in which we live.

154

PUBLIC RESORT
Warmbatus, Transvaal, South Africa

ARTIST: Edoardo Villa, "Suspended Sculpture," tubular steel, 1977.

155, 156

HYDROELECTRIC POWER PLANT
Proaza, Asturias, Spain

ARCHITECT OF BUILDING (CONCRETE), INTERIOR
 DESIGN, SCULPTURES, AND MURAL PAINTINGS:
 Joaquin Vaquero Palacios, building inaugaration, 1972.
CONSULTING ENGINEER: Pedro Colmanero

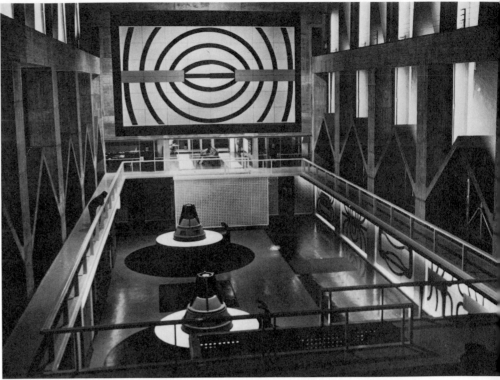

155

156

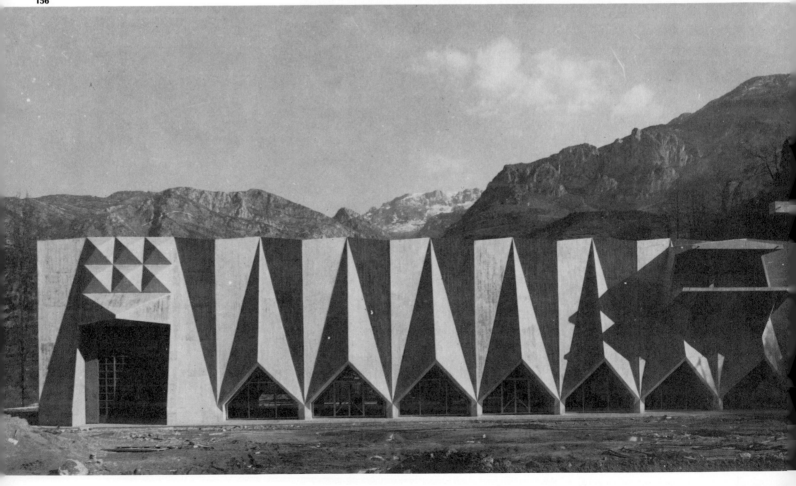

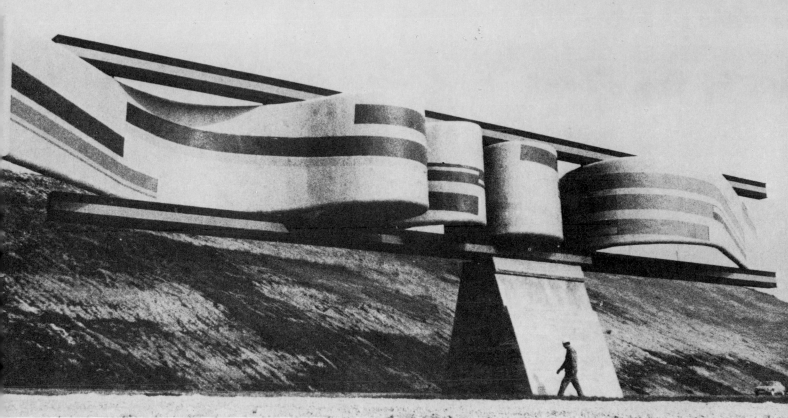

157

This monumental sculpture marks the confluence of the three branches of the highway. It is considered to be a kinetic form that "moves optically" while seen from the car. It is painted on both sides with a strong graphic mural that reinforces the effect of the irregular undulations in two yellows and two blues. Some of the lines are painted in colored reflecting paint, which reflects car lights in the night.

157

MONUMENTAL SCULPTURE, "Y" HIGHWAY CROSSROAD

Uniting Cities of Oviedo, Gijon, and Aviles, Asturias, Spain

ARTIST: Vaquero Turcios, 9' high × 210' long × 1' wide polyester and glass fiber on steel, between two weathering steel beams, 99' long, the whole standing on a concrete base 12' high, 1976.

158

HIGHWAY MONUMENT TO THE REVOLUTION

Podgaric, Yugoslavia

ARTIST: Dusan Dzamonja, sculpture, concrete and metal.

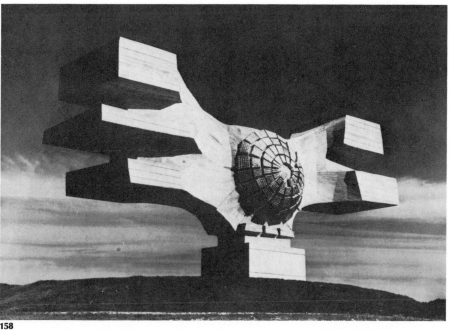

158

PLAZA DE COLON, CITY CENTER

Madrid, Spain

ARTIST: Vaquero Turcios, "Monument to the Discovery of America," sculpture, in sections, 30' high × 270' long × 36' wide, reddish color, pink-grey concrete, 1977. (In foreground, the century-old monument to Columbus; in background, the new monument.)
ARCHITECT: Manuel Herrero Palacios

159

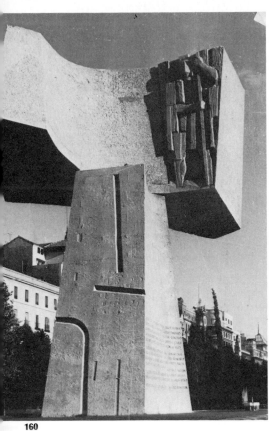

160

Comments by the sculptor, Vaquero Turcios:

The city of Madrid has a main axis: La Castellana Avenue. Along it there are several plazas: Atocha, Neptuno, la Cibeles, Colon, Castelar.

The Plaza de Colon (Columbus Plaza) had a monument in its center, a Gothic revival column, with the discoverer's statue on the top, built in 1885. Next to this plaza there was a block of buildings, most of them industrial, belonging to the government. The entire block was given to the city of Madrid to make into a garden and open area by tearing down the existing buildings.

The new plaza area, covering 470,000 square meters, provides for a new monument, which consists of three sculpture volumes. An underground area includes a cultural center with theater, conference rooms, large exhibition gallery, restaurant, offices and four levels of parking. On the plaza's landscaped areas are olive trees, pines, cypresses and cedars.

Manuel Herrero Palacios, the architect and urban planner in charge of the parks and gardens of the city, commissioned the project. The concept was to create a long, tall, and narrow wall-type screen. This wall consists of four differently oriented segments with convexed and concave movements that create a light-and-shadow rhythm and allow breakthrough views, both from the garden and from the street. A 7-foot-high platform, serving as a base for three of the four volumes, is accessible from both sides, permitting an approach to the monument segments and enabling one to read the inscriptions or to sit and walk freely.

The three volumes on the platform have a median height of 23 feet. The fourth volume, standing on the ground level, is much higher. It is composed of two segments of wall superimposed and reaches 51 feet high.

It was built in concrete, using a red stone and mixing brick powder in the mortar, so as to achieve a final color of pale terracotta. The surfaces were worked to create different color and texture zones.

The structure, with bold cantilevers, some of 12 meters, was engineered by José Enriqué Bofill. The building works were directed by Jesus Luzuriaga.

It was my responsibility to thoroughly research the subject of the discovery of America. I started with the old astonishing prophecies of the first-century Roman philosopher Seneca (who was born in Spain) and the seventh-century prophecies of Isidora de Sevilla as well as the pre-Columbian prophecies of the "discovery of America" by the Maya and the Aztec. The story continues with Columbus's struggle to achieve his ideas in seven long years of stubborn fight in Spain. During these seven years he was helped by a small number of persons who had a decisive influence on his success. Some of the them are well known, like the friars of La Rabida or Columbus's colleague in navigation, Martin Alonso Pinzon. But other names have been completely forgotten at the popular level. Nobody knows, for instance, that the one who financed the discovery of America was not Queen Isabella but a man of Jewish origin, minister of finances to King Fernando, Luis de Santangel. He was, with Juan Cabrero, Diego de Deza, and Gabriel Sanchez, one of Columbus's closest friends, and they personally convinced the King to back the journey. But their names, I repeat, are always forgotten, probably because they were "uncomfortable" facts to fit into the official version of the story which has been repeated through the centuries. This official version gives the main role to the Queen. Those other names, most of them of Aragonese and Jewish descent, were obscured to the advantage of Isabel and the Castilians. I am very proud to have been able to give them their due honor, and their names are written in large capital letters in the heart of the monument.

Beside these names I was able to put, for the first time in a monument to the discovery of America, the names of all the men in the crews of the three "carabelas." They are known thanks to the research of an American historian, Miss Alice B. Gould, who dedicated her life to this study. The very words of the diary of Columbus on the day of the discovery are also recorded within the monument.

The monument has a double meaning: the megalithic commemoration of the historical event as well as the commemoration of a supposedly well-known story in its *real dimension*—rich, popular, and dramatic.

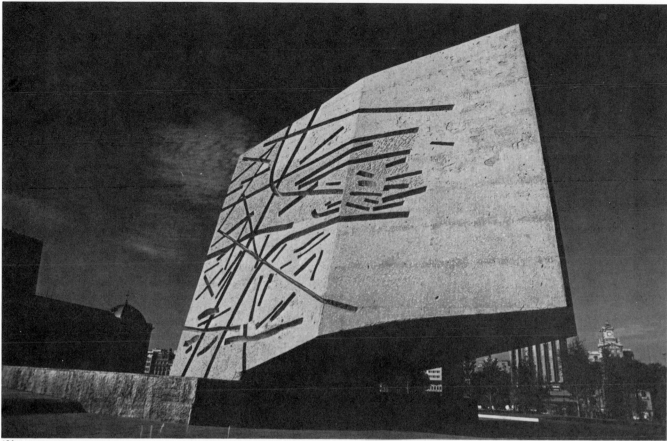

161

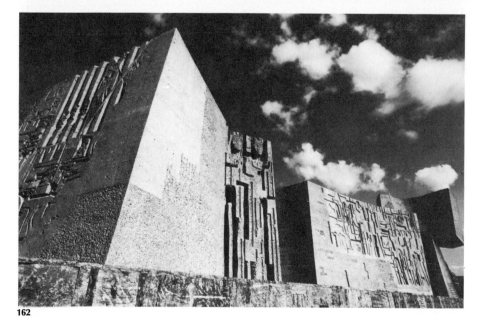

162

161, 162

PLAZA DE COLON, CITY CENTER

Madrid, Spain

ARTIST: Vaquero Turcios, "Monument to the Discovery of America," sculpture, in sections, 30' high × 270' long × 36' wide, reddish color, pink-grey concrete, 1977.
ARCHITECT: Manuel Herrero Palacios

163

CEMETERY, ENTRANCE
Bottmingen, near Basle, Switzerland

ARTIST: Erwin Rehmann, "Tree-Stump Figure," 20" high × 11' × 11' bronze, 1976.

164

CANTON THURGOVIA HOSPITAL, GARDEN POND
Munsterlingen, on Lake Constance, Switzerland

ARTIST: Erwin Rehmann, "Plane Pond Span," pond diameter 27', sculpture diameter 36', bronze, 1973.
ARCHITECT: Bosshardt and Stuckert

165

TRAMWAY STATION, BLEICHERWEG
Zurich, Switzerland

ARTIST: Erwin Rehmann, "Sculptured Island," 27' × 18' bronze, 1975. (Water level is 18".)

163

164

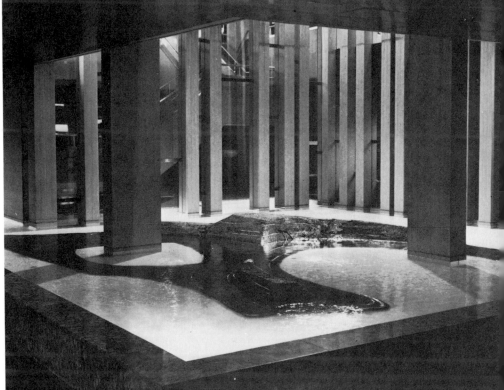

165

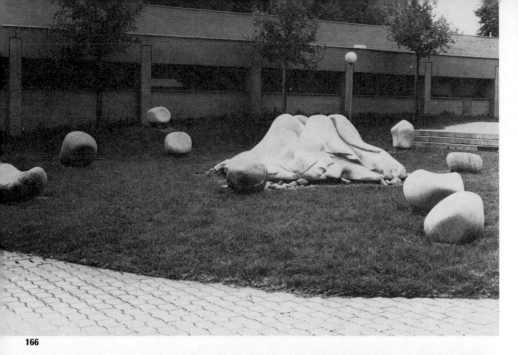

166

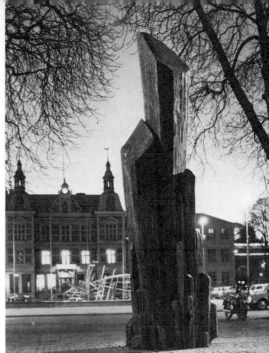

168

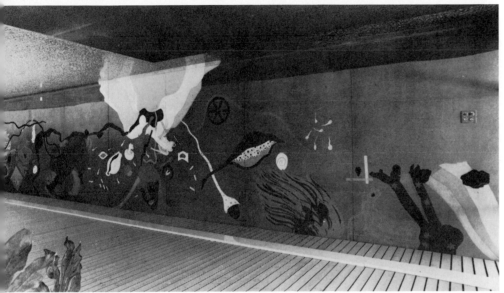

167

166

UTENBERG SCHOOL CENTER, FOUNTAIN ENTRANCE
Lucerne, Switzerland

ARTIST: Andreas Gehr, volcano form made of rose marble in which water bubbles and flows slowly down the surface; fountain is surrounded by eleven differently colored stones which serve as seats. Olga Zimmelova, wife of Andreas Gehr, created a concrete wall mural inside the entrance of the auditorium (not shown). This husband-wife team won first prize in the school's competition, 1976.

167

UTENBERG SCHOOLCENTER, AUDITORIUM ENTRANCE
Lucerne, Switzerland

ARTIST: Olga Zimmelova, "Vulkan," mural, 8½' × 36' painted with mineral color on concrete wall, 1975.

168

MUSEUM, PLAZA
Kristianstad, Sweden

ARTIST: Folke Truedsson, "Sinfonia," 18' high bronze.

169

CEMETERY
Zollikerberg, Switzerland

ARTIST: Charlotte Germann, untitled, sculpture, red concrete, 1975.
ARCHITECT: Louis Perriard

170

PUBLIC PARK
Lake of Zurich, Switzerland

ARTIST: Henry Moore, "Sheep Sculpture," 12' high × 19' long bronze, 1976. The pyramidal office building in the background (the Ferro House) is by architect Justus Dahinden. (The city of Zurich has a law mandating that 1½ percent of the construction costs of public buildings be spent on art.)

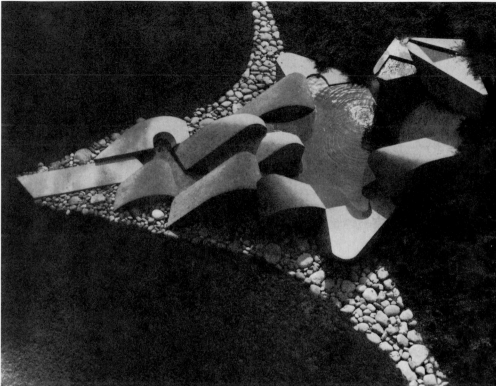

169

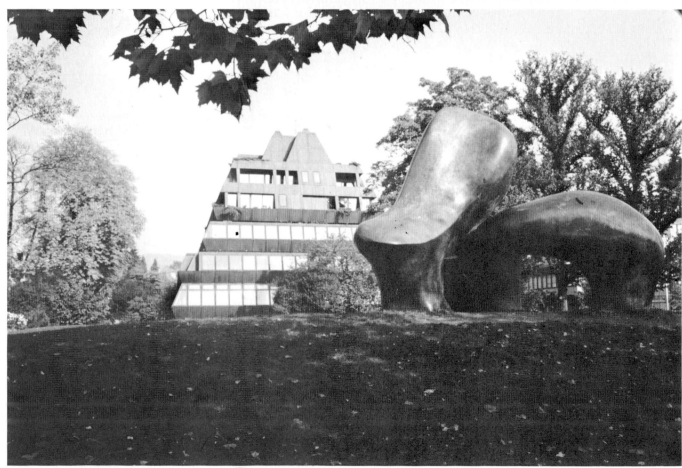

170

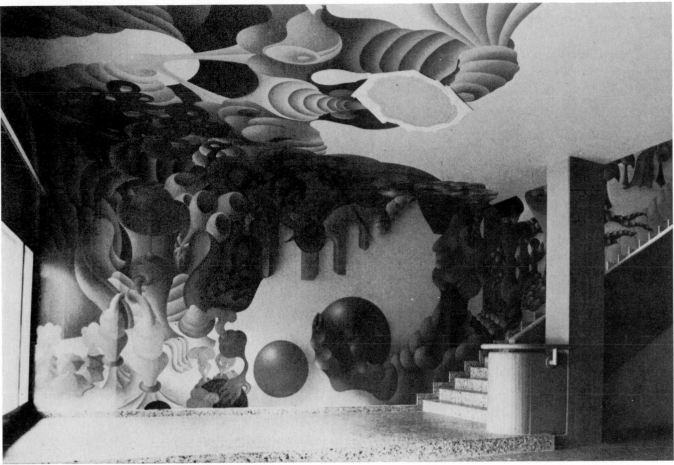

171

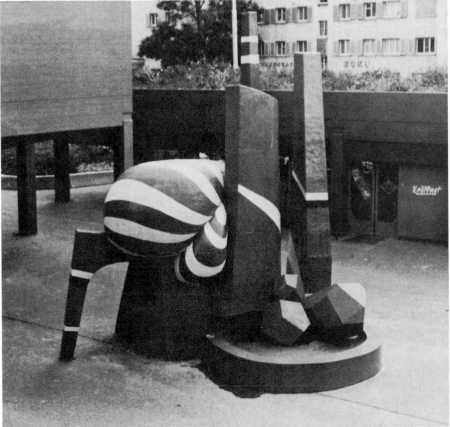

172

171

CITY RECREATION CENTER, LOBBY
Zurich-Oerlikon, Switzerland

ARTIST: Josef Egger, untitled, wall and ceiling mural, 2000
 ft² area, oil and acrylic on stretched canvas.
ARCHITECT: Funk and Fuhrimann

172

PUBLIC SQUARE
Zurich, Switzerland

ARTIST: Wilfrid Moser, untitled sculpture, polyester and
 concrete painted blue, white, and black.
ARCHITECT: Funk and Fuhrimann

TRAINING CENTER FOR VOLUNTEERS FOR UNDERDEVELOPED COUNTRIES (PEACE CORPS), PASSAGEWAY

Berlin, West Germany

ARTIST: Ursula Sax, "Allee," 13' high wood, 1977. (A project of the Federal Republic of Germany.)
ARCHITECTS: A.G.P. Architects Collaborative

174

CITY PLAZA

Wiesbaden, West Germany

ARTIST: O. H. Hajek, plaza sign, 13' × 13' × 20' steel 1977.
ARCHITECT: Andreas Plattner

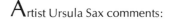

Artist Ursula Sax comments:

Art presents mute inner meanings in evocative images, meanings that can be faced and interpreted by word, music, or fine art. Thus man proceeds from a condition of animal-like simplicity to full awareness. Art is a process that continually creates a new order or arranges new phenomena within this order.

The formula found by another era is important to us as the cultural background in which we live, but it can never offer an answer to the issues of the present time. Art is a process of assimiliation that enables us to react now and to be directed toward the future.

I made my first plastic creation as a child, and it seemed to me to be a miracle that I myself was able to create some little reality, some new three-dimensional object that had never existed on the earth before. This magical process impressed and excited me very much, and this same astonishment is still at the base of my work.

173

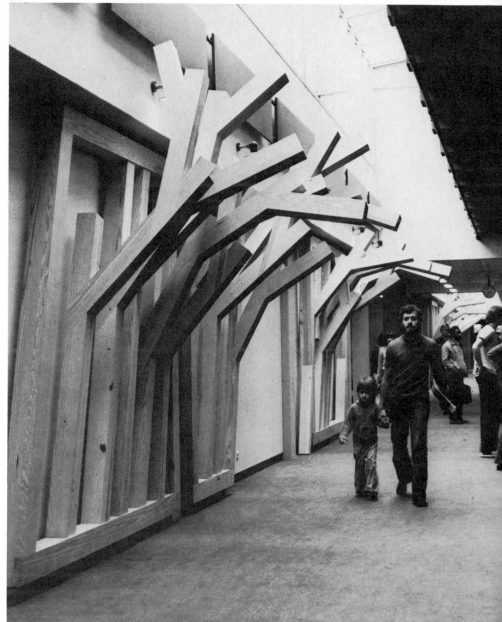

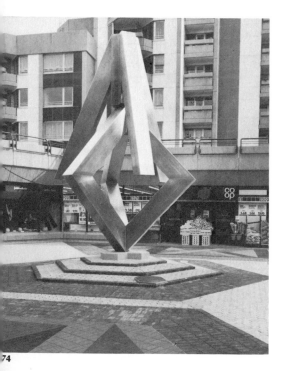

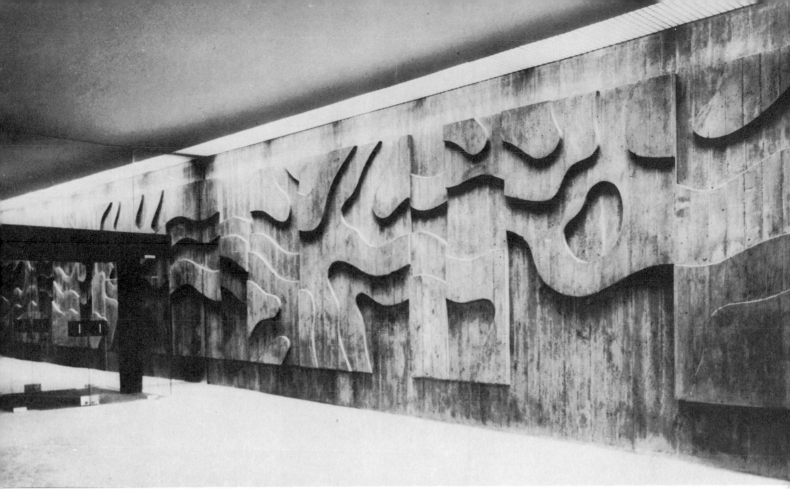

175

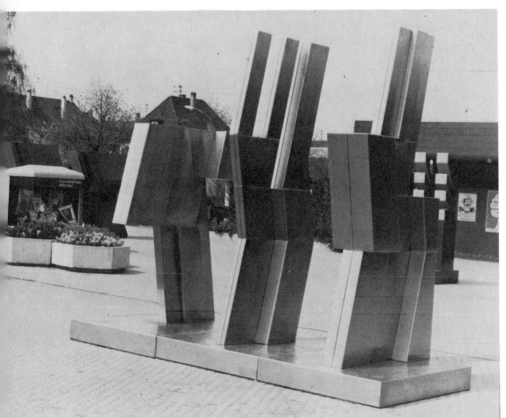

176

175

COMMERCE BUILDING, FOYER
Berlin, West Germany

ARTIST: Ursula Sax, untitled, 12' high × 60' long
concrete, 1972. (Funded by private interest.)
ARCHITECT: Werner Duttmann

176

PLAZA
Near Stuttgart, West Germany

ARTIST: O. H. Hajek, "3-Gliederung," three-piece
sculpture, 10' × 12' × 5' steel, 1975.

ROSENGARTEN THEATER AND CONFERENCE CENTER, PLAZA

Mannheim, West Germany

ARTIST: Andre Volten, "Luftbrunnen" (air-conditioning system), involving twenty-five cylinders, each 9' high arranged in two lines, twenty-two cylinders 16" and 28" high, diameter 28" (one column 18' high stainless steel, not shown in this photo), 1974. (Commissioned by the city of Mannheim.)

The solution is a daring combination of functionalism with an artistic statement of formal beauty.

The twenty-five air-conditioning outlets are rigidly arranged in two lines, one group veering away from the other in a V-formation, the other in a series of A's. From the side these create a deep trough, but frontally, in contrast to monumental formality, the leaning cylinders crisscross in playful, rhythmic patterns. On both sides of these lines, sections of columns, at different heights, are arranged as seats. On the nearby terrace, a tall articulated column stands in solitary attendance, uniting the building, the plaza, and the trees of the garden.

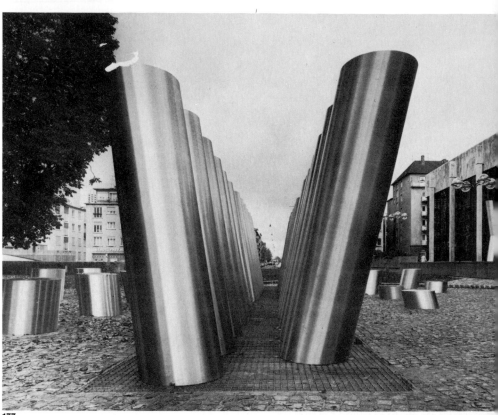

177

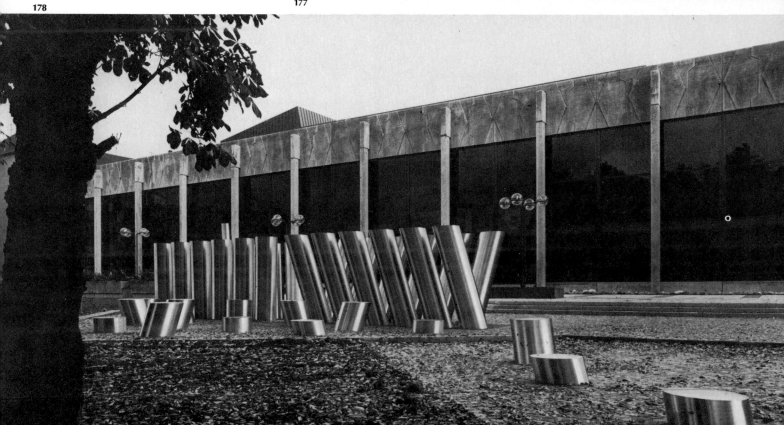

178

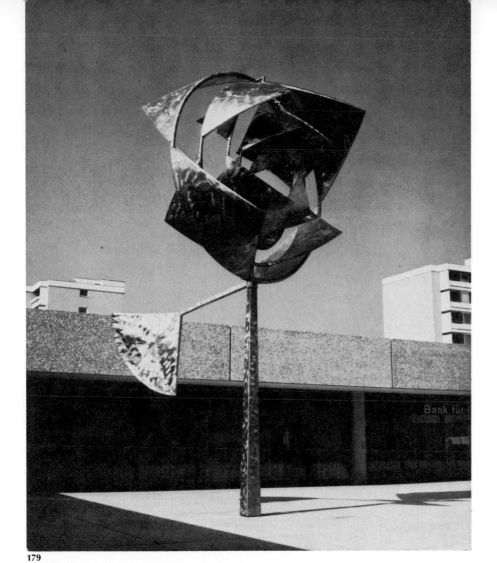

179

179

NEUE HEIMAT BAYERN, PLAZA
Munich-Perlach, West Germany

ARTIST: George Rickey, "Space Churn with Spheres," 26'
 high steel, 1970.

180

UNIVERSITY CLINIC
Berlin, West Germany

ARTIST: George Rickey, "Two Rectangles Vertical
 Gyratory," 25'7" high stainless steel, 1970.
ARCHITECT: Curtis and Davis

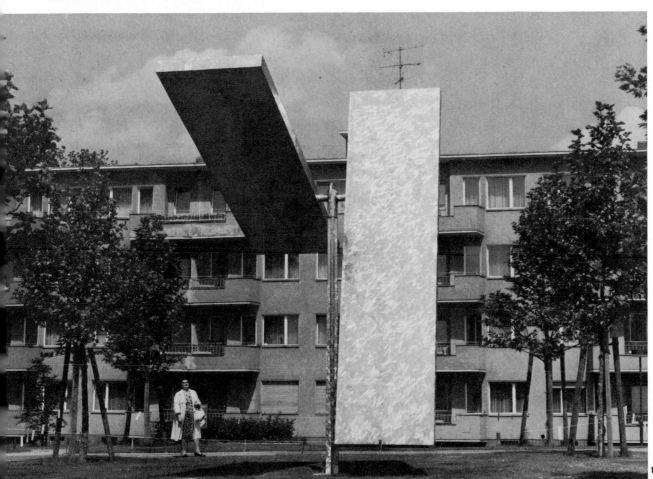

180

Commissioning the Artist

The methods of commissioning an artist vary among different agencies, institutions, and business enterprises. Although in some instances we have explained the procedures by which artists are engaged, it will be helpful to enumerate here more fully the steps to be taken when the commissioning of art is contemplated. The General Services Administration (GSA) in its program of art-in-architecture uses the following method of selecting artists.*

■ When the architect-engineer contract negotiations take place, the architect is informed that one half of one percent of the estimated construction costs will be allocated for fine arts. He is encouraged to submit an art-in-architecture proposal as part of his overall design concept. This proposal must include a description of the location and nature of the artwork(s) to be commissioned.

■ Shortly after the award of the construction contract, the GSA requests the National Endowment for the Arts (NEA) to appoint a panel of qualified art professionals to meet with the project architect for the purpose of nominating three to five artists for each proposed artwork. At least one of the panelists is to be from the area of the project.

. The artist-nomination panelists, who are appointed on an ad hoc basis for specific projects, and the architect meet at the project site with representatives of the GSA and the NEA to review visual materials of artists whose work would be appropriate for the proposed commission(s).

. The nominations are forwarded to the GSA by the NEA. After evaluation of the nominated artists' works by a design review panel in the GSA's Public Buildings Service (PBS), the GSA administrator selects the artist(s) for the particular project. The GSA and the artist(s) then negotiate a fixed-price contract for the design, execution, and installation of the artwork. Artists' concepts are reviewed and approved by PBS's design review panel.

Artists wishing to receive GSA consideration for art-in-architecture projects should send a resume and 35-millimeter slides of their work to:

Art-in-Architecture Program
General Services Administration
Washington, DC 20405

When artists are commissioned by state authority for state public buildings, procedures vary. In Michigan, a Special Commission on Art in State Buildings, appointed by the governor, used the following procedure for commissioning an artist.** The commission's subcommittee on design selected a suitable site near the state capitol complex. From a list of twenty-one art professionals, it chose a five-member jury to recommend three artists for the project. The jurors, after preliminary consideration of some forty major artists associated with large-scale public sculptures, narrowed the list to three, and after carefully screening their works, ranked them in order of preference. When the top-ranked artist indicated a willingness to create a work of art within the suggested guidelines, he was asked to prepare a scale model of his concept with cost estimates for final approval. In this instance, because of the complexity of the project, the commission awarded separate contracts to the sculptor, the structural engineer, and the general contractor for construction and erection of all sculptural elements.

Among the cities in which civic leaders recognized the importance of public art and established funding for it by ordinance, Seattle has an impressive record of uninterrupted activity since 1971. To administer

the program, the Seattle Arts Commission was established. Appointed by the mayor (subject to city council approval) are fifteen citizens who serve two-year terms as volunteers. The commission is charged by a 1971 city ordinance "to promote and encourage public programs to further the development and public awareness of and interest in the fine and performing arts in Seattle. . . ."*** The commission established three methods of selecting arts: an open competition, a limited competition, and direct selection.

The Art in Public Places Committee names an ad hoc jury, usually of from three to five people, for each project. Over the years more than fifty people of diverse backgrounds, including artists, architects, community representatives, city employees, collectors, and art historians have participated in the selection process. Because of the unique character of each project, jury selection is a key to success. Jurors are chosen for the special skills, knowledge, or concerns that they can bring to the complex decision making.

Each jury receives background information on the project, including site plans or a site visit, and a review of the sponsoring department's special concerns. Serving as a juror requires patience and dedication, and the level of professionalism required is recognized by the fact that jurors not employed by the city are compensated.

In the open competition, a prospectus describing the site, budget, and nature of the artwork to be commissioned is published, with a call for proposals from artists. Artists are not paid for proposals, which are returned following jury review. The jury meets to review the proposals, and recommends an artist for the commission.

In a limited competition, an announcement of the proposed project and commission is published; artists are requested to place slides on file at the registry of northwest artists at the Henry Gallery and to write a letter indicating interest in the project to the Seattle Arts Commission. The jury reviews slides and material at the registry, although they are not limited to registered artists in their considerations. Several artists, usually between three and five, are selected by the jury to prepare proposals. Artists are paid for submission of proposals, which are retained by the city. The jury then reviews the proposals and recommends an artist to be commissioned.

In a direct selection process, this is handled in the same way as a limited entry, except that the jury chooses only one artist, who then submits a proposal prior to final award of the commission. The contract form used between the city and the artist in Seattle can serve as a guide for similar agreements in other cities, with modifications for individual conditions.

Commissions planned by corporations, developers, or individuals can be implemented more directly. The most important thing is that there must be a mutual understanding between owner and architect on the necessity of incorporating art as part of the entire building concept and of budgeting an adequate amount of money for it. (This applies to existing buildings also.)

There are several ways to secure the services of an artist. If the architect is considered to be sufficiently knowledgeable in the art field, he or she may commission the artist who could handle the assignment successfully. Presumably, this artist has performed well in the past and is dependable. Architect and artist should meet at the very inception of the project to discuss location, size, material, scale, and cost of the commission. It is necessary that the artist submit a scale model or drawing for approval by both the architect and the owner. At this point, the difference of opinions of art expression is apt to come to the fore. It is here that the architect should guide the owner in reaching an understanding and acceptance of the model. Should the preliminary model still be unacceptable, the artist may have to submit revised concepts until complete agreement is reached.

*U.S. General Services Administration, Washington, DC, Publication March 1, 1979.
**This special commission, the first of its kind in Michigan was created by executive order of Governor William G. Milliken on July 7, 1975.
***Seattle City Ordinance, 1971.

Another method of commissioning an artist is to have a limited competition by inviting three or four artists to submit their concepts in the form of models or sketches. In this instance, each artist is paid an agreed amount for his or her preliminary work. Often the understanding is that the successful competitor credits this preliminary remuneration toward the total cost of the commission. Here again, the final choice is made by the architect and the owner.

Another method is to set up an art committee consisting of the architect, the owner or a representative, and several recognized art authorities, for example, the director of a museum, the head of a university fine art department, the dean of an architectural or urban planning school, or other persons in this field who are acceptable to architect and owner. The procedure thereafter is similar to that previously described.

I suspect that one of the reasons why architects and owners shy away from considering art for their buildings is that they generally know only a few outstanding artists whose fees are higher than their budgets allow. The fact is, however, that there are many young and talented artists in every region who can be sought out to execute commissions. From my own experience I have found that these young artists, once given a chance, show competence and responsibility. In many cases, such a commission has been the first big step toward a successful art career. I am certain that the experience can be repeated in many parts of this country and elsewhere.

Another reason why architects are reluctant to consider working with artists is that such collaboration adds a new responsibility to the many they already carry. To be added to the many pressures of deadlines and budget limitations, collaboration with an artist has to be a labor of love and the product of a conviction that art is an essential part of the building concept. Some architects whose buildings suggest sculptural forms do not feel a need to add or integrate other artwork. This may be well justified. It is also advisable to omit artwork where it serves as the only redeeming element in an otherwise poorly designed building.

Whether a new or an experienced artist is being engaged, there must always be a businesslike approach in reaching a working arrangement. The following items need to be considered:

1. Preparation of detailed specifications for the artwork, similar to specifications for the building trades.
2. Guarantee by the artist of the permanency of the materials to be used and of functional operation (as in the case of fountains).
3. Definite arrangements for the installation of the artwork on the premises.
4. Time limit for completion of the project.
5. Periodic visits by the architect to the artist's studio to check progress and to solve unforseen problems.

Detailed specifications are very important for a clear understanding of the proper materials to be used, the required finishes, and all component parts, whether mechanical, electrical, or other. Good specifications make it possible to avoid misunderstanding and friction between the parties.

To protect the owner's interest, liability insurance should be carried by the artist or by the structural engineer responsible for the soundness of the design (this applies especially to large concrete and steel works requiring special foundations, special framing, and reinforcing).

In all cases the artist should provide a written guarantee for a two-year period. The intent of this guarantee is to stimulate the artist to study the permanency of materials and, if necessary, to consult specialists in the field. This is especially important when artwork is exposed to the weather—regardless of climate. The problem of permanency applies to all materials, such as marble, welded steel, aluminum, paint finishes, plastics, mosaics, and any other media.

As for the installation of art work, the artist should be responsible for delivering the work to the premises in good condition, but the installation itself should be handled by the general contractor's staff. Because the artist has limited contact with the various trades involved in the installation, and because the general contractor has all the subtrades at his disposal, this provides for a mutually satisfactory arrangement.

The time limit for completion of the artwork is a very important factor. The completion of a building project is a big event in every owner's experience. The artwork, which the owner may consider to be a "luxury item" in the building costs, serves as an additional highlight at the opening festivities of a new building. Obviously, lack of completion on time causes a big letdown for owner and architect alike.

It is important for the architect to keep in touch with the artist during the entire period, but especially at the beginning, when the general character of the composition begins to take shape. The architect should visit the artist's studio periodically to discuss the problems and, if required, to assist the artist with technical know-how. Even though the artist should have freedom to develop a theme, the concept needs to relate to the architectual surroundings and to the total environmental character.

This chapter deals in detail with the practical aspects of commissioning artists because this is an important element in achieving the goal of this book—the integration of art into architecture and the total environment. A mutual understanding and effective working relationship between architect and artist may also serve as a bridge between the public and the artist.

In closing, I would like to repeat what I said in *Art in Architecture:* The eternal quest of man for beauty will find its channels of expression in a multitude of art forms. It is a responsibility and a challenge for civic leaders as well as architects and artists to heed this human need and do the utmost to create surroundings where art becomes an essential part of our daily lives.

Index

Aalborg, Denmark, Public Square, *color plate* 59
Aarhus, Denmark:
 Radio and Television Headquarters, 138
 University Physics Building, 138
Aasland, Nils Kare, untitled, Stovner subway station, Oslo, 189
Aberg, Anders, Stockholm subway station, *color plate* 99
Adelaide, South Australia, Festival Centre, 131, *color plates* 50 – 52
Aegina, Greece, Capralos residence, 155
Agam, Yaacov:
 La Défense, fountain, Paris, *color plates* 60 – 62
 "Hundred Gates," President's House, Jerusalem, 169
Akron, Ohio, University of Akron, 77
Albany, N.Y., Empire State Plaza, 18, 44
Alleaume, Bernard, Cergy-Pontoise, school entrance court, 154
Allentown, Pa., Lehigh University, 68
Ames, Iowa, murals, *color plate* 25
Amsterdam:
 Nederlandsche Middelstands-Bank, *color plate* 73
 Zeist Insurance Company, *color plate* 72
Anderson, Ruthadell:
 banners, Honolulu International Airport, 46
 "Group Eleven – 1977," Federal Building, Courthouse, Honolulu, *color plate* 11
Andrews, Oliver:
 "Column and Prism," fountain, Federal Reserve Bank Plaza, Cincinnati, 55

"Water Blade," fountain, Los Angeles Times-Mirror Newspaper Company, Costa Mesa, Calif., 55
Ann Arbor, Mich.:
 Federal Office and Courthouse Building, *color plate* 15
 University of Michigan, 66
Antonakos, Stephen, "Red Neon Circle," Federal Building, Dayton, Ohio, *color plate* 18
Antwerp, Belgium, Park at Middelheim, 132
Anuszkiewicz, Richard, wall painting, YWCA Building, New York, *color plate* 31
Arad, Israel, Panorama, 174
Arcadia, Calif., Santa Anita Fashion Park, Regional Shopping Center, 95
Artpark, Lewiston (Niagara Falls), N.Y., 56 – 57
Artrain, State of Michigan, 61
Ashkelon, Israel, garden, 175
Aspen, Colo., Anderson Park, Children's Playground, 99
Asturias, Spain, monumental sculpture, "Y" highway crossroad, 197
Atlanta Ga.:
 Martin Luther King Memorial Station, Rapid Transit Authority, 121
 Omni International Megastructure, 102
Auckland, New Zealand, harbor, 188
Aveiro, Portugal, Central Plaza, 192
Aycock, Alice:
 "And the World Takes Shape," Cranbrook Academy of Art, Bloomfield Hills, Mich., 78

"Ups and Downs or Hanging and Oscillating Spring," Cranbrook Academy of Art, Bloomfield Hills, Mich., 78
Azaz, Henri, "The Form Makers," Rosary College, River Forest, Ill., 83

Baber, Alice, "Swirl of Sounds: Ghost of the Banyan Tree," R. L. White Company, Louisville, *color plate* 45
Baird, Ron, "Wind Machine," Meteorological Building, Toronto, 53
Baker, George, "Nebraska Wind Sculpture," Nebraska Interstate 80 Bicentennial Sculpture Project, *color plate* 3
Balazs, Harold, "Seattle Project," Federal Building, Seattle, 20
Baldinelli, Armando, mural, Jan Smuts Airport, Johannesburg, *color plate* 89
Baltimore:
 Commodore John Rogers Elementary School No. 27, *color plate* 20
 Edward A. Garmatz Federal Building, U.S. Courthouse, Plaza, 24
 Furman L. Templeton Elementary School No. 125, *color plate* 21
 Greater Baltimore Medical Center, *color plate* 26
 Luther Craven Mitchell Primary Center No. 135, *color plate* 19
 Mayland Science Center, Promenade, 32
 wall, Wilkins Avenue and Payson Street, *color plate* 27
Barr, David, untitled Fairlane Shopping Center, Dearborn, Mich., Ill.
Barrett, Bill, untitled, Mercy College, Dobbs Ferry, N.Y., 75
Baroso, Haroldo:
 Monument to Youth, Culture, and Sport, President Medici Square, Rio de Janeiro, 136
 untitled, Shopping Center, Rio de Janeiro, 136
Bayer, Herbert, "Organ Fountain," Bruckner Concert Hall, Linz, Austria, 132
Beal, Jack, "History of Labor in American Industry," Department of Labor Building, Washington, D.C., *color plate* 17
Bearden, Romare, "Berkeley, The City and Its People," City Council Chambers, Berkeley, Calif., 47
Beasley, Bruce, "Red Welded Sculpture," Oregon International Sculpture Symposium, Eugene, 80, 81
Beaulne, Guy, 50
Beljon, J. J., 133
 fountain, City Center, The Hague, 160
 fountain, Utrecht University, 160
 fountain and plaza, Nymegen University, 161
Belle Épine Shopping Center, near Paris, 145
Belsky, Franta, "Totem," Arndale Shopping Center, Manchester, England, 141
Bennett, Douglas, "The Spirit of Christopher Columbus," Waterfront Park, Seattle, 40
Berkeley, Calif., City Council Chambers, 47
Berlin:
 Commerce Building, 205
 Training Center for Volunteers for Underdeveloped Countries (Peace Corps), 204
 University Clinic, 207
Berman, Esmé, 195

Bertoia, Harry:
 fountain, First National Bank, Tulsa, 92
 "Sounding Sculpture," Standard Oil Company (Indiana) and Amoco Subsidiaries, Plaza Pool, Chicago, 88
 untitled, Genesee Valley Center, Flint, Mich., 104
 untitled, University of Akron, Ohio, 77
Beyer, Richard S., "Waiting for the Interurban," Fremont, Wash., 60
Bezem, Naftali, President's House, Jerusalem, reception hall, 169
Biasi, Alberto, bronze sculpture plaque, elementary school courtyard, Rovigo, 178
Birmingham, Ala., South Central Bell Company, 90
Bjork, Karl Olov, Stockholm subway station, *color plate* 99
Black, Michael, Paul Julius Reiter, memorial statue, Royal Exchange, London, 140
Bladen, Ronald, "Vroom-Shhh," Marine Midland Center, Buffalo, N.Y., 93
Blatas, Arbit, "The Holocaust" and "The Quarry," Public Square, Venice, 178
Bloomfield Hills, Mich. (see Cranbrook Academy of Art)
B'nai B'rith Martyrs' Forest, near Jerusalem, 170
Bohlin, Annie, "People Seats," Downtown Public Square, Wilkes-Barre, Pa., 33
Bohlin, Peter:
 "People Seats," Downtown Public Square, Wilkes-Barre, Pa., 33
 "Petroglyph," Downtown Public Square, Wilkes-Barre, Pa., 33
Bolomy, Roger, "Sculpture for Meditation," Oregon International Sculpture Symposium, Eugene, 80, 81
Bolotowsky, Ilya, untitled, Social Security Administration, Great Lakes Program Center, Chicago, *color plate* 8
Bonet, Jordi:
 "Death," "Space," "Liberty," three walls, Performing Arts, Theater, Quebec, 50–51
 "Resurgence," Oceanic Plaza Office Building, Vancouver, 116
 untitled mural, Public Library, Edmonton, 116
Bonn, Ministry of Health Plaza, *color plate* 67
Bordeaux-Begles, France, College d'Enseignement Secondaire, 144
Bosch, Beatrix, "Knowledge in Motion," Stellenbosch University, South Africa, *color plate* 87
Boston:
 Boston Architectural Center, *color plate* 29
 India Wharf at Harbor Towers, 91
 Boston University, Campus, 70
Bottmingen, Switzerland, cemetery, entrance, 200
Boys, George, stainless steel environment, Johannesburg, 194
Brabrand, Denmark, Skjoldhoj Kollegiet, *color plates* 57, 58
Bradford, Peter, 52
Brasilia, Cathedral of Brazil, 137
Brenner, Art, "Atlas X," Sheraton Airport Inn, Philadelphia, 96
Brose, Morris, "Sentinel X," Capitol Park, Detroit, 65
Brownlee, Edward, "The Clouds of Pele," Honolulu International Airport, 46
Bruner, Barry, "Break Away," mural, Old Hat Neighborhood Center, Chicago, 58, 59

Buffalo, N.Y.:
Federal Building, 4
Marine Midland Center, 93
Bulfin, Michael, "Aldebar," Bank of Ireland, Dublin, 166

Cahn, Marcelle, "Spatial C," College Paul-Port, Is-sur-Tille, 147
Cajandig, Catherine, "Break Away," mural, Old Hat Neighborhood Center, Chicago, 58, 59
Calder, Alexander:
"La Grande Vitesse," Civic Center Plaza, Grand Rapids, Mich., color plate 4
"Universe," Sears Tower, Chicago, 87
Calgary, University of, 76
Campinas, São Paulo, Brazil, Museum of Contemporary Art, Annual Exhibition, 134, 135
Canberra, Australia, Treasury Building, Courtyard, 130
Cape Town:
Nico Malan Theatre Centre, color plate 88
Stellenbosch University Conservatoire of Music, 194
Capralos, Christos, residence, Aegina, Greece, stone sculpture, 155
Cashwan, Samuel:
"Hippopotamus," play sculpture, Oakland Mall Shopping Center, Troy, Mich., 106
untitled, Manufacturers National Bank Operations Center, Detroit, 94
Castell, Moshe, President's House, Jerusalem, reception hall, 169
Cergy-Pontoise, France, school entrance court, 154
Chagall, Marc, "The Four Seasons," First National Bank of Chicago, Plaza, 86
Chandigarh, India, City Centre, 165
Chapel Hill, N.C., Blue Cross and Blue Shield Building, 121
Charlotte, N.C., North Carolina National Bank Plaza, 93
Charlotte Amalie, St. Thomas, U.S. Virgin Islands, Federal Building, 32
Chiba, Japan, Chiba College of Technology, 180
Chicago:
Chicago Lawn community, 58
Dresden Bank, 100
First National Bank of Chicago, 86
Lincoln Mall, 103
Nielsen Plaza, 42, 43
Old Hat Neighborhood Center, 58, 59
Sears Tower, 87
Social Security Administration, Great Lakes Program Center, color plate 8
Social Security Administration Building Plaza, 7
Standard Oil Company (Indiana) and Amoco Subsidiaries, 88
wall painting, 4040 West Belmont, color plate 35
wall painting, 41st Street and Drexel Avenue, color plate 34
wall painting, 4338 West North Avenue, color plate 36
Christo:
"56 Barrels," Kroller-Muller Museum, Otterlo, Holland, color plate 68
"Running Fence," Sonoma and Marin Counties, Calif., 114 – 15
"Valley Curtain," Rifle, Colo., color plate 48
"Wrapped Walk Ways," Loose Park, Kansas City, color plate 49
Christoffersen, Frede, "Sol-efter-Billeder," Ranum Teachers Training College, Denmark, color plate 56
Cincinnati:
Cincinnatus Concourse and Forum, Urban Riverfront Park, 74

Federal Reserve Bank Plaza, 55
Clonmel, Ireland, Commercial Building, 164
Columbia University, New York, School of Law, 70
Columbus, Ind., Commons and Courthouse Center, 95
Columbus, Ohio, Federal Building, color plate 14
Comby:
"Clearsange," Lycée Technique d'État Louis Vincent, Metz, 150
"The Croncelhorbe," Auditorium de la Parc Dieu, Lyon, 150
Copenhagen County Hospital, Herlev, Denmark, color plates 53, 55
Costa Mesa, Calif., Los Angeles Times-Mirror Newspaper Company, 55
Costanza, John:
mural, American Molding Plastic Corporation, Mount Vernon, N.Y., 120
untitled, 200 Executive Hill Office Building, West Orange, N.J., 122
"Waterwall," Monsanto Corporation, Montvale, N.J., color plate 46
Cranbrook Academy of Art, Bloomfield, Mich., 78 – 79
Crawford, Elsie, bas-relief wood forms, Southland Center, Taylor Mich.,105
Crovello, Richard, "Steel Study," University of Houston, 67
Crovello, William, untitled, Lakeforest Shopping Center, Gaithersburg, Md., 109

Dalwood, Hubert, untitled, Southland Center, Taylor, Mich., 105
Daphnis, Nassos, untitled wall painting, New York, color plate 32
D'Arcangelo, Allan, untitled wall painting, New York, color plate 33
Davis, David E., "Harmonie Grid IX," Progressive Insurance Corporation Headquarters, Mayfield Heights, Ohio, 120
Dayton, Ohio, Federal Building, color plate 18
Dearborn, Mich., Fairlane Town Center, 110
den Arend, Lucien A. M., "Walburg, Project," Zwijndrecht, Holland,162
Des Moines, Iowa, Franklin Avenue Branch, Public Library, 37
de Swart, Jan, "Lincoln Tower," Lincoln Mall, Chicago, 103
de Swart, Jock, "Belay On," Westminster Mall, Westminster, Calif., 103
Detroit:
Blue Cross and Blue Shield of Michigan, 123
Capitol Park, 65
Manufacturers National Bank, Operations Center, 94, 97
Manufacturers National Bank, Tower 100, 94
Michael Berry International Terminal, Metropolitan Wayne County Airport, 48
Philip A. Hart Plaza, Horace E. Dodge & Son Fountain, Civic Center, 30 – 31
Plaza Hotel, 119, color plate 41
333 West Fort Building, color plate 43
Wayne State University, Health Care Institute, 106
Devan, Justine, and others, "Time to Unite," wall painting, Chicago, color plate 34
Dijon, France:
High School Marcelle-Parde, 146
University Campus, 146
Di Suvero, Mark:
"Motu," Federal Building, Courthouse Plaza, Grand Rapids, Mich., 14

"Snowplow," Indiana Convention and Exposition Center, Indianapolis, 18
Dobbs Ferry, N.Y., Mercy College, 75
Dordrecht, Holland, Refaja Hospital, landscape, 158, 159
Douglass, Lathrop, untitled wire sculpture, Belle Epine Shopping Center, near Paris, 145
Dublin:
Bank of Ireland, 166, color plate 75
Dun Ladghaire Shopping Center, 164
Irish Life Headquarters, color plate 74
University College, color plate 76
Duckworth, Ruth, "Clouds over Lake Michigan," Dresdner Bank, Chicago, 100
Dundalk, Ireland, P. J. Carroll and Company, Ltd., 166
Durst, David, "Max," Mercy College, Dobbs Ferry, N.Y., 75
Dwan, Virginia, and Michael Heizer, Collection, Nevada, 118
Dzamonja, Dusan, Highway Monument to the Revolution, Podgaric, Yugoslavia, 197

Edison, N.J., Charles T. Bainbridge and Sons, Inc., Headquarters Office,122
Edmonton, Alberta:
Edmonton Plaza hotel, color plate 42
Public Library, 116
Efrat, Beni, "Mural Mutation," Mount Carmel Leisure Center and Auditorium, Haifa, 170
Egger, Josef, untitled mural, City Recreation Center, Zurich-Oerlikon, 203
Eloul, Kosso:
"Anada," Sculpture Walk, Ottawa, 9
"Canadac,." Hamilton, Ont., Art Museum, Plaza, 69
Emery, Lin:
"Aquamobile," Fidelity Bank, Oklahoma City, 90
"Aquamobile and Memorial Column to de Lesseps S. Morrison," New Orleans, 19
"Magnetmobile," South Central Bell Company, Birmingham, Ala.,90
Engman, Robert:
"Triune," Girard Bank and the Fidelity Mutual Life Insurance Company, Philadelphia, 96
untitled, Woodfield Shopping Center, Schumberg, Ill., 108
Escobedo, Helen, "Signals," Auckland, New Zealand, harbor, 188
Eskolin, Veiko, "Water Sphere," Poutunpuisto Park, Nokia, Finland, 141
Esmonde-White, Eleanor, "Orpheus with His Lute," Nico Malan Theatre Centre, Cape Town, color plate 88
Eugene, Ore.:
Federal Building and U.S. Courthouse, 16
Oregon International Sculpture Symposium, 80 – 82
Evans, James., 43
Evry, France, 149

Felguerez Manuel, untitled mural, Alfa Cultural Center, Monterrey, Mexico,185
Ferber, Herbert, "Oval and Triangle," Ciba-Geigy Corporation Headquarters, Greensboro, N.C., 89
Feuerlicht, Herbert A., "Embrace," Office Building, East 65th Street, New York, 91
Ficheroux, Mathieu, portrait of Multatuli, wall painting, Rotterdam, 156
Field, Richard, "Memorial to American Bandshell," Nebraska Interstate 80 Project, 11

Fink, Robert, "Flame," Kensico Plaza, Valhalla, N.Y., 36
Fischer-Hansen, Else, "Complimentary Sun," Copenhagen County Hospital, color plate 53
Fitchburg, Mass., Public Library, 43
Flint, Mich.:
Genesee Mall Shopping Center, 106
Genesee Valley Center, Main Court,104
Flugelman, Bert, untitled, Festival Centre, Adelaide, South Australia, 30
Fort Worth, Tex., Municipal Building, 5
Fowler, Bob, untitled, University of Houston, 64
Fredericks, Marshall M.:
"Friendly Frog," play sculpture, Genesee Mall Shopping Center, Flint, Mich., 106
"Saints and Sinners," Oakland University, Rochester, Mich., 83
Fremont, Wash., "Waiting for the Interurban," 55
Friedberg, M. Paul, 43
Fromel, Gerda, "Sails," mobile pool sculpture, P. J. Carroll and Company, Ltd., Dundalk, Ireland, 166

Gaithersburg, Md., Lakeforest Shopping Center, 109
Gallagh, Robert, "People with a Modern Painting," Comercial Building, Clonmel, Ireland, 164
Galway, Ireland, University College, 166
Garden City, Mich., Osteopathic Hospital, Chapel, 117
Gee, Paula, "Break Away," mural, Old Hat Neighborhood Center, Chicago, 58, 59
Gehr, Andreas, fountain entrance, Utenberg School Center, Lucerne, 201
German, Charlotte, untitled, cemetery, Zollikerberg, Switzerland, 202
Gernes, Paul, untitled, Copenhagen County Hospital, color plate 55
Gibbs, Tom, "Broken from Whole," Franklin Avenue Branch, Public Library, Des Moines, Iowa, 37
Gilbert, James, "Spatial Transitions," Plaza Hotel, Edmonton, color plate 42
Gilhooly, David, "Seattle's Own Ark," Woodland Park Zoo, Seattle, 29
Gillespie, Dorothy, "Gambol Series #1," Parkway, Roosevelt Island, N.Y., color plate 23
Gladish, William, "People Seats," Downtown Public Square, Wilkes-Barre, Pa., 33
Goeritz, Mathias:
"The Big Dipper," Anderson Park, Aspen, Colo., 99
"Cocono," Manhattan Tower Office Building, Entrance Plaza, Mexico City, 184
"The Milky Way," Middelheim Park, Antwerp, 132
"The Pyramid of Mixocoac," Public Square, Mexico City, 184
Goss, Monique, wall painting, Wilkins Avenue and Payson Street, Baltimore, color plate 27
Governors State University, Park Forest South, Ill., 71
Grand Rapids, Mich.:
Belknap Park, 14
Civic Center Plaza, color plate 4
Courthouse Plaza, 14
fish ladder/sculpture, 14, 15
Granville, France, campus sculpture, 149
Grauman, Frank, 33
Greene-Mercier, Marie Zoe:
"Arboreal Form," Leucate, Barcares, 151
"Composition with Twenty Cubes," St. Nicolas-les-Arras, 150

Greensboro, N.C., Ciba-Geigy Corporation Headquarters, 89
Gregory, Kathe, "Ho' ele' elu," Honolulu International Airport, color plate 24
Grenoble, France, University, 153
Grigny-la-Grande, Borne, France, Housing Project, 146
Groth, Jan, "Sign," Radio and Television Headquarters, Denmark, 138
Gruen Associates, Southland Center, Taylor, Mich., 104 – 105
Gunnerud, Arne Vinje, "Gerd and Froy," Aker Hospital, Oslo, 189
Gussow, Roy, "Two Forms," Combustion Engineering Corporation, Stamford, Conn., 120

Haarlem, Holland, drawbridge connecting Heenstade with Schalwijk, color plate 71
Haas, Richard, "City Scenes," Boston, color plate 29
Hadzi, Dimitri:
 "Basalt Forms," Oregon International Sculpture Symposium, Eugene, 82
 "River Legend," Federal Building, Portland, Oreg., 6
Hague, The, City Center, 160
Haifa, Israel:
 Mount Carmel Leisure Center and Auditorium, 170
 sculpture along sea highway, 175
Hajek,, O.H.:
 Adelaide, South Australia, Festival Centre, color plates 50 – 52
 "Environmental City Symbol," Bonn, color plate 67
 Regional Headquarters, City Plaza, Schwelm, color plate 66
 sign, City Plaza, Wiesbaden, 204
 "3-Gliederung," plaza near Stuttgart, 205
Halahmy, Oded, "Talisman," U.S. Federal Building Plaza, New York, 43
Halprin, Lawrence, 26 – 29
Hamden, Conn., Hamden Plaza, Shopping Center, parking lot, 98
Hamilton, Ont., Art Museum, Plaza, 69
Hamrol, Lloyd, "Soft Wall for Artpark," Artpark, Lewiston, N.Y., 57
Handy, Arthur, untitled, Lester B. Pearson Building, Ottawa, 49
Hansen, Svend Wiig, untitled, Aarhus University, Physics Building, 138
Hatchett, Duayne, "Equilateral Six," Federal Office Building, Courthouse, Rochester, N.Y., 24
Hayden, Michael:
 "Arc-en-ciel," subway station, Toronto, color plate 5
 "Ice Wedge," Ontario Place, Toronto, 118
Heiberg, Kasper, "Environmental Atmosphere," Skjoldhoj Kollegiet, Brabrand, Denmark, color plates 57, 58
Heizer, Michael:
 "Adjacent, Against, Upon," Myrtle Edward City Park, Seattle, 22
 "Complex One/City," Collection: Virginia Dwan and Michael Heizer, Nevada, 118
 "This Equals That," State Capitol Pedestrian Plaza, Lansing, Mich., 23
Held, Al, "Order/Disorder/Ascension/Descension," Social Security Administration Mid-Atlantic Program Center, Philadelphia, 21
Helsinki:
 Children's Playground, Myllypuro, 142
 City Hall, 142
 Hesperia Hotel, Pool Plaza, 143
 waterfront, 140

Henderson, Jean, "City Spirits '76," Louisville, color plate 30
Henry, John R., "Illinois Landscape # 5," Governors State University, Park Forest South, Ill., 71
Herning, Denmark, Carl-Henning Pedersen and Else Alfelts Museum, 139
Hicks, Sheila:
 "Conditioned by Life and Death," curtain, City Hall, Montreuil, France, 145
 "Migration of Birds," banners, First National Bank, Little Rock, Ark., color plate 47
Highland Heights, Ky., Northern Kentucky University, 75
Highland Park, Ill., City Hall, Parkway, 5
Highland Park, Mich., Community College, 59
Hill, Barbara, N'debele Wall Replication," Highland Park, Mich., Community College, 59
Honegger, Gottfried, "Homage to Jacques Monod," Dijon University Campus, 146
Honolulu:
 Federal Building, U.S. Courthouse, color plate 11
 International Airport, 46, color plate 24
 Municipal Building, 17
Horowitz, Marvin, untitled, Charles T. Bainbridge & Sons, Inc., Headquarters Offices, Edison, N.J., 122
Houdain, France, College d'Enseignement Secondaire (Secondary School), 144
Houston, Tex., Rothko Chapel, 62
Houston, University of, 63 – 65, 67
Howard, Linda:
 "Round About," University of Houston, College of Optometry, 65
 "Up Over," Nebraska Interstate 80 Bicentennial Sculpture Project, color plate 1
Huhtamo, Kari, "Monument for the Rebuilding of Lapland," Rovaniemi, 142
Hunt, Richard:
 "Historical Circle" and "Peregrine Section," University of Michigan, Bentley Library, Garden, 66
 "Martin Luther King Memorial," Memphis, Tenn., 44
 "Richmond Cycle," Social Security Administration Building Plaza, Richmond, Calif., 20
 "Slabs of the Sunburnt West," University of Illinois at Chicago Circle, 77

Ihara, Michio:
 untitled, Christian Pavilion, Expo '70, Osaka, 181
 untitled, Fitchburg, Mass., Public Library, 43
 untitled, International Building, Rockefeller Center, New York, 125
 untitled, Saigo Hospital, Kumamoto, 181
Iida, Yoshikuni:
 untitled, Museum of Art, Utsanomiya, 179
 untitled, Namegawa Island, 179
Indianapolis, Indiana Convention and Exposition Center, 18
Iowa City, University of Iowa, 66
Is-sur-Tille, France, College Paul-Port, 147

Jacksonville, Fla., Police Memorial Building, 25

Janema, Arie, untitled sculpture wall, Interpolis Insurance Company, Tillburg, Holland, 156
Janesville, Wis., Shopping Center, 101
Jerusalem:
 Hadassah University Hospital, 171
 Jerusalem Theater, 167
 Memorial Building Sacher Park, 167
 President's House, 168 – 169
Johannesburg:
 Esselyn Towers, 194
 Exchange Square, 195
 Jan Smuts Airport, color plate 89
Jonsson, Ted, fountain, Seattle Water Department Maintenance and Control Center, color plate 22
Judd, Donald, "Box," Northern Kentucky University, Highland Heights, Ky., 75
Junno, Tapio, "Love on the Alert," Children's Playground, Myllypuro, Helsinki, 142

Kadishman, Menashe:
 Inspiration," Habima National Theater Square, Tel Aviv, 171
 "Trees," Lehigh University, Saucon Valley Athletic Complex, 68
 untitled, President's House, Garden, Jerusalem, 168
Kagawa-ken, Japan, Ohbayshi Hospital, 180
Kaivanto, Kimmo:
 "Chain (A Positive Visionary Diagonal)," City Hall, Helsinki, 142
 "Ode to the 60,000 Lakes," Hesperia Hotel, Helsinki, 143
Kansas City:
 downtown, 45
 Loose Park, "Wrapped Walkways," color plate 49
Kaplan, Penny, "The Queen's Chamber," Westchester County Courthouse Plaza, White Plains, N.Y., 37
Katzen, Lila, "Oracle," University of Iowa Museum, 66
Kelly, Lee:
 fountain, Portland Mall, Portland, Oreg., 26
 "Waterfall, State, and River," University of Houston, Cullen Family Plaza, 65
Kepes, Gyorgy, untitled, Commodore John Rogers Elementary School No. 27, Baltimore, color plate 20
Kibbutz en Shemer, Israel, park, 172
Kibbutz Hazorea, Israel, 173
King, Brian, untitled, University College, Galway, Ireland, 166
King City, Canada, property of Roger Davidson, earth sculpture, 99
Kingston, Ont., Queen's University, 69
Kinnebrew, Jospeh E.:
 "Fish Ladder," Grand Rapids, Mich., 14, 15
 IV-III/4K spun aluminum spheres, Wayne State University, Health Care Institute, Detroit, 106
Kirkpatrick, Diane, 23
Knodel, Gerhardt:
 "Free Fall," Plaza Hotel, Detroit, color plate 41
 "Gulf Stream," University of Houston, Library, 63
 "Sky Ribbons: An Oklahoma Tribute," Alfred P. Murrah Federal Building, Oklahoma City, color plate 13
Kortrijk, Belgium, Exposition Grounds, 133
Kralingen, Holland, waterworks, 157
Krebs, Rockne:
 "Canus Major" and "Atlantis," Omni International Megastructure, Atlanta, 102

"Green Isis," Artpark, Lewiston, N.Y., 57
Kreilick, Marjorie, untitled mosaic, Mayo Clinic, Rochester, Minn., 117
Kristianstad, Sweden, Museum Plaza, 201
Kuemmerlein, Janet, "Odyssey," Social Service Administration Building, Richmond, Calif., color plate 12
Kuh, Katherine, 5
Kumamoto, Japan, Saigo Hospital, 181

Lahiti, Finland, Municipal Hospital Plaza, 143
Lansing, Mich., State Capitol Pedestrian Plaza, 23
Laranjeira dos Santos, Joaquim, "I° Travessa Aerea," Tower of Belem, Garden, Lisbon, 190
Lardera, Berto, "Deesse Antique," High School Marcelle-Parde, Dijon, 146
Las Vegas, Nev., Theater for the Performing Arts, 92
Lehigh University, Allentown, Pa., 68
Leiria, Cristina, environmental painted murals, The New University of Lisbon, Municipality of Alamada, Portugal, color plate 86
Leroy, Hugh, untitled, Sculpture Walk, Ottawa, 10
Le Tendre, Rita, untitled, Toronto subway station, color plate 6
Leucate, Barcarès, France, 151
Lewiston, N.Y. (see Artpark)
Liberman, Alexander, "All," Ciba-Geigy Corporation Headquarters, Greensboro, N.C., 89
Lichtenstein, Roy, untitled, Santa Anita Fashion Park, Regional Shopping Center, Arcadia, Calif., 95
Lincoln, Nebr., Federal Building, 18
Lindblom, Sivert, Stockholm subway station, color plate 100
Line, Austria, Bruckner Concert Hall, 132
Lipchitz, Jacques:
 "Bellerophon Taming Pegasus," Columbia University, New York, School of Law, 70
 "Government of the People," Municipal Service Building Plaza, Philadelphia, 4
 "Tree of Life," Hadassah University Hospital, Jerusalem, 171
Lipkin, Aileen, "Growth," Exchange Square, Johannesburg, 195
Lippold, Richard:
 "Ad Astra—'To the Stars,'" National Air and Space Museum, Washington, 68
 untitled, Fairlane Town Center, Dearborn, Mich., 110
Lipton, Seymour, "Laureate," Milwaukee Center for the Performing Arts, 69
Lisbon:
 Calouste Gulbenkian Foundation, 193
 Funchal Hospital, Garden, 193
 Tower of Belem, Garden, 190
Littel, Sander, untitled, environmental sculpture, Middleburg, Holland, 163
Little Rock, Ark., First National Bank, color plate 47
London:
 Department of Environment, Headquarters, 140
 Royal Exchange, 140
Longarone (Cadore), Italy, Church, 177
Lorcini, Gino, untitled, Sculpture Walk, Ottawa, 9
Los Angeles Times-Mirror Newspaper Company, Costa Mesa, Calif., 55
Louisville, Ky.:
 R. L. White Company, color plate 45
 wall painting, color plate 30

Lower Columbia College, Longview, Wash., Learning Resources Center Building, 73
Lucerne, Utenberg School Center, 201
Luz, Arturo R.:
 untitled, Fast Food Center, Manila, 190
 untitled tapestry, Philippine Plaza Hotel, Manila, 191
Lyngby, Denmark, City Library, *color plate 54*
Lyon, France:
 Auditorium de la Parc Dieu, 150
 Graduate School of Commerce, 153

McCarter, Keith, screen wall, Department of Environment Headquarters, London, 140
McClure, Tom, "Universe," Blue Cross and Blue Shield of Michigan, Service Center, Detroit, 123
McCracken, Philip, "Freedom," Federal Office Building, Seattle, 40
McDonnell, Joseph Anthony, "Again," Janesville, Wis., Shopping Center, 101
McElcheran, William, untitled Sculpture Walk, Ottawa, 8
Macomb County Community College, Warren, Mich., 71
Madox, Robert, wall, Wilkins Avenue and Payson Street, Baltimore, *color plate 27*
Madrid, Plaza de Colon, City Center, 198–199
Madureira, Maria Manuela, "Grito de Dor, Grito de Alegria," Funchal Hospital, Lisbon, 193
Maki, Robert:
 "Trapezoid E," Federal Building and U.S. Courthouse, Court, Eugene, Oreg., 16
 untitled, sculpture fountain, Portland Mall, Portland, Oreg., 26
Manchester, England, Arndale Shopping Center, 141
Mandal, Norway, Public Square, 189
Mangold, Robert, "Correlation," Federal Building, Columbus, *color plate 14*
Manila:
 Cultural Center of the Philippines, 191
 Fast Food Center, Court, 190
 Philippine Plaza Hotel, Cultural Center Complex, 191
 wall painting, Roxas Boulevard, *color plate 84*
Mannheim, West Germany, Rosengarten Theater and Conference Center, 206
Mariano, untitled, Cuban Embassy, Mexico City, *color plate 83*
Markson, Jerome, untitled, Larry Sefton Memorial Parkette for the United Steelworkers of America, Toronto, 100
Marseille, Science Building, Court of the Amphiteaters, 154
Martens, Chris, "Centripeton," Spitznagel Partners Office Building, Sioux Falls, S. Dak., 101
Mass and Individual Moving (artist group), "Sound Stream," Vlissingen, Holland, 162
Massapequa, N.Y., Sunrise Mall, 89
Mathieu, Herve, untitled, Paris Metro station, *color plate 65*
Mayers and Schiff, posters for New York subway station, 52
Mayfield Heights (Cleveland area), Ohio, Progressive Insurance Corporation Headquarters, 120
Meade, George, "City Spirits '76," Oakland, Calif., *color plate 28*
Meadmore, Clement:
 "Split Level," University of Houston, Continuing Education Center, 63

"Verge," Empire State Plaza, Albany, 44
Melioni, Regis:
 "Beast," Downtown Public Square, Wilkes-Barre, Pa., 33
 "Petroglyph," Downtown Public Square, Wilkes-Barre, Pa,. 33
Memphis, Tenn., Mid-America Mall, 42–44
Mercy College, Dobbs Ferry, N.Y., 75
Metz, France, Lycée Technique d' Etat Louis Vincent, 150
Mexico City:
 College of Civil Engineering, *color plate 80*
 Cuban Embassy Building, *color plate 83*
 "Eugenia" Housing Complex, Sculpture Plaza, 186
 Hotel Camino Real, *color plate 81*
 Manhattan Tower Office Building, Entrance Plaza, 184
 National University of Mexico, campus, spacial sculpture project, 187
 Polyform Building, *color plate 82*
 Public Square, Mixcoac, 184
Michaels, Glen, untitled, Tower 100, Manufacturers National Bank, Detroit, 94
Michelucci, Giovanni, Church of Longarone, Italy, 177
Michigan Artrain, 61
Middleburg, Holland, grounds near Provinciale Waterstaad, 163
Miller, Richard, "Sandy in Defined Space," University of Houston, Science and Research Building, 63
Milwaukee:
 Center for the Performing Arts, 69
 Northridge Shopping Center, 111
Mohr, Dietrich:
 gate, College d'Enseignement Secondaire, Bordeaux-Begles, 144
 untitled, College d'Enseignement Secondaire, Houdain, 144
Monterry, Mexico, Alfa Cultural Center, 185
Montreuil, France, City Hall, Lobby Entrance, 145
Montvale, N.J., Monsanto Corporation, *color plate 46*
Moon, Milton, "Glover Memorial Fountain," Adelaide Festival Centre, South Australia, 131
Moore, Charles, fountain, Piazza d'Italia, New Orleans, 32
Moore, Henry, "Sheep Sculpture," Lake of Zurich, Public Park, 202
Morais, A., environmental painted murals, The New University of Lisbon, Municipality of Almada, Portugal, *color plate 86*
Morgan, William, fountain, Police Memorial Building, Jacksonville, Fla., 25
Mork, Lennart, Stockholm subway station, *color plate, 98*
Morris, Robert, "Earth Sculpture," Belknap Park, Grand Rapids, Mich., 14
Moser, Wilfred, untitled, Public Square, Zurich, 203
Motonaga, Sadamasa, untitled, Saigo Komika Public Bath, Osaka, 183
Mount Vernon, N.Y., American Plastic Molding Corporation, 120
Municipality of Almada, Portugal, The New University of Lisbon, *color plate 86*
Munich-Perlach, West Germany, Neue Heimat Bayern, 207
Munsterlagen, Switzerland, Canton Thurgovia Hospital, 200
Murphy, Harry untitled, Lakeside Shopping Center, Sterling Heights, Mich., 110

Murray, Robert, "Tundra," Sculpture Walk, Ottawa, 10

Naarden, Holland, Coordination Building, *color plate 69*
Namegawa Island, Japan, 179
Nashville, Tenn., Commerce Place, Lobby, 102
Naylor, Geoffrey, "Artifact," Federal Building and U.S. Courthouse, Orlando, Fla., *color plate 7*
Ndebele Village, Republic of South Africa, *color plates 90–93*
Nebraska Interstate 80 Bicentennial Sculpture Project, 11–13, *color plates 1–3*
Negev, Israel, Sde-Boker College Grounds, 175
Nery, Eduardo:
 exterior gate facade, Todos-os-Santos, Lisbon, *color plate 85*
 environmental painted murals, The New University of Lisbon, Municipality of Almada, Portugal, *color plate 86*
 pavement, Main Square, Redondo, Portugal, 192
Neuilly, France, Roche S. A. Headquarters, 147
Nevelson, Louise:
 "Bicentennial Dawn," William J. Green, Jr., Federal Building and James A. Byrne U.S. Courthouse, Philadelphia, 6
 "Celebration II," Pepsico World Headquarters, Purchase, N.Y., 91
 "Shadows and Flags," Louise Nevelson Plaza, New York, 25
 "Trilogy," Bendix Corporation Headquarters, Southfield, Mich., 107
New Jersey Port Authority, 45
New Orleans:
 Civic Center, 19
 Piazza d'Italia, 32
New York:
 Columbia University, School of Law, 70
 Federal Building Plaza, 43
 La Guardia Place, 38–39
 Louise Nevelson Plaza, 25
 Office Building, East 61st Street, Entrance Plaza 91
 Parkway, Roosevelt Island, *color plate 23*
 Rockefeller Center, International Building, 125
 subway stations, Pelham Parkway IRT, 52
 wall painting, 26th Street and Madison Avenue, *color plate 32*
 wall painting, 64th Street between Amsterdam and West End Avenues, *color plate 33*
 YWCA, wall painting, *color plate 31*
Newman, Barnett, "The Broken Obelisk," Rothko Chapel, Houston, Tex., 62
Niagara Falls, N.Y. (see Artpark)
Nicholson, Patrick J., 64
Niemeyer, Oscar:
 Cathedral of Brazil, Brasilia, 137
 Hotel Nacional, Rio de Janeiro, 137
Niiza City, Japan, Municipal Office Building, 182
Noguchi, Isamu:
 Hart Plaza and Fountain, Detroit, 30–31
 "Landscape of Time," Federal Building Plaza, Seattle, 7
 "Sky Gate," Municipal Building Civic Center Area, Honolulu, 17
Nokia, Finland, Poutunpuisto Park, 141
Norris, George:
 fountain, Botanical Gardens, Vancouver, 76
 untitled, University of Calgary, 76

North Pietersburg, South Africa, Sculpture Park near highway, 194
Northern Kentucky University, Highland Heights, Ky., 75
Nova Milano, Brazil, Federal Roadside, 135
Novi, Mich., Twelve Oaks Shopping Center, 112–113
Novros, David, untitled mural, University of Texas, Dallas, 72
Nymegen, Holland, University, campus, 161

Oakland, Calif., wall painting, *color plate 28*
Oakland University, Rochester, Mich., 83
Oklahoma City:
 Alfred P. Murrah Federal Building, *color plate 13*
 Fidelity Bank, 90
Okumura, Lydia:
 "Disappearance of Perspective," Museum of Contemporary Art, Annual Exhibition, Campinas, São Paulo, 134
 "Positive and Negative—Breath of Earth," Museum of Contemporary Art, Annual Exhibition, Campinas, São Paulo, 135
Oldenburg, Claes:
 "Batcolumn," Social Security Administration Plaza, Chicago, 7
 "Clothespin," Central Square Plaza, Philadelphia, 16
Oliner, Eric, 33
Olsson, Sigvard, Stockholm subway station, *color plate, 102*
Oregon International Sculpture Symposium, Eugene, 80–82
Orion, Ezra, environmental art, Sde-Boker College Grounds, Negev, Israel, 175
Orlando, Fla., Federal Building and U.S. Courthouse, *color plate 7*
Orlowski, Dennis, "Nigeria Street Scene," Highland Park, Mich., Community College, 59
Orskov, Willy, untitled, City Library Lyngby, Denmark, *color plate 54*
Osaka, Japan:
 Christian Pavilion, Expo '70, 181
 Saigo Komika Public Bath, 183
Oseotuk (Eskimo), "Inuksh'ook," Lester B. Pearson Building, Ottawa, 49
Oslo:
 Aker Hospital, 189
 Stovner subway station, 189
Oss, Holland, Post Office, *color plate 70*
Ostrov, Lyn, untitled, Greater Baltimore Medical Center, *color plate 26*
Otero, Alejandro, "Delta Solar," Smithsonian National Air and Space Museum, Washington, 54
Ottawa:
 Lester B. Pearson Building, Department of External Affairs, 49
 Sculpture Walk, 8–10
Otterlo, Holland, Kroller-Muller Museum, Garden, 163, *color plate 68*
Overhoff, Jacques, "Socio Sculpture Garden," San Francisco College, 73

Padovano, Anthony:
 "Nebraska Gateway," Nebraska Interstate 80 Project, 11
 "Probe," University of Northern Iowa, Cedar Falls, 72
 "Spherical Division," downtown, Kansas City, 45
Pappas, John Nick, untitled, Blue Cross and Blue Shield of Michigan, Detroit, 123

Papua/New Guinea School of Art, students, house post, Adelaide Festival Centre, South Australia, 131

Paris, Harold, untitled, Northridge Shopping Center, Milwaukee, 111

Paris:
La Défense, fountain, *color plates 60–62*
La Défense, monument at Metro Station, 148
École National d'Administration, 152
Metro stations, 152, *color plates 63–65*
Les Olympiades Building Complex, 152

Park Forest South, Ill., Governors State University, 71

Patel, Narendra, "Detroit Panorama," Manufacturers Bank, Southfield, Mich., 117

Peart, Jerry:
"Devil's Heart," Twelve Oaks Shopping Center, Novi, Mich., 113
"Falling Meteor," Governors State University, Park Forest South, Ill., 71

Pedersen, Carl-Henning, facade, Carl-Henning Pedersen and Else Alfelts Museum, Henning, Denmark, 139

Penalba, Alicia, fountain, Roche S.A. Headquarters, Neuilly, France, 147

Petri, Hans:
concrete forms, Erasmus University campus, Rotterdam, 159
landscape, Refaja Hospital, Dordrecht, 158, 159

Philadelphia:
Central Square Plaza, 16
Girard Bank and Federated Mutual Life Insurance Company Plaza, 96
Municipal Service Building Plaza, 4
Sheraton Airport Inn, entrance, 96
Social Security Administration Mid-Atlantic Program Center, 21
William J. Green, Jr., Federal Building and James A. Byrne U.S. Courthouse, 6, 21, *color plate 10*

Phillips, James, untitled, Luther Craven Mitchell Primary Center No. 135, Baltimore, *color plate 19*

Pinheiro, Jorge, pavement, Central Plaza, Aveiro, Portugal, 192

Podgaric, Yugoslavia, Highway Monument to the Revolution, 197

Pomodoro, Arnaldo, "Grande Disco," North Carolina Independence Plaza, Charlotte, N.C., 93

Portland, Oreg.:
Civic Auditorium, Forecourt, 26
Federal Office Building, 6, *color plate 16*
Portland Mall, 26
Transit Mall, 27, 28

Porto Alegre, Brazil, City Plaza, 134

Pressman, Hope Hughes, 80

Proaza, Spain Hydroelectric Power Plant, 196

Purchase, N.Y., Pepsico World Headquarters, 91

Quebec, Performing Arts Theater, 50–51

Queen's University, Kingston, Ont., 69

Quinton, Pamela Weir, play sculptures, Santa Anita Fashion Park, Regional Shopping Center, Arcadia, Calif., 95

Radek, Celia:
"The Fruits of Our Labor," wall painting, Chicago, *color plate 36*
"Razem," wall painting, Chicago, *color plate 35*

Radycki, Lucyna, "Roots and Wings," Chicago Lawn community, 58

Raimondi, John, "Erma's Desire," Nebraska Interstate 80 Project, *color plate 2*

Ramat Gan, Israel, King David's Park, 173

Ramos, Salvador, 60

Ranum Teachers Training College, Denmark, *color plate*, 56

Rappoport, Nathan:
"Jacob Wrestling with the Angel," YM-YWHA Plaza, Toronto, 54
"Scroll of Fire," B'nai B'rith Martyrs' Forest, near Jerusalem, 170

Recanati, Dina, "Crown of Jerusalem," President's House Garden, Jerusalem, 168

Redondo, Portugal, Main Square, 192

Redpath, Norma, untitled, fountain, Treasury Building, Canberra, Australia, 130

Redstone, Louis G.:
"Eternal Hope," Jewish Community Center, West Bloomfield, Mich., 48
untitled Brick mural, First Federal Bank of Detroit, 119
untitled tapestry, 333 West Fort Building, Detroit, *color plate 43*

Redstone, Louis G., Associates, Southland Center, Taylor, Mich., 104–105

Rehmann, Erwin:
"Plane Pond Span," Canton Thurgovia Hospital, Munsterlingen, Switzerland, 200
"Sculptured Island," tramway station, Blecherweg, Zurich, 200
"Tree-Stump Figure," cemetery, Bottmingen, Switzerland, 200

Reilinger, Roda:
Memorial to Two Kibbutz Members, Amnon and Hanan, Fallen in 1967 War," Kibbutz en Shemer, Israel, 172
untitled fountain sculpture, Ramat Gan, Israel, 173
untitled wall, Kibbutz Hazorea, Israel, 173

Reis, Jon, untitled mural, Commerce Place, Nashville, Tenn., 102

Richmond, Calif., Social Security Administration Building, 20, *color plate 12*

Rickey, George:
"Space Churn with Two Spheres," Neue Heimat Bayern, Munich-Perlach, 207
"Twelve Triangles," Municipal Building, Fort Worth, 5
"Two Planes Vertical Horizontal, Var. 1," downtown, Kansas City, 45
"Two Rectangles Vertical Gyratory," University Clinic, Berlin, 207

Rieti, Fabio, "Tobacco Pots," mosaic, Grigny-la-Grande, Borne, Housing Project, 146

Rietta, John, untitled, Federal Building and Courthouse, Roanoke, Va., 24

Rifle, Colo., Grand Hogback, "Valley Curtain," *color plate*, 48

Rio de Janeiro:
Hotel Nacional, 137
Monument to Youth, Culture, and Sport, 136
Shopping Center, Niteroi, 136

River Forest, Ill., Rosary College, 83

Roanoke, Va., Richard H. Poff Federal Building and Courthouse, 24

Rochester, Mich., Oakland University, 83

Rochester, Minn., Mayo Clinic, 117

Rochester, N.Y., Federal Office Building, Courthouse, 24

Rodriguez, Manuel, Jr., "Antoinette's Dream," wall painting, Manila, *color plate 84*

Rohm, Robert:
"Untitled 1977 (Artpark Shelf)," 56
"Untitled 1977 (Artpark Small Shelf,)" 56

Roling, Louis C., painting on drawbridge, Haarlem, Holland, *color plate*, 71

Rosa, Artu, "Sculpture and Relief," Calouste Gulbenkian Foundation, Lisbon, 193

Rosary College, River Forest, Ill., 83

Rosenthal, Bernard, "Turning Piece," Oregon International Sculpture Symposium, Eugene, 82

Ross, Charles, prismatic sculpture, Federal Building, Lincoln, Nebr., 18

Rothko, Mark, paintings, Rothko Chapel, Houston, Tex., 62

Rotterdam, Holland:
Erasmus University, campus, 159
wall painting on street, 156

Rovaniemi, Finland (Lapland), "Monument for the Rebuilding of Lapland," 142

Rovigo, Italy, elementary school courtyard wall, 178

Rubin, Reuben, President's House, Jerusalem, reception hall, 169

"Running Fence," Sonoma and Marin Counties, Calif., 114–115

Rutzky, Ivy Sky, "Glacial," Macomb County Community College, Warren, Mich., 71

Ruusuvaara, Liisa, "Flower Greeting," Municipal Hospital, Lahiti, Finland, 143

Safed, Israel, Sculpture Garden, 155

Safir, Moshe, sculpture, Sculpture Garden, Safed, Israel, 155

St. Louis, Mo., Mercantile Tower, North Patio, 124

St. Nicholas-les-Arras, France, court, 150

Saint-Quentin-en-Yvelines, France, community buildings, front lawn, 154

Ste. Geneviève des Bois, France, school, 148

Salem, Oreg., Oregon State Building, 36

Sanchez Macgregor, Joaquin, 187

San Francisco College, Bateman Hall, 73

Sano, Masumi, "Boy," Ohbayashi Hospital, Kagawa-ken, Japan, 180

Santa Rosa, Calif., Federal Office Building, *color plate 9*

Santen, Christa van, "Faces," Prinses Christianaschool, Zoetermeer, Holland, 156

Santen, Joost van, untitled, Coordination Building, Naarden, Holland, *color plate 69*

Sato, Mamoru, "Dyad," Honolulu International Airport, 46

Sax, Ursula:
"Allee," Training Center for Volunteers for Underdeveloped Countries, Berlin, 204
untitled wall, Commerce Building, Berlin, 205

Scarff, S. Thomas, "Pipevine Swallowtail 1544," Twelve Oaks Shopping Center, Novi, Mich., 112

Schatz, Bezalel:
President's House, Jerusalem, entrance gates, 169
untitled, Memorial Building, Jerusalem, 167

Schultz, Saunders (see Severson, William)

Schultze, Klaus, "Reclined Man," Saint-Quentin-en-Yvelines, community building, 154

Schumburg, Ill., Woodfield Shopping Center, 108

Schwartz, Buky, untitled, Lakeforest Shopping Center, Gaithersburg, Md., 109

Schwelm, West Germany, Regional Headquarters, City Plaza, *color plate 66*

Scully, Larry, "The Mandorla Murals," Stellenbosch University, Cape Town, 194

Searles, Charles, "Celebration," William J. Green Jr. Federal Building and James A. Byrne U.S. Courthouse, Philadelphia, *color plate*, 10

Seattle, Wash.:
Federal Office Building, 7, 20, 40
Freeway Park, 29
Gasworks Park, 41
Myrtle Edward City Park, 22
Water Department, Maintenance and Operations Control Center, *color plate 22*
Waterfront Park, 40
Woodland Park Zoo, 29

Sebastian:
play sculpture, "Eugenia" Housing Complex, Mexico City, 186
untitled, city sculpture, Villahermosa, 186
untitled, mural, College of Civil Engineering, Mexico City, *color plate 80*

Segal, George, "The Restaurant," Federal Building, Buffalo, 4

Sekine, Nobuo:
"Cone," Tochigi Museum, Japan, 182
"Walking Stones," Municipal Office Building, Niiza City, Japan, 182

Serra, Richard:
"Shift," environmental earth sculpture, King City, Canada, 99
"Spin Out," Garden, Kroller-Muller Museum, Otterlo, Holland, 163

Severson, William, and Saunders Schultz:
"Aspirations," Martin Luther King Memorial Station, Rapid Transit Authority, Atlanta, Ga., 121
"Computer Connectors," Blue Cross and Blue Shield Building, Chapel Hill, N.C., 121
"Synergism," Mercantile Tower, North Patio, St. Louis, 124

Sharma, N.M., fountain, City Centre, Chandigarh, India, 165

Shemi, Y., untitled, Jerusalem Theater, Jerusalem, 167

Silva, F., environmental painted murals, The New University of Lisbon, Municipality of Alamada, Portugal, *color plate 86*

Simkin, Phillips, "Choices Prototype," maze, Artpark, Lewiston, N.Y., 57

Sioux Falls, S. Dak., Spitznagel Partners Office Building, 101

Siqueros, Polyform Building, Mexico City, *color plate 82*

Skidmore, Owings, and Merrill, 26–28

Slade, Roy, 78

Slepak, Paul, "Pumping for Sedgwick," Twelve Oaks Shopping Center, Novi, Mich., 112

Smit, Josje:
wall decoration, Nederlandsche Middenstands-Bank, Amsterdam, *color plate 73*
wall decoration, Zeist Insurance Company, Amsterdam, *color plate 72*

Smith, Sherri, "Firedrake," Federal Office and Courthouse Building, Ann Arbor, Mich., *color plate 15*

Smith, Tony, "She Who Must Be Obeyed," Labor Department Building, East Plaza, Washington, D.C., 17

Smithsonian National Air and Space Museum, Washington, D.C., 54, 68

Smyth, Ned, "Reverent Grove," Federal Building, St. Thomas, U.S. Virgin Islands, 32

Snelson, Kennneth:
"Easy Landing," Maryland Science Center, Baltimore, 32
untitled, Woodfield Shopping Center, Schumburg, Ill., 108
Snoek, Jan, untitled, Post Office, Oss, Holland, *color plate 70*
Snyder, Don:
"Sorcerer's Apprentice," Theater for the Performing Arts, Las Vegas, 92
stained glass window and stainless steel sculpture, Osteopathic Hospital Chapel, Garden City, Mich., 117
Sonfist, Alan, "Time Landscape," La Guardia Place, New York, 38–39
Sotho Village, Republic of South Africa, *color plates 94–97*
Southfield, Mich.:
Bendix Corporation Headquarters, 107
Manufacturers Bank, 117
Stackhouse, Robert, "Cranbrook Dance," Cranbrook Academy of Art, Bloomfield Hills, Mich., 79
Stahly, Francois, "Labyrinth," Tower Building, Empire State Plaza, Albany, 18
Stamford, Conn., Combustion Engineering Corporation, 120
Stellenbosch, South Africa, University, 194, *color plate 87*
Sterling Heights, Mich., Lakeside Shopping Center, 110
Stiebel, Hanna, "Source II," Plaza Hotel, Detroit, 119
Stockholm, subway stations, *color plates 98–102*
Stuart, Imogen, "The Scholar and His Cat," Dun Ladghaire Shopping Center, Dublin, 164
Stuttgart, Germany, plaza near, 205
Sugarman, George, "Baltimore Federal," Edward A. Garmatz Federal Building, U.S. Courthouse, Plaza, Baltimore, 24
Szekely, Pierre:
"La Boule," Vitry-sur-Seine, 148
"La Dame du Lac," Evry, 149
"L'Homme Libre," La Défense Metro station, Paris, 148
"Observatoire a Einstein," Ste. Geneviève, des Bois, school, 148
"Variations sur les Armes," campus sculpture, Granville, 149

Takiguchi, Masaru, "Ocean," University of Houston, 67
Tamayo, untitled mural Hotel Camino Real, Mexico City, *color plate 81*
Tawney, Lenore, "The Cloud," Federal Office Building, Santa Rosa, Calif., *color plate 9*
Taylor, Tom, untitled, IBM house, Wellington, New Zealand, 188
Tel Aviv, Israel:
City Hall Plaza, *color plates 78, 79*
Habima National Theater Square, 17 ı
Marina, *color plate 77*
Tenius, Carlos Gustavo:
"Monument to Acorianos," Porto Alegre, Brazil, 134
"Monument to Italian Immigration Centennial," Nova Milano, Brazil, 135
Tessier, Adam, "Le Cosmos," Metro station, Paris, *color plate 64*
The New University of Lisbon, Municipality of Almada, Portugal, *color plate 86*
Tilburg, Holland, Interpolis Insurance Company, 156

Tinguely, Jean, "Chaos No. 1," Commons and Courthouse Center, Columbus, Ind., 95
Tinsley, Barry, "The Arch of Prometheus," Twelve Oaks Shopping Center, Novi, Mich., 113
Tochigi, Japan, museum, 126
Tokyo, Medical Treatment Center of Setagaya, 180
Toronto:
Glencairn subway station, *color plate 6*
Larry Sefton Memorial for the United Steelworkers of America, Parkette, 100
Meteorological Building, 53
Ontario Place, 118
Tenth International Sculpture Conference, *color plates 37–40*
YM-YWHA Plaza, 54
Yorkdale subway station, *color plate 5*
Townley, Hugh, "Eugene Group," Oregon International Sculpture Symposium, Eugene, 80, 81
Tremois, Pierre-Yves, "Energies," Metro station, Paris, *color plate 63*
Troy, Mich.:
First Federal Bank of Detroit, 119
Oakland Mall Shopping Center, 106
Somerset Inn, Plaza Entrance, 119
Truedsson, Folke, "Sinfonia," Museum Plaza, Kristianstad, Sweden, 201
Tsutakawa, George, "Spirit of Spring," Somerset Inn, Troy, Mich., 119
Tulsa, Okla., First National Bank, 92
Tumarkin, Igael:
"Earth," Marina, Tel Aviv, *color plate 77*
"Monument for the Holocaust and Revival," Tel Aviv, *color plates 78, 79*
"Reflecting Wall No. 1," Boston University campus, 70
"Seats and Table," Arad, Israel, 174
"Signpost," Haifa, Israel, 175
"Sundial," Ashkelon, Israel, 175
Turcias, Vaquero:
"Monument to the Discovery of America," Plaza de Colon, Madrid, 198–199
monumental sculpture, "Y" highway crossroad, Asturias, Spain, 197

Ultvedt, Per Olof, Stockholm subway, *color plate 101*
University of Akron, Ohio, Guzzetta Hall Music, Speech, and Theatre Arts Building, 77
University of Calgary, Alberta, 76
University of Houston, Tex., 63–65, 67
University of Illinois at Chicago Circle, 77
University of Iowa, Iowa City, 66
University of Michigan, Ann Arbor, 66
University of Northern Iowa, Cedar Falls, 72
University of Texas, Dallas, Texas Health Center, Gooch Auditorium, 72
Uthaug, Jorgen, "Expansion," Public Square, Mandal, Norway, 189
Utrecht, Holland, University, fountain, 160
Utriainen, Raimo, "Outdoor Sculpture," Helsinki, 140
Utsunomiya, Japan, Museum of Art, 179

Valhalla, N.Y., Kensico Plaza, 36
"Valley Curtain," Rifle, Colo., *color plate 48*
Vancouver, B.C.:
Botanical Gardens, 76
Oceanic Plaza Office Building, 116

Van de Bouvenkamp, Hans, "Roadway Confluence," Nebraska Interstate 80 Project, 11
Van der Waat, Hannetjie, "Abstract 1 '78," Sculpture Park, North Pietersburg, South Africa, 194
Van Nuys, Calif., Federal Building, 20
Vaquero Palacios, Joaquin, Hydroelectric Power Plant, Proaza, Spain, 196
Vasarely, Victor, untitled, Science Building, Marseille, 154
Venice:
oldest wall of Campo di Nuovo Ghetto Synagogue, 178
proposal for renovation of Molino Stucky, Guidecca Island, 176
Villa, Edoardo, "Suspended Sculpture," Warmbaths, South Africa, 195
Villahermosa, Mexico, City Square, 186
Vincent-Alleaume, Yvette, Cergy-Pontoise, school entrance court, 154
Visieux, Claude:
"Clepsydre," Les Olympiades Building Complex, Paris, 152
"Sablier," University of Grenoble, 153
"Strucutre Suspendue," Metro station, Harve-Caumartin, Paris, 152
untitled, École Nationale d'Administration, Paris, 152
untitled, Graduate School of Commerce, Lyon, 153
Vitry-sur-Seine, France, plaza, 148
Vlissingen, Holland, wind organ, 162
Volten, André:
"Luftbrunnen" (air conditioning), Rosengarten Theater and Conference Plaza, Mannheim, West Germany, 206
untitled, waterworks, Kralingen, Holland, 157
untitled, waterworks, Weesperkarspel, Holland, 157
Von Ringelheim, Paul:
"Arrival," Nebraska Interstate 80 Project, 11
"Continuum III," Worcester Center, Downtown Commercial Complex, Worcester, Mass., 87
Von Schlegel, David:
untitled, India Wharf at Harbor Towers, Boston, 91
"Voyage of Ulysses," William J. Green, Jr. Federal Building and James A. Byrne U.S. Courthouse Plaza, Philadelphia, 21
Voulkos, Peter, untitled, Highland Park, Ill., City Hall Parkway, 5

Warmbaths, South Africa, Public Resort, 195
Warren, Mich., Macomb County Community College, 71
Washington, D.C.:
Labor Department Building, 17, *color plate 17*
Smithsonian National Air and Space Museum, 54, 68
Wayne State University, Detroit, Health Care Institute, 106
Weesperkarspel, Holland, waterworks, 157
Wejchert, Alexandra:
"The Flowing Relief," Bank of Ireland, Dublin, *color plate 75*
untitled, Irish Life Headquarters, Dublin, *color plate 74*
untitled, University College, Dublin, *color plate 76*

Wellington, New Zealand, IBM House, 188
Wells, Betty, "Love," Furman L. Templeton Elementary School No. 125, Baltimore, *color plate 21*
West Bloomfield, Mich., Jewish Community Center, 48
West Orange, N.J., 200 Executive Hill Office Building, 122
Westminister, Calif., Westminister Mall, 103
White Plains, N.Y., Westchester County Courthouse, Plaza, 37
Wiesbaden, West Germany, City Plaza, 204
Wilkes-Barre, Pa., Downtown Public Square, 33
Williams, Sherman, "N'debele Wall Replication," Highland Park, Mich., Community College, 59
Williamson, Anne, untitled, Police Memorial Building, Jacksonville, Fla., 25
Wilson, David, 33
Wines, James:
"Ghost Parking Lot," Hamden Plaza Shopping Center, Hamden, Conn., 98
proposal for renovation of Molino Stucky, Guidecca Island, Venice, 176
Woodson, Van, untitled, Greater Baltimore Medical Center, *color plate 26*
Woody, Howard, "Sky Sculpture," Tenth International Sculpture Contest, Toronto, *color plates 37–40*
Worcester, Mass., Worcester Center, 87
"Wrapped Walk Ways," Loose Park, Kansas City, *color plate 49*

Yasko, Caryl, and others:
"Razem," wall painting, Chicago, *color plate 35*
"Roots and Wings," Chicago Lawn community, 58
Young, Robert, Detroit Metropolitan Wayne County Airport, frieze and columns, 48
Youngerman, Jack, "Rumi's Dance," Federal Office Building, Portland, Oreg., *color plate 16*
Youngman, Robert, "Industrial Images," Manufacturers Bank Operations Center, Detroit, 97
Yuhara, Kazuo:
"Sun and Verdure," Medical Treatment Center of Setagaya, Tokyo, 180
untitled, Chiba College of Technology, 180

Zach, Jan, 80
"Drapery of Memory," Oregon State Building, Salem, 36
"Galaxy," Lower Columbia College, Longview, Wash., 73
Zimmelova, Olga, "Vulkan," Utenberg School Center, 201
Zoetermeer, Holland, Prinses Christianaschool, 156
Zollikerberg, Switzerland, cemetery, 202
Zuniga, Francisco, "Woman with Shawl," University of Houston, McIlhinney Hall, 64
Zurich, Switzerland:
Lake of, Public Park, 202
Public Square, 203
tramway station, Blecherweg, 200
Zurich-Oerlikon, City Recreation Center, 203
Zwijndrecht, Holland, environmental sculpture, 162